THE MATERIALS AND METHODS OF SCULPTURE

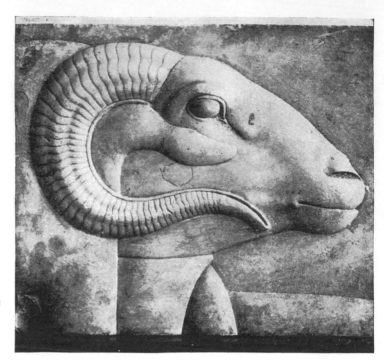

A. RAM'S HEAD. Late Dynastic
or early Ptolemic.

Egyptian Sculptors' Models

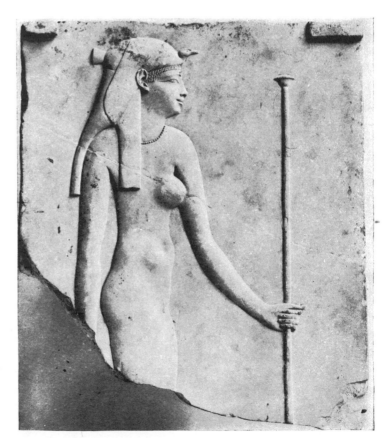

B. FIGURE OF A GODDESS.
Relief. Limestone. xxvi Dynasty.
Models carved by the master
sculptors either for apprentices
to copy for practice, or as a
guide for work on a statue or
relief. On the back is another
figure, of a king.

THE MATERIALS

AND METHODS

OF SCULPTURE

JACK C. RICH

DOVER PUBLICATIONS, INC., NEW YORK

Published in Canada by General Publishing Company, Ltd., 30 Lesmill Road, Don Mills, Toronto, Ontario.
Published in the United Kingdom by Constable and Company, Ltd.

This Dover edition, first published in 1988, is an unabridged and unaltered republication of the ninth printing (1973) of the work first published by Oxford University Press, Inc., New York, in 1947.

Manufactured in the United States of America
Dover Publications, Inc., 31 East 2nd Street, Mineola, N.Y. 11501

Library of Congress Cataloging in Publication Data

Rich, Jack C., 1914–
The materials and methods of sculpture.

Reprint. Originally published: New York : Oxford University Press, 1947.
Bibliography: p.
Includes index.
1. Sculpture—Technique. 2. Artists' materials. I. Title.
NB1170.R5 1988 731′.028 88-7144
ISBN 0-486-25742-8

TO JUDITH AND JENNIFER

PREFACE

A KNOWLEDGE OF MATERIALS is the foundation upon which real achievement is based.

The true sculptor possesses for his material a respect that is the result of a knowledge and understanding of the substances with which he works, and that is further enhanced by the pleasure of executing the material with his own hands.

Primitive and peasant art are examples of the great strength and power achieved when the artist is at once the conceiver and the doer of the work.

This book is designed primarily to meet the needs of the student sculptor and to supplement his enthusiasms and experiences, for although one may pioneer by sheer enthusiastic application and persistence, a factual knowledge of media facilitates practical achievement. It is hoped that the book may also prove of value to the professional sculptor.

To cover in precise detail the technical aspects of the sculptor's art is to cover a field so broad as to require several volumes. This book is an attempt to present a comprehensive picture of the anatomy of sculpture, with specific references to the materials used, the properties of these materials, and the methods employed in their use, together with pertinent historical and other notes, and a recording of the trends in contemporary sculpture. The whole is colored by the point of view of the most advanced modern sculptors: the indissoluble relation of material to subject and treatment.

The volume is arranged in large and compact divisions. For purposes of clarity and precision, new terms and phrases have been introduced where it was found necessary and desirable to do so. The subject of clay is, for example, divided into Plastic Earths and Plastic Waxes, the first to include water-base earth-clays, and the second to embrace artificially compounded wax or oil-base modeling clays. Where the term clay is used by itself, it generally has a twofold connotation, to include both varieties.

Liquids, such as acid and water combinations, are generally measured in terms of volume. Solids are generally measured by weight.

There are no short cuts in the mastery of an art. The elements must be mastered by hard work and persistent study. The dictum that perpetual practice or application is the only way in which an art or craft may be mastered is particularly true of the sculptor's art.

An effort has been made wherever possible to illustrate the text with examples selected from contemporary sculpture, and acknowledgment is made to the many sculptors who have co-operated with me and who have furnished photographs of their work.

Grateful acknowledgment is made to the many organizations and individuals who have provided me with technical information and photographic material: to Riccardo Bertelli of the Roman Bronze Works for reading the section devoted to the technical aspects of bronze casting; to the Revertex Corporation of America for information on latex; to the U. S. Gypsum Company for reading the chapter devoted to plaster of Paris; to the Catalin Corporation of America for reading the section on plastics; to Frank Jansma of the B. F. Drakenfeld Company for data on earth-clays; to Dr. F. H. Pough, Curator of Physical Geology and Mineralogy, American Museum of Natural History, for reading a portion of the chapter on stone; to Dr. Robert W. Hess, Yale University, School of Forestry, for reading a portion of the chapter on wood; to Donald P. Falconer for reading the section on oxychloride cements; to the Portland Cement Association for reading the section on concrete and for several text illustrations; and to Wallace Kelly, formerly of the Metropolitan Museum of Art, for reading the sections devoted to plaster and gelatine casting.

Acknowledgment and appreciation are also due to Professor A. Philip McMahon of New York University for helpful suggestions; to my sister and to Robert Barri for reading and correcting portions of the manuscript; to Leon Schwartz, who made several of the necessary photographs; and to the many friends with whom I have discussed my problems and who made helpful suggestions.

The drawings illustrating the text are by the author, except where otherwise indicated.

J. C. R.

New York City
June 1947

CONTENTS

LIST OF PLATES

LIST OF FIGURES

PLATES

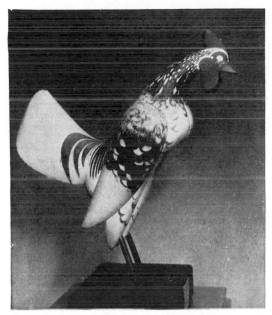

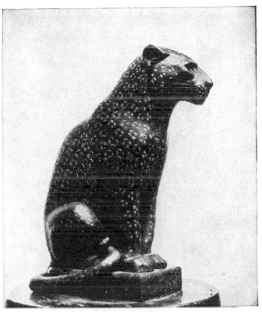

A. COCK, by Emma L. Davis. A painted wood carving, mounted on copper legs. 13½ inches.

B. LEOPARD, by Paul Manship. This interesting work, apparently inspired by Oriental metal sculpture, is inlaid with silver spots. Bronze. 1931.

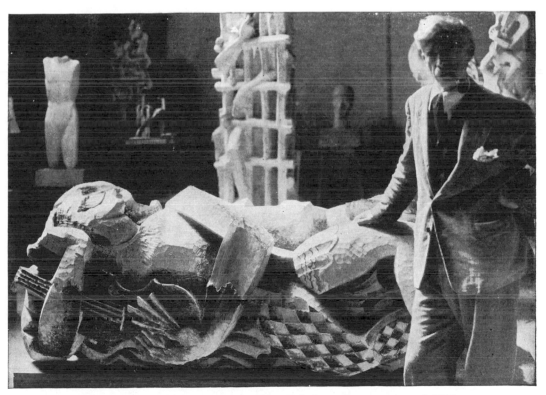

C. IL PENSEROSA, by Ossip Zadkine. Polychromed sycamore wood. 1945.

PLATE 1

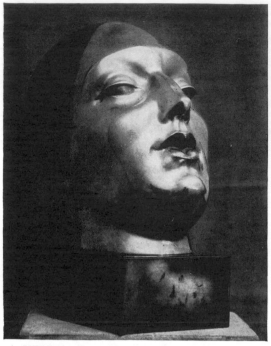

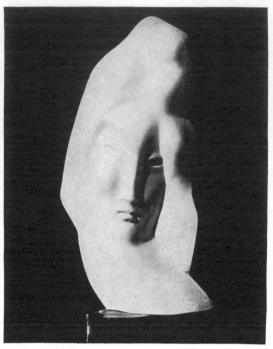

A. HEAD, by Gaston Lachaise. Nickel-plated bronze. 13¼ inches. 1928.

B. THE PAST, by Alexander Archipenko. Silver-plated bronze mask. 14 inches.

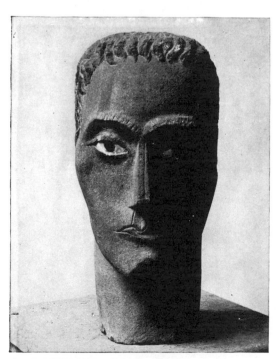

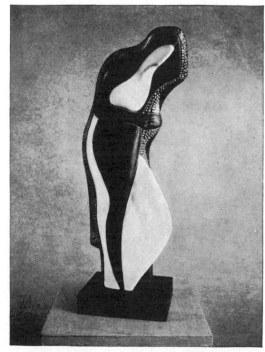

C. LIMESTONE HEAD WITH MARBLE-EN-CRUSTED EYES, by Ossip Zadkine. 1934.

D. WHITE AND BLACK, by Alexander Archipenko. Terra-cotta inlay. 20 inches. 1938.

PLATE 2

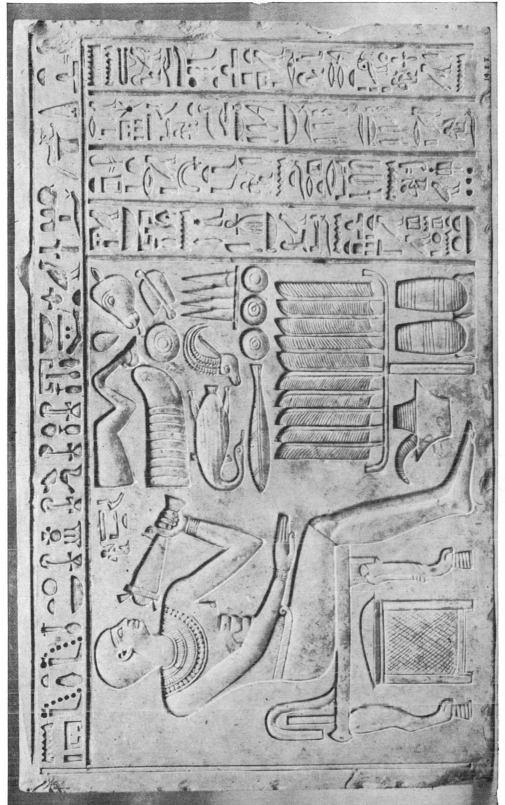

EGYPTIAN LIMESTONE STELA. xi Dynasty. Coelanaglyphic or inverse bas relief. c.2150 B.C.

PLATE 3

A. OLD MAN: Subway subject, by Jack C. Rich.　　B. DERELICT: Subway subject, by Jack C. Rich.

C. PANTHER, by Gaudier-Brzeska. Rapid sketch done on scrap paper.

PLATE 4

A. PENCIL STUDY, by Fred R. Peloso.

B. ACROBATS, by Chaim Gross. Pencil drawing. 1935.

C. STANDING NUDE, by Gaston Lachaise. Pencil drawing. c.1927.

PLATE 5

A. OBERMENZING: IRON BAPTISTRY GRILLE, by Hans Panzer. Church of the Passion.

B. PARIS: DEBUSSY MONUMENT. Panel by Jan and Joël Martel.

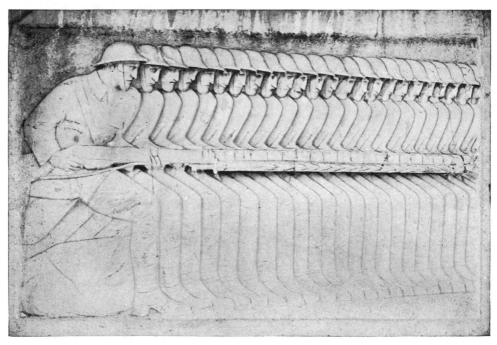

C. THE CANADIAN PHALANX, by Ivan Meštrović. A simple and direct War Memorial, utilizing the Greek practice of superimposition of planes. 1918.

PLATE 6

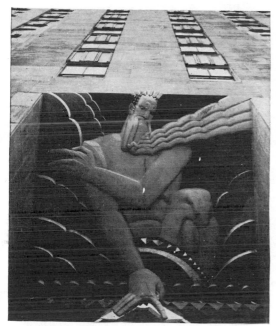

A. WISDOM, designed by Lee Lawrie. Polychromed glass relief, over the main entrance of the RCA Building, Rockefeller Plaza, New York City. The work is painted in brilliant red, gold, and black, with a solution of water-glass and pigment applied with a brush, and personifies the mathematical science involved in the creation of such architecture.

B. NIGHT, by Jacob Epstein. London: Underground Railways Offices Building.

C. VIENNA: KARL MARX HOF, sculpture by Josef Riedl and Otto Hofner.

PLATE 7

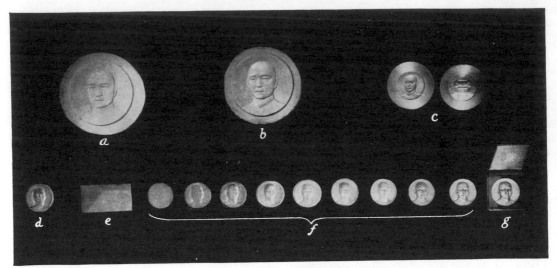

A. FROM MODEL TO MEDAL: THE SUN YAT SEN MEDAL, by Robert Aitken.

a.
b. } Original metal models.

c. Steel dies for both sides of the medal.

d. Lead impression. Should changes be desired in the die, they are made at this stage.

e. The bronze blank from which a circular disc is cut out for the medal.

f. Strikes. The first disc represents the bronze circle cut from the rectangular blank. The others illustrate the evolution of the medal. Striking is a gradual process. After each strike, annealing is required before restriking.

g. The finished medal in its case.

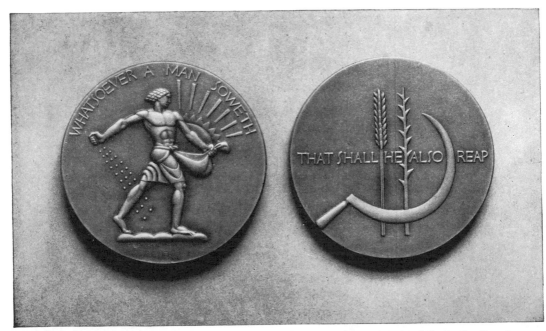

B. WHATSOEVER A MAN SOWETH, THAT SHALL HE ALSO REAP (medal), by Lee Lawrie.

PLATE 8

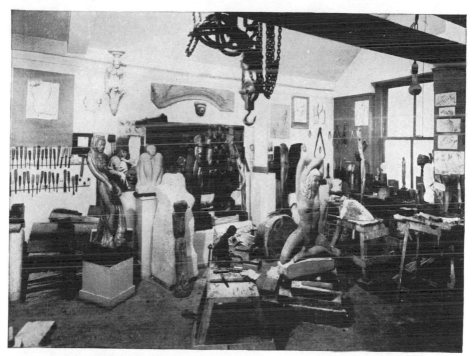

A. A WELL-ORGANIZED STUDIO. Finished pieces are set against the wall, while pieces being worked are arranged in the center of the studio. The block of plastic secured in a vise in the foreground is in the process of being carved directly. A block and tackle on an overhead beam solves the problem of lifting heavy stone masses.

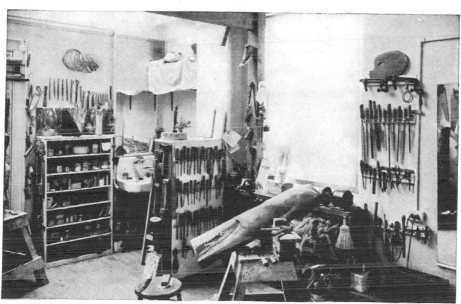

B. A CORNER OF HESKETH'S STUDIO. Clay modeling tools hang on the rear wall. The back of the center cabinet serves as a rack for wood-carving tools, while the front portion is used to contain stone-carving chisels and points. Some stone carving hammers can be seen hanging on the side of the cabinet. In the foreground a block of wood is in the process of being carved directly. To the right are hung files, pliers, and odd tools.

PLATE 9

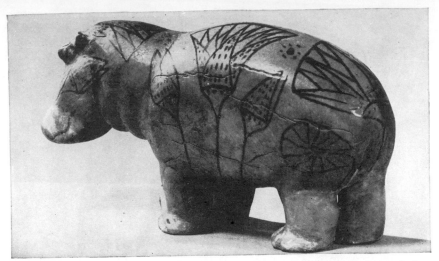

A. HIPPOPOTAMUS. Faïence. Egyptian, XII Dynasty (2000-1788 B.C.) An earth-clay form covered with a beautiful rich blue glaze. The drawings of the lotus flower suggest the native habitat of the animal and, by following the masses, also serve to emphasize the form. *c.*8 inches long.

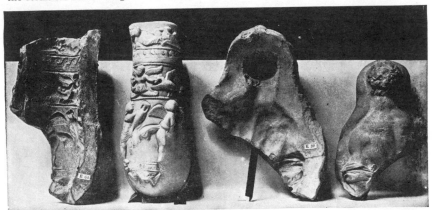

B. GREEK TERRA-COTTA MOLD FRAGMENTS. The numbered fragments represent the original terra-cotta negatives, while the objects on their right are recently fashioned positive impressions.

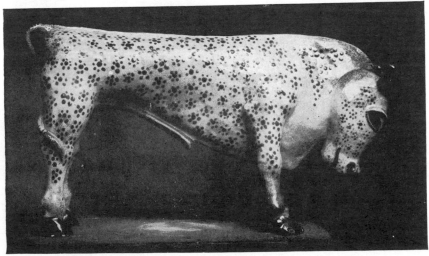

C. BUIL, by Carl Walters. Glazed ceramic. 8¼ inches high.

PLATE 10

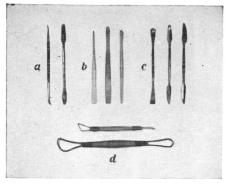

A. MODELING TOOLS.
 a. Metal tools. b. Wooden tools.
 c. Metal tools with serrated edges; also
used in working plaster.
 d. Double-ended wire tools.

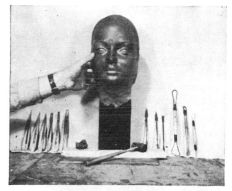

B. MODELING. The thumb and fingers
are considered by many modelers to be
superior to tools in clay modeling.

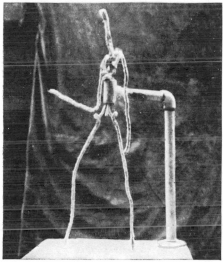

C. A FIGURE ARMATURE. The lead or
aluminum wire is generally supported by
an iron rod secured to the baseboard, since
the wire framework is more or less flexible
and the added weight of the clay masses
might otherwise cause a sagging of the
armature and masses, or an actual collapse.

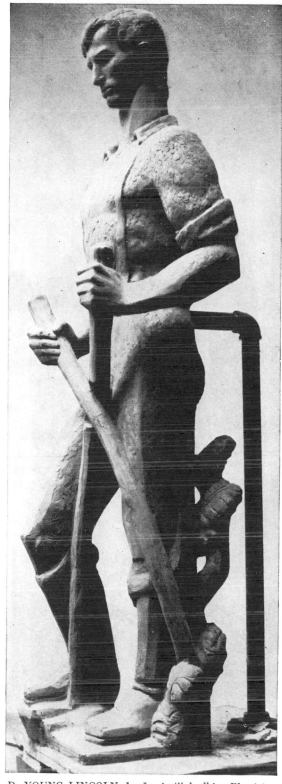

D. YOUNG LINCOLN, by Louis Slobodkin. Plasticine
model showing the armature supporting piping.

PLATE 11

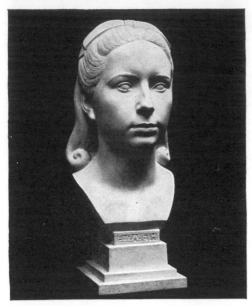

A. ELIZABETH, by Paul Manship. A sensitive and delicately executed life-size portrait head in terra cotta. An excellent example of the meticulous detail that can be achieved in this highly plastic material.

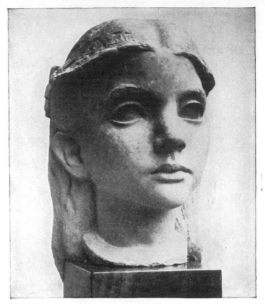

B. DALE, by Berta Margoulies. A life-size head in terra cotta. The piece was modeled directly in a solid manner, and then cut up into sections, hollowed, rejoined, and fired, after which it was worked for textural qualities.

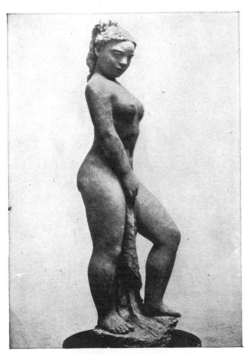

C. YOUNG GIRL, by Berta Margoulies. Terra cotta. Modeled directly in a hollow form over a small metal rod armature that projected to the hip and was removed after the work had been begun.

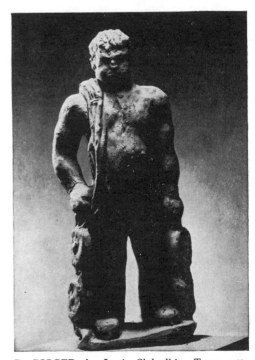

D. RIGGER, by Louis Slobodkin. Terra cotta. 20 inches.

PLATE 12

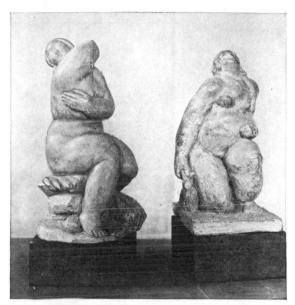

A. TERRA-COTTA STUDIES, by José de Creeft.

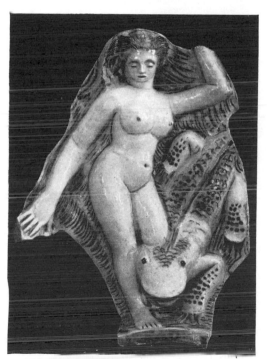

B. NUDE WITH ALLIGATOR, by Henry Varnum Poor. Ceramic. 20½ inches.

C. TORSO, by Henry Varnum Poor. Terra cotta. 21 inches.

PLATE 13

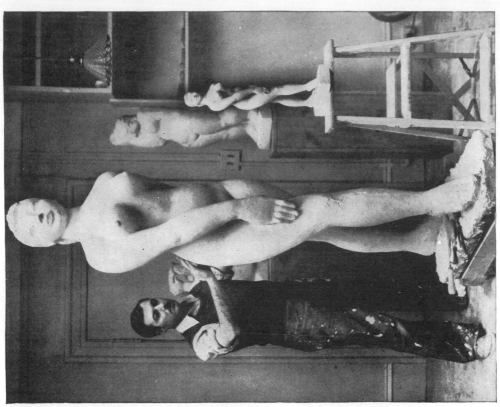

B. John Hovannes finishing plaster NUDE. It was made over a metal armature covered with burlap and plaster. A pointing machine was used and nails were imbedded to mark each point. Plaster was added to the height of the nail tops.

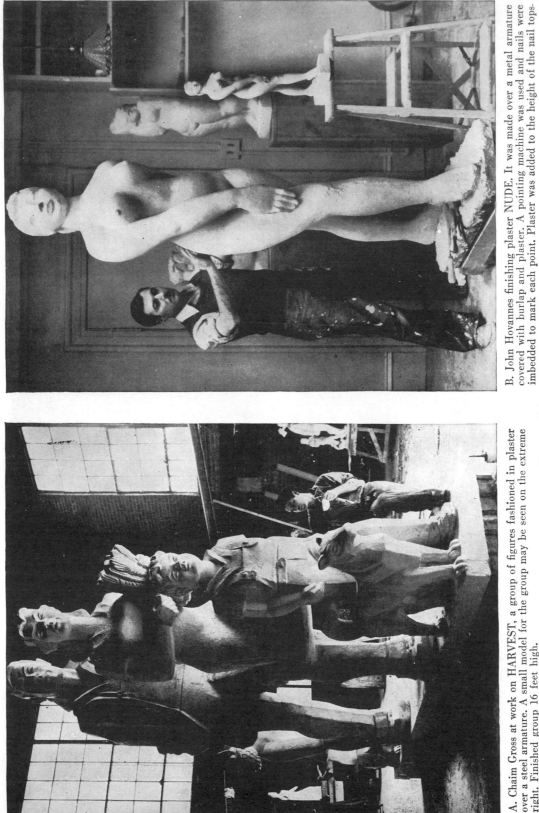

A. Chaim Gross at work on HARVEST, a group of figures fashioned in plaster over a steel armature. A small model for the group may be seen on the extreme right. Finished group 16 feet high.

PLATE 14

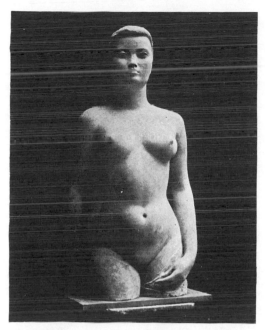

A. TORSO, by Concetta Scaravaglione. Plaster. Life size.

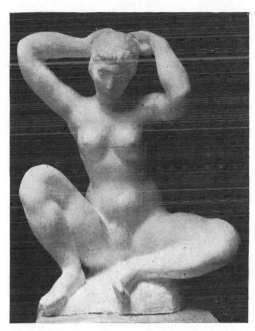

B. BETHSHEBA, by Louis Slobodkin. Plaster. Almost life size.

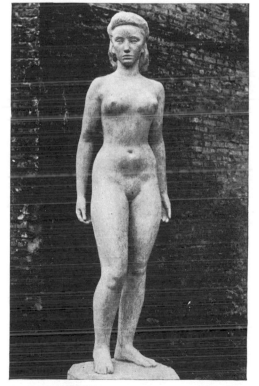

C. ADOLESCENCE, by Berta Margoulies. Plaster. Over life size.

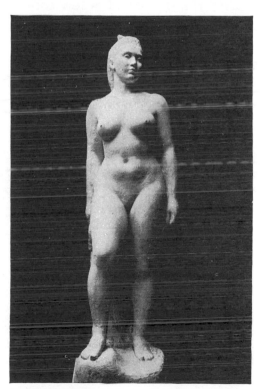

D. GIRL WITH TOWEL, by Dorothea Greenbaum. Plaster. 5½ feet. 1938. Roughly cast in a waste mold and worked upon by the artist after its removal from the negative. It is hollow and reinforced with iron supports.

PLATE 15

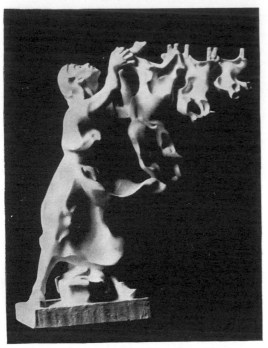

A. MONDAY AFTERNOON, by John Hovannes. Reinforced plaster. 16 by 14 inches.

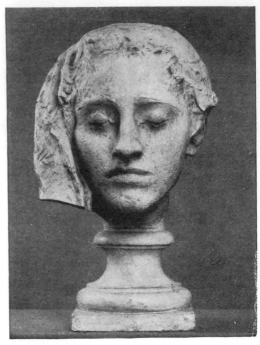

B. HEAD, by Andrew O'Connor. Plaster. 22 inches.

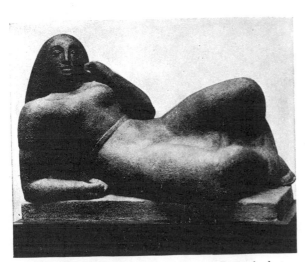

C. RECLINING GIRL, by Clara Fasano. Patined plaster. About life size.

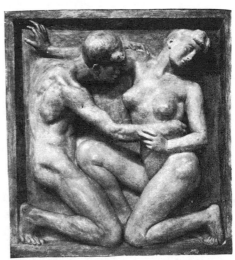

D. DESIRE, by Aristide Maillol. Plaster relief. 47 by 45 inches.

PLATE 16

A. WALLING OFF A RELIEF FOR CASTING.

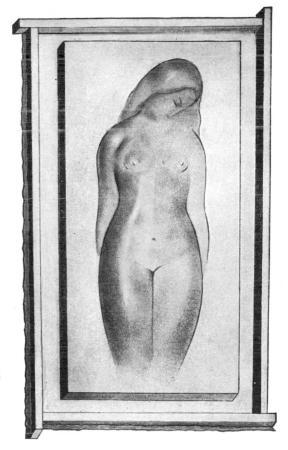

COMPOSITION CLAY STRIP → WOOD FENCE

BASE BOARD

B. PIECE MOLDING IN PLASTER OF PARIS, from the French *Encyclopédie*. The top and middle illustrations show the two halves of the piece mold, with the sections in place and with the registration holes and projections which guarantee the perfect fitting of the negative halves when they are placed together for casting the positive. The seam lines on the positive cast, illustrated at the bottom, are carefully removed after the casting has been completed.

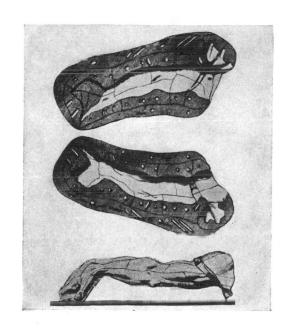

PLATE 17

a. The cardboard outline frame is placed in position on the subject's face before the first application of the agar composition.

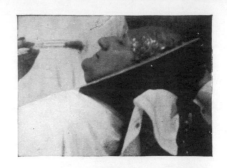

b. The second application of agar is being completed with a larger brush. The nostril openings are left free.

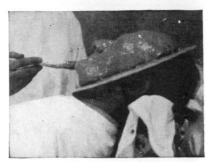

c. Breathing tubes are next placed in position in the nose.

d. The third coating of agar is now applied with a larger, flat brush.

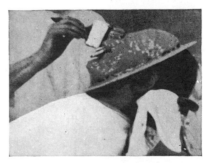

e. Anchor wires are placed at prominent points over the forehead, nose, chin, and about the edges of the agar negative mass.

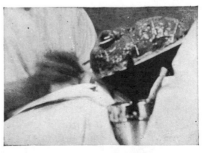

PLATE 18

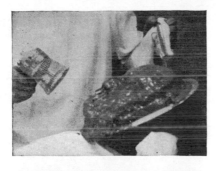

f. A small electric fan is used to speed the setting of the agar.

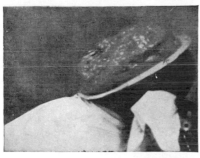

g. The completed negative is ready for reinforcement with a casing or mother-mold of plaster of Paris.

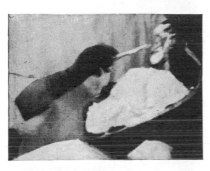

h. Application of the plaster.

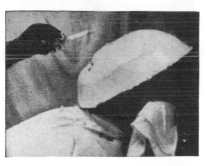

i. The finished negative mold is ready for removal.

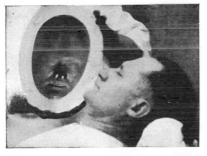

j. Internal view of the agar negative showing the finely detailed impression the material takes. The negative is now ready to be charged with plaster of Paris or other positive material.

MAKING AN AGAR FACE MOLD

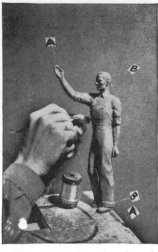

1. Fine wire is first placed on the plasticine figure along the mold-cutting or separation lines, and each wire is marked. The wire applied last is removed first in the final mold-cutting stage, as shown in #5. By placing the wire in a zigzag pattern keys can be made in the negative mold. The sections of the piece mold should not have undercuts.

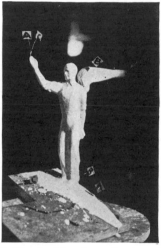

3. The final brush application of the plaster of Paris.

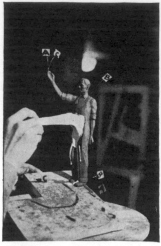

2. The negative plaster of Paris coat is applied with a broad, soft brush. The mix was prepared by using equal parts (by weight) of plaster of Paris and water. The powdered plaster was sieved slowly into the water, permitted to stand for a minute, stirred for a minute, and then used.

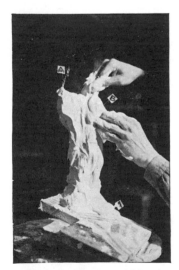

4. When the plaster mold has begun to set, the fingers are used to build up quickly a heavier mold thickness.

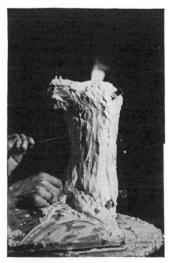

5. When the negative mass has achieved the consistency of butter, the wires are pulled, cutting it into pieces. The last wires are pulled first and the first wires last.

PLATE 19

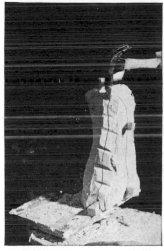

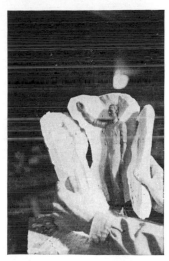

6. After about 25 or 30 minutes following the wire-pulling, a flat is cut along the lengths of the mold dividing lines. Notch marks are also made for matching the mold sections perfectly. Long, thin, hardwood wedges are then driven into the negative mold wherever they are required to separate the piece mold parts and permit the removal of the original.

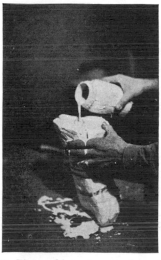

7. The original plasticine form is removed from the negative mold.

8. The mold parts are cleaned and treated with separator, after which they are reassembled, securely bound together, and the positive material poured to charge the mold.

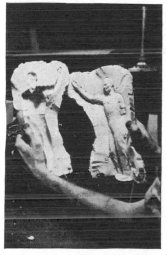

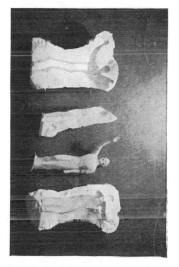

9. Removing the positive cast from the negative mold.

10. The positive cast is now ready for retouching and the removal of the seam lines.

Making a Wire-cut Plaster Piece Mold

1. Beginning the sand molding. The plaster model is placed in a bed of specially cohesive French sand.

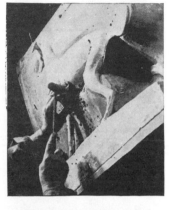

2. Separate piece molds are made of all projecting parts of the model, so it can later be removed without breaking the mold.

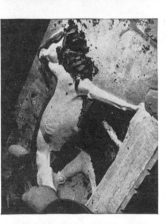

3. The plaster cast is turned over and sections are also made of the overhanging parts of the other side.

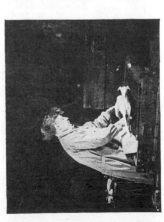

4. When sections are in place and powdered with bone dust, the whole surface is covered with sand for the top model.

5. The top of the mold is next removed, the mold sections remaining on the plaster model.

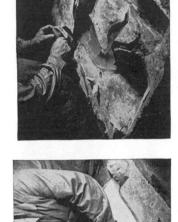

6. In order to release the plaster cast, the mold sections are carefully removed.

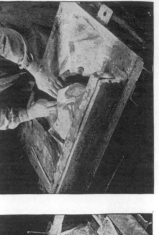

7. The mold parts are carefully reassembled in the second mold. Should one fall apart while the bronze is being poured, the entire cast would be ruined.

8. Because of its weight, a bronze cast is rarely cast solid; a 'false' core is made of sand to achieve a hollow casting.

PLATE 20 THE SAND-MOLD PROCESS

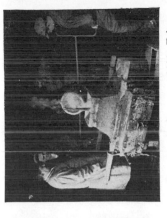

9. The top surface of the core is determined by the other mold.

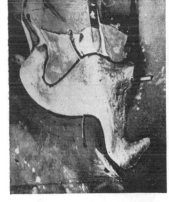

10. Preparing the 'gates' or channels through which the molten bronze will race. The mold and core mass are now dried by baking and the molds are smoked to prevent sand from adhering to the bronze. Iron rods suspend the core in place.

11. The molten bronze will fill the open spaces between the core and the mold. The legs of the animal will be cast solid.

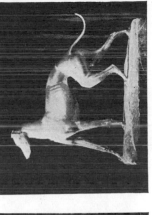

12. Pouring the bronze at 1900° Fahrenheit.

13. The bronze cast is removed from the mold while it is still hot and the surface is cleaned with acid.

14. Removing the false core.

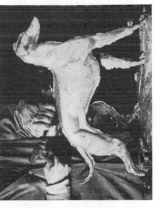

15. Chasing is now begun, after which the surface is patined.

16. The finished piece.

PLATE 21 THE SAND-MOLD PROCESS (*Continued*)

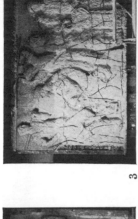

1

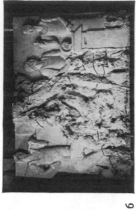

2

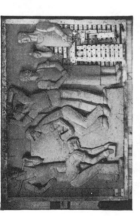

3

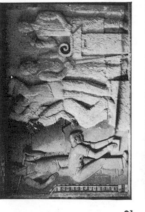

4

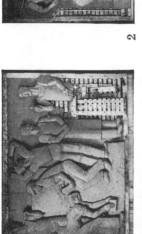

5

6

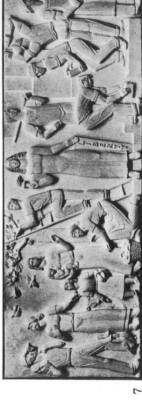

7

1. The earth-clay modeling material is applied over a lath-strip armature and modeled.

2. When the modeling has been completed, a facing coat of colored plaster of Paris is applied over the relief.

3. A second, heavier coating of white plaster is then fashioned over the tinted layer to form the negative body, which is physically reinforced with iron strips to prevent portions of the negative mold from cracking.

4. A framework of large iron pipes is fitted over and secured to the negative mass with strips of burlap, saturated with plaster of Paris, to reinforce further the negative mold. When this has been done, the modeled original is removed and the negative mold cleaned and retouched wherever necessary.

5. The completed negative, which is now ready to be charged with the selected positive casting material.

6. The chipping away of the negative mass, to release the positive cast, has been begun.

7. The completed model, with its separately cast sections assembled. The work was designed in large planes and the forms were carefully distorted to have the figures appear correct when viewed from some 65 feet below.

PLATE 22 DEVELOPMENT AND CASTING OF A FAÇADE RELIEF MODEL

By Jean de Marco for the new War Department Building, Washington, D. C.

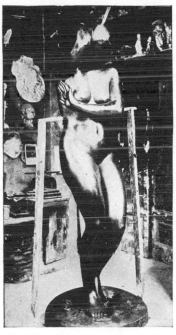

1. The first step in casting aluminum by the indirect lost-wax process consists of covering the plaster form with a thin wax coating.

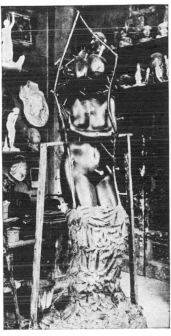

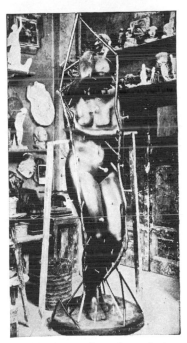

2. The gates, channels, and risers are then attached to the model.

3. The entire mass is encased in a plaster of Paris investment.

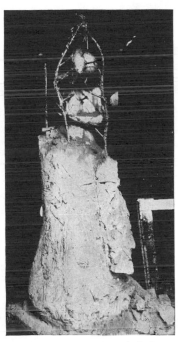

PLATE 23

CASTING IN ALUMINUM BY

THE INDIRECT LOST-WAX

PROCESS

4. The mold is then baked to melt away the wax and the molten metal is poured to occupy the space vacated by the 'lost wax.' When the mass has cooled, the plaster mold is broken away. This illustration shows the partly freed form.

5. All of the plaster investment material has now been broken away from the aluminum casting. The gates and risers are still attached. These are then machined off and the surface is worked for the final finish.

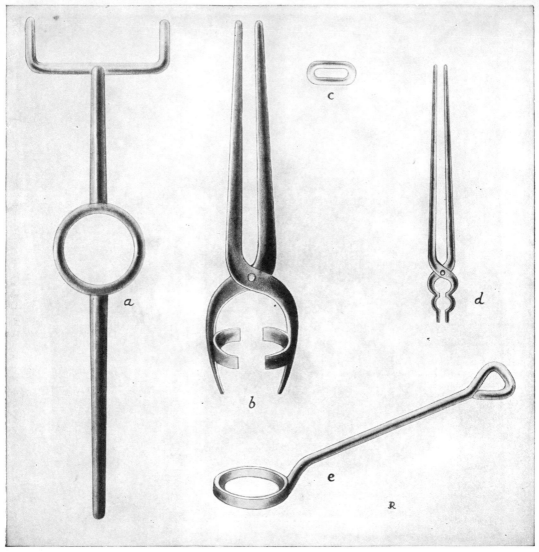

a. Two-man wrought-iron shank for carrying and pouring large loaded crucibles with capacities of between 100 and 300 pounds. For very heavy loads, shanks that are handled on both ends are generally used.
b. Lifting tongs used to take crucibles and their molten contents from the fire.
c. Ring for locking the arms of the lifting tongs.
d. 'Pickout' tongs, used to remove crucible covers and to add metal ingots to the crucible.
e. One-man wrought-iron shank. Used for carrying small loaded crucibles with capacities of up to about 75 pounds.

PLATE 24

SOME BRONZE FOUNDRY TOOLS

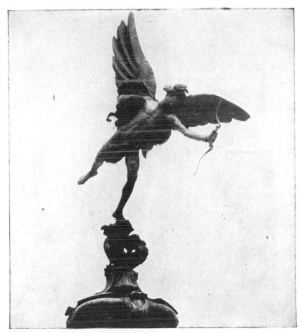

A. EROS, by Sir Alfred Gilbert. One of the earliest examples of the use of aluminum in sculpture. Piccadilly Circus, London, 1893.

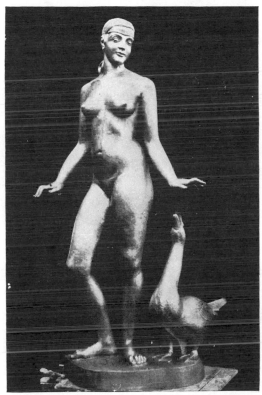

B. GOOSE GIRL, by Robert Laurent. Indirectly cast aluminum statue, Rockefeller Center, New York. 7 feet, exclusive of pedestal.

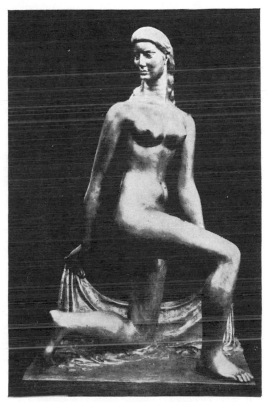

C. SPIRIT OF THE DANCE, by William Zorach. Indirectly cast aluminum statue, Rockefeller Center, New York. 6 feet.

PLATE 25

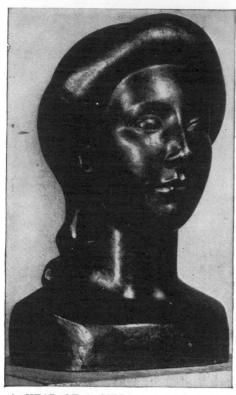

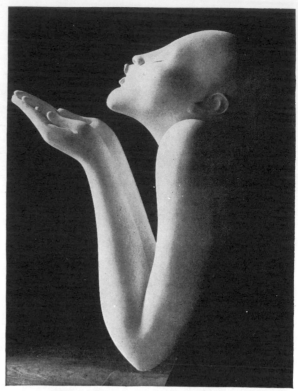

A. HEAD OF A GIRL, by Aristide Maillol. Bronze. 14¾ inches.

B. SUPPLICATION, by Hugo Robus. Bronze. 22 inches.

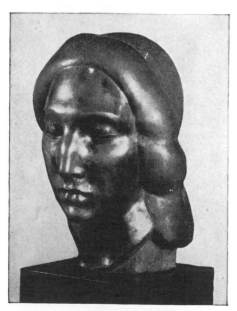

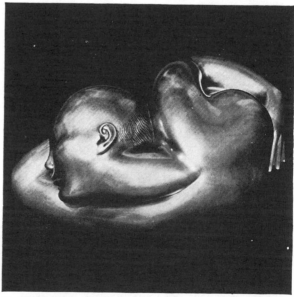

C. EGYPTIAN HEAD, by Gaston Lachaise. Bronze. 13 inches.

D. DREAMER, by Hugo Robus. Bronze. 20 inches long.

PLATE 26

A

B

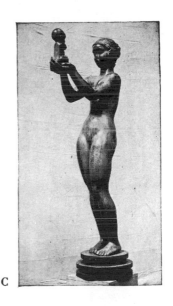

C

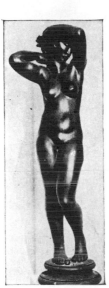

D

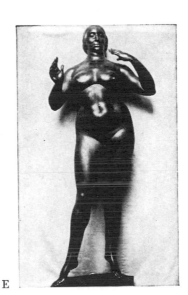

E

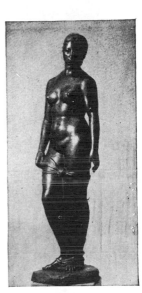

F

A. GIRL LOOKING UP, by Georg Kolbe. Bronze. c.42 inches.
B. THE VISITATION, by Jacob Epstein. A life-size, well-designed bronze.
C. EVE AND THE APPLE, by Kai Nielsen. Bronze. c.69 inches.
D. WOMAN STANDING, by Kai Nielsen. One of the finest examples of contemporary sculpture in bronze. In the foreground of the main building of the Aarhus Stadium.
E. STANDING WOMAN, by Gaston Lachaise. Bronze. 69 inches.
F. STANDING WOMAN, by Wilhelm Lehmbruck. Bronze. 76 inches.
G. THE AVENGER, by Ernst Barlach.

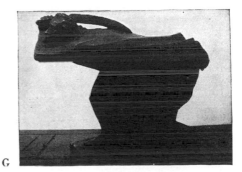

G

PLATE 27

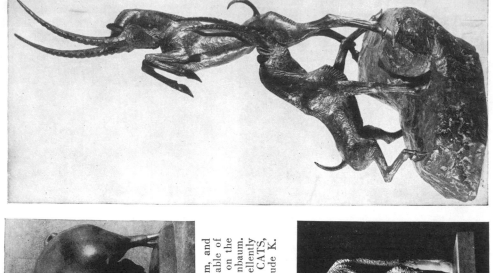

C

B

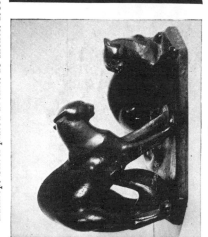

A. BIRD IN SPACE, by Constantin Brancusi. This emphasizes balance, form, and surface texture, and is an illustration of the mirror-like polish bronze is capable of taking. B. WALKING BEAR, by Paul Manship. Bronze model for a figure on the Rainey Memorial Gate. 20 inches long. C. ROOTING HOG, by Dorothea Greenbaum. Bronze. 16 by 8 inches. 1931. D. GOATS, by Hunt Diederich. Bronze. Excellently illustrates the openness of design it is possible to achieve in this medium. E. CATS, by Hunt Diederich. Bronze. c.18 inches long. F. YOUNG LAMB, by Gertrude K. Lathrop. Silver-plated bronze. 15 inches. 1936.

F

E

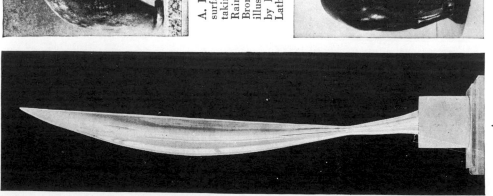

A

PLATE 28

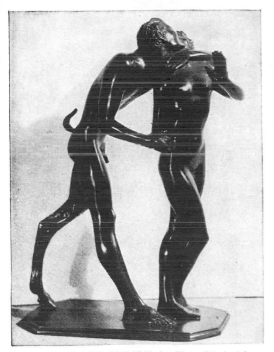
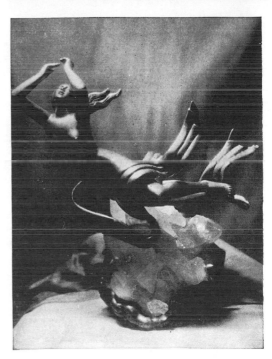

A. SATYR AND NYMPH, by Hunt Diederich.
B. EURIDICE, by Paul Manship. A unique work in gold bronze, mounted on a mass of rock crystal.
19½ inches

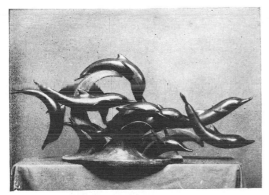
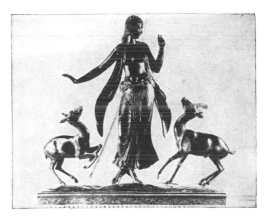

C. DOLPHIN FOUNTAIN, by Gaston Lachaise. 17 by 41 inches.
D. DANCER AND GAZELLES, by Paul Manship. The original of this work, which was cast in 1916, is
life size, and two copies exist, one in the Corcoran Gallery in Washington and the other in the Toledo
Museum, Ohio. Twelve copies of a smaller bronze version were also cast indirectly. The group, which
was influenced by Greek art, is infused with life and grace, and there is a delicate relationship of the
base to the forms.

PLATE 29

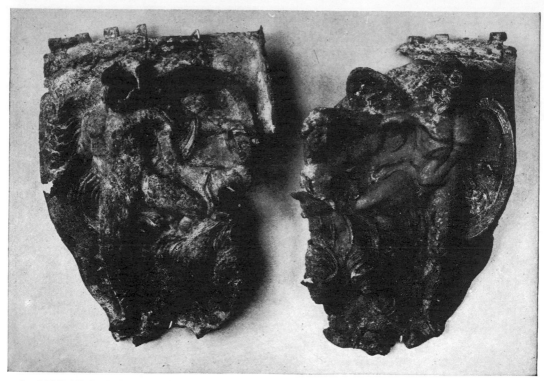

A. COMBAT BETWEEN A GREEK WARRIOR AND AN AMAZON. Siris bronzes. These repoussé bronzes are fairly small, one fragment measuring 7 inches and the other 6½ inches. It is believed that the pieces were originally gilded.

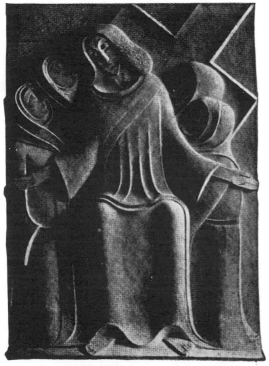

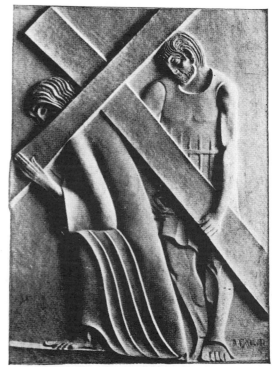

B. BRONZE RELIEFS, by Alfeo Faggi. Church of St. Thomas the Apostle, Chicago.

PLATE 30

A. HOD CARRIER, by Aaron J. Good-
elman. Wrought bronze. 15½ inches.

B. ROAD BUILDERS' HORSE, by Saul Baizerman. 1921.

C. ITALIAN WOMAN, by Saul Baiz-
erman. 6½ inches. 1920.

PLATE 31

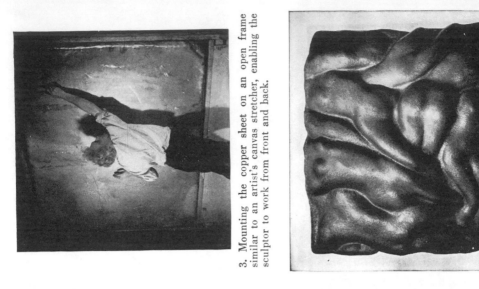

3. Mounting the copper sheet on an open frame similar to an artist's canvas stretcher, enabling the sculptor to work from front and back.

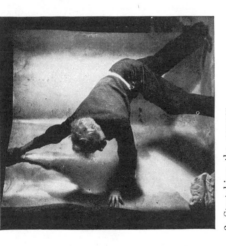

2. Stretching the copper.

1. Rolling out the copper.

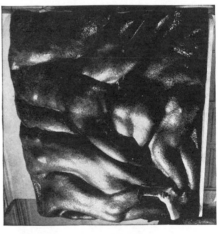
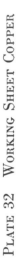

5. Surface finishing.

6. The completed work,

4. The forms of EXUBERANCE, by Saul Baizerman, emerging from the sheet.

PLATE 32 WORKING SHEET COPPER

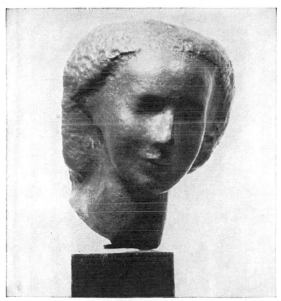

A. HEAD OF A YOUNG WOMAN, by Saul Baizerman.
15 inches. The original sheet was about 20 inches. 1935.

B. DAWN, by Aaron J. Goodelman.
7½ feet.

C. UGESIE, by Saul Baizerman. c.5
feet. 1936.

PLATE 33 SCULPTURE IN SHEET COPPER

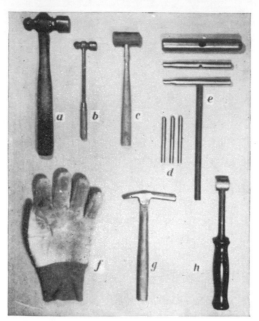

A. TOOLS FOR WORKING SHEET LEAD. a. Ball-pein hammer used together with taped wood-carving mallets for the initial shaping and rounding out of forms. b. Small shaping hammer. c. Small buffalo-hide surface-finishing mallet. d. Finishing punches for use with hammers b, c, and h. e. Steel shaping and finishing hammers. f. Protective work glove. g-h. Surface finishing hammers.

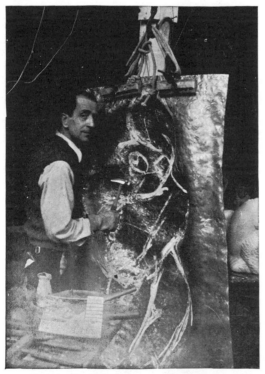

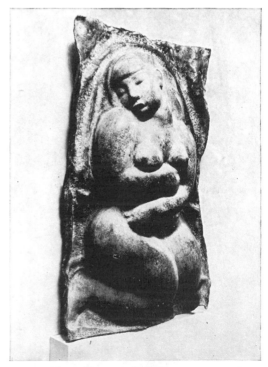

B. José de Creeft at work on SATURNIA, a relief in hammered lead. The sculptor is hammering out the initial forms from the back of the sheet with a broad-headed hammer. The upper portion of the design originally sketched upon the sheet was changed during its development. The sheet was ¼ of an inch thick. Note the clamps, used to suspend conveniently the heavy sheet, enabling the artist to work from front and back simultaneously.　　　　　　　　　　C. The finished work. 60 inches.

PLATE 34

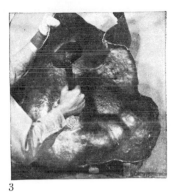

1
2
3

1. Pencil sketch for the MATERNITY, by Jack C. Rich. 2. The sketch chalked on the flat lead sheet.

3. Shaping the basic forms and rounding out the large masses from the back of the sheet with a large, taped wood mallet.

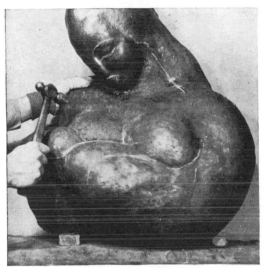

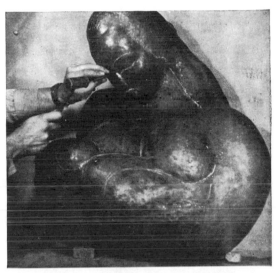

4. Rounding out the forms from the front of the sheet.

5. Working the detail with small fiber mallet and punch.

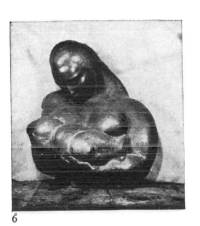

6. A more developed stage.

7. The work in its final stage. The finishing touches will be applied before backing up and mounting the piece.

6

7

PLATE 35 HAMMERED LEAD SCULPTURE

A. TORSO, by Jack C. Rich. Hammered lead. 13 inches long. 1942-3.

B. MOTHER AND CHILD, by Jack C. Rich. Hammered lead. 15¼ inches. Fashioned from a flat sheet of lead ⅛ of an inch thick, by hammering the sheet from both front and back.

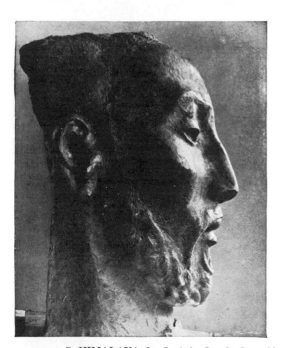

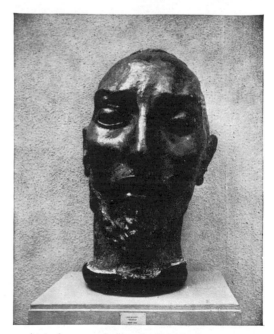

C. HIMALAYA, by José de Creeft. Superbly wrought in hammered sheet lead. 34 inches.

PLATE 36

A. YOUNG PEASANT GIRL, by Charles Despiau. Pewter. 11½ inches. B.
LIZZIE, by Dorothea Greenbaum. A hollow casting in copper-nickel alloy, cast
by the lost-wax method. 10 inches.

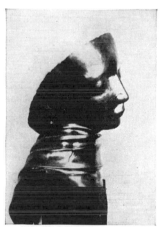
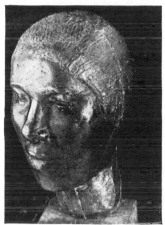

C. HEAD, by Professor Maier. A unique example of sculpture in wrought tin.
The head is hollowed out to form a vessel. D. UZBEC WOMAN, by Minna
Harkavy. A fine portrait study in German silver (brass whitened by the addi-
tion of nickel), cast by means of the sand-mold process. The mold marks are
clearly visible under the neck and along the side. Slightly smaller than life size.

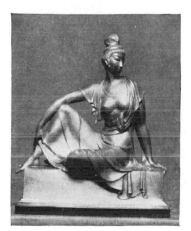

E. STUDY FOR GARDEN POOL, by Allan Clark. Cast in tin. 18 inches.
F. MINER'S SON, by Bernard Walsh. Cast iron. 27½ inches. 1940.

PLATE 37

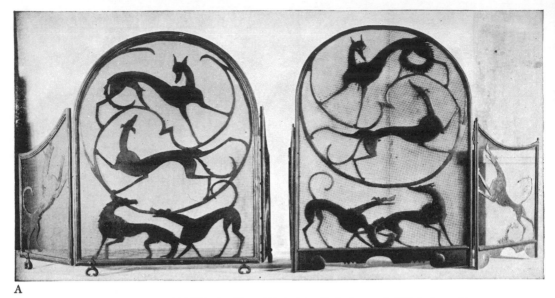

A

A. IRON FIRESCREENS, by Hunt Diederich. 42 inches and 41¼ inches wide.

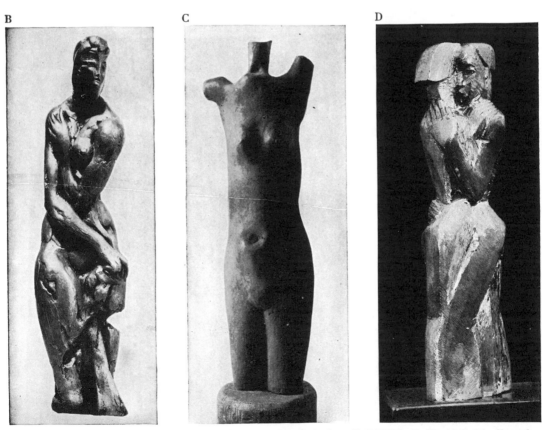

B. SUZANNE, by Alexander Archipenko. Lead casting. 20 inches. C. TORSO, by David Smith. Forged iron. 36 inches. D. RHYTHM, by Aaron J. Goodelman. A novel work carved directly in a length of solid brass with mallet and cold chisels, and worked with files.

PLATE 38

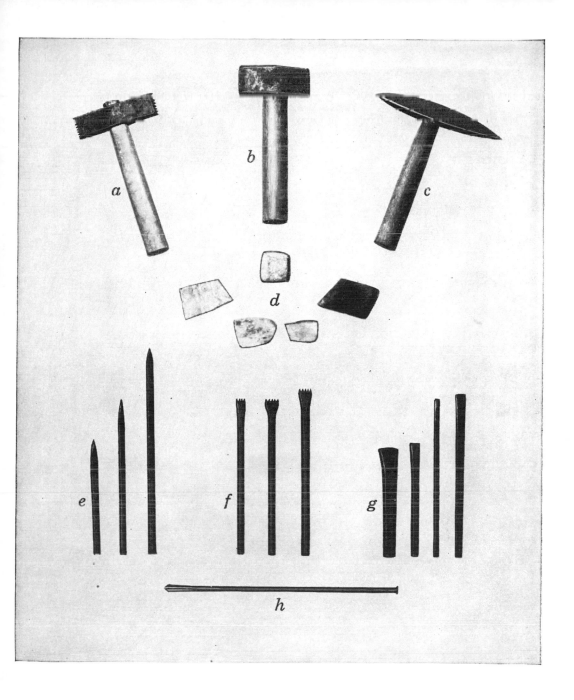

a. Bushhammer
b. Hammer
c. Pick
d. Abrasive stones

e. Points
f. Tooth chisels
g. Flat chisels
h. Star drill

PLATE 39 STONE-CARVING TOOLS

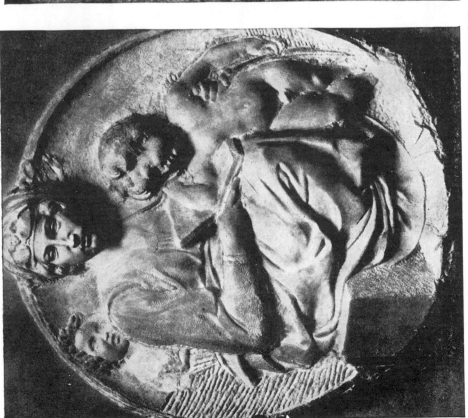

MADONNA AND CHILD, by Michelangelo. Marble relief. c.1504. The use of the point for the initial cutting is apparent on the extreme right and left of the work. Michelangelo's use of the toothed chisel for developing his forms is obvious throughout the piece, particularly on the face and body of the child. Note how the tool follows the forms. Detail of head of child at right.

PLATE 40

A. José de Creeft at work in his studio. Note the large bushhammer being used, the cushioning bed beneath the stone form, and the sculptor's mask to prevent the inhalation of fine particles of stone dust.

B. PERUVIAN GIRL, by José de Creeft. This carving in pink Tennessee marble is approximately a foot in height and superbly illustrates the qualities achieved by the use of the pick, boucharde, claw chisels, point, and polishing abrasives.

PLATE 41

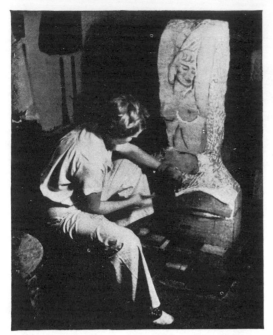

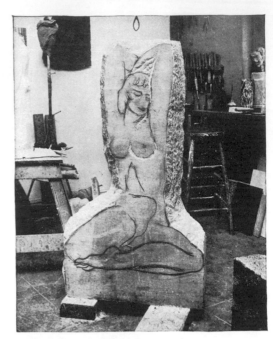

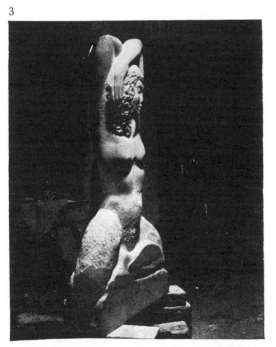

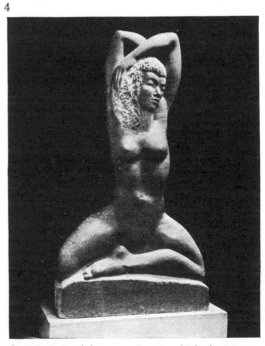

DIRECT CARVING IN STONE: PRELUDE, by Hesketh.

1. The initial 'roughing out' stage. The artist has made a sketch upon the crude stone block and proceeds to carve directly without further assistance from models. 2. Second stage.

3. Third stage. Note the changed position of the arm, a characteristic of direct carving, in which changes or design modifications may be made as the work progresses. 4. The finished work. Pink Tennessee marble. 4½ feet. 1942.

PLATE 42

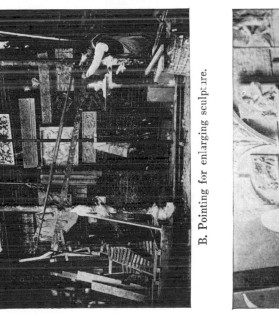

B. Pointing for enlarging sculpture.

D. Pointing by compass in marble cutting.

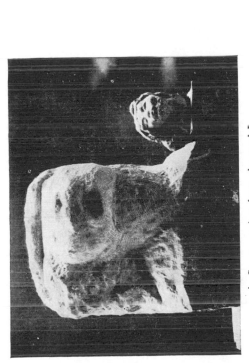

A. Stone carving from the model

C. Pointing from plaster to marble.

PLATE 43

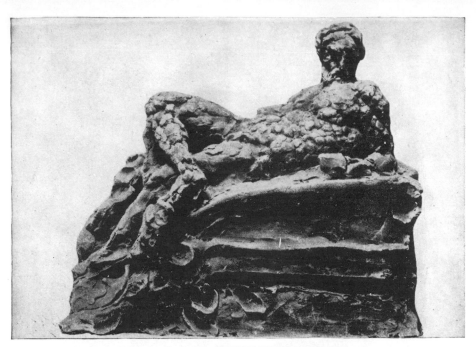

A. Wax sketch for ÏL CREPUSCULO, by Michelangelo.

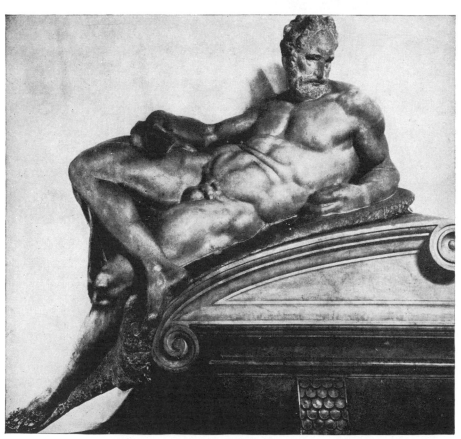

B. IL CREPUSCULO (EVENING), by Michelangelo.

PLATE 44

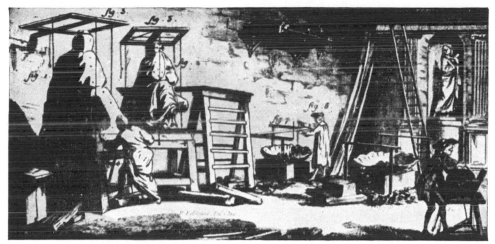

A. Interior of a sculptor's studio in the 18th century, showing the methods of measurement then in use.

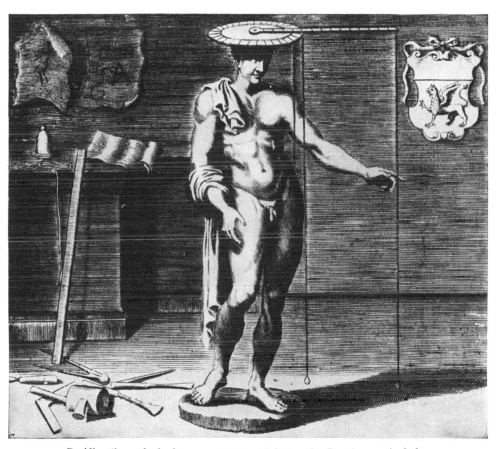

B. Alberti's method of measurement used during the Renaissance in Italy.

PLATE 45

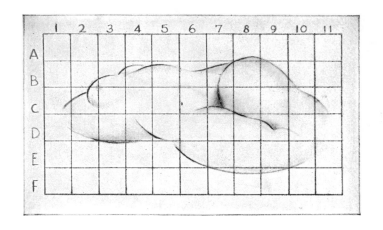

ENLARGING BY SQUARES

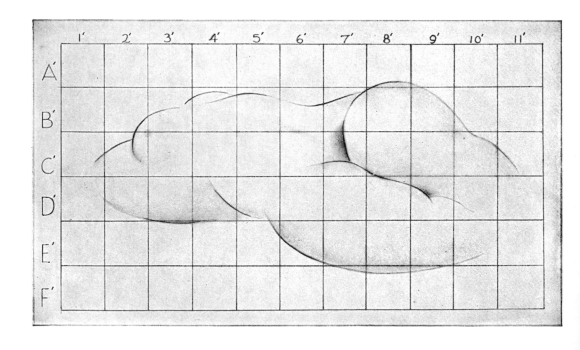

PLATE 46

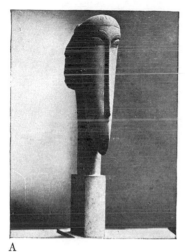

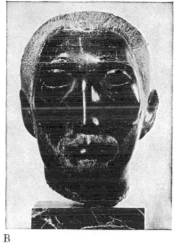

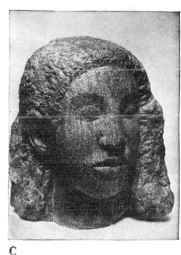

A B C

A. HEAD, by Modigliani. A decorative, elongated head in limestone, showing the influence of Negro art. B. HEAD OF CHRIST, by William Zorach. A fine head carved from a black granite field boulder. 14¾ inches. C. CREOLE GIRL, by Jean de Marco. Carved directly in red sandstone. Life size.

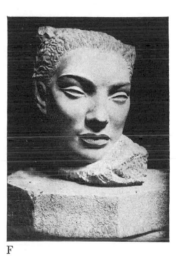

D E F

D. HEAD OF AN ARTIST, by James E. Fraser. A fine example of indirect sculpture. The marks of the pointing machine are clearly discernible along the collar and on the hair. 16½ inches. E. FRANCES, by Chaim Gross. A fine creation in black and gold, an imported Italian commercial marble. 23 inches. 1944. F. MARGARET, by José de Creeft. Caen stone. Larger than life-size. G. HEAD OF RENEE, by Chaim Gross. Lithium stone. 12 inches. 1941.

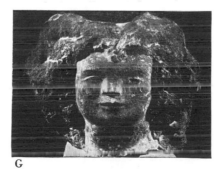

G

PLATE 47

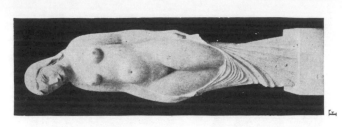

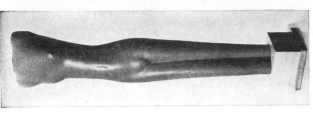

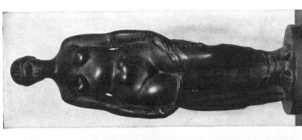

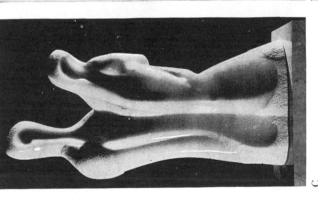

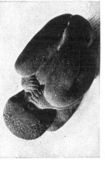

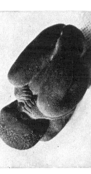

A B C D E F

G H

A. GIRL IN GRANITE, by Richard Davis. A fine figure carved in Westerly granite. 48 inches. 1938. B. TORSO, by John Hovannes. Pentelic marble. 18 inches. C. FRIENDS, by Alexander Archipenko. Mexican onyx. 26 inches. 1937. D. SUZANNE, by S. F. Bilotti. African wonderstone. 22 inches. E. TORSO, by Ahron Ben-Shmuel. Serpentine. c.47 inches. F. CHLOE, by Eric Gill. A fine contemporary example of the application of color to a stone carving. The lips and hair are painted. G. NEW ONE, by John B. Flannagan. A direct carving in bluestone. 12⅝ inches long. 1935. H. THE TATTOOED DREAM, by Ossip Zadkine. Brownstone, 1942.

PLATE 48

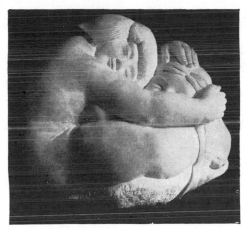

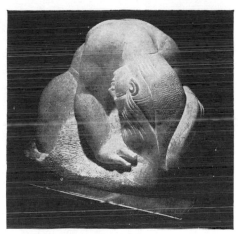

A. SALOME, by Robert Laurent. Alabaster. 18 inches.

B. GIRL WASHING HER HAIR, by Robert Laurent. Alabaster. 14 inches.

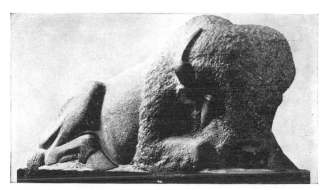

C. BISON, by Richard Davis. Black granite. 48 by 28 by 24 inches. 1939.

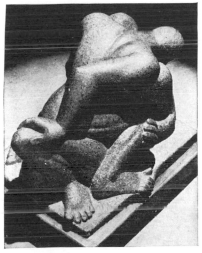

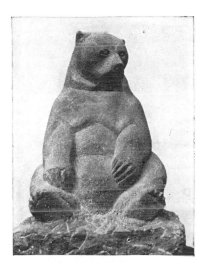

D. WRESTLERS, by Ahron Ben-Shmuel. Quincy granite, c.¾ life size. 1931.

E. BEAR, by Richard Davis. Red sandstone. 16 inches. 1940.

PLATE 49

1. Making a preliminary series of drawings prior to carving the wood.

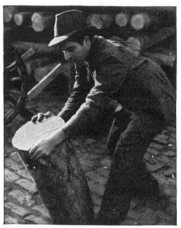

2. Chaim Gross selecting a block of lignum vitae at the lumber yard.

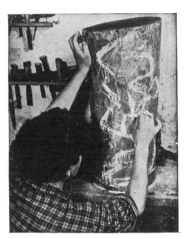

3. Drawing the design upon the log with chalk.

4. Close-up showing the use of a large gouge for roughing out the masses.

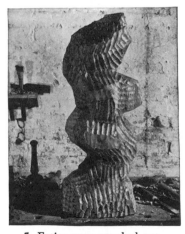

5. Entire mass roughed out.

PLATE 50 DIRECT SCULPTURE IN WOOD

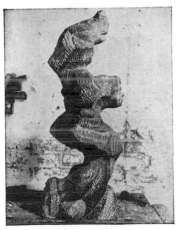

6. The forms emerging from the block after use of a smaller gouge.

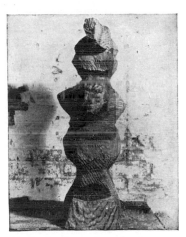

7. Front view of work at same stage.

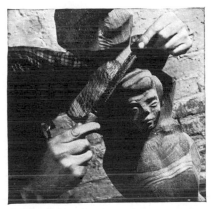

8. Clarifying the forms by use of the rasp.

9. Application of beeswax for polishing, after the surfaces have been worked smooth.

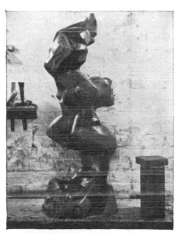

10. The completed work, BALANCING, now in the collection of the Philadelphia Museum of Fine Arts.

PLATE 51 DIRECT SCULPTURE IN WOOD (*Continued*)

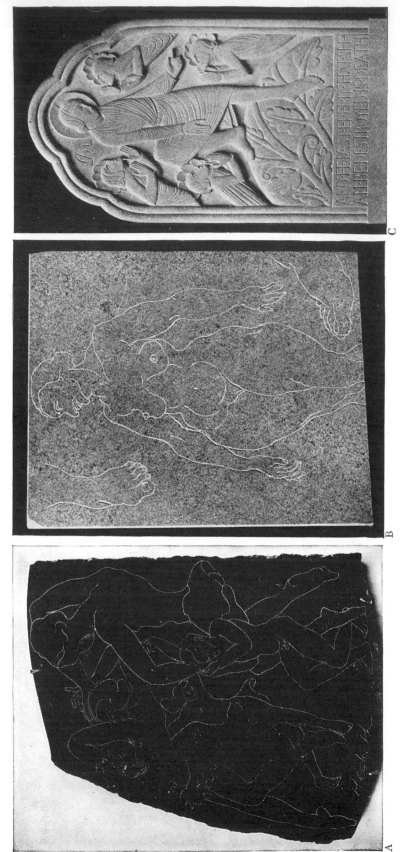

PLATE 52

A. ALLEGRO MA NON TROPPO, by Hesketh. An incised carving or 'stone cut' in Belgian black marble. 19½ by 17 by 1 inches. 1940. B. AN INCISED STONE 'DRAW-ING' ON GRAY GRANITE, by Hesketh. 8 by 10 inches. In fashioning a 'stone cut,' Hesketh freely cuts the continuous and uninterrupted linear design with a very fine and sharp flat chisel that is struck with a mallet. There is no previous drawing on paper or on the generally polished stone surface. The cave dwellers were the first to practice a type of sculptural engraving in which forms were incised or scratched into small stones and fragments of bone. C. STELE, by Eric Gill. A simple, charming relief in Hopton-wood stone. c.3 feet.

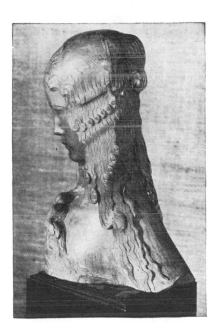

A. MALUA, by A. J. Oakley. Pearwood. 19 by 8 by 11½ inches.

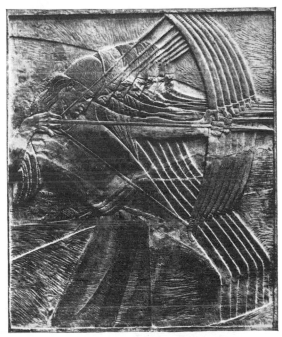

B. THE ARCHERS OF DOMORGOI, by Ivan Meštrović. An outstanding contemporary wood relief. Note how the illusion of perspective and depth are achieved by delicate recession of the forms. By repetition, Meštrović has succeeded in creating a design with great dramatic power.

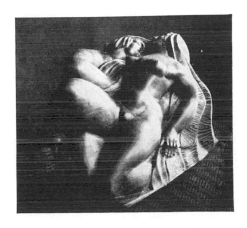

C. PELLEAS AND MELISANDE, by Robert Laurent. Walnut. 16 inches.

PLATE 53

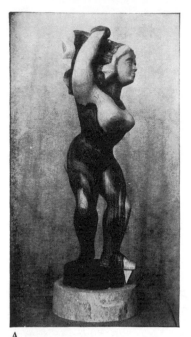

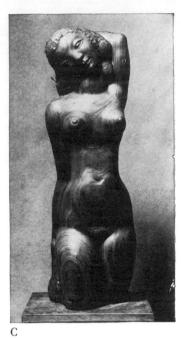

A B C

A. TIGHT-ROPE DANCER, by Chaim Gross. Lignum vitae. 27 inches. 1933. A superb example of the utilization of the natural graining of a wood as a vital design element. Note the light areas of outer wood, which have been retained for their contribution to the design. B. SMALL TORSO IN EBONY, by Ossip Zadkine. 1944. C. TORSO, by John Hovannes. Walnut. 30 inches. 1932.

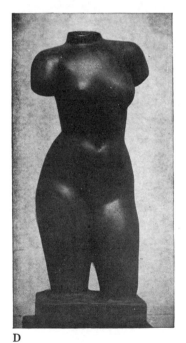
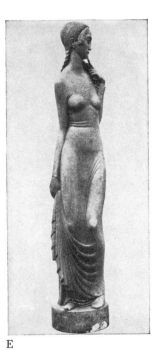
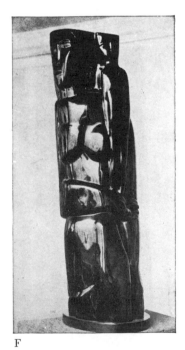

D E F

D. TORSO IN WOOD, by John Hovannes. Mexican mahogany. 14 inches. E. LA PUCELLE, by Rosandić. A lovely figure, carved in walnut. Life size. F. MOTHER AND CHILD, by Ossip Zadkine. Japanned mahogany. The natural qualities of this beautiful wood are completely masked by superficial color.

PLATE 54

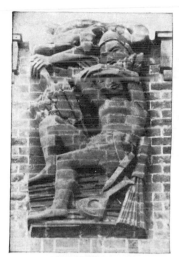
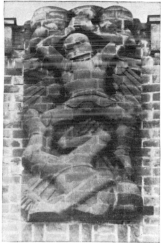
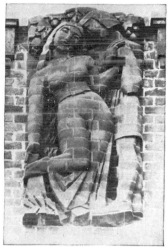

A. TREACHERY, WAR, LOVE, by Eric Kennington. From the Shakespeare Memorial Theatre, Stratford-on-Avon. The tools used to execute these three brick sculptures were fine punches, sharp claws, and chisels.

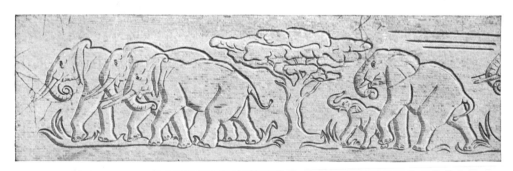

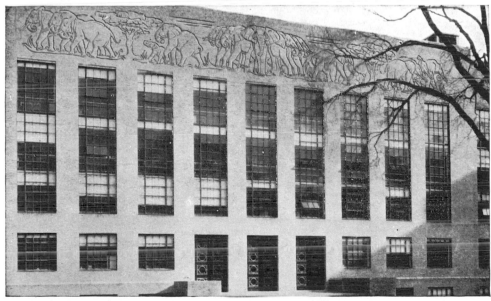

B. CARVED BRICK FRIEZE, by Katherine Lane. Carved directly on the brick wall of the Biological Laboratory at Harvard University.

PLATE 55

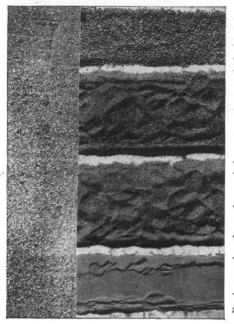

A. A standard set of laboratory sieves.

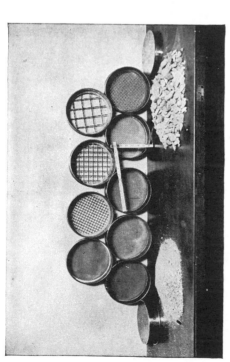

C. A sample of well-graded construction sand before it has been sorted according to different sizes.

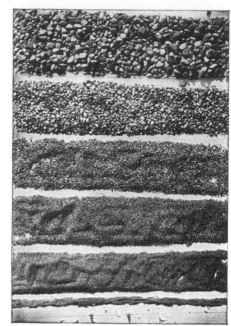

B. A sample of poorly graded construction sand, lacking in particles coarser than 1/16 inch, after it has been separated into four sizes by screening.

D. The same sand after sorting. The particles vary from fine to 1/4 inch in size. For good workability in concrete, at least 5 per cent of the particles should pass a 50-mesh sieve.

PLATE 56

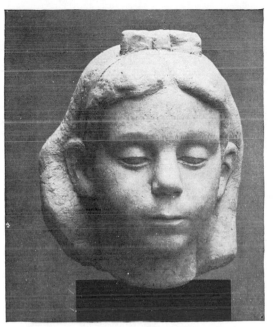

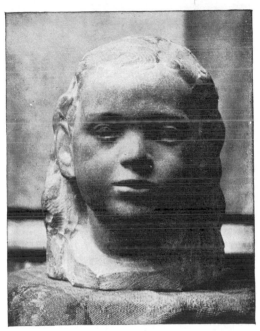

A. ANNE, by Concetta Scaravaglione. Cast stone. Life size.

B. BARBARA, by Louis Slobodkin. Cast stone. Life size.

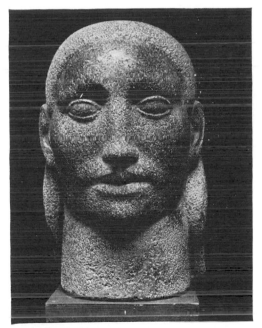

C. HEROIC HEAD, by Clara Fasano. Terrazzo.

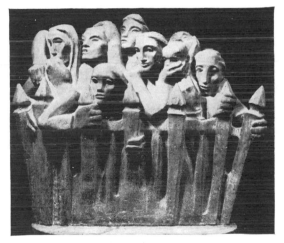

D. MINE DISASTER, by Berta Margoulies. Cast stone, cast rough and finished after casting with abrasive stones and files, 30 by 12 inches.

PLATE 57

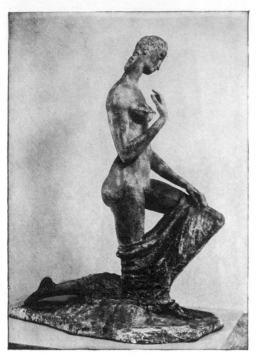

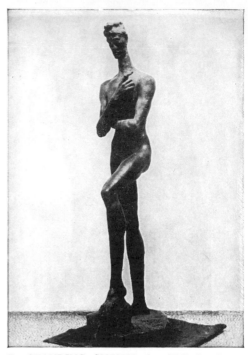

A. KNEELING WOMAN, by Wilhelm Lehm-
bruck. Cast stone. 69½ inches.

B. STANDING YOUTH, by Wilhelm Lehm-
bruck. Cast stone. 7 feet, 8 inches.

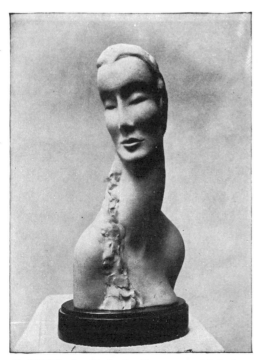

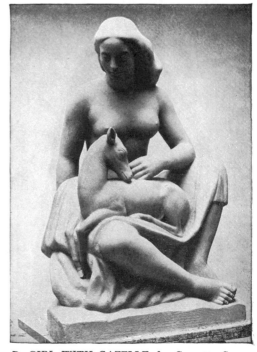

C. MAYA, by Hesketh. Cast stone. 19 inches.
1942.

D. GIRL WITH GAZELLE, by Concetta Scara-
vaglione. Cast stone. Larger than life size. 1937.

PLATE 58

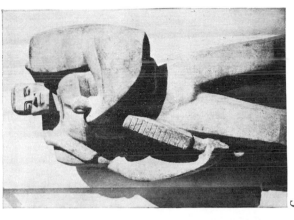

C

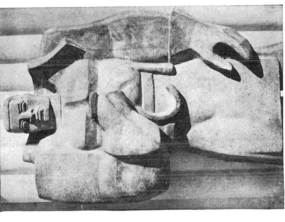

B

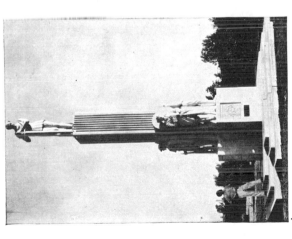

A

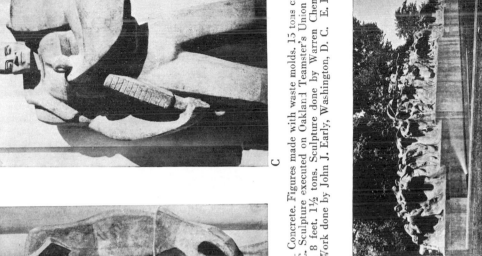

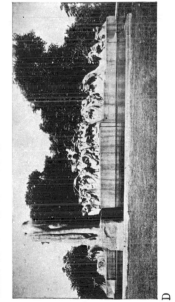

E

D

A. WAR MEMORIAL, by Ellis L. Burman. Antelope Park, Lincoln, Nebraska. Concrete. Figures made with waste molds. 15 tons crushed marble used in concrete as outside layer. Total of 75 tons of material used. B-C. Sculpture executed on Oakland Teamster's Union Building, California. Tan cement with crushed California travertine for aggregate. 8 feet. 1½ tons. Sculpture done by Warren Cheney. D. FOUNTAIN OF TIME, by Lorado Taft. Washington Park, Chicago, Illinois. Work done by John J. Early, Washington, D. C. E. FOUNTAIN OF TIME. Other views.

PLATE 59

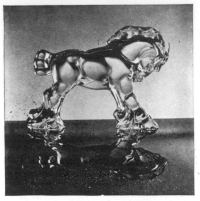

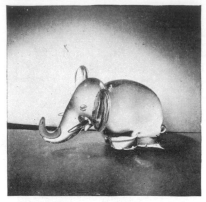

A. POLISHED CRYSTAL HORSE, designed by Sidney Waugh. A heavy and solid mass of glass was first poured into a mold and then finished by laborious grinding and polishing. 7½ inches. B. SOLID CRYSTAL ELEPHANT. Modeled glass. The material was worked while hot and plastic. The ears, tusks, eyes, and tail were separately formed and joined to the main mass while all were at an equally high temperature. 6½ inches long.

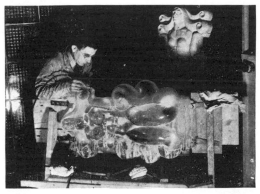

C. Polishing away mold markings on the glass reproduction of ATLANTICA, the largest cast figure produced in crystal. The plaster original can be seen in the upper background. A copper wheel rack is in the lower foreground.

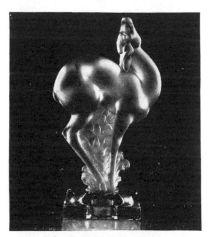

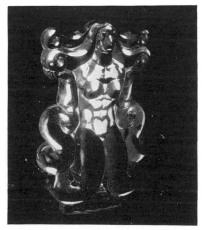

D. CRYSTAL FAUN, designed by Sidney Waugh. The base and figure are of one piece of glass. The animal form is finished opaque by means of fine sand blasting. E. ATLANTICA, designed by Sidney Waugh.

PLATE 60

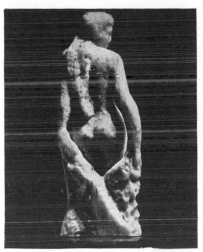
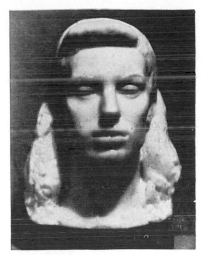

A. MLLE POPO, by Hesketh. Carved onyx plastic. 10 inches. B. GLORIA, by Anita Weschler. Cream-colored Catalin. 13 inches. 1945. Cast solidly in a plaster of Paris waste mold by the Catalin Corporation of America. A special plastic separator was employed and the curing temperatures were carefully controlled. The method is not a practical one for the average sculptor with limited studio facilities.

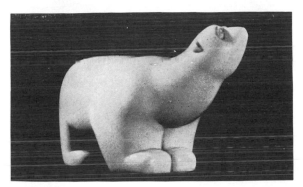

C. POLAR BEAR, by Robert I. Russin. Carved Catalin. 5 inches long. 1936.

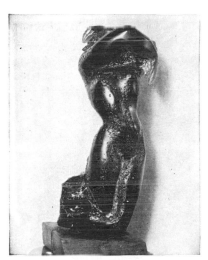
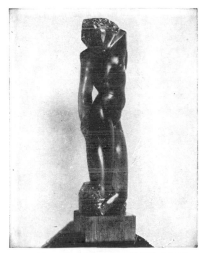

D. CADENZA, by Hesketh. Carved amber colored plastic. About 10 inches. E. FORM IN BLUE, by Hesketh. About 12 inches.

PLATE 61

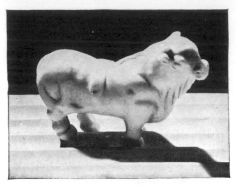

A. FERDINAND, by Mathew Gelfand. Awarded second prize (Junior Class, for those under 15) in the 19th Annual Soap Sculpture Competition.

B. PAIR OF HORSES, by Cora Sims.

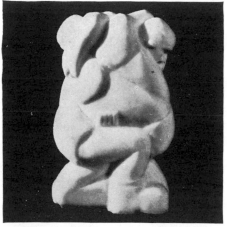

C. WRESTLERS, by Kermit Ruyle. Awarded first prize (Senior Class, for those 15 to 21 years).

D. HANDS.

PLATE 62 SOAP SCULPTURE

THE MATERIALS AND METHODS OF SCULPTURE

1 THE ANATOMY OF SCULPTURE

A DEFINITION OF SCULPTURE

THE TERM SCULPTURE is derived from the Latin *sculptura,* from *sculpere,* to carve or cut out of stone. A strict application of this rather restricted interpretation would exclude all forms save that of carving in stone. The term is today employed in a wider and more inclusive sense and embraces an abundance of materials and methods.

Sculpture is, essentially, a three-dimensional art concerned with the organization of masses or volumes. The sculptor composes his work in terms of volumes or masses, planes, contours, light and dark areas, and textures.

MATERIALS OF SCULPTURE

The materials available for use by the sculptor are many and in-clude a great variety of organic and inorganic substances. Among these are stones, woods, metals, plastic earths and waxes, ivory, bone, and horn. Each substance has its individual color, texture, and hardness; each possesses capacities and limitations peculiar to itself, determined by its physical characteristics. Materials are therefore not interchangeable. The familiar phrases 'respect for one's medium' and 'being true to the medium' refer directly to this fact. The camouflaging of one substance in imitation of another manifests lack of respect for the medium.

Sculptural media are roughly divisible into two large groups, consisting of the hard and relatively permanent substances, such as stone, wood, and metal, which are either carved directly or beaten into final form; and the impermanent, transitory materials that may be easily altered in shape or destroyed, such as the plastic earths and the plastic waxes. A work in one of the latter is usually rendered permanent by casting in metal, although many of the plastic earths (terra cottas) may be rendered hard and relatively permanent by firing, a process in which heat is applied to bake the plastic mass solid and compact.

Virtually any material that can be cut, carved, modeled, shaped by hammering, or cast is a potential sculptural medium. The material should, naturally, also possess qualities of physical permanence. Although a mass of butter is said to have been modeled by Canova, butter as a medium is much too perishable to be considered seriously as a means of concrete artistic expression.

Very few hard substances exist that have not been used for sculpture. Virtually all materials that are employed at the present day, with the exception of new alloys, refined clays, cements, and plastics, were used in previous cultures. There were, however, in the past, natural limitations to the availability of many materials, as determined by the geological nature of the specific areas and the environmental or climatic conditions. Today, transportation makes remotely grown tropical woods, ivory, and foreign mineral varieties accessible to the sculptor.

CARVING MATERIALS

The materials used in carving are generally hard substances and are often quite weighty. Carving is a painstaking and laborious procedure and progress is usually slow. It is an analytical operation, consisting of cutting away superfluous material until the desired form or forms remain exposed. The design is generally a compact one and is governed by the fundamental physical nature of the material used.

MODELING MATERIALS

The materials used in modeling are invariably soft and yielding and are, therefore, highly plastic and easily shaped. The media permit a wide range of possible treatment, from forms that may be finely detailed to those broadly executed.

A rapidity of execution is also possible with the plastic earths and waxes, and these are very often utilized for three-dimensional sketches and for capturing and recording fleeting impressions. The materials used in modeling permit corrections as the work is brought forward. Open and free designs are possible, since the process is often a transitory phase or preliminary preparation for the ultimate casting of the piece in bronze or some other durable, structurally strong and permanent substance. Many of the plastic earths may be baked to achieve a hardness of structure and increased durability. The plastic waxes are fragile and cannot be baked, so that casting the piece in another material is the only means of achieving permanence for the work

unless the object is preserved in a cabinet or under glass. The nature of modeling is one of synthesis or building up of form.

CARVING VERSUS MODELING

A great deal of energy has been, and is regularly being, expended in controversy over the relative merits and the aesthetic status of modeling as opposed to carving. Some sculptors feel that modeling and carving are two separate and distinct fields of artistic endeavor, and have vigorously attacked modeling as not constituting 'real' or 'pure' sculpture, as being only a 'minor' art.

A degree of tolerance in art, as in other things, is important. The fundamental natures of the two art forms are distinct and nonconflicting, and they should be appreciated as such; for while both concern themselves directly with three-dimensional form, work in clay is essentially a process of building-up or synthesis. It is generally employed as a transitory medium, and is by its very nature directly opposed to work in wood, stone, and other hard materials. The carving of stone or wood is a process of cutting away and exposing the final forms, but both modeling and carving deal directly with the same fundamental art elements and principles. To waste energy and time in debating the purity of one as opposed to the other is mere pedantic hairsplitting.

The great sculptors both carved and modeled; masterpieces have been produced in both forms. The late Eric Gill once wrote that modeling 'is no less creative than carving; good modelling is every bit as good as good carving.'

It should be remembered that in ancient cultures carved statues were not the invariable rule, and that if all of the works of sculpture created in the past had survived to the present day, a numerical tabulation would undoubtedly reveal a heavy balance in the scales on the side of modeling. The plastic earths and waxes were used extensively as both direct and transitory media.

Sculpture may therefore be regarded as an art with two major facets or divisions—carving and modeling.

The hammering or beating into form of various sculpturally malleable metals, such as lead, copper and aluminum, may be regarded as partaking of the plastic qualities of modeling and the solidity and permanence of form of carving materials. The nature of these quasiplastic metallic media allows for moderate changes or modifications of form and design as the work progresses, yet the material possesses

firmness and durability from the inception of work until the final stages are reached. (See Plates 30A, 32, 33, 34, 35, 36, 37C.)

TREATMENT OF MATERIAL

The particular qualities of the individual material should be exploited to the fullest extent. Camouflaging the identity of a substance in imitation of another, different material is aesthetically dishonest. True artists, as was pointed out earlier, have a profound respect for their materials, 'treating marble as marble and wood as wood, and making bronze figures in still a different fashion. They do not try to cut drapery as thin as real cloth nor make their statues look like "stuffed" men and women.'[1]

The harder the material, the more difficult it is to achieve realism or a naturalistic treatment. This applies particularly to the carving of stone. The fine texture that is characteristic of many varieties of marble lends itself to a delicacy of treatment. The comparative coarseness of the granites is suited to a rugged and strong treatment.

The design of hard and friable materials such as stone should be kept compact and, as Michelangelo stated, a stone statue should be capable of being placed inside a conical or pyramidal form so that if it were rolled downhill none of the parts would be broken off. The sculptor using hard materials can fashion his statues in the full round or cut his forms into slabs, as in reliefs, in which the background becomes an integral part of the design. Forms can be depicted emerging from uncarved masses of stone or wood. Free-standing statues in the round, however, must be capable of being viewed from all sides, so that the problem of adequately composing a free, three-dimensional work becomes the sculptor's most difficult task.

The plastic media offer unlimited possibilities of open and free treatment.

COMBINATION OF MATERIALS

In the past, materials were often used together for decorative purposes, and it is believed that the Greeks employed what were probably the most luxurious combinations of different substances. Wood was frequently used in conjunction with marble and ivory, and akrolithic statues generally had faces, hands, and feet composed of marble, while the rest of the statue was fashioned of wood that was usually

[1] Taft, Lorado, in *The Significance of the Fine Arts*, Boston, 1923, p. 261.

gilded. Ivory was often used as an inlaying material and set into a base of ebony or some other wood (see also Chryselephantine statues, pp. 335-6).

Precious and semiprecious colored stones have occasionally been used as an inlaying material, principally for the eyes of statues, by many peoples, including the early Egyptians, the later Greeks, and the sculptors of India.

Today, materials are seldom combined sculpturally, because while an additional richness may be achieved by using two or more different substances in the same work, the unity of effect may be affected by the conflicting colors and textures of the different materials. (See Plates 1, 2, and 54F.)

FORMS OF SCULPTURE

For purposes of classification we can divide sculpture into three major forms:

1. Intaglio
2. Reliefs
3. Sculpture in the round

INTAGLIO.

Intaglio is a form of incised relief in which the design is sunk below the surface. A type of incised relief employed largely by the Egyptians for architectural ornament is the *inverse bas-relief*, also referred to as coelanaglyphic or Egyptian relief. (See Plate 3.) It is an intaglio form in which the figures do not project from the wall, but are cut into it, as on the pylon of the Temple at Philae (Temple of Isis). In this form of intaglio relief, the figures are outlined by means of grooves or furrows cut around the forms. The highest points or portions of the completed work are on a level with the original surface plane. This 'sunken relief' is characteristic of Egypt and is rarely found elsewhere, although the Greeks and other peoples sometimes cut into the surfaces of their materials and removed the backgrounds.[2]

RELIEFS

The term 'bas-relief' is frequently used in a broad sense to include all types of raised reliefs. The difference between the type or degree

[2] The contemporary tendency in working reliefs is to synthesize or to build up the forms rather than to cut away, although both types of approach are practiced.

of relief is a difference of degree of projection of form from the background surface or plane.

Flat relief, *stiacciato-relievo*, is the lowest possible true relief. In this form, the effects are achieved by means of contour outlines and finely incised lines. The projection of the modeling is very slight and there are no undercuts in this type of relief.

Low relief is also referred to as bas-relief and *basso-relievo*.[3] In this type of relief the forms have relatively little projection from the background and have no undercuts, but the modeling is developed higher than it is in flat relief.

Medium relief is also known as *mezzo-relievo* or half relief. The modeling is fuller than in the bas or low relief. Undercuts are occasionally present and the modeling may reach a height of approximately half the thickness of a head or body.

Full relief is also known as high relief and *alto-relievo*. This is the highest type of relief. The forms are often modeled in the full round, but remain attached to the background, although some portions, such as heads or arms, may be entirely free from the background.

Sculpture in the Round

In relief sculpture, the figures or forms are generally attached either entirely or partially to a background, whereas in sculpture in the full round, the figures or forms are free-standing and can, in almost every instance, be seen from all sides. A sharp line of demarcation is difficult to establish, since one form or degree of relief can, and often does, merge subtly into another, and occasionally several degrees or types may be incorporated in a single work.

A continuous progression can be traced from the *intaglio*[4] or sunken sculpture relief form (as illustrated by the Egyptian inverse bas-relief and some cameos), through the true reliefs to the full round.

Following the intaglio form there comes sculpture in very low relief, as typified by coins and medals, where the modeling is extremely fine and low. The low relief evolves into the medium relief, after which comes the alto or high relief, and then sculpture in the full round.

[3] The French word *bas*, and the Italian *basso*, mean 'low.'
[4] The intaglio form of relief is very frequently classified with the raised or true-relief forms.

THE SUBJECT MATTER OF SCULPTURE

Sculpture is the nearest and most intimate approach of the arts to life, since its essence is three-dimensionality. While the painter works on a two-dimensional basis and suggests the third dimension, the sculptor works directly with mass.

Whereas there are broad possibilities in the treatment of materials in sculpture, the 'body' or subject matter is limited, with the exception of the geometric and the abstract (and these are quite frequently based upon natural forms; see Plate 8B), to the human and animal forms and, to a lesser degree, to plant forms.

Clouds, earth and water, and other inanimate forms are occasionally represented in bas-reliefs and, more infrequently, in works in the full round, as accessories or background.

Symbolism is sometimes used today in much the same way it was by the Greeks. An organic form such as a fish is employed to represent a body of water. Reeds are used to suggest a freshwater shoreline or bank, and plants to indicate meadows.

DRAWING

Subject matter for sculpture is everywhere—in the streets, in the subways, and in the country—and the student should carry a sketchbook with him at all times, observing constantly and recording his observations. Drawing originally meant design and it is the basis of much sculptural accomplishment.

Concepts are frequently evolved and fixed by means of drawings (see Plates 4 and 5), and many sculptors who disdain three-dimensional preliminary models utilize drawing as a means of registering impressions and developing their concepts, since this procedure also serves to lessen the risks involved in direct carving. While many sculptors draw on paper, others sketch directly upon the block of stone or wood, to organize their designs before beginning to carve. (See Plates 34B, 35, 42, 50-51.)

There are many media that can be used for drawing and the sculptor should experiment with all of them. Some of those frequently employed are: Pencil, Pastel, 'Sauce,' Charcoal, Pen and ink, Chalk (red, white, black), and Crayon (Conté, soft to hard, and colored crayons).

Drawings can be rendered linearly or in mass, and the paper can be either white or colored, whichever is preferable. A colored paper

is generally softer to look at and more 'sympathetic' to the drawing. It is interesting to note that the drawings of the Old Masters are almost never entirely black and white. They are largely in bistre, with golden browns and neutral grays, in red chalk, or in charcoal accented with sepia.

It will be found that sculptural activity in any of the many media will have a positive effect upon the nature of the individual's drawing, which often becomes stronger and takes on a 'sculptural' or three-dimensional quality.

ANATOMY

An anatomical or structural knowledge of both the human and animal forms is the basis or alphabet of sculpture.

The artistic equipment of many significant painters and sculptors of the past included a knowledge of anatomy. Many artists, such as Leonardo da Vinci and Michelangelo, believed so keenly in the importance of a structural knowledge of skeletal and muscular structure to artistic accomplishment, that they engaged in dissection at a time when the practice was fraught with danger.

Some anatomy instructors advocate dissection as a means of learning anatomy, but to many students this is a difficult, if not impossible requirement, and one calling for a very strong stomach to make the beginning. However, if a course in dissection at a medical college or university is available, the student should endeavor to take advantage of it.

A personal reference library together with a collection of drawings, photographs, and engravings of bony structure and musculature are invaluable aids for the student sculptor. Attendance at life-sketch classes, visits to zoological gardens, and perpetual drawing are also vitally important means of developing anatomical knowledge.

PORTRAITS

Portraiture is a very important and popular part of sculpture and almost every sculptural material has been used for it. However, each material demands a different treatment, and while the plastic substances, such as earth-clay and composition clay,[5] the softer stones, and many varieties of marble permit of detailed realism, many of the harder materials, such as granite and Belgian black marble de-

[5] Used as a transitory medium.

mand a compactness of form and a simplified treatment. (See Plate 12A and Plate 47B.)

Size is another element in portraiture that requires consideration. While some sculptors feel that portraits should be life size, and neither smaller nor larger, they disregard some of the best examples of antiquity.

In portraiture an important objective is to capture the essence of the subject in a material that is suitable for the purpose, and it is recommended that the character and type of the sitter be carefully studied [6] before the medium is chosen and the portrait is begun.

A 'prescription' for student training consists of observing and recording nature realistically and studying anatomy and materials in order to achieve knowledge and technical ability. A study of caricature will serve to sharpen the judgment of the sculptor and enable him to select facial characteristics that are to be emphasized or modified in order to achieve the desired sculptural results.

ANIMALS

A knowledge of the skeletal structure and musculature of animals is also important to the sculptor who may occasionally use animals as subject matter for his creations.

Several progressive zoological gardens, including the Jardin des Plantes in Paris, the Zoo in Vincennes, and the New York Zoological Gardens in the Bronx, have provided special facilities for the artist and sculptor to make studies of live animals unhampered by jostling crowds and unfavorable weather conditions.

In addition to systematic sketching (both on paper and three-dimensionally with plastic clays), which is of major importance in the acquisition of knowledge, the student should steadily build up his art library and form a collection of good animal drawings and photographs of animals and their skeletal structures.

Motion pictures of animals in action are particularly useful to both the student and the practicing sculptor. The speed of the projection machine can be regulated so that by a slowing of the motion the subject can be carefully studied as it moves about.

[6] It may occasionally be discovered that a likeness of one who is very familiar to the sculptor may, paradoxically, present real difficulties because of a beclouding of the senses resulting from that very familiarity.

ARCHITECTURAL SCULPTURE

Sculpture during the great periods of artistic achievement was an integral part of architecture, but much of the architectural sculpture produced during the past century has been more in the nature of an afterthought, a sort of pastry or icing applied over the finished building, with an almost complete disregard for consistency and aesthetic considerations. However, there are now signs of a happy reunion between the architect and the sculptor, and many progressive architects within recent years have actively collaborated with sculptors in achieving finished creations that are harmonious and meaningful wholes. (See Plates 6, 7, 55, 59.)

In designing for architectural sculpture, the sculptor must consider many elements, including the purpose of the building, its style, its environment, and the materials of construction, as well as the funds that are to be spent on the project. The theme or subject matter should be in keeping with the purpose of the work, and the size of the sculptural decorations should bear a direct relation to the size of the building.

The sculptor is frequently required to work according to blueprints and to submit sketches, drawings, and scale models of his three-dimensional designs. He should, therefore, be able to read blueprints, to work according to scale, and to draw.

If blueprints of a planned architectural undertaking are available, it is recommended that the sculptor construct or have constructed a scale model of the project, this model to include a portion of the adjacent environment or surroundings. The 'stage set' can then be analyzed, small clay or plaster models of the contemplated sculpture can be placed in their respective positions, and the relation of the works to the building and the immediate environment studied.

However, in designing small-scale models, it should always be remembered that when they are enlarged to heroic dimensions, the work requires simplification of detail and of mass in order to achieve greater strength. A work that is to be placed in the open also invariably tends to appear diminished in size.

The larger the work is to be, the greater will be the simplicity of treatment that is required. Large-scale façade sculptures for high, massive buildings are usually treated broadly with simple masses, since an elaborate and delicately detailed treatment would not be consistent with the dimensions of the building.

The angle of vision of the beholder on the ground or street level and his distance from the sculpture should always be considered and the proportions of works that are to be placed high up on a building have to be adjusted as the height from the ground is increased. The foreshortening and elongation of forms are other important factors to be considered.

Figures that are to be placed in niches or superimposed several stories above the street are sometimes tilted forward very slightly to appear erect when they are viewed from the ground. For this reason they frequently require a counterbalancing to prevent them from falling to the street below.[7] If the sculpture is fashioned of stone, extra masses are generally left on the back of the stone block to function as ballast.

The height at which a work is to be placed has also to be considered in designing reliefs for building façades, and as the height of the relief from the street level is increased, the deeper the relief will have to be incised. That this fact was known centuries ago by the Greek sculptors is evident by a study of the Parthenon frieze, which represents the highest point of centuries of gradual evolution and mastery by the Greek sculptors of the relief form and the problems of space representation and foreshortening. In it the carving of the relief is deeper at the top than it is at the base.

The lighting or exposure of the portions of the building that are to be decorated sculpturally is another very important factor, and one that assumes particular significance in the designing of reliefs. If the work is to be exposed in brilliant sunlight it is possible to utilize lower relief forms, since the shadows that are cast will be intensified and the higher areas will be bathed in light.

GARDEN SCULPTURE

The ancients made extensive use of garden sculpture; bird baths, sundials, and fountain forms decorated with running reliefs date back many centuries as garden decoration.

In designing for a garden that is to be sculpturally embellished, an excellent and highly recommended procedure is first to make a small three-dimensional scale model of the garden and its immediate environs, and to use this small 'stage-set' actively as an aid in determining the nature and placing of the garden ornament.

[7] Tilting must, naturally, be extremely slight, and may be accomplished by the treatment of the statue mass itself, rather than by any actual setting of the stone.

The size, shape, and environment of the garden (and this includes roadways, paths to a fountain or pool, shrubbery, and foliage, together with light and climatic conditions) are some of the factors that should be taken into consideration in determining the materials that are to be employed for the work, the size of the pieces, and their treatment. (See Plate 59.)

In designing sculpture for gardens, the sculptor is sometimes required to work with water as a sculptural adjunct in conjunction with fountains [8] and pools, so that the reflective or mirrorlike nature of a still pool and the decorative possibilities of water in motion become important sculptural elements.

Light and space are elements that are to be seriously considered in designing for gardens. Free-standing figures, when they are placed outdoors, are literally bathed in light from all sides and are frequently set in open space. Thus there is a tendency for the works to appear markedly reduced in size when they are set in their permanent positions.

The nature of the region, and this includes atmospheric and weather conditions, must also be taken into consideration in determining material and treatment. The effects of atmospheric and climatic conditions upon different media are dealt with elsewhere in this book.

Outdoor sculpture should be of an outline type akin to the best Greek sculpture, in which the masses are quite simple, the planes broad and defined with a strong outline or silhouette, as opposed to indoor pieces, which permit of a more detailed modeling and treatment.

The landscape architect should co-operate and work with the sculptor just as many progressive architects actively collaborate with artists and sculptors in their desire to achieve the finest possible aesthetic results.

MEDALS AND COINS

A very delicate and precise variety of modeling is required for medals and for coins and a primary objective in designing for these forms is to achieve the effect of roundness or mass with the lowest possible relief. (See Plate 8B.)

When we consider that the modern designer invariably develops his

[8] Some of the earliest water basins were fashioned in Babylonia and Assyria about 3000 B.C. These were frequently decorated with bas-reliefs.

design two, three, four [9] and more times the actual size of the con-
templated coin or medal, the results achieved by the ancients, par-
ticularly by the Greeks and Romans, who worked in the exact size
or equal scale, become truly remarkable in view of the minute size
of their decorations. A significant characteristic of these old coins and
medals is the fundamental simplicity of the designs, in which all un-
essential details were eliminated.

A knowledge of symbolism and lettering, and the ability to space
letters harmoniously are other important requisites of successful coin
or medal designing.

A recommended procedure in designing for medals or coins con-
sists of first developing the design on paper as a series of drawings
or sketches. After corrections and refinements have been made and
when the drawing has been successfully developed to a satisfactory
stage, the actual process of modeling the three-dimensional relief may
be begun.

As the modeling progresses,[10] the angle or source of light should be
frequently changed, so that the work can be developed consistently
and without overemphasizing any area or portion.

The designer has a choice of low, medium, and high relief, or a
combination of these, but the nature of the relief should be deter-
mined by the purpose or use to which the piece will be applied. Since
commemorative medals are invariably preserved in special cases or
cabinets as collectors' items or for exhibition, a high or very low
relief is in their case practical. For coins that are to be actively cir-
culated as monetary units, a high or very low relief would not be
desirable: a low relief would be worn away fairly quickly, and the
details on a high relief would inevitably be blurred as the high areas
wore down. In addition to this, coins bearing high reliefs are not
adapted to easy stacking. Hence a medium to low relief is used for
coins, with a raised rim about the edge of the coin to protect the
relief from such wearing factors as vending machines, turnstiles, and
stacking.

After the modeling of the design has been completed, a plaster
negative mold is made [11] (see also Plaster Casting, pp. 109-10) and the
hard containing surfaces of this negative can be retouched and worked

[9] It is a good procedure to make the original model at least four times that
of the desired ultimate size of the medal or coin.

[10] See also under Modeling Reliefs, pp. 34-5.

[11] The original model should be set aside and preserved as insurance against
accidents in casting.

if it is desired to do so. The retouching can be checked by pressing wax or composition clay into the plaster negative and studying the positive impressions.

The next step consists of fashioning a plaster positive from the negative mold. The plaster positive is then prepared for electroplating and since plaster of Paris is a porous material, the surface to be electroplated is treated with melted wax and then brushed with fine graphite (see also Electroplating, pp. 194-6) or coated with a fine metallic copper or bronze powder. A copper wire is then placed around the prepared plaster positive and the model or cathode is suspended in a tank containing the acid solution and sheets of copper, or anodes.

Across the top of the plating tank is set a bar of copper charged with a specific voltage of electric current; as the electric current runs through, a thin layer of copper slowly forms on the surface of the cathode or plaster model. This electrolytic deposition of copper is continued until the desired deposit thickness has been achieved. The time required for this may vary from one to two and a half or three days.

The electroplating process will yield an accurate copper-covered model, which is then ready for the machine used to cut the soft steel dies mechanically. This machine also reduces the proportions to the size of the desired medal or coin. When the steel die has been cut, a small, flat unit of the metal or alloy of which the medal or coin is to be made is cut to the die size, and the die and metal blank are then subjected to the stamping action of a press. A given unit may require several stampings to achieve the full design relief (see Plate 8f) and some blanks require a softening or annealing between stampings, but this depends upon the nature of the metal or alloy that is used for the blank. When the stamping operation has been completed, the metal is finished off by lathe, and cleaned.

TECHNIQUE

Sculptural technique consists of the skill of the sculptor and the means (methods and tools) he employs in achieving his desired forms in the material that has been selected for the work.

The hard materials, such as stone, wood, bone and ivory, and plastics, are cut or chiseled until the desired forms are achieved. In some cases the shaping of a hard material is approached indirectly, and preliminary models are first constructed in a plastic material such

as clay or wax, and these are used for guidance in working the hard stone or wood into final form.

Sculpture is also fashioned by means of casting. In bronze, terra cotta, plaster, and cement work, negative molds are frequently made from models that have been constructed of plastic materials. The positive substance is then poured into the negative mold to achieve the finished work. This form of sculpture enables an artist to secure as many positives as he may desire.

STYLE

The development of a style should never be a conscious objective. Style is not something that can be acquired by choice or consistently and consciously incorporated in a work or series of pieces. It will never be achieved deliberately. The sculptor should work naturally, and a style or manner of working will eventually evolve of itself, as an integral part of the work, and based upon experience and the natural development of the sculptor as an artist.

CASTING

Casting is the means whereby the form of a modeled work may be imitated and rendered rigid and durable by mechanical transformation or reproduction in another more substantial and permanent material, which is temporarily plastic at the moment of pouring or filling of the mold. It is also a means of reproducing a work of art fairly economically, accurately, and in quantity.

Works originally modeled in the plastic earths and composition clays—with the possible exception of the terra cottas, which may be fired hard—have to be reproduced in a more durable material, since both the earths and the composition clays are fragile substances.

Historically, casting is an ancient practice. Molds have been brought to light by archaeological excavation on the sites of ancient Greece (see Plate 10B) and Egypt, which proves that casting was practiced by sculptors many centuries ago. We have similar evidence that the principles of casting were familiar to the Aztecs in the New World.

Since modeling is an important and comprehensive portion of the art of sculpture, a knowledge of the mechanics and materials of casting is important to the sculptor.

The process of casting consists of two fundamental stages or phases —that of first fashioning an impression or negative mold from the

original, and secondly, securing a positive cast or reproduction of the original object from the negative impression. The 'negative' is the term applied to the hollow containing form or mold into which the positive, temporarily plastic casting material is poured. The 'positive' is the term applied to the copy or reproduction resulting from filling the negative mold with the substances selected for the specific cast.

Substances frequently used for negative containing molds are:

Plaster of Paris	Agar Compositions
Glue or Gelatine	Baked Sand
Rubber	Terra Cotta

Wax is infrequently employed as a negative material. Wood, metal, and concrete are used industrially.

The factors that determine the selection of negative casting materials are:

1. The physical nature of the object to be cast
2. The positive casting material to be used for the finished cast
3. The number of positive casts to be secured from a specific mold.

COLOR IN SCULPTURE

Polychromy is the art of using many colors harmoniously as a decorative adjunct to architecture, sculpture, and the minor arts. The term means 'many colored' and is derived from the Greek.

The application of color to sculpture appears to have had its beginnings in prehistoric times. There are paleolithic figures extant with definite vestiges of superficial coloring matter, suggesting that a substantial proportion, if not all of the sculptures of this period were colored. However, pigment is highly perishable when thousands of years are involved, and the superficially applied coloring matter of few ancient works has survived to the present day. The majority of ancient and originally colored works we now possess in museums and private collections are either entirely devoid of color or have only vestigial remains of their original coloring.

All forms of Egyptian sculpture, both in the round and in relief, are believed to have been originally colored. The Greeks, who lived under clear and brilliant climatic conditions, almost invariably colored their statues, from the Archaic period to the fifth century B.C., and even their bronzes were occasionally colored.

The color applications of the Greeks to stone sculptures seem to

have varied with the nature of the stone that was used. The finer-grained stones, such as the marbles, generally received only a light wash of color to modify their whiteness, while the coarser and pitted stones, such as some of the limestone varieties, received heavier-bodied coloring of a pastelike consistency. Wood and baked clay sculptures were also painted superficially. Naturalism was often disregarded by the Greek sculptors, who sometimes colored hair red or blue.

The color employed by the Greeks was very fugitive because of the media they used, which consisted largely of egg yolk, white of egg, and glue. All of these are water-soluble and therefore possessed little permanence, particularly when they were applied to outdoor sculpture, where rain could wash away the superficially applied coloring.

During the Italian Renaissance, polychromy was practiced by some sculptors in their painted stone sculpture and in terra cottas.

The contemporary connotation of polychromy broadly includes all forms of integrated and superficially applied coloring, but this is not entirely accurate. Two sculptors who have experimented with applied color are Zadkine, who has worked with colored lacquers on wood carvings (Plate 54F), and Eric Gill, who painted portions of his stone sculptures (Plate 48F); but they are fairly unique. The addition of superficial coloring to wood and stone is rarely practiced by the majority of modern sculptors, who seek to exploit the natural qualities of the material they employ, placing emphasis upon the inherent beauty of the specific material.

The coloring of terra-cotta sculpture, which had its beginnings many hundreds of years ago, is the best contemporary example of the survival of polychromy in sculpture.

SIZE OF SCULPTURE

A distinction is frequently made between statues and statuettes according to size. Works under 12 inches are generally termed statuettes, although the classification is arbitrary; many apply the term to any work up to a maximum of 10 inches. Eleanor Rowland states that carvings should be at least 12 to 14 inches high to be considered sculpture. Works smaller than this are referred to as statuettes if they are fashioned in the round.[12]

[12] Rowland, Eleanor, *The Significance of Art*, Boston, 1913, p. 27.

Statues are further classified according to size as follows:

1. Life size
2. Heroic, or larger than life size; approximately between 6 and 7 feet in height
3. Colossal, or larger than heroic.[13]

THE BASE

The proper mounting of a finished work of art is an important phase of sculpture, requiring a developed taste and a sense of proportion.

Bases are both functional and decorative. They are used to set off and thereby to enhance the appearance of the piece, and they also function as physical stabilizers for works which would not otherwise remain securely upright and balanced. (See Plates 1, 2, 7, 12, 27-9.)

Almost every solid-bodied substance has been used as base material. The most frequently employed is wood, since it can be readily cut into desired shapes and then sanded smooth and polished. However, the underside of a wooden base should not be polished or waxed, because this may result in a slippery and insecure surface. The bottom of a wooden base is generally left rough, or a layer of felt is glued to it, to cushion the total weight and to provide a firm, clinging surface.

Stone has also been used for bases. Rough stone masses have been employed for this purpose, but more frequently, the stone has been carefully cut and polished.

In cases where metallic rods are to be used for joining the model and the base together, accommodating holes may be drilled in the stone base by means of a star drill.

LETTERING

A knowledge of lettering is frequently important in sculpture, particularly when the sculptor is asked to design memorial plaques, friezes, medals and coins, and other forms requiring the incorporation of inscriptions in the design. (Plates 8B, 12A, 52C.)

It is advisable, therefore, that the student familiarize himself with the various lettering styles. By study and application he should cultivate a taste that will enable him to choose and adapt styles of lettering to the design problems he will encounter.

[13] The monumental cliff sculptures of India and Egypt fall into the colossal category, as do many of the wall reliefs of Assyria, Babylonia, and Mesopotamia.

The ability to space individual letters and words satisfactorily is an art in itself, and good spacing is vital for legible and interesting lettering. This is not so much a question of mathematical measurement of the spaces between letters as it is a matter of feeling and taste. For example, straight letters like 'M' and 'I' should not be spaced as closely together as a straight and a curved letter, such as 'M' and 'O,' or they will appear crowded.

Lettering may be incised or cut into a surface or it may be raised, in which case the background is cut away, leaving the letters in relief.

The raised type of lettering is frequently employed in designing for bronze, because the appearance of raised letters in bronze is much richer than an incised inscription would be.

THE STUDIO

Virtually every sculptor aspires to 'the ideal studio,' the nature of which varies with individual requirements. (See Plate 9.) Some have lavishly luxurious conceptions that they hope eventually to realize; but since sculpture is not a very lucrative profession, most sculptors are forced to adapt themselves to reality.

Adaptations of existing units are very frequently made. Sculptors have worked and are working in lofts, attics, apartments, basements, barns, converted stables, stores, and garages adjoining private homes.

An even floor, preferably on the ground or street level and sufficiently strong to support the heavy blocks of stone that are often used in sculpture, is necessary for a sculptor's studio. The finest type of studio floor is one that is composed of solid concrete. If the floor does not rest firmly upon the ground, it is advisable to find out the load each square foot of flooring is capable of sustaining.

A source of fresh, running water is another important studio requirement. Running water is needed for many studio jobs, including mixing plaster, cleaning tools, and hosing the studio floors.

If an extra room is available, it is recommended that the studio work be divided so that the stone and wood carving is done in one room and clay modeling in another, because the process of carving stone results in fragments being scattered all over the room, and the fine stone dust settles over everything.

Each tool should have a place (Plate 9B). There should be racks for tools, bins for clay, and shelves for small models. Too much emphasis cannot be placed upon the importance of keeping the studio

in an orderly condition, as a means of saving both time and energy.

Good studio lighting is an element that is all too frequently disregarded. While the sculptor enjoys an advantage over the painter in that he can work under artificial light, overhead natural lighting in the form of skylights are as desirable for working as they are for exhibiting sculpture. This is particularly true for working on delicate pieces during the daytime. Wall windows, preferably with northern exposure, are also valuable studio and working assets.

Concealed artificial light sources are superior to those which yield a garish and brilliant illumination. Movable light sources, such as candles, are occasionally of value while working for examining and 'testing' a piece of sculpture.

SINCE the plastic earths or water-base earth-clays permit the greatest freeness of design and delicacy of modeling, they are often used by sculptors as a three-dimensional sketching material and for registering fleeting impressions or concepts.

Plastic earth can be used as a transitory medium or as a medium in its own right. As a transitory or preliminary material, the plastic earths are frequently employed in developing the original three-dimensional model from which the final version of the work is cast in a more durable material, such as cast stone, bronze, or some other metal or alloy. However, the plastic earths can also be used as a direct medium and fired hard and permanent.

A plastic earth suitable for sculptural use as a modeling medium must possess two important basic properties. It must possess plasticity and be able to yield freely and easily to the shaping influence of the sculptor's fingers and tools, and it must also have porosity. In addition to these qualities, an earth-clay should be capable of being fired hard and permanent if it is desired for use as a final medium.

There are abundant natural clay deposits that are suitable for use as modeling clays or terra cottas,[1] but they are frequently found below the surface of the earth and in many cases the raw material has to be cleansed and refined before it can be used as a fine art medium.

The usual appearance of clay is that of a close-textured and uniform body, varying in color from blue to green. For sculptural purposes, the lighter-colored earths are preferable to the darker varieties, because delicate modeling is more apparent in pieces fashioned with the lighter-colored earths.

The plastic earths that are used as modeling clays are usually made up of a clay base (hydrous aluminum silicate) and sand.[2] The sand

[1] While many of the natural-occurring earth-clays can be used for modeling and casting purposes, they should first be subjected to tests before time and energy are expended in working them up into sculpture.

[2] An earth-clay is occasionally mixed with small amounts of fine sand or other silicates to increase the body of the material and to make the eventual fired piece harder, but the purer clay will yield more delicate results.

may vary greatly in its physical nature from grains as fine as the clay particles to larger, coarse units; it may vary chemically from a fine quartz to the remains of virtually any rock. Impurities in small amounts determine the specific types of clay and their use or applications.

Two or more natural clay varieties are often blended in order to achieve a product with finer physical qualities.

The best clays are those that have been prepared for use by first washing out the soluble impurities, then sifting the dry earth to remove solid foreign matter, and finally grinding the particles into a fine and uniformly bodied powder. Many of the clay varieties that are marketed commercially are highly refined and processed materials.

Natural earth-clay deposits are not always accessible, and an artist may live in a region devoid of earths suitable for sculptural use. Also, some artists feel that the labors involved in securing their raw earths and in testing, sifting, and preparing the material are inconsistent with the resulting product and the savings that are involved; they prefer to purchase their modeling clays processed and ready for use.

When earth-clay is to be purchased, it is advisable to secure it in dry powder form; and, if much modeling is contemplated, large unit quantities will prove most economical. When a moist earth-clay is bought, the sculptor pays for the large amount of water added to the dry powdered earth by the processors in order to produce a plastic modeling material.

Earth-clays will keep indefinitely in either a dry form or in a wet state, but precautions must be taken in storing a moist earth; it should be kept in sealed, rustproof containers.

One of the finest modeling clays for developing small pieces is a natural-occurring earth known as 'Monmouth clay,' because it comes from Monmouth, Illinois.

'French clay' is a fine variety of plastic earth imported from France. The material is fairly dense and rather sticky, requiring experience in handling. However, the physical qualities of the substance are such that it requires less 'butterfly' support (see p. 37) than do many other earth-clays. The material is very plastic and sensitive to detail and does not dry out as rapidly as do the more common varieties of domestic plastic earths. 'French clay' is almost invariably marketed in a wet, prepared state and in fairly large unit containers.

TERRA COTTA

Terra cotta is a term meaning 'baked earth,' and since all earth-clays can be fired, the term is frequently applied rather broadly to include any suitably plastic and workable natural earth, which can be fired hard and compact. The American Ceramic Society definition[3] of a terra cotta clay is as follows:

'A clay of suitable plasticity and working properties for the manufacture of terra cotta, such as vases, statuary, or architectural shapes. It should have good plasticity. Much of that used in the United States is of the stoneware or fireclay type.'

The definition for a stoneware clay is:

'A clay suitable for the manufacture of stoneware; it possesses good plasticity, vitrifies between cones 4 and 10, and has a long firing range. The color (on firing) is buff to gray.'

A fire clay is defined as:

A clay either of sedimentary or residual character which has a P.C.E. [Pyrometric Cone Equivalent] of not less than cone 19. It may vary in its plasticity or other physical properties and while it often fires to a buff color, it does not necessarily do so. It is recommended that clays with a P.C.E. from 19 to 26, inclusive, be called 'low heat duty fire clays,' and that fire clays with a P.C.E. of cone 27[4] or higher be designated 'refractory.'

The terms Nos. 1, 2, and 3 fire clay, as sometimes used, do not always refer to the same degree of fusibility.

While some fire clays are found underlying coal beds, many show no association with coal; in fact some clays underlying coal beds do not conform to the description given.

Historically, the use of terra cotta as a sculptural medium dates back to prehistoric times, when Stone Age man first dug up and modeled earth-clay and dried or burned his product hard. Since all clays can be fired and since natural earths suitable for modeling and firing are abundantly distributed geographically,[5] the medium was used extensively by many peoples.

The Etruscans and Romans used terra cotta, as did the Greeks, for innumerable statuettes; a substantial number of terra-cotta statuettes

[3] Bulletin, *American Ceramic Society*, June 1939, vol. 18, no. 6, pp. 213-15.
[4] The firing point of cone 27 is approximately 3000 F.
[5] Natural-occurring clays suitable for modeling are widely distributed in the United States.

have been unearthed at such sites as Tanagra, Rhodes, and Athens (Plate 10B). The Greeks modeled the material solidly and also molded it hollow, employing it principally for their smaller works. They rarely used terra cotta for large statues.

The use of terra cotta declined in the Middle Ages and revived with great vitality during the Italian Renaissance when it was a favored sculptural medium.

PORCELAIN

Porcelain is a prepared silicate member of the terra-cotta family that fires pure white and translucent at a substantially higher temperature range than does the average earth-clay or terra cotta. The material has been employed from Antiquity, notably by the Chinese.

There are hard porcelains and soft porcelains. In the hard varieties the component elements render the resulting material very infusible, while the soft types of porcelain are much more easily fused. Porcelains are frequently glazed after firing in order to achieve a perfectly smooth ceramic surface.

The best type of porcelain is made from relatively pure kaolin, with which is usually mixed quartz and feldspar.

PREPARATION OF NATURAL EARTH-CLAYS

TESTING PLASTICITY

The plasticity of a natural earth-clay can be determined by a simple and commonly employed test, based upon the amount of water necessary to render a dry earth-clay mass plastic.

One hundred parts of the dry powdered earth-clay (by weight) are placed in a mortar, and water is added in weight units of 1. The clay mass is continuously stirred as each water unit is added, and this procedure is continued until the entire mass achieves a plasticity that is suitable for modeling purposes.

The more plastic earths require a proportionately larger quantity of water; conversely, the less plastic earths require the addition of less water to achieve plasticity. If the dry clay required the addition of 38 units of water before it became satisfactorily plastic, then 38 per cent was needed. An earth-clay requiring up to 25 per cent water will not be a very plastic or suitable modeling clay. A sample requiring about 40 per cent of water should be a satisfactory modeling

material. A clay requiring more than 40 per cent water is very fre-
quently too plastic for modeling purposes.

TESTING FOR SHRINKAGE

To test a clay specimen for shrinkage, a mass of the material is
fashioned into a solidly packed cube. If inches are to be used as a
basis for measurement, it should be decided whether 64ths of an inch,
32nds of an inch, or 16ths of an inch will be used as measurement
units. As the unit size is increased the dimensions of the resulting
cube will naturally be similarly increased.

The surfaces of the cube are then marked off in units of 100. A
$1\frac{9}{10}$-inch cube may be divided into 100 units, spaced $\frac{1}{64}$ of an inch
apart. A $3\frac{1}{8}$-inch cube can be divided into a hundred spaces, each
$\frac{1}{32}$ of an inch apart; and a $6\frac{1}{4}$-inch cube can be marked off in a
hundred 16ths of an inch. If centimeters are used, the cube should
be 10 centimeters in each direction.

The surface calibration may be made with a fine needle and rule
and should be measured both vertically and horizontally on the cube.

After marking, the clay cube is permitted to dry out slowly and
when the mass has thoroughly air-dried, the measurements are
checked. If centimeters were used, each millimeter of shrinkage will
be the equivalent of 1 per cent.

To test for firing shrinkage, a calibrated cube is placed in a kiln
and heated. After firing, the measurements are checked with a rule
and the percentage of shrinkage is noted.

Terra cotta shrinks in baking approximately 1 inch to each foot.

If a naturally occurring clay has been tested and has proved satis-
factory for sculptural use, for reasons of economy a large quantity
of the material should be secured for future use as a modeling or
casting medium.

PROCESSING

Clay with a slight 'grain' or coarseness is preferable for modeling
purposes to finer varieties. However, most of the natural-occurring
clays require a processing or cleansing before they can be used, be-
cause of an overabundance of impurities. The finest method of proc-
essing a natural clay consists of first screening the dry clay mass and
then 'washing' the clay if it contains too much sand.[6]

[6] As the quantity of sand in a clay is increased, the porosity of the mass will
also be increased, but its plasticity will be progressively reduced.

A large barrel and several clean pails are required for the screening and washing operation. The clay mass is first dried thoroughly and the large masses are broken up and reduced to finer particles, which are then sifted through a large screening of about ⅛-inch mesh, and received by one of the dry and clean pails. The sifted clay is then slowly sprinkled by hand into a second pail partly filled with clean water. As the fine clay is added to the second pail, it should be 'fingered' and small lumps broken up. The clay will slowly settle in the water and pile up at the bottom of the pail. The process of adding clay should be continued until the surface of the water is broken by the accumulating clay. After the clay-water mix has been permitted to stand for about half an hour, the entire mass should be thoroughly stirred with a tool or with the hand. Actually, the use of the hand for this purpose is to be preferred, since by this means the sculptor can get the 'feel' of the clay and any lumpy matter can be broken up.

After the clay has been thoroughly stirred, the slip is poured through a fine screen placed over the barrel, to strain out smaller particles. This procedure is repeated until the barrel has been filled.

If the clay is very sandy it can be washed to remove the bulk of the sand. The washing is done before the slip is poured into the barrel through the fine screening, and the procedure consists of first stirring the mass vigorously and then permitting it to stand for about half a minute. Since the particles of sand are substantially heavier than the clay particles, they will settle out of the mix more rapidly. The slip is then poured into another clean pail and the residue at the bottom of the original pail is discarded.

When the particles suspended in the slip have settled, the sculptor should insert his hand into the mix and rub the material at the bottom of the pail between his fingers. If the clay is still too sandy, the mass can be restirred and the process of pouring into another vessel repeated. Some sand is necessary for porosity in the modeling clay, so all of it should not be washed out.

The refined slip is poured into the barrel as it is prepared, until the container is full, after which it is allowed to stand for several hours; the suspended clay particles will slowly settle down, leaving a surplus of fairly clear water at the top of the barrel. This may be siphoned away with a small rubber tube. The process of siphoning at intervals is continued until the slip possesses the desired working consistency. It should be noted that as the water is removed, the slip will become thicker.

MODELING WITH THE PLASTIC EARTHS

Since modeling with the plastic earths is fundamentally a process of synthesis or building up of form, the earth-clay used should be fine and even-textured [7] and it is best when it is in a soft and moist condition. It should be sufficiently soft to respond readily to a delicate touch, but not to the extent that it will be sticky and adhere to the fingers or modeling instruments.

MODELING TOOLS

Myriads of tools have been devised for clay modeling, and a well-stocked art supply store will confront the student with a really perplexing assortment of hundreds of different wood and metal modeling instruments of all shapes and size.

The best tools for general clay modeling are the fingers, and whatever other tools are used should be regarded as 'extensions' of the fingers. The number of instruments employed should be kept to a bare minimum, and each should be thoroughly mastered. Tools for modeling can be easily made from small pieces of hardwood and metal. (See Plate 11A and B.)

All modeling tools should be washed and cleaned after they have been used. They should not be permitted to soak in the clay tub or they may become cracked and decayed.

ARMATURES

Armatures constructed of flexible metal wire, pipe or tubing are very often employed as artificial 'skeletons' or supporting structures over which the 'flesh' or clay is formed and shaped, but their use is indicated only if impressions or casts are to be fashioned from the modeled earth-clay forms. The use of armatures is not indicated where works are to be eventually fired hard, and such pieces have to be fashioned solidly, compactly, and carefully unless a very heavily bodied earth is used with a dangerously low moisture content.

For small pieces, lead piping is frequently used for constructing the supporting framework. The piping or wires are bent in the general direction of the bones or the movement of the forms. Since lead is a fairly soft metal and is apt to sag, large works are often fashioned

[7] For fine china and small ceramic sculptures, a fairly fine-grained earth is employed. Large architectural pieces are generally formed from a coarse-grained earth-clay.

over armatures constructed of steel, iron, or aluminum rods. (See Plate 11C, D, and Figure 2.)

Small pieces of wood called 'butterflies' are often tied to the basic support or armature when earth-clay is used as the modeling ma-

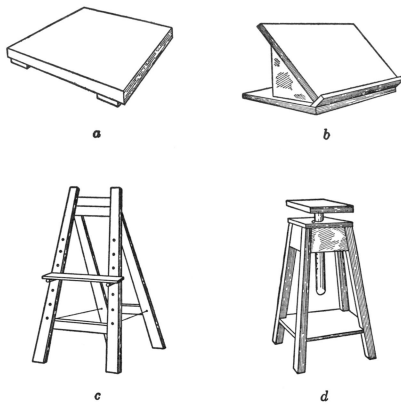

a *b*

c *d*

FIG. 1. STUDIO MODELING FURNITURE

a. Modeling board. *c.* Modeling easel.
b. Table modeling stand. *d.* Modeling stand.

terial. The butterflies help to prevent the plastic material from slipping or sagging. They are simple mechanical devices that are easily constructed in the form of a cross from small, flat strips of wood about two inches in length and less than an inch in width. Copper wire is used to bind the two strips together at the center.

The 'core' or initial application of earth-clay to the armature should contain less moisture than subsequent additions, because of the tendency of the plastic mass to settle down; the use of a fairly dense clay for the initial application will also markedly lessen the dangers of

sagging. As the work progresses, the clay additions should be slightly thinner in consistency than the material added to the main mass the day before. The thinner-bodied fresh additions can be more easily applied to the model and will be 'accepted' more readily by the clay mass than would heavier-bodied additions.

The mass of a work may be built up by the progressive addition of small masses or pellets of earth-clay applied over the armature, and the form of the piece is best developed uniformly and consistently.[8] No one portion or area should be carried forward to a greater degree than another.

If a contemplated work is to be eventually fired, the artist must dispense with armatures or artificial supports within the earth-clay model for several reasons. All water-base clays contract on drying and the presence of a foreign body, such as wood or metal, within the clay mass would result in a cracking or splitting of the plastic form.

The heat of the kiln would also cause a metallic support to expand while the outer earth-clay mass shrank or contracted as it lost moisture, and the results would be disastrous. If shellacked wood were utilized as armature material over which the earth-clay forms were modeled, the heat of the firing operation would set fire to the wood and this would certainly destroy the surrounding clay mass.

Hollow Forms

In developing a form (in the round) that is to be eventually fired, the object should be modeled with a hollow interior or core unless the piece is very small, in which case it can be made solid. Terra cottas are fashioned hollow to allow for the contraction of the earth-clay mass on drying and firing. The thickness of the modeled earth-clay body should be equal throughout and it should be modeled compactly to prevent air pockets being left in the mass, since these may expand or explode during the firing operation and thereby ruin the work.

It is, however, exceedingly difficult to model a figure or bust with a hollow interior, and a simpler procedure would be to fashion the work solidly. After the modeling has been completed the back of the work can be cut open with a fine wire and the interior can be scooped and hollowed out, leaving a uniform external clay thickness or shell,

[8] Many modelers work with their models at eye level on a stand with a revolving top so that the clay work can be easily turned about, viewed, and worked from all sides.

which can vary from half an inch to almost two inches, depending upon the dimensions of the work. The section of the back that has been cut away to permit hollowing can be replaced after the edges of the unit have been moistened to guarantee adhesion of the earth-clay, and the joining marks are then smoothed over.[9] After drying, the form is ready to be fired.

CRACKING

Should the clay mass begin to fissure or to develop fine surface cracks, steps should be quickly taken to treat the mass, because there is then present the danger of larger and deeper fissures' developing and possibly ruining the work.

The method of treating cracks is quite simple. Take a narrow clay-modeling stick and press it deeply into the fissure area. The hollows thus formed are then packed with fresh, moist earth-clay.

PREMATURE DRYING

Precautionary measures against the drying out of a clay mass are of great importance during the modeling process, because a mass of clay tends to dry out quickly if it is left exposed to the atmosphere. The greatest evaporation takes place from the surfaces and as the loss of moisture content continues, the work may become serrated with fine to large fissures. The warmer the climate or weather, the greater will be the precautions that have to be taken against drying out. The temperature of the room or studio and the moisture content of the atmosphere are other factors that have a direct influence upon a work.

Some modelers spray their clay work once or twice each day with water. If this practice is followed, care should be taken not to saturate the surface, thereby possibly washing away the surface modeling. The spraying can be done with a fine atomizer and must be very light. The procedure can be repeated once or twice, at intervals of a few minutes. The care exercised in spraying should be increased as the model approaches the finishing stages.

In order to retain moisture and preserve the plasticity of the clay mass, many modelers cover the clay form with damp cloths after they have finished working for the day. The cloths should not be saturated with water and must not be placed in direct contact with the modeled

[9] Tiny air holes are occasionally made in obscure places on the model to permit steam to escape during the firing operation.

form, or there may be a slurring of the detail. Small wooden pegs can be inserted into the clay model and the wet cloths can be draped over these pegs to form a shell-like container. Oilskin is sometimes placed over the cloths, with the treated oilskin surface facing the model.

A rectangular framework can be fashioned from strips of wood and covered with rubber sheeting. If this protective shell is placed over the model after the day's work has been completed, it will prevent the excessive loss of moisture from the clay mass. Zinc-lined boxes or cabinets are also used for this purpose.

As the modeled work approaches completion, it may be allowed to harden slightly by drying, and the finishing touches, which are generally the subtle touches, can be applied. It should be remembered that this is an extremely delicate stage of modeling, since if the model is permitted to dry out too rapidly or unequally, a shrinkage and fissures may ruin the entire effort.

If a clay form dries out during the working stage, the end of a pointed instrument can be pushed into the mass at close intervals and these small openings can be filled with clean water with a small glass dropper. Following this, the form can be covered with a wet cloth and allowed to absorb moisture.

Redeeming Dried-out Material

A clay mass that has thoroughly dried out and hardened can be redeemed for future use as a modeling material by pulverizing the clay body and reducing the pieces to a fine powder. Water is then added to this, and the mixture is stirred until it is of an equal and uniform consistency.

Drying

After the modeling has been completed, the piece should be set aside to dry slowly in the air, because quick drying frequently results in a cracking of the fragile clay body and the destruction of the work. The time required for drying will depend upon the thickness of the piece. Thicker pieces invariably dry out more slowly than do thinner works.

Porous clays permit moisture to escape readily and this type of clay often dries out with a minimum of cracking, because of the presence of fine particles of sand in the clay body. The sand may be present naturally in the clay or it may be added by the modeler. A

sand that is too fine will not yield the desired porosity, since it will be too similar physically to the clay particles and may result in a clay that is dense rather than porous. However, the presence of a coarse sand may interfere with delicate modeling.

A clay mass may dry uniformly and not crack if it is of equal consistency throughout, but some degree of shrinkage will inevitably occur. The shrinkage varies with the type of clay used, the rapidity of the drying, and the solidity or thickness of the clay mass. A degree of physical change is inevitable even if care is exercised in maintaining moisture and controlling drying.

If it is desired to fashion a precise negative for casting a number of copies from a modeled earth-clay original, the negative mold should be made as soon as possible after the modeling has been finished, since the clay will otherwise lose moisture and shrink.

Modeling Reliefs

Reliefs in plastic earth or composition clay are most satisfactorily developed on wooden modeling boards (see Figure 1). Plywood is excellent for this purpose, because it eliminates the necessity for reinforcing the modeling board with strips of wood to prevent warping.

After deciding upon the dimensions of the board, the wood should be cut so that the corners are perfect right angles. Both surfaces and all edges of the board are then treated with several coats of shellac and alcohol to seal the pores of the wood and thereby prevent the absorption of moisture from the plastic earths or the loss of oil from a composition clay. The shellac treatment will also make it easier to keep the modeling board clean.

The form of a relief can be built up freely and directly, or drawings can be used for guidance. Some modelers make use of a modeling board consisting of a sheet or slab of slate on which their design is sketched, and the plastic forms are then built up over this.

A common method of developing a plastic relief consists of first preparing a uniform clay mass that is slightly larger in its dimensions than the contemplated relief. This can be fashioned by covering the area to be used with small lumps of clay and then pounding the soft material level and compact. Plastic earth can be smoothed down and leveled by drawing a straight-edged board across the surface: each end of the board is held firmly and pressed down evenly, while the board is drawn over the yielding surface toward the body.

The drawing can be transferred to the clay by outlining the design

on tracing paper and then placing the sheet evenly over the clay surface. The outlines can then be traced with a rounded wood modeling tool and light finger pressure. When the entire design has been transcribed, the tracing paper is removed and the process of modeling is started.

A small design can be transferred to a larger clay area by the process of 'squaring-up' the original sketch or drawing, and then outlining the surface of the clay mass with corresponding squares. The design is then freely drawn on the clay with the squares serving as guides. (See Plate 46.)

The forms of the relief can be built up on the flat surface, or the background of the clay mass can be dug into and removed; then the modeling of the design is begun.

Medium to large, and high projecting reliefs generally require supporting armatures. The materials used in constructing these foundations over which the clay forms are built up include wood strips (see Plate 22), lead pipe or wire, compo piping, and occasionally iron rods, which have been shaped by bending into the desired forms.

The base or foundation surface is provided by a sturdy wooden board reinforced with strips of wood screwed to its back surface. The modeling-board surface should also be treated with several coatings of shellac or lacquer to further minimize the possibilities of warping and twisting.

Four wooden strips are nailed or screwed to the foundation board, one on each border of the board, to form a containing wall or fence for the clay relief. The actual supporting framework or armature is built up on the modeling-board surface, and this should be done carefully, with thought and without haste. The lead or compo piping strips are bent to conform with the shapes to be modeled, and these are nailed to the board in their proper places.

'Butterflies' may be hung from the top wood fence strip.

Modeling a Head

As large masses of moist plastic earth tend to sag under their own weight, supporting skeletons or armatures are required when modeling heads or figures, to serve as foundations over which the plastic-earth forms may be built up and modeled.

There are several types of armatures available commercially for use as supports in modeling heads, busts, and figures. The materials required for a commonly used variety that can be easily constructed

by the sculptor consist of a length of wood about 2 inches wide, 2 inches thick, and from 12 to 15 inches long, for use as an upright; a flat wooden board for use as a base; lead pipe or heavy lead wire or composition tubing; screws, nails, and fine but strong copper wire.

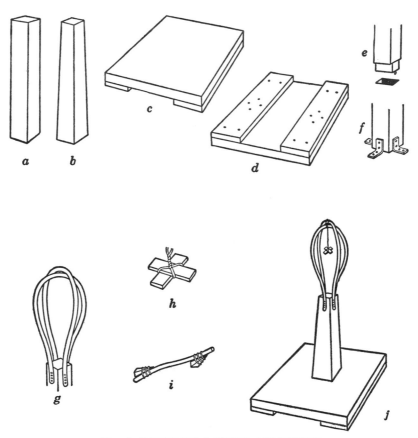

FIG. 2. PARTS OF A HEAD ARMATURE

a. Rectangular length of wood used as an upright.
b. A tapered variety of upright.
c. The baseboard foundation.
d. Baseboard inverted, showing reinforcing strips of wood nailed or screwed to its underside.
e. Mortise tenon method of joining an upright to a baseboard.
f. Method of securing an upright to a baseboard with metal angles.
g. Metal head armature.
h. A 'butterfly,' used to sustain a weight of plastic earth and to prevent excessive sagging of the earth clay mass.
i. Wooden wedges that may be bound to the armature metal at intervals with fine copper wire. These function in a manner similar to that of the true 'butterflies.'
j. The completed armature.

The long length of wood should be fixed securely and at right angles to the wooden baseboard to serve as an upright upon which the tubing or wire is attached to form the framework for the head. This upright length of wood can be tapered slightly to narrower dimensions of about 1¼ to 1½ inches toward the top. It may be joined to the baseboard in several ways, some of which are illustrated in Figure 2. A metal rod or bar may also be used as an upright.

The baseboard should be perfectly flat and from about 12 to 18 inches square, depending upon the size of the work that is to be undertaken. If a single board is to be employed, the wood thickness should be about 2 inches. Plywood is excellent for use as a baseboard material.

All exposed wood surfaces should be varnished or treated with shellac to prevent the wood from warping from the moisture of a plastic earth. The baseboard may be additionally reinforced and strengthened by nailing or screwing two flat strips of wood to its underside, as illustrated in Figure 2d.

The next step in constructing the armature consists of bending 2 strips of lead wire or pipe or composition piping, each length about 25 inches long, to conform with the general shape of the head and neck to be modeled.[10] These are so fashioned that the metal framework will be smaller in size than the finished clay head is to be. Sufficient space must be provided for the clay thickness that is to be applied over the supporting skeleton. The tubing or piping should be securely fastened to the upper portion of the wooden upright by means of wire, screws, nails, or tape, to form the foundation over which the head is built up in clay; the two bent portions of the metal head form are also tied together with wire at the place where they cross: at the top or highest point of the armature.

If the modeling medium is to be a plastic earth, 'butterflies' (see Figure 2h) can be suspended to hang freely from where the lengths of wire or piping cross. Small wood wedges, also occasionally referred to as 'butterflies,' may be tied to the tubing at intervals with fine wire to prevent undue sagging of the plastic earth.

It is recommended that all metallic portions of the armature be treated with metal lacquer subsequent to the completion of the frame-

[10] Lead wire, lead pipe, and composition tubing possess physical strength and are also moderately flexible, so that they may be carefully bent in different directions.

work and prior to the application of the clay, to prevent corrosion from taking place.

If the shoulders are to be included in the work, the use of a longer upright is indicated, and a wooden crossbar should be nailed or screwed to the upright at right angles to help support the clay mass used in forming the shoulders. Additional 'butterflies' can be suspended from the crossbar.

The initial application of clay to the armature can be accomplished by squeezing or pressing the plastic material compactly around the piping and wood, and additional clay is gradually added until the head mass is built up in an ovoid or egg shape, slightly smaller dimensioned than the final head mass is to be.

As noted elsewhere in the text, the first application of a plastic earth to an armature should possess less moisture than later additions, to minimize sagging. The clay employed for subsequent additions may be more fluid.

The angle at which the head is set should be noted, and the general head form from front and profile carefully studied and reproduced in the clay model. When this has been satisfactorily accomplished, the component parts of the head may be developed.

For purposes of accuracy, measurements may be taken with calipers, and corresponding marks may be made on the clay form for guidance.

The student should realize that the sides or halves of the face tend to vary in expression and in form, just as limbs tend to vary in their proportions. For this reason, students occasionally find it of value for purposes of study and guidance to incise superficially a fine line on the clay head from the hairline to the center of the chin, dividing the head mass in half.

The model should be observed constantly and the student should try to carry his work forward evenly and consistently, and from all angles, and not to develop any one area or part more than another.

In developing a portrait head or bust in clay, the work, the sitter, and the eye level of the sculptor should be approximately on the same line. It is advisable to shift the position of the piece occasionally to different parts of the studio while the work is in progress, or to change the light source, so that the light that at the beginning of the work fell in front of the head now falls on the other side. This changing angle of light will help the modeler to judge his work.

The utilization of a mirror, enabling the artist to view his work in

reverse, occasionally proves of some value in judging proportions and likeness. Another method of testing a work during its development consists of using a single light source, such as a candle. This is held above the work and below it and the piece is viewed from all sides.

A work being modeled in plastic earth should be covered between working periods, as mentioned earlier, with damp cloths, to prevent the substance from drying out, hardening, and possibly cracking. To prevent a marring of surface detail and modeling, the modeled object is sometimes 'pegged' by sticking small wooden pegs into the earth-clay form and draping damp cloths over these pegs. A waterproof material such as oilskin may be placed over the layer of damp cloths to reduce further the degree of moisture loss through evaporation. The finest method of caring for a work between modeling periods consists of placing a protective cage over the plastic-earth form being developed.

CASTING WITH THE PLASTIC EARTHS

There are two major methods of casting with earth-clay:

1. Pressing or squeezing the clay into molds, or hand forming against the mold
2. Slip casting.

Earth-clay or terra cotta can be employed as a positive casting material and cast in sectional plaster negative molds when more than one copy of a terra cotta is desired. The casting of earth-clay in absorbent plaster molds is extensively practiced commercially for producing hollow ware easily and quickly. As the negative molds are passed through a drier as each unit is made, they can be used repeatedly.

However, the technique of casting objects in clay differs from that used for cements or cast stone, because the earth-clay begins to shrink almost as soon as the casting is finished,[11] and the material does not 'air-set' to its ultimate physical strength.

PRESSING AND SQUEEZING INTO MOLDS

The pressure molding of earth-clay is largely used for fashioning tile. However, it also has been and can be employed for fashioning

[11] The design of a terra-cotta work must be such that the piece, in shrinking, will not 'hang' on parts of the negative mold, with dangers of fracture.

sculpture. Plaster of Paris negative molds are very frequently employed for this purpose.

The earth-clay used in squeezing or pressing into negative molds must be plastic, but not too fluid and it must be compactly pressed against the containing surfaces of the negative mold.

Occasionally, about 34 parts of grog [12] are added to the raw earth-clay to minimize the dangers of warping and cracking of the clay body during the drying and firing processes. The grog also serves to reduce the plasticity of the clay.

The containing surfaces of the plaster negative mold may be treated with a finely powdered talc before the introduction of the clay, to insure a clean removal of the positive mass. After three or four positives have been fashioned, the plaster mold should be carefully cleaned and dried over heat.

Hand forming against a negative mold is frequently practiced in studios as well as in the architectural terra-cotta industry, and by this method some of the shrinkage difficulties may be overcome. The result is somewhat unequal in positive thickness, but the positive mass achieved by this method will be more compact-bodied than that which results from slip casting.

Dry Pressing

Dry pressing is a commercial process that is not practical for the sculptor, since it involves pressing a slightly moist clay in metal dies under tremendous pressure. The earth-clay generally contains a maximum moisture content of about 12 per cent. This low moisture content is sufficient to bind the clay mass until it hardens on drying and is fired. Occasionally, organic binding materials are added to the clay mass to increase the dry strength.

Slip Casting

Making a Slip: The slip employed in casting must flow easily and its consistency should be about that of a thick cream. However, it is also quite desirable that the water content of the slip be kept as low as possible, because the negative mold has to absorb excess moisture from the slip. By decreasing the water content of the slip, the 'casting operation' will be accelerated and the positive shrinkage will also be reduced.

[12] Earth-clay that has been calcined and pulverized.

There are certain chemicals known as electrolytes that markedly increase the fluidity of the slip when they are added in very small quantities to the clay-water. Sodium silicate or water glass and sodium carbonate are two frequently employed electrolytes. Electrolytes, when they are properly employed, make it possible to achieve a slip fluidity with approximately half of the water the mix would require if electrolyte were not used.

Earth-clays vary in their reaction to electrolytes, but, generally, a combination of both sodium silicate and sodium carbonate will yield the most satisfactory results. The precise amount to use varies with the kind and quantity of the earth-clay, and with the percentage of water that is employed. Either an excess or insufficiency of electrolyte will tend to thicken the slip consistency. The exact amount needed is most satisfactorily determined by experiment. Generally, however, the percentage of electrolyte used is less than 1 per cent of the dry weight of the earth-clay employed. An initial quantity of about ⅛ of 1 per cent of sodium silicate and an equal amount of sodium carbonate can be used for beginning the experiments. One hundred parts of dry clay are used to about 25 parts of mixing water.

The procedure in preparing a slip consists of introducing and thoroughly dissolving the electrolyte in the mixing water. The mixing container should be nonporous and preferably rustproof. Glass or enameled metal vessels can be used for this purpose.

After the electrolyte has been dissolved, dry and finely powdered earth-clay is slowly added to the water, and the mixture is permitted to stand for several hours, being stirred at intervals. Additional water may then be added until a slip of creamy consistency is achieved. As a means of insuring that the mix is of a uniformly fine and even consistency, the slip can be screened through a fine mesh to remove any lumps.

To determine whether sufficient electrolyte has been used, two small slip samples are taken from the mix. Sodium silicate is added to the first specimen, a drop at a time, and the slip is stirred after the addition of each drop. If the specimen becomes more fluid just after the addition of the water glass, then more electrolyte can be added to the main slip mix. If, however, the slip specimen begins to thicken subsequent to the addition of the electrolyte, it will be evident that the mix already contains too much electrolyte. A small amount of additional clay can then be added to the second slip specimen, and if the slip does not thicken, this reaction will verify the fact that too

much electrolyte is present in the mix. By this method it can be determined approximately how much additional earth-clay to add to the main slip mixture.

The weight of a slip mix is a fairly good index to its consistency. For most purposes, a quart of slip should weigh about 54 ounces. A heavier slip, weighing up to about 58 ounces per quart can be used for heavy casting. For very fine work and for small statuettes, the slip can weigh as little as 52 ounces per quart.

Casting Procedure: The piece mold is first securely bound with wire or string and all edge cracks are sealed with composition clay. The slip is then poured slowly and continuously into the mold opening until the mold is charged. As the mold absorbs water from the slip, the level of the slip will lower. Additional slip can be added if this is necessary.

As the mold absorbs water from the slip, a film of thickened clay forms on the inner surfaces of the negative and continues to thicken as moisture is absorbed from the mix. About 10 minutes are required for the formation of a positive clay shell approximately ¼-inch thick on the inside of the mold.

The clay thickness can be seen by scraping the top edge of the deposit with a knife. When the desired thickness is achieved, the excess slip is poured out by turning the negative mold upside down. The mold is then permitted to remain in an inverted state so that all of the excess slip can drain out.

The clay positive will shrink loose from the containing negative in about an hour. The mold portions are now *very carefully* removed from the soft and easily injured positive, which is set aside until it has further hardened. The clay form is then retouched with fine tools and a very fine, moist sponge or soft sable brush. Superficial air holes may be retouched and filled with additional slip. The work is then set aside once more until it becomes thoroughly dry, after which it can be fired.

Another popular method of terra-cotta casting consists of forming a clay positive by the successive application of layers of fluid clay or 'slip' to the inner surfaces of a negative piece mold. The negatives are generally composed of plaster of Paris that has been well dried subsequent to fashioning. When the slip is poured into the mold it absorbs moisture from the fluid earth-clay and a fine clay layer or deposit is formed on the inner surfaces of the containing negative. The excess slip is poured off.

The process of pouring the fluid slip into the negative is repeated several times until the desired positive thickness is realized; then the cast is carefully removed and retouched wherever necessary. Mold seams should be removed from the positive at this point. The mass is then dried before it is baked by exposing it to a controlled moderate heat. After firing, the work can be glazed if desired.

The process of casting terra-cotta forms by pressing the material into negative molds has been practiced for many centuries. (See Plate 10B.) The beautiful and delicate, hollow-molded terra-cotta Tanagra figurines of the third century B.C. were made by first fashioning a negative terra-cotta mold. This was then baked hard and earth-clay was pressed into the sectional piece mold. The front part of the work was formed in one mold section, and the back portion was cast in another mold part. The clay positive mass shrank as it dried out, and the form was then easily taken from the mold. There were frequently small openings in the negative to allow for the evaporation of moisture.

After fashioning, the positive parts were removed from the negative sections and were joined together and retouched by the artist before baking or firing. Projecting portions were usually separately molded and subsequently added to the main clay mass. This process was used for hollow statuettes.

The process of baking the positive was a delicate task. The temperature had to be carefully controlled and provision had to be made for the evaporation of moisture. The terra-cotta form was usually exposed to the air and sun before baking to guarantee that the mass would not contain too much moisture and that it would not dry too rapidly during the firing process.

The Greeks generally painted the entire surface of the finished terra cotta after it had been baked hard.

MODELING WITH SLIP

Slip can be used for modeling by removing some of its water content. A batch of slip can be poured onto heavy plaster slabs and these will absorb moisture from the slip, thickening it considerably. When the slip has become thickened into a denser, but still plastic condition, it can be removed from the plaster slab.

After this the clay mass should be thoroughly kneaded and slapped with a flat slab of wood to remove air bubbles that may have become embedded in it, and the material will then be ready for use.

Pâte sur pâte is the phrase applied to a method of modeling very low reliefs with slip. The slip may be either white or colored with finely ground metallic oxides. It is applied with a soft brush in successive coatings and when the material has dried and become moderately hard it may be carefully worked and finished with fine tools.

The process is occasionally employed in fashioning tiles, and the color of the slip may be different from that of the ground. However, it should be remembered that while the slip is relatively opaque before firing, the mass frequently becomes semitransparent in firing, and the ground color may tint a thin slip application. If the thickness of the relief is substantial, there will be little or no tinting effect.

STORING SLIP

Slip improves with age and is most satisfactorily stored in closed, rustproof containers. It is important that the containing vessels be kept sealed, because exposed slip will lose moisture through evaporation, and varying amounts of water may have to be added to the mix to restore fluidity and consistency. The exposure of a slip mix to the atmosphere may also result in the formation of a dense surface skin.

Stored slip should be occasionally screened to remove any lumps which may have formed in the mass. Before using an old slip mix it is a good practice to pour the material from one vessel into another to break up any air bubbles that may have become incorporated in the mix.

FIRING

Baking or firing is a very important phase of ceramic sculpture and the satisfactory completion of a work very frequently hinges upon successful firing.

The clay form that is to be baked hard must be adequately and carefully dried *before* it is placed in the kiln and exposed to high temperatures or it may crack apart.

A clay mass frequently appears to be drier than it really is and this is particularly true of heavy, thick pieces. To guarantee that a work has been thoroughly dried, the final drying of the clay mass should be accomplished by the exposure of the work to a *low* artificial heat.

The 'fire' of the kiln should rise gradually, for even if the earth-

clay mass has been dried out over a prolonged period of time, it is still possible that some moisture may have been retained in the mass, and this has to be driven off slowly or the resulting steam pressure may cause a cracking of the mass or an actual explosion of the clay body.

In firing a work in a kiln, the heat that is generated by the kiln should circulate all around the object that is to be fired, which may be set or mounted on a piece of firebrick.

Earth-clay generally 'matures' at between about 1830° and 1900° F., but the length of the firing is largely dependent upon the nature of the earth used and the dimensions of the clay model.

The shrinkage of earth-clay when it is fired is approximately 1 in 12, or one inch to the foot, so that if it is desired to secure a finished form of a specific size, the size of the original should be correspondingly increased to compensate for firing shrinkage.

Another important fact to be kept in mind in fashioning a work that is to be eventually fired is that the model must be made hollow to allow for the shrinkage or contraction accompanying firing, otherwise there will be an unequal contraction of thin and thick portions and the modeled form may fracture and fall apart.

Large works should be mounted on an even floor for firing. Occasionally a bed of grog is used to cushion the work, and as the clay mass shrinks during the firing operation, the mass 'rolls' smoothly on the yielding bed, thereby preventing stress on the base portion of the earth form.

KILNS

Forms in plastic earth are usually baked hard and permanent in special stoves or ovens that are called *kilns*. These ovens or kilns vary in their design and size and in the type of fuel they utilize, from the primitive but efficient baking holes hollowed in the sides of hills by the Chinese, to the excellent but expensive modern electric kilns that are equipped with automatic pyrometers that can be regulated and set for specific temperatures.

Although gas or oil-fired ovens are those most frequently used and are preferred by many workers, electric kilns are definitely cleaner and easier to use, in addition to being more efficient. The atmosphere of an electric kiln is also always neutral. This is often an advantage, although in some cases a strong reducing or oxidizing atmosphere may be desired. A temporary reducing atmosphere can

be produced by placing a substance containing carbon, such as a piece of coal, into the kiln, or by sealing the air vent. A high oxidizing atmosphere can be achieved by permitting an excess of air to flow to the burners.

A major disadvantage of the electric kiln, and one which has led many ceramists to prefer and utilize fuel-type kilns, is the fact that the electric kiln fires too rapidly. While this may occasionally be desirable, in many cases it is an objectionable characteristic (see pp. 49-50).

For low-temperature firing,[13] electric kilns equipped with nichrome wire heating elements are very efficient.

PYROMETRIC CONES

Pyrometric cones (see Figure 3) are used to determine and thereby control the firing temperatures of the kiln. The cones are composed

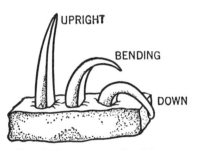

UPRIGHT

BENDING

DOWN

FIG. 3. PYROMETRIC CONES

of clay bodies and they react to the kiln temperature and the length of firing as the materials constituting the model would react.

Cones have a wide fusing or melting range. Cone 022 fuses at approximately 1085° F., and cone 42 requires a temperature of about 3660° F. to melt.

Pyrometric cones are frequently imbedded at a slight angle[14] in small pieces or slabs of plastic earth-clay in which has been mixed a small quantity of sand. A mixture of equal parts of grog and earth-clay can also be used for this purpose.

The general procedure in firing is to set a given cone in the soft clay base together with the next lower fusing cone and the next higher

[13] About 1840° F., or cone 06 is a good and safe firing temperature.
[14] The American Society for Testing Materials specifies an angle of 8° to the vertical.

fusing cone. The earth-clay base is then dried and the cones mounted in this single base are then set in the kiln with the object to be fired. The cone unit should be placed so that it can be viewed through a kiln window or peephole.

When the lowest firing cone begins to bend over to form an arch the desired temperature will have been reached, and the heat source is either lowered or shut off and the kiln left to cool. The heat of the kiln will frequently prove sufficient to bring down the next cone. If the highest melting cone goes down, it will indicate that the kiln temperature has been too high.

INGREDIENTS OF MIXES FOR FIRING

Clays and other ingredients are occasionally combined to produce a material with superior working and firing qualities. Some of the ingredients that are used in such mixtures are as follows:

Ball clay is a creamy white-to-gray mixture of kaolin and fine, eroded quartz plus feldspar, which bakes quite hard. While the substance can be fired, it is too plastic for use as a modeling clay. It imparts plasticity to a ceramic mixture, but tends to shrink excessively [15] in drying and firing.

Feldspar is a nonplastic substance that increases the porosity of an earth-clay body before firing. During the firing operation the material softens and functions as a flux. It also contributes density and durability to the fired piece.

Flint is another nonplastic substance that shrinks very little in drying and firing. Because of its low degree of plasticity, the amount of this ingredient in an earth-clay mix should be kept low. Flint, china clay, and quartz serve to stiffen clays that are otherwise liable to warp.

Grog is a calcined and pulverized earth-clay that is occasionally added to a mix to reduce the shrinkage and warping of the earth medium.

Kaolin or china clay is a fine white clay that can be fired, but is not employed by itself as a modeling clay because it is not sufficiently plastic in its pure form. The substance is very porous and has low shrinkage properties, which make it capable of drying and firing with a minimum danger of warping and cracking

[15] Shrinkage appears to be directly related to plasticity, since the most plastic varieties of the earth-clays are those which have the greatest shrinkage.

FORMULA FOR WHITE BURNING BODY

All of the natural earth-clays that are suitable for use in modeling and firing burn or fire to colors other than pure white, owing to the presence in the earth-clay of contaminating oxides such as iron oxide;[16] firing may result in a light buff to deep red to black color.

In order to achieve a 'white burning body' with desired properties of plasticity, it is necessary to combine or blend several natural occurring earths and minerals. The following formula,[17] suggested by Mr. Frank Jansma, is that of a typical composition or mix:

	Parts by weight
Ball clay	16
China clay	25
Feldspar	32
Flint	27

These proportions can be varied and other ingredients can be added in minute quantities. The formula can be used for modeling small works. For modeling larger pieces, it is advisable to employ a true terra-cotta clay.

As a general rule, the darker natural earth-clays contain impurities such as iron oxide, which act as fluxes; they are, therefore, the lower burning varieties, while the whiter types are higher firing.

COLOR IN CERAMIC SCULPTURE

Many contemporary sculptors utilize terra cotta as a means of integrating or incorporating color in their work. Ceramic sculpture can be colored in several manners.

1. The color of an earth-clay can be varied by mixing it with differently colored varieties of earth-clay or by the addition of small amounts of powdered earth pigments, such as the siennas and ochers. Some simple combinations are as follows:

Ball clay and calcined sienna will yield an earth that fires to a fine buff color.

Ball clay and light red will produce a material that will fire to an attractive warm pink color.

[16] The red color of ordinary brick is owing to the presence in the earth-clay of iron compounds that are converted by the heat of the firing operation into red iron oxides.

[17] This material fires between cones 6 and 8.

2. Slip or engobe [18] painting is a common ceramic process consisting of covering a colored body with a thin coating of another, differently colored body.

3. Underglazing is a method in which colors are either painted or sprayed on the bisque.[19] An underglaze color is a concentrated pigmenting agent that depends upon the glaze subsequently applied over it for 'life' or gloss and brilliance.

4. Overglazing is a process in which color or overglazes are applied over glazes for decorative effects; they require an additional exposure to heat. Overglazes can be applied in several ways, the most frequent of which are direct painting with a soft brush, and fine spraying. The vehicles for spraying are water and alcohol. For painting, turpentine and fat oil are used. A minimum amount of fat oil is employed to render the color plastic, and sufficient turpentine is then added to achieve a loose and flowing medium. When the decoration has been accomplished, the work is exposed to a *slowly rising heat* or a blistering may result.

5. Glazing has been used extensively in the art of ceramics, as a means of achieving color and texture in ceramic sculpture, and for waterproofing pieces fashioned in the plastic earths. There are many types of glazes, including gloss or Majolica glazes, matt and semimatt glazes, crystalline and crackle glazes. These offer almost unlimited coloring and design possibilities.

Glazes are basically silicates or glasses that cover and adhere to fired clay foundations. The clear types of glazes are frequently silicates in combination with potassium, sodium, lead, zinc, aluminum, or boron. When some of the ingredients are present in an excess, the result is a matt glaze. Opaque glazes are achieved by the use of tin oxide and are referred to as tin or stanniferous glazes.

The artist can grind his own glazes in a mortar and pestle, but since the glaze particles must be minutely ground, this is frequently a long and tedious process requiring care and patience.

When a glaze is applied to the outer surface of a plastic earth mass and the piece is exposed to heat, the glaze melts and forms a glasslike adhering coating. The 'firing range' over which the glaze 'matures' varies considerably with different varieties.

[18] Greek terra cottas were frequently covered with a white engobe and color was applied over this, yielding a highly decorative effect.

[19] The bisque or biscuit is an earth-clay mass that has been subjected to its first baking or firing, before it is glazed.

A good glaze is one that is insoluble and therefore resistant to atmospheric action, and it should also possess an attractive appearance. In firing, it should flow slightly, but should not be sufficiently fluid to flow off the piece.

Glazes are secured commercially in a powdered form and are prepared for application by grinding and mixing with water until a mixture of creamy consistency is secured. The proportion of water to glaze is approximately one pint of water to each pound of glaze. However, this varies with the porosity of the bisque and the nature of the glaze.

Glazes are generally applied very thinly, varying from extremely thin films to layers about $\frac{1}{32}$ of an inch. Matt glazes are applied heavier than bright glazes.

Glazes are applied by the following methods:

Brushing	Pouring
Dipping	Spraying

GLAZE DEFECTS

Some of the most common glaze defects occurring during the firing operation are:

Blistering	Crazing
Bubbling	Drying
Crawling	Pinholing
Shivering	

Blistering is a defect that is frequently caused by the presence in the clay body or glaze of sulphur or carbon. During the baking process there is a formation of gas bubbles that blister the glaze. To minimize the possibility of blistering, the glaze material and the bisque should be kept as clean as possible and the firing should be both slow and long.

Bubbling is caused by underfiring and is a term that is used to describe the appearance of small bubbles in the glaze.

Crawling is a phenomenon in which the glaze 'crawls' or recedes to form tiny globules, leaving areas of the body uncovered. This may be caused by many things. The glaze application may have been too heavy, the bisque dirty, or the glaze particles may have been ground too fine. A too rapid drying or firing sometimes causes crawling. Proper firing of the bisque, which should not be underfired or overfired, is another important element.

Crazing is the term that is used to describe the development in a glaze of minute surface cracks. It is usually caused by the unequal expansion of the glaze and the body. The defect is present in many Chinese pieces and has often added to the attractive appearance of the fired work. The addition of flint to the earth-body or to the glaze occasionally serves to prevent crazing. Other elements that have a bearing upon crazing are the temperatures under which the bisque and glaze are fired, and the nature of the cooling of the fired work.[20]

Dryness is a term that is used to describe a glazed piece that appears rather rough and dry. It may be overcome by the application of a thicker glaze coating and care not to overfire.

Pinholing is frequently caused by firing the ceramic body and the glaze at the same time, although air that has been incorporated in the clay mass, dirt, and quick kiln cooling may also cause pinholing.

Shivering is a phenomenon in which the glaze peels off the body. It may be caused by the presence in the body or glaze of an excess of flint. Another cause of shivering is firing at too low a temperature.

[20] A slow cooling is recommended.

PLASTIC WAX

THERE ARE TWO major categories of plastic waxes: the modeling waxes, which are used primarily in developing three-dimensional forms for the lost-wax casting of nonferrous metals such as bronze; and the composition clays, which are not true waxes and which are referred to by many names, including Plastilene and Italian Plasticine.

MODELING WAX

Plastic modeling wax is excellently adapted physically to a freedom of handling; it has been used for medallions, statuettes, and busts for hundreds of years (Plate 44A). Vasari mentions the characteristics of various ingredients of a modeling wax in his treatise on techniques.[1]

Wax is employed as the base. Turpentine adds tenacity to the formula. Animal fat will contribute softness and suppleness, and pitch will color the material black in addition to adding some consistency to the wax. Earth pigments, such as the ochers and siennas, can be used for other colors.

While the form of a work in earth-clay may be 'fixed' by means of heating or firing, a work modeled in a plastic modeling wax remains soft and it is, therefore, relatively impermanent. Its use as a pure medium is restricted by virtue of its permanent plasticity to works that are to be exhibited indoors and protected from unfavorable conditions of temperature and physical abrasion, which would alter its delicate make-up. Since the material will receive superficially applied color, and will retain this coloring if protected, wax has been employed as a medium for polychromed sculpture.

The major use of modeling wax has been as a transitory medium for eventual casting in metal or another fairly durable material.

[1] Vasari, Georgio, *Vasari on Technique,* trans. by Louisa S. Maclehose, New York, 1907; The Preparation of Wax, ch. II (IX), § 42, p. 148.

The Chemical Formulary gives the following modeling wax formulas: [2]

SCULPTOR'S MODELING WAX

Formula No. 1		*Formula No. 2*	
Burgundy pitch	1 g.	Burgundy pitch	2 g.
Beeswax	10 g.	Beeswax	16 g.
Lard	1 g.	Lard	1 g.
Venice turpentine	1 g.	Tallow can be substituted for the lard.	

Petrowax and approximately 10 per cent of rosin yields a very ductile modeling wax. If it is too sticky, the proportion of rosin should be reduced.

The waxes described as 'working waxes' in the section of this book dealing with *Lost-Wax Casting* (pp. 159-60), are modeling waxes and can be colored by the addition of fat-soluble dyes or with pigments, if desired.

CARVING WAX

Within recent years wax has been suggested as a three-dimensional carving medium and experimentally introduced into the classrooms of many progressive schools with fine results. The material can be very easily prepared and the tools required for working it are quite simple and are readily available.

Pure cake paraffin can be carefully melted over a low fire and tinted by the addition of a colored wax crayon. The fluid wax may be poured into cardboard containers and permitted to cool and harden, after which the containing paper walls can be removed with a knife or by soaking in water. If metal containers are used, the application of heat will cause the wax to melt on its outer surfaces and by inverting the vessel and gently tapping, the wax mass will slide out of the container.

Pure carnauba wax has been suggested as a carving wax, but the material is very hard and flake-fractures during carving; it is therefore not to be recommended for use by itself. Softening waxes such as Japan wax or beeswax may be added to carnauba, and will markedly improve its carving qualities.

Johnston [3] gives the following carving wax formula:

[2] *The Chemical Formulary*, New York, 1935, vol. 2, p. 432.
[3] Johnston, R. W., *The Practice of Direct Casting*, Fogg Art Museum, Apr. 1940, p. 223.

IVORITE

Parts by weight

Halowax [4]	16
Carnauba	1

'Ivorite' is a hard, white, and opaque substance that has the general appearance of ivory. It has a high melting point and carves fairly well. After it has been carved, a fine steel wool can be used for smoothing the wax surface.

Wax can be carved with ordinary pocket knives, linoleum cutting tools, or with carving instruments fashioned from discarded dental tools. A clean cloth moistened with turpentine may be used for polishing.

To repair broken wax fragments, the fractured surfaces of the broken pieces are heated for a short interval by immersion in hot water and are then pressed firmly together.

COMPOSITION CLAY

Composition clay has come into use comparatively recently and little is known of its actual composition. The finest varieties of the composition clays are really excellent modeling materials that never harden, but remain permanently soft and plastic. The best variety is that known as Italian Plasticine, which is believed to be composed of tallow, some powdered sulphur, and a special form of native Italian earth, together with coloring matter. The domestic versions of this material vary in quality and ingredients with the individual manufacturer, and the better grades are quite expensive. The formulas are closely guarded trade secrets, but the majority of these products appear to consist of an earth-clay, an inert filler, and varied petroleum derivatives or oils employed as plasticizers.

Information I have secured from the United States Bureau of Standards indicates that modeling clays of the Plasticine type may be composed of about 60 per cent earth-clay, and the balance in varying proportions of flowers of sulphur, and such nondrying plasticizers as lanolin, petrolatum, or glycerine.

[4] Halowax, as noted elsewhere in this book, may cause a dermatitis on prolonged handling.

The Chemical Formulary [5] lists the following composition-clay formulas:

BASIC CLAY MIXES

The clay mix consists of 100 mesh Florida Kaolin and finely ground sulphur (Rubber Makers' Grade). Clay and sulphur are thoroughly mixed.

Formula No. 1		*Formula No. 2*	
Clay	67 parts	Clay	55 parts
Rubber makers sul-		Sulphur	25 parts
phur	33 parts	Lithopone	20 parts

Either of the formulas above can be used as a basic clay mix, to which can be added one of the following vehicles or plasticizers:

VEHICLES

1. No. 2 Petroleum	
2. No. 3 cup grease	50%
National Refining Special T & R Grease	50%
3. Palm oil	80%
Japan wax	20%
4. Lanolin	60%
Glycerine	40%
5. Lanolin	60%
Palm oil	20%
Glycerine	20%
6. Palm oil	80%
Lanolin	20%

The amount of vehicle is that which will have the proper feel when mixed with the clay. It is approximately one part of vehicle to three parts of clay—sulphur or clay-sulphur-lithopone mix.

The following coloring ingredients are also given:

Green: Chrome Oxide in Formula No. 1.
Orange: Oil Ground Chrome Yellow in Formula No. 1.
Blue: Oil Ground Ultramarine Blue in Formula No. 1.
Yellow: Oil Ground Chrome Yellow in Formula No. 1.
Brown: Oil Ground Burnt Sienna in Formula No. 1.
Black: Oil Ground Drop Black in Formula No. 1.

[5] *The Chemical Formulary,* New York, 1935, vol. 2, p. 249.

Gray: Oil Ground Drop Black in Formula No. 2.
Pink: Ruby Red Dry Powder in Formula No. 2.
White: Formula No. 2 alone.

It should be noted that the majority of yellow pigments are poisonous and include the lead chromates (chrome yellows), the zinc chromates (zinc yellow), and lead ammoniate (Naples yellow). The yellow ochers, which are earth colors, are the safest yellow pigmenting agents to employ.

Oxide of chromium is a nonpoisonous green pigmenting agent.

Natural ultramarine is derived from lapis lazuli, a semiprecious stone, and is quite expensive but far more stable than artificial ultramarine. Cerulean blue is a durable blue pigment with a light greenish-blue hue.

Lithopone, when it is used as a pigmenting white, is not wholly stable and tends to yellow. A fine quality of titanium white (titanium oxide), which is nonpoisonous, has been used as a pigmenting white, but this substance may also yellow slightly. The lead whites should not be used for composition clay formulas.

It may occasionally be desired while developing a design in composition clay to increase the hardness of the model. Exposure to cold generally results in a substantial hardening of the plastic mass. The modeled work can be placed either in a refrigerator or in a sealed container into which has been placed some frozen carbon dioxide, commonly referred to as 'dry ice.' Exposure of the modeled work to the low temperature of the dry ice will harden the model sufficiently to permit final surface finishing or casting. If dry ice is used, care should be taken not to handle particles of the material directly with the bare hands or severe burns may result from contact with the extremely low temperature of the substance. A softening of composition clay is most liable to occur during warm weather.

Some varieties of composition clay may dry out slightly and superficially following prolonged exposure to the atmosphere because of an oxidation of the surface oils, but most of the varieties need only to be reworked or kneaded and they will become uniformly plastic.

4 PLASTER OF PARIS

HISTORICAL

THE word *gypsum* is derived from the Greek γύψος, *gypsos*.

The use of gypsum as a sculptural material dates back to Antiquity.
Many contemporary writers trace the origins or earliest uses of the
substance to Greece, and there they cease their search. That the use
of the material was familiar to the Greeks is revealed by the writings
of Theophrastus and Pliny. Pliny, in his *Natural History*, Book xxxv,
153, attributes to Lysistratos the discovery of fashioning plaster casts
of statues. 'He [Lysistratos] [1] also discovered how to take casts from
statues, a practice which was extended to such a degree that no figure
or statue was made without a clay model.' While this statement by
Pliny is accepted by many scholars, and while plaster negative molds
that date from the Hellenistic period have been discovered,[2] this
contention completely ignores the Egyptian use of the material.

During early periods of Egyptian culture, particularly during the
reign of Akh-en Aten, parts of the human body, or of statues, were
cast in plaster and used as models.

The familiar casts of faces and other parts of the human form found
at el 'Amārneh date from about 1370 B.C. The earliest-known Egyptian
example of such a cast is a mask discovered in the temple of the Step
Pyramid at Saqqara.[3] It is believed to be a death mask of King Tety
of the VI Dynasty, who died about 2400 B.C.

The art of casting in plaster declined with the fall of Rome, and
literature makes no reference to it again until the time of Andrea
Verrocchio (1432-88).

[1] Lysistratos was a Greek sculptor of the fourth century B.C. He was a brother
of the famous sculptor, Lysippus. There is some controversy regarding the precise
nature of his use of plaster. Some claim that the practice was essentially one of
modeling with gypsum.

[2] Rubensohn, Otto, *Hellenistisches silbergerät in antiken Gipsabgüssen*, Berlin,
1911. See references, pp. 3-5.

[3] Quibell, J. E., *Excavations at Saqqara* (1907-8), pp. 112 f., and pl. LV;
Service des Antiquités de l'Egypte, Le Caire, 1909.

Andrea took much pleasure in making models of gypsum, from which he might take casts; he made his moulds from a soft stone found in the neighborhood of Volterra, Siena, and other parts of Italy, which, being burnt in the fire, pounded finely, and kneaded with water, is rendered so soft and smooth, that you may make it into whatever form you please; but afterwards it becomes so close and hard that entire figures may be cast in moulds formed of it. Andrea, therefore, adopted the practice of casting in moulds thus prepared such natural objects as he desired to have continually before his eyes, for the better and more convenient imitation of them in his works—hands, feet, the knee, the arm, the torso, etc. Artists afterwards—but in his time—began to make casts of the heads of those who died, a thing they could by this means do at but little cost; whence it is that one sees in every house in Florence vast numbers of these likenesses, over the chimneys, doors, windows, and cornices, many of them so well done and natural that they seem alive. . . We are indeed greatly indebted for this . . . to the skill of Andrea Verrocchio, who was one of the first to put the practice into execution.[4]

CHEMICAL AND PHYSICAL NATURE

Plaster of Paris is one of the most extensively used materials in the sculptor's repertoire. (See Plates 14-20.) It is important, therefore, that the sculptor possess an understanding of the chemical and physical properties of the substance. The material derives its name from the earth of Paris and its surrounding regions, which contains an abundance of the parent mineral *gypsum*, from which plaster of Paris is manufactured. It is also known as $CaSO_4 . \frac{1}{2}H_2O$, sulphate of lime, hemihydrate of calcium sulphate, casting plaster, gypsum plaster, and dental plaster, in addition to specific trade names.

Gypsum is occasionally referred to as hydrated sulphate of lime, hydrated calcium sulphate and, chemically, $CaSO_4 . 2H_2O$. It has a hardness of 2 in the Mohs scale.

The substance is found in several forms. Alabaster is a white, fine-grained, opaque to semi-opaque, massive variety of gypsum, which is quite soft and can be easily cut or carved. It is particularly appropriate for use in the fashioning of small sculptures or statuettes. White spar or satin spar is a fibrous variety of gypsum. Selenite is a mica-like, transparent, crystalline form of the mineral.

Several explanations are offered to explain the origin of gypsum

[4] Vasari, Georgio, *Lives of Seventy of the Most Eminent Painters and Sculptors,* trans. by Blashfield and Hopkins, London, 1897, vol. II, pp. 251-2.

formations. Some deposits are thought to have been formed by changes in existing calcium-carbonate beds by chemical reaction, such as occur when the decomposition of pyrites liberates sulphuric acid, which in turn attacks carbonate of lime, converting it into calcium sulphate. This process may cause an evolving or gradual change of a limestone formation into gypsum rock. The majority of gypsum deposits, which are widely distributed geographically, are believed to have been formed in another way, involving the slow evaporation of sea water, with an increasing mineral concentration resulting as the water is evaporated. When approximately 75 to 80 per cent of the sea water has been evaporated, the gypsum is deposited.

Commercially, gypsum is secured from underground deposits by mining or quarrying. It occurs as a solid, crystalline mass containing contaminating silicates and carbonates, and the purity of the substance is regulated largely by the selection of the rock in the quarry or mine.

PREPARATION

Plaster of Paris is prepared by the partial calcination or dehydration of gypsum by heat. Gypsum, when calcined at approximately 350° F., loses about 75 per cent of its water of crystallization and is transformed into $CaSO_4.\frac{1}{2}H_2O$, which is known as plaster of Paris.

$$2CaSO_42H_2O + heat \rightarrow (CaSO_4)_2H_2O + 3H_2O \uparrow$$

The overcalcination of gypsum so comminutes the material that no gypsum particles are left sufficiently large to function as nuclei about which the formation of crystals can begin when the plastic plaster mass is ready normally to set. Fine grinding of the substance does not appear to have any apparent effect upon the setting powers of a properly calcined gypsum.

Underburned gypsum is not recommended for use in casting. The substance is fairly insoluble in cold water and only slightly soluble in warm water.

The transition point at which the gypsum, $CaSO_4.2H_2O$, is converted to plaster of Paris, $2CaSO_4.H_2O$, is approximately 225° F. (107° C.).

When the roasted powder is mixed with sufficient water to render the mass creamy in consistency, it recovers the $1\frac{1}{2}$ parts of water it possessed prior to calcination, and the mass 'sets' to a uniform, inert,

and solid mass of substantially the same composition as the original gypsum.

If gypsum is calcined at a temperature greater than 350° F. for a prolonged period of time, the material loses all its free water and water of crystallization and becomes inert.

Keene's cement is a thoroughly calcined gypsum, one of the so-called 'accelerated plasters,' from which all of the combined moisture has been evaporated by means of prolonged exposure to high heat. To this substance an alum or other salt is frequently added. The product sets uniformly and dries quite hard. Keene's cement was formerly prepared by baking gypsum and then soaking it in a solution of alum, after which the material was re-calcined. Today, single burning is used.

Dry, powdered mineral colors can be added to Keene's cement, which is occasionally used sculpturally as a casting material. The coloring pigment should be permanent, finely ground, and water soluble.

Keene's cement is generally poured in a heavy, fluid state into the negative mold.

Solubility

Plaster of Paris is only partially soluble in water. Its highest solubility is in water at room temperature. At this temperature about 1 part of plaster is soluble in 400 parts of water.

In setting, small quantities of the plaster crystallize out and either tie up with, or cement together, the insoluble plaster particles. The gypsum crystals interlock as they form from the slurry of water and plaster.

Plasticity

The plasticity of a plaster mixture can be increased by the addition of lime putty in the proportion of 2 parts of lime putty to each part of plaster by volume. The addition of lime putty to a plaster mix is also accompanied by a noticeable retardation of setting.

The material is very infrequently employed for finish and in view of the very caustic nature of the mixture to human tissue, it is not to be recommended sculpturally.

ADVANTAGES AND DISADVANTAGES OF PLASTER OF PARIS

The advantages of plaster of Paris are:

1. It is universally available.
2. It is inexpensive and economical.
3. It is easily and quickly prepared for use and is ready for application soon after mixing with water.
4. It is quick-setting.
5. It can be cast, shaped, or modeled while in a plastic state, then setting hard, strong, and compact.
6. It expands slightly on setting and fills out the form of the negative mold perfectly. This physical characteristic is very important to the sculptor.

The disadvantages of plaster of Paris are:

1. Most important, it completely lacks elasticity.
2. Complex subjects, involving undercuts, require the use of plaster piece or waste molds or recourse to flexible mold materials such as rubber and gelatine.
3. It adheres to fine body hair, requiring the use of a lubricant prior to fashioning a life mask or cast of a portion of the body.
4. It has to be used soon after mixing or discarded, since it sets quite rapidly.

Plaster of Paris is the material of choice when the object to be cast is large; when the object has no undercuts or very few undercuts; and when these undercuts are simple. It is also employed as a reinforcing material for flexible negatives of agar, rubber, and gelatine.

There are many varieties of plaster that are commercially available. These vary in structural strength, in the time required for setting, and in volume changes occurring during the setting. Potters' plaster, of which there are several varieties, is a fine grade to use. For sculptural use, the finer-grained plasters are preferable, since these result in smoother casts and reproduce detail more accurately.

It is advisable to keep casting records for reference purposes. The factors recorded should include the characteristics of the varieties of plaster employed, the weight of the ingredients constituting the mixes and the water-plaster ratio used, together with the results achieved in each instance.

MIXING PLASTER

Physically, a mixture of water and plaster is a suspension of a solid in a liquid. The particles of plaster are heavier than water and tend, therefore, to settle out of the mixture. This can be prevented by either making the mixture sufficiently thick so that the plaster will not easily settle out prior to its setting or crystallization, or, if it is desired to work with a thinner and more plastic mix, the plaster should be sifted or stirred constantly until it is ready to be poured.

Powdered plaster should always be added to the mixing water; it is a good practice to scatter the plaster uniformly over the surface of the water. Handfuls of plaster should never be dropped into the liquid, since this procedure invariably results in an imperfect and lumpy mix. The powder can be sifted through the fingers and allowed to fall into the water, while the mixture is being stirred with a spoon or spatula at the bottom of the container. The plaster should be permitted to sink below the surface of the water before mixing, and the stirring should be done at a moderate rate. If it is stirred too rapidly, air bubbles and froth will become incorporated in the plastic mass, and if too slowly, and thereby prolonged, setting may overtake the mass before it is ready to be poured. Any scum that may rise to the surface of the plastic mixture should be removed, because it is made up of impurities and air bubbles.

The water used for mixing should be as clean as drinking water, and should not contain acid or alkali in solution. The presence of lead or iron in solution will discolor a positive cast.

The plastic mass should be stirred with a spoon or spatula until all of the plaster has been uniformly mixed to a smooth and creamy consistency. Stirring should be done from the bottom of the mix, forcing the fluid material to the top. Occasionally, the hand may be used to stir the plaster. This makes it possible for the caster to feel and break up any lumps that may be present in the mass, but it is somewhat messy. Excessive mixing should be avoided, because it tends to 'rot' the plaster. A too prolonged mixing, carried into the setting phases, will seriously prejudice the hardening properties of the plaster mix. Mixing should be continued until a smooth, consistent mass is achieved.

After stirring, the plaster is ready for use.

In the application of the plaster to the object, air bubbles may be

caught between the plaster and the model. These may be eliminated by blowing the initial application of the fluid plaster over the surface of the model to be cast. If a negative mold is being filled or 'charged,' the vibration of the mold and its plastic contents will serve the same purpose.

People who use a great deal of plaster employ mechanical mixers which are capable of mixing substantial quantities at a time. The finest results are achieved by this means, since the plaster-water mass is thereby thoroughly and uniformly mixed, and the resulting texture of the finished cast is extremely compact and smooth. Small amounts may also be mixed mechanically, since small mixing units are available or may be easily constructed. A small motor should be used, to which is connected a shaft and a bladed propeller. The speed of rotation or circulation of the plaster mass should be sufficient to agitate the entire mix, but not great enough to cause splashing or the sucking in of air into the mix.

Plaster of Paris expands on setting, filling its containing mold intimately, and this sculpturally desirable physical characteristic should be kept constantly in mind in preparing the plaster mixture. If a strong mix is used in which more plaster is added to the water than is readily absorbed, then the heat and expansion during crystallization and setting may fracture the plaster negative mold into which the mixture is poured.

When preparing a plaster mixture to be poured into a mold, care should be taken to achieve a mix of proper consistency. The mix should be normal in terms of the water-to-plaster ratio. Since this proportion varies with different plasters, it is of great importance to keep records of mixes and results.

The use of a normal mix has two advantages:

1. It eliminates the danger of fracturing the negative mold. This may result if too dense a mix is employed for casting.
2. The material, when it is properly prepared, runs into and fills the finely detailed areas.

In addition to determining the porosity of the set and dried mass, the ratio of plaster to the water used in mixing affects the ultimate hardness and physical strength of a plaster cast.

In mixing plaster, a quantity slightly in excess of what is deemed necessary for a specific undertaking should be prepared, because freshly mixed plaster, when it is added to a mass that has set or begun

to set, will be weaker at the joining surface. The preparation of an adequate quantity of plaster for the particular undertaking will also eliminate the necessity of having quickly to prepare an additional quantity of the material at a time when the attention should be concentrated on other more important phases of the casting operation.

Spun-copper bowls are highly recommended for use in mixing plaster of Paris, as are enameled bowls or basins. Small quantities of the material may be prepared in a rubber mixing bowl that can be made by cutting a large rubber ball in half.

It is important to keep all plaster mixing tools and vessels perfectly clean and free from vestiges of set plaster remaining from previous jobs, since bits of hardened plaster will interfere with the normal setting of a fresh plaster mix. Hardened plaster can be removed from mixing containers by pouring water over the hardened areas and pushing the masses forward with the fingers. The pieces of plaster adhering to the surface of the vessel will break free and may then be flushed away with clean water.

Plaster should always be weighed and records kept of the ratio of plaster to water used in each undertaking, and the final results which are achieved.

Accelerating Agents

The use of an accelerator is rarely required in casting plaster of Paris. Most sculptors seem to feel that a normal plaster mix sets sufficiently quickly for casting purposes. Occasionally a sculptor may find in taking an impression from a small area, delicately modeled and detailed, that the use of a thin mixture of plaster and water is necessary to achieve a perfect negative impression. Since a thin mix will set substantially slower than denser mixes, it may be desired to accelerate the set. Another possibility is that large editions of a work may be required with a minimum expenditure of time, in which case an accelerator can be resorted to to speed the setting.

Accelerators:

1. A rich mix consisting of a maximum quantity of plaster to a minimum of water will be quick-setting, but the resulting cast may be less durable than one achieved with a normal mix.
2. Undercalcined gypsum will set very rapidly, but it is not advisable for use as a positive casting material.

3. Set plaster that has been ground and powdered, when added to a plaster mix in small quantities, will greatly accelerate the setting.

4. The addition of about 1 per cent of raw, ground gypsum [5] to the mix will serve as an accelerator.

5. A sound accelerator may be made by mixing 4 ounces of plaster to a quart of water and stirring the mass for about half an hour or until the mixture begins to thicken. A small quantity of this is added to the mixing water and mixed thoroughly, after which the powdered fresh plaster is added. A teaspoon of this creamy plaster to each pound of fresh plaster will quicken the setting from 5 to 10 minutes.

6. Common table salt may be used to hasten a set. About 1 teaspoon of salt is used to each quart of mixing water. This is the most frequently employed method. As the concentration of the salt solution is increased the time interval necessary for the setting of the plaster is decreased. The addition of salt to the mixing water is believed to increase the solubility of the plaster.

7. Potassium alum is used as an accelerating agent. For each quart of mixing water, up to 1 teaspoonful of alum is used. As the quantity employed is increased to a maximum solution of 1 teaspoon to each quart of water, the setting of the plaster will be hastened.

8. Potassium sulphate is occasionally used both to hasten the setting of a plaster mix and to prevent the expansion of the material. A saturated solution of potassium sulphate is first prepared by adding as much potassium sulphate as a given amount of water will dissolve at room temperature. One part of this solution is used to each ten parts of mixing water. As the amount of the potassium sulphate solution is increased, the time required for the setting of the plaster mix is decreased.

9. The addition of about 10 per cent of lime to a plaster mix will accelerate the set.

10. Intense agitation of the plastic plaster mix will accelerate the set, but this procedure is not recommended, since it involves the possibility of incorporating large quantities of air bubbles and air pockets in the plaster mix, with resulting pinholes and surface blemishes in the finished cast.

[5] Terra Alba, a finely pulverized raw gypsum powder may be used. The substance is a fine accelerator.

11. The use of warm to hot water will accelerate a plaster set and is recommended, since it is the least harmful and therefore the best accelerating agent to use.

RETARDING AGENTS

The retarding of the normal time required for a plaster mix to set is sometimes deemed desirable, and is, occasionally, actually necessary. Retardation of the set permits additional care to be exercised in the application of the material to the original positive and tends to minimize, if not to actually eliminate, mistakes and miscalculations due to haste.

There are several substances which, when added to a plaster mixture, serve to extend the time required for setting and thorough hardening. Many of the materials that may be added to strengthen the plaster physically and thus render it more durable and permanent also tend to increase the time required for hardening or setting. A good precautionary procedure to observe when substances are incorporated in a plaster mixture to retard the setting is to add a strengthening ingredient to the mixture.

While it is possible by means of retarders to slow the setting of a plaster mixture substantially and extend the time required for setting to several hours, it is not advisable to practice retarding to this extreme, because this may weaken the strength of the finished cast.

Retarders:

1. Cold water is recommended as the least harmful and safest retarding agent to employ.
2. A saturated solution of borax is used for retarding purposes. About 1 part of this solution is added to each 10 parts of mixing water.
3. Carpenter's glue when added to the mixing water will retard the set of the mix and also increase the structural strength of the finished cast.
4. Approximately half a teaspoonful of calcined lime to each quart of mixing water will retard the setting of the plaster.
5. Powdered marshmallow root acts as a retarding agent. About 1 part of this ingredient is used for each 100 parts of powdered plaster.
6. Alcohol, added to the mixing water, acts as a retarder, by reducing the solubility of the plaster of Paris.

7. Sugar, low-grade glue dispersed on lime, sorghum, potassium acid tartrate, and various organic substances, such as a physical mixture of horn and hair in a finely divided state, will act as retarding agents.
8. Small quantities of citric or acetic acid serve as retarding agents. Solutions of about 5 parts of acid to each 100 parts of mixing water are used.

PHENOMENON OF SETTING

When plaster of Paris is thoroughly mixed with an equal volume of water or approximately ⅓ of its weight, it will slowly change physically from a thin, fluid state to a denser plastic form, thence becoming more viscous as the setting progresses, until it finally solidifies to a solid, hard mass as crystallization is completed. The time interval required for setting varies with the variety of plaster used, but it is approximately 30 minutes for the average plaster.

The setting of plaster of Paris after it has been mixed with water is also referred to as a *rehydration* and occasionally as a *recrystallization* of the calcined gypsum back to its original hydrated rock form.

When plaster of Paris is mixed with water it returns to its original solid crystalline form within a relatively short time interval. Plaster that has been exposed to moisture will set more quickly than protected plaster that has been kept dry. If the mixing is done on a minute scale upon a glass microscope slide, and the phenomenon is viewed through the microscope, the crystals will be seen to form quite rapidly and to interlock. This interlocking of crystals is responsible for a great deal of the eventual physical strength of a set plaster positive or negative mass.

The setting phase, which begins soon after the mixing of the powdered plaster with water, and during which the plaster changes from a liquid of creamy consistency to a solid state, is of extreme importance, and the plaster mass should not be physically disturbed during this period, or the cast will not achieve its maximum potential physical strength.

The 'critical period' may be said to extend from the moment of initial pouring or application of the freshly mixed and plastic plaster, to the time when all of the heat evolved during crystallization has disappeared from the plaster mass. If the mass is disturbed before the complete crystallization or setting, the minute crystals will not inter-

lace intimately, and the plaster will not achieve its maximum physical strength.

The crystals, which form after plaster is mixed with water and begins to set, are made up of approximately 20 per cent of water of crystallization. Subsequent to the setting or crystallization, all of the water in excess of that which was required for crystallization slowly evaporates from the set plaster mass. The time interval required for this evaporation varies with atmospheric moisture, temperature, and air circulation. It may take place within a few hours, or it may require many days. If the temperature of the air is high, and the humidity low, and the air is circulated freely about the plaster cast, the time required for drying is substantially reduced. A cast may appear dry externally, and yet contain a substantial quantity of water internally. A period of from one to two weeks should be allowed for adequate natural drying. The larger the cast or thicker the application, the longer the time required for drying. As the free water slowly evaporates from a cast, the strength of the cast will increase.

HEAT OF CRYSTALLIZATION

Shortly after a plaster mass has begun to set or harden a warmth becomes apparent if the cast is touched with the fingers. This warmth is the accompaniment of crystallization of the plaster and is known as the *heat of crystallization*. This heat of crystallization, evolved as a plaster mass sets, is roughly equivalent to the heat that was required to decompose the original crystalline gypsum into plaster of Paris.

SETTING TIME

The time required for a plaster mix to set differs with the variety of plaster that is used. The average setting time for a normal plaster mixture is approximately thirty minutes.

The setting time can be artificially controlled by the use of accelerators and retarders (see pp. 64-7), the majority of which are chemical substances that interfere with normal crystallization.

All accelerating and retarding agents should be used conservatively. It is desirable, whenever possible, not to resort to the use of these agents, but to permit a particular plaster mix to set normally.

Most retarding and accelerating agents appear to have a minimum effect upon the ultimate crystallization of the plaster mix, although

when these substances are used in excessive quantities they may prevent crystallization.

Cooling Plaster

A cast should be evenly and slowly cooled after the plaster has been poured and the heat of crystallization evolved. If desired, the cast may be permitted to remain within its containing negative mold until it is thoroughly cooled. If it is removed from its containing mold while the mass is still warm, it should be wrapped in a soft, clean, protective cloth to cool slowly and either to dry normally or by exposure to the controlled circulation of warmed air.

Cool air touching a warm cast may result in an uneven cooling with subsequent surface cracks and possible fractures.

Drying Plaster Casts

All plaster casts should be carefully and thoroughly dried at a maximum temperature of 125° Fahrenheit. If the drying heat exceeds this, a surface calcination or chalky disintegration of the cast may result. Drying should be done as soon as possible after a work has been cast to achieve the greatest possible physical strength, because a plaster cast will not reach its maximum strength until its 'free water' has been evaporated. Drying also serves as a protective measure against the development of mildew, which, particularly in warm weather, often develops on a moist cast.

To render plaster of Paris sufficiently plastic for sculptural use, more water is needed than the substance requires for actual crystallization, so that there remains an excess of free water after the mass has set. This should be evaporated from the cast as soon as possible after its removal from the negative mold. Drying a cast quickly will also yield a smoother and more uniform plaster surface.

One hundred units of powdered plaster of Paris require approximately 20 units of water to crystallize or 'set,' whereas to achieve a satisfactory plastic plaster mass suitable for pouring, about 60 units of water are required. This leaves an excess of about 40 units of 'free water' remaining within the plaster cast after setting, and the surplus has to be removed by accelerated drying or by the natural, slow evaporation of the moisture through the surface of the set mass. The time required for natural evaporation under normal conditions of atmospheric temperature, humidity, and air circulation varies from a

few hours to several days, depending on the mass or thickness of the unit cast.

The most satisfactory method of drying a cast is by a continuous circulation of warmed air bathing the entire plaster mass. For this an ordinary hair dryer, operating on the blower principle, may be used.

RETOUCHING AND REPAIRING PLASTER CASTS

Plaster casts frequently require retouching after their removal from the negative mold. The most common surface blemishes that may mar an otherwise perfect cast are caused by pinholes resulting from air bubbles imprisoned in the plaster mix. Raised portions on a positive cast constitute another type of surface imperfection, but these may be easily removed mechanically with fine sandpaper or a sharp blade.

Occasionally fragments may be chipped off a plaster cast. To retouch a cast it is first necessary to make certain that the plaster surface is completely free from dust and dirt.

It is essential to 'kill' the plaster used for retouching a cast. A weak mix of plaster, in which there is an excess of water, is used for this purpose. This may be prepared by placing a small quantity of water in a vessel and adding an equal volume of plaster.

The area to be retouched should be roughened by careful scratching with a sharp blade or knife. After it has been roughened, the region should be thoroughly saturated with clean water flooded on with a sponge, dropper, or small rubber syringe, until the plaster cast ceases to absorb water. If the surface of the cast is dirty it should be cleaned before retouching by submersion in water, as described on page 71. The submerging operation will also serve to saturate the cast with water. Saturation is very necessary, particularly when a dry cast is to be retouched, because the dry, untreated cast will quickly absorb all of the moisture contained in the freshly applied plaster before the recent addition has had sufficient time in which to set, with the result that the addition will be very fragile and chalky.

The 'killed' plaster can be applied with a wooden clay tool after the cast has been saturated with water. To smooth the freshly applied mass, a soft, wide brush should be wet with clean water and passed gently over the area while the plaster addition is still fresh and plastic. The work should be permitted to remain undisturbed until the freshly applied area is thoroughly dry and hard.

Another method of repairing broken portions of a plaster cast consists of recovering the fragments broken off the main mass and using a strong solution of shellac dissolved in alcohol as a cementing medium,[6] by means of which the broken fragments may be rejoined to the parent mass. A fine grade of carpenter's glue can also be used for this purpose. The solution or glue is applied to the fracture surfaces of the parent cast and the portions that have been broken away. Two coats may be used for a dry cast. The first coat serves as a pore-sealing treatment and the second coat, applied after the first has thoroughly dried, is employed as the cementing agent. While this second coating is still wet, the fractured portion should be fitted into place and pressed tightly against the main mass, and then tied or bound compactly until the shellac or glue hardens.

When a broken fragment is pressed into place against the cast, a thin glue or shellac seam may be forced out at the point of joining. This may be removed by the careful use of a sharp blade after the material has been allowed to dry and harden. Painting the dried area with a thin mixture of water and fresh plaster will adequately cover the retouched blemish.

Cleaning Old Casts: Plaster that has become soiled by dust can be cleansed by first submerging the cast in clean water. The piece should be permitted to remain under the water for several hours until the saturation of the cast is complete. The water should loosen all of the fine particles of dust and dirt. If any vestige of dust or dirt remains after this treatment, the plaster cast should be resubmerged beneath fresh, clean water and gently wiped while still below the surface, with a soft, clean cloth, brush, or sponge.

Another method of cleaning superficial dust and dirt from a plaster cast involves the use of starch paste applied to the surface of the plaster cast as a poultice. It is allowed to remain on the plaster until it is almost dry, and may then be peeled away carefully. A heavy, even application of cornstarch mixed with hot water to form a paste of heavy consistency can be applied with a wide, soft brush. The hot

[6] Burning shellac is required to make the material adhesive. In order to 'burn' shellac, an open container is partly filled with cut shellac, which is ignited and stirred at intervals during the burning. Bubbles will form, and when these cover about ¼ to ⅓ of the surface, the fire is extinguished and the mass is permitted to cool. On cooling, a protective skin will form over the surface, and this should not be removed. Burned shellac is applied to plaster after the surfaces to be joined have been primed or prepared with several applications of a solution of ordinary shellac and alcohol, and after these applications have thoroughly dried.

mixture should be permitted to dry slowly and naturally. The coating will shrink and split as it dries, and can be removed together with the dirt by using boiling water.

Painted plaster casts can be cleaned with lukewarm water and the sparing use of a mild soap.

HARDENING AND STRENGTHENING PLASTER CASTS

It may occasionally be desired to achieve a positive cast possessing greater physical strength and permanence than that which results from a normal mix cast under normal conditions. There are several methods that can be used for this purpose, and these are listed below. While piece molds can be strengthened to insure greater wearing qualities, which is of particular importance when large editions of a work are desired, negative molds in general should not be hardened to a strength exceeding that which the plaster positive will possess.

Several factors are responsible for the ultimate hardness of a finished plaster of Paris cast:

1. *The kind or variety of plaster used*

Different plasters vary markedly in their setting powers and in their final hardness. Some varieties are marketed with added accelerating agents. The calcification control of the substance by the manufacturer is an important element influencing the setting rate of the plaster and the hardness achieved by the cast.

2. *The amount of water employed in the mix*

The water-plaster ratio is probably the most important factor in determining the ultimate hardness and physical strength of a mix. A heavy plaster mix, consisting of a low proportion of water to plaster, will yield a harder and heavier positive than that which would result from a normal or subnormal mixture in which an excess of water to plaster is employed.

3. *The degree of crystallization achieved by the cast in setting*

The degree of crystallization achieved by a cast during the process of setting is responsible for most of the physical strength of the cast (see also p. 68).

4. *The addition of chemical-hardening ingredients to the mixing water*

Plaster mixed with lime water will result in a harder cast. A lime-water solution can be prepared by placing lumps of ordinary lime in

water and stirring the mass at frequent intervals until most of the lime has been dissolved. This lime water, or 'milk of lime,' is then added to the mixing water.

Magnesium fluosilicate, a white powder, is occasionally used as a plaster-hardening ingredient. This substance can be added either to the mixing water or to the plaster. A maximum of from 4 to 5 per cent of the chemical is generally used.

The toughness or hardness of a plaster cast can be increased by dissolving a small quantity of white dextrine or gum arabic in the mixing water. The addition of 1 part of dextrine to each 100 parts of plaster of Paris, by weight, will increase the superficial hardness of a cast. The dextrine should be added to the mixing water and thoroughly dissolved before the plaster is added. When dextrine is used in a plaster mix, the positive cast must be dried fairly quickly and thoroughly after it is removed from the negative mold.

White Portland cement is sometimes mixed with plaster of Paris to achieve a very hard and strong positive cast. About 5 per cent of cement is used.

5. *The addition of fibrous, binding material*

Fibrous substances are occasionally added to a plaster of Paris mix to increase the cohesive strength of a cast. Long and short-fibered asbestos, ordinary white absorbent cotton, sisal or hemp, and animal hair from the goat, ox, or horse are some of the ingredients which when added to a plaster mix will increase the cohesive strength of the plaster cast. These mixtures are sometimes referred to as 'fibrous plasters.' While fibrous substances impart additional strength to a plaster mass, their use is not to be recommended, since the substances may mar the surfaces of the finished positives.

6. *The application of superficial surface-hardening ingredients subsequent to casting*

Some of the impregnating substances that result in harder plaster casts are:

a. *Borax* (Sodium borate)

The plaster cast should be thoroughly dried after its removal from the negative mold. The cast is then immersed in a 2 per cent solution of borax, which is then heated until it boils. Hot washes of a saturated solution of borax can also be used as a means of superficially hardening a plaster cast.

b. *Bicarbonate of soda* (Sodium bicarbonate)

Immersion of a dried cast in a saturated solution of bicarbonate of soda will result in a harder cast. The cast is placed in the solution until it becames thoroughly saturated, when it is removed and dried.

c. *Lime water*

Painting or washing a finished plaster cast with lime water will superficially harden the plaster surface. The plaster is influenced as deeply as the lime water can penetrate.

d. *Magnesium fluosilicate*

A solution of this substance is used as a surface washing material for purposes of hardening plaster casts.

e. *Aluminum sulphate*

A solution of this substance is used as a plaster-hardening agent. The solution is generally applied as a surface wash to the finished cast.

f. *Alum*

Hot washes of a saturated solution of alum are occasionally used as a means of superficially hardening plaster casts. Several washes or applications may be required.

g. *Paraffin, waxes, and oils*

Paraffin, various waxes, and drying or oxidizing oils, such as linseed oil, can be used to impregnate plaster surfaces. These substances do not increase the physical strength of casts to any appreciable degree. The oils can be applied with a brush. Casts can be dipped or soaked in melted wax.

h. *Varnish, lacquer*

Varnishes and lacquers contribute little to the hardness of a cast, but are sometimes used for this purpose. The effect of these substances is superficial and their use invariably results in a shiny and aesthetically objectionable surface.

7. *The method of casting employed*

a. Vibrating a mold charged with a plaster mixture will yield a positive cast of maximum density or strength. The method also permits the utilization of a very heavy or dense mix. Vibrating a charged mold also aids in ridding the plaster (while it is still plastic) of minute bubbles of air and insures a more uniform and physically compact cast.

b. Tamping or pressing a heavy mix of plaster into a negative mold is occasionally employed to achieve dense, hard positives, but the results generally secured are not as uniformly satisfactory as those resulting from vibration.

8. *The thoroughness of drying of the finished cast*

As the free water is evaporated from a plaster cast the physical strength of the cast will increase (see also *Drying of Plaster*).

REINFORCING CASTS

Plaster of Paris has a fairly low tensile strength, and projections such as an extended arm or leg may break off the main mass by the strain of its own weight. Irons are frequently employed to reinforce portions of a plaster cast that may be subject to weight stress. (See Plate 14.) The iron rods should be lacquered with clear metal lacquer or waxed before they are incorporated in the plaster cast to prevent corrosion.

Iron reinforcing strips or rods are generally inserted into the positives after the plaster has been poured and while it is still in a plastic state, although a metallic framework may be constructed and placed within the negative mold before the plaster positive mass is poured.

The supporting irons should be bent to correspond with, or fit the form of, the work to be reinforced. If the rod is wound round with cord, it will be held more securely by the plaster. In the case of large objects, which have extended portions, such as outstretched arms on a human figure, the projecting limbs are often cast separately and later joined to the torso after setting. Sockets are employed to fit in the main mass and to receive the supporting iron encased within the plaster limb. Supports are frequently fitted into the negative mold and held in place with a fine waxed thread, such as dental floss, which is quite thin and yet possesses great strength. The iron support may be covered with plaster after first having been treated with a lacquer, wax, or shellac, and then pressed into position within the containing mold form. The plaster is then poured in over this to form a solid unit upon setting.

Large negatives may be reinforced and physically strengthened by incorporating a loosely woven burlap in the plastic mass. The material should first be moistened with water or a thin plaster solution and then pressed into the plaster mass and covered with additional plaster.

POROSITY OF CASTS

When the free water has been evaporated from a set plaster mass, air spaces remain between the crystals. These spaces, formerly occupied by the free water, give to a plaster cast its porosity and absorptive power.

It follows that the less water used, the smaller will be the degree of porosity of the mass. This will also result in harder, more compact casts and has important implications in the use of plaster of Paris as a negative mold material in the casting of molten metal and glass.

Waterproofing Casts

The materials used for waterproofing a plaster cast are substantially the same as those which are employed for reducing the surface porosity of a finished cast. Waxes, dissolved in volatile solvents or liquefied by heat, shellac, and other resins dissolved in substances such as alcohol, turpentine, and various oils such as linseed oil, are used for this purpose.

The basic requirements of a waterproofing substance are:

1. That it fill or seal the surface pores of a cast.
2. That it form an impervious film or coating on the exposed plaster surface that will prove resistant to the effects of moisture.

Outdoor Use of Plaster of Paris Statues

Plaster of Paris is much too fragile a substance for permanent outdoor exposure and it is not recommended that casts in this material be thus exhibited except in ideal climates. A statue in plaster may survive outdoors for several years if it has been carefully and thoroughly dried subsequent to casting, has received several coats of linseed oil, and has been painted with oil color and varnished. However, there will still be a hazard, and plaster of Paris should not be so completely camouflaged.

Casts intended for outdoor use should be cast as densely as possible, since this procedure will reduce the porosity of the positive to a minimum. Subsequent to drying, a thorough wax impregnation should follow.

Important factors to be considered in the weathering of plaster casts that are placed outdoors are:

1. The penetration of moisture
2. Chemical reaction of the plaster with atmospheric gases dissolved in rainwater
3. The effects of heat and cold
4. The weathering effects of fine, air-borne dust particles carried by winds.

A plaster cast should also be protected from direct contact with the earth or there may be an absorption of moisture together with deep staining.

Whenever possible, plaster statues intended for outdoors should be cast solid. If the cast is hollow, the interior should also receive a wax or oil treatment.

SURFACE TREATMENT OF PLASTER

The surface treatments of plaster of Paris often serve the dual function of protection and decoration.

After a plaster cast has been removed from its containing mold and adequately dried, it should be treated to seal the surface pores and to protect the work from later, superficial discoloration by dust and dirt. Many substances may be used for this purpose, among which are oils and waxes.

WAX

In applying a surface treatment of oil or wax, the dry cast should be warmed slightly. If a wax is the substance selected, the material should be carefully and slowly melted in a double boiler over a low flame. After the wax has been liquefied, the utensil is removed from the flame and turpentine is added in a proportion of approximately 8 ounces of turpentine to each ounce of wax used. Since turpentine is highly inflammable, great care should be observed while the solution is being prepared. After the addition of turpentine to the liquid wax, the mixture is warmed slightly in the double boiler and stirred to guarantee a thorough mixing. This solution is applied with a large, soft brush, and is best worked from the highest point of the cast down toward the base, since the solution will naturally tend to run downward.

On a small work, the cast itself may be heated and the wax-turpentine solution poured over it, the surplus being allowed to drain off.

A brush may be used so that all of the surface is covered by the solution. The procedure may be repeated if it is deemed necessary. After the application of the solution, the positive should be slowly cooled. The treatment results in a soft, ivory-like appearance. After the work has cooled it may be rubbed with a soft cloth to impart a high polish.

Paste wax is occasionally employed and is applied to the cast with a soft cloth, but this is not as satisfactory a substance to use as a wax-turpentine solution, since the paste waxes dry slowly and dust particles adhere to the sticky coating.

Oil

Linseed oil and other oxidizing oils are not as desirable as wax-turpentine or shellac treatments, because the cast will tend to discolor and darken with time as the oil slowly oxidizes. The general procedure in oiling a work is to immerse the cast in the warmed oil for several hours. After thorough saturation, the work is removed from the bath and the excess oil is allowed to run off. The cast is then permitted to dry, after which the surface may be rubbed with a silk cloth. Another disadvantage encountered with the use of oils is that the porosity of a plaster surface generally varies, so that the absorption of oil will not be equal in all areas. This often results in blemishes or surface spotting.

Shellac

The opacity of a plaster cast can be substantially reduced by the application of clear French polish, which consists essentially of shellac dissolved in methylated alcohol. Methyl or ethyl alcohol can also be used satisfactorily for this purpose. This solution also serves to close or fill the superficial pores of a dry plaster cast. The number of applications required depends upon the strength of the solution used, or the proportion of shellac to alcohol in the mixture. Each coating is applied after the preceding coat has been permitted to dry thoroughly. Approximately 30 minutes is sufficient for the solvent to evaporate completely. The primary coating tends to seal the surface pores. Succeeding applications result in the formation of a thicker shellac layer or skin on the surface of the cast, and a naturally higher shine or luster. Very fine detail and delicate modeling may be blurred by too many coats. The solution is best applied evenly with a soft, wide brush, which should be thoroughly rinsed and cleansed with pure alcohol after being used, or it may dry stiff and hard.

The surface of a cast treated with shellac solution may be polished to a higher degree by rubbing the dried surface gently with a soft woolen cloth. The entire mass can be polished, or the polishing may be restricted to specific areas, for purposes of contrast and highlight.

COLORING OF PLASTER

Gypsum occurs in nature in several tints or colors, which range from white to gray, green, blue, red, and brown. The whiter and purer varieties are those which are generally used for the manufacture of plaster of Paris.

Pure white plaster, when it is used as a positive casting material, has a rather cold and lifeless appearance, and this element has resulted in what has become a traditional practice of camouflaging a plaster surface in imitation of stone and metal, particularly that of bronze. Some sculptors actually pride themselves on being able to achieve a close approximation to old marble, but this is pure deception, and is aesthetically objectionable, since it involves a flagrant lack of respect for medium.

The coloring of plaster consists of two categories:

1. External or superficially applied color
2. Internal or integrated color.

INTEGRAL COLOR

The colors used for pigmenting plaster of Paris should be limeproof. Yellow ocher, red ocher, and the other earth colors are excellent pigmenting agents, as are the metallic oxides. Care should be exercised in selecting colors, since some colors may contain impurities that may accelerate the setting of the plaster mass.

The water required for a given quantity of plaster should be measured out, and the coloring matter added to the mixing water at this point, prior to the addition of the powdered plaster.

Color, in powdered form, is first mixed with a small quantity of water in a mortar and pestle and this is worked into a uniform paste. The mixed color paste should be placed in a small piece of fine muslin, the corners of which are turned up and sealed with a piece of string to form a color bag, which is then stirred about in the mixing water until the desired tint is achieved.

The mixed color paste can also be diluted with an additional quan-

tity of water and allowed to filter through a piece of muslin or other finely meshed material to impede the passage of any gritty impurities and undissolved lumps of color. The material-filter will insure a uniform tinting of the mixing water and the subsequent plaster mix.

Dry, powdered color may also be mixed with the dry plaster of Paris. The procedure consists of mixing the powdered color with about 4 times its weight of plaster of Paris powder. The mix is thoroughly ground together and then mixed with the remaining quantity of plaster of Paris. Mixing must be sufficiently thorough so that no color streaks will appear when the dry mixture is troweled through on a flat surface.

Under no circumstances should the color be added directly to the mixing water, or the tinting may not be uniform.

It should be noted that the addition of white plaster powder to the tinted water will enormously lighten or dilute the intensity of color of the mixing water, and this factor should be borne in mind in calculating the strength to which the mixing water is pigmented.

From the point of view of honesty, appearance, and permanence, integral or internal coloring is decidedly preferable to superficially applied external coloring. It involves no subterfuge or imitation, and the color is uniformly distributed throughout the plaster mass.

The coloring substances used for the surface coloring of a plaster cast include oil paint, tempera, and metallic powders.

SUPERFICIAL COLOR

If color is not incorporated with the water used to dissolve and form the plaster mix, then the pores of the finished and thoroughly dried cast have to be sealed, so that the superficially applied surface coat of color will be received uniformly, and will adhere to the plaster cast. The absorbent plaster may be treated with a thin solution of glue, shellac dissolved in alcohol, or a weak casein solution. Of these, shellac dissolved in alcohol is best. Thin, successive coatings are applied to the plaster surface until the surface becomes glossy. A cast so treated should be permitted to dry thoroughly before color is applied.

Color that has been superficially applied to the external surface of a plaster cast is quite fragile and may easily peel off or fracture away.

Milk has been used to change the appearance of a plaster cast. The repeated saturation of a cast with successive milk applications, each of which is allowed to dry thoroughly before the next is ap-

plied, will yield a marblelike effect. Skimmed milk added to the mix-
ing water before the addition of the powdered plaster will result in a
cast that may be rubbed to a polish after the work has been dried.

A cast should be rid of all of its free water before external color is
applied, because the adhesion of color, particularly oil color, is greater
on a dry surface than on a damp one. Before using oil pigment a
cast should receive a thorough oiling with linseed oil, because raw
plaster is highly absorbent. Subsequent to oiling, the cast may be
painted with the oil colors and then set aside to dry thoroughly, after
which it may be rubbed lightly with silk.

Oil color may be thinned with turpentine and applied in thin
washes to a cast. This method may be used to secure effects ranging
from a thin, transparent tinting of a cast to an opaque coloring, de-
pending on the quantity of turpentine used to thin the coloring matter.
Thinned oil color is also used subsequent to bronzing a plaster cast
to achieve a transparent tinting of an area or mass.

After a surface treatment with French polish, dry color in pow
dered form may be added to some of the shellac-alcohol solution or
to pure alcohol, and applied to the plaster with a soft brush. The
use of this solution as a painting medium has an advantage over the
use of pure alcohol, in that the shellac solution will bind the powdered
color more intimately to the plaster surface. A soft cloth saturated
with clean alcohol and wiped across the surface will completely re-
move this color. It is also possible to add the coloring matter to the
original priming application of the alcohol and shellac solution, which
is thereby tinted or pigmented with color. Another method of color-
ing a plaster surface consists of mixing the coloring matter with al-
cohol and applying this to the whole surface of the cast, after first
treating the cast with the shellac-alcohol solution. While the coloring
material is still wet, areas may be wiped away with a soft, dry brush.

Bronzing is a process by means of which a simulated bronze surface
can be imparted to other metals and to plaster casts. It is most fre-
quently a camouflaging procedure that is applied to plaster of Paris.

The process consists essentially of coating the metal or plaster with
a size, and then covering this surface with a bronze powder. The
bronzing powder can be made by beating Dutch metal into very fine
leaves and then powdering the leaves.

Plaster surfaces should be free from moisture and the surface pores
should be sealed with a shellac solution or with varnish, and allowed
to dry. The bronze powder can be diluted by mixing with a copper

powder to achieve a richer, more coppery effect. The bronze powder is mixed with a small quantity of shellac and alcohol solution and painted over the plaster cast. The solution should be applied with a soft brush. Two or three applications may be necessary to cover the plaster surface adequately, and each application should be permitted to dry before the next coating is made. The bronze-shellac mixture should be stirred each time the' brush is dipped into it, since the metallic powder will slowly settle out of the mixture owing to the weight of the metallic particles.

Another method involves coating the metal or plaster with an application of mastic varnish. When this has become tacky it is dusted with a bronzing powder, prepared as outlined above.

Raw umber, in powder form, can be added to a bronze-shellac solution for a warmer, more bronzelike effect. Other earth colors can also be used for this purpose.

Another method consists of filling the pores of the plaster with isinglass or fish-glue size and applying a thin coating of gold size over this. The work is allowed to dry thoroughly and is painted with the bronzing powder. A clean and soft cloth can be used to rub off the surplus powder.

After it has been bronzed, the piece can be waxed by applying a solution of wax dissolved in turpentine to the bronzed surface. A major disadvantage of superficially applied color, aside from aesthetic considerations, is the danger of chipping or scratching the bronzed work. Retouching frequently proves quite difficult.

Imitation Silver Finish: An imitation silver appearance can be imparted to a plaster cast by the application of a mixture composed of bismuth of zinc [7] and mercury. The plaster cast should be thoroughly dried before the treatment. Equal amounts of bismuth of zinc and metallic mercury are mixed together and painted over the surface of the plaster cast. A coating of varnish or clear lacquer can be subsequently applied.

The method is very rarely employed and is not to be recommended because of the care that must be exercised in handling the mercury, which has poisonous qualities.

Electroplating a plaster surface with gold, silver, and other metals has been frequently employed. The result obtained with this method

[7] 'Bismuth of zinc' is an alloy of bismuth and zinc in the proportions of bismuth 40 per cent and zinc 60 per cent.

completely camouflages and covers the natural plaster surface with a thin, uniform, metallic film.

SOLUBLE PLASTER NEGATIVES

A variety of different starches has been employed in formulating plaster mixtures that can be dissolved away after setting has occurred, and potato flour has been recommended for this purpose.

Potato flour, when it is mixed with plaster of Paris in proportions of approximately one part of potato flour to two parts of plaster of Paris is said to yield a negative that may be softened by immersion in boiling water. After the positive fashioned of this mixture has set completely, the mass is placed in boiling water. Immersion in the hot water causes the potato flour to swell and the negative mold slowly to disintegrate, leaving a clean positive. This type of soluble negative material should not be used when the positive cast is to be fashioned of wax.

Dental Formulary [8] gives the following formula for disintegrating plaster of Paris negatives:

	Parts by weight
Plaster of Paris	75
Potato starch	23
Infusorial earth	2
Potassium sulphate	1

After pouring and setting, the mass is immersed in hot to boiling water and it will proceed to disintegrate, leaving a sharp and clean positive.

The addition of finely divided pumice stone in small quantities will increase the ease with which the negative mold will be dissolved and disintegrated by immersion in the boiling water. This ingredient serves to reduce the physical strength of the negative mold.

Plaster of Paris is soluble in boiling hydrochloric acid. It is deposited upon cooling in the form of crystalline needles. However, the use of acid, particularly highly heated acid, is dangerous and not to be recommended. If the substance is employed the worker should observe the precautions necessary in handling acids.

The use of acid is not recommended as a negative mold dissolver

[8] Prinz, Hermann, *Dental Formulary*, 6th ed., Philadelphia, 1941, p. 13.

except when the negative plaster mold contains a wax positive, in which case much care must be observed since the temperature of the hot hydrochloric acid may also prejudice the wax positive, which may be softened and thereby destroyed by the heat. If it is decided to employ this acid for negative dissolving purposes, preliminary experiments should first be made with moderately heated, dilute solutions.

A plaster negative can be softened by immersion in a weak solution of acetic acid in cases where it is desired to remove the negative slowly and manually—but safely—and as a waste mold. This process naturally results in a loss of the negative mold for additional positive casts, and it should be restricted to plaster of Paris negatives containing wax positives. It should not be employed where plaster or celluloid positives are contained within a plaster negative mold.

A plaster cast may be manually cut away and slowly removed from the inner positive by applying hydrogen peroxide along the line to be cut. The peroxide should be applied continuously as the cutting progresses. Acetic acid or vinegar may also be used in the same way for this purpose.

Plaster negative molds containing wax positives can be disintegrated by immersion in a 25 per cent solution of potassium or sodium citrate for several hours. A weak solution of acetic acid can be used to soften the plaster negative when the positive cast is composed of wax.

USE AS A MOLD MATERIAL FOR THE CASTING OF NONFERROUS METALS

Plaster of Paris is frequently used industrially in foundries as a negative mold material for the accurate casting of nonferrous metals such as lead, pewter, aluminum, brass, and bronze. There are specially prepared plasters commercially available for use in making negative molds for metal casting.

A plaster negative must possess four important properties before it can be used safely and satisfactorily to receive molten metal:

1. It must be thoroughly dry or 'cured' before it is exposed to molten metal. The mold should be exposed to a constant temperature, under 125° F., for average varieties of plaster or the mold may become calcined and chalky. There are special casting plasters that can be exposed to higher curing temperatures, reaching in some cases as

high as 1000° F. After heating, the mold should be allowed to cool slowly or it may fracture.

2. The negative should possess a higher degree of porosity or permeability than the normal plaster-water mixture has. A high-water low-plaster ratio can be used to produce a negative mold with a maximum porosity or pore space. This factor is very important, because the pores act as minute escape valves for the heated gases that may be generated by the molten positive material. This is particularly true of the aluminum bronzes, which are notoriously 'gassy.'

3. The mixture used to form the plaster negative mold should contain added refractory substances. There are specially prepared plasters available that contain refractory materials incorporated with the powdered plaster of Paris. Finely pulverized or powdered pumice stone mixed with an equal quantity of plaster of Paris will make a physically strong, heat-resistant negative mold for the casting of lead and alloys of lead with fairly low melting points. Asbestos fibers are also added to plaster mixes as a refractory material.

4. The mixture used to form the plaster negative should contain added fibrous matter. The intense heat of molten metal will calcine a plaster negative mold and render it chalky and physically fragile. The addition of fibrous organic or inorganic matter to the plaster mix serves to increase the physical strength of the plaster containing mold.

Dental Formulary [9] lists the following formulas for heat-resisting negative molds:

I		II	
Parts by weight			*Parts by weight*
Plaster of Paris	10	Powdered sand	3
Powdered asbestos	12	Powdered chalk	3
Powdered chalk	4	Marble dust	3
Marble dust	1	Plaster of Paris	6

These two formulas can be used after the molds have been thoroughly dried and warmed, for the casting of lead and alloys with low melting points.

Negative plaster molds for the casting of metal should have satisfactory vents and gating. The ingate through which the metal is poured into the mold should be wide. Gates can be carved into the

[9] Ibid. p. 14.

negative. High portions of the mold should be vented to prevent back pressure as the molten metal is poured into the plaster negative.

TESSO DURO

An Italian hard plaster, known as *Tesso Duro,* is used for fashioning bas-relief casts. The substance retains its plasticity for a long time, during which it can be modeled into form. It dries hard and is very durable. The following formula [10] is given by *The Chemical Formulary:*

Fish glue	1⅝ gallons
Water	½ gallon
Oil of sassafras	3 fluid ounces
Boiled linseed oil	5 pints
Belgian whiting	37½ pounds
Domestic whiting	50 pounds

CARVING PLASTER

The tools required for carving plaster are simple, consisting mainly of chisels, knives, rasps, files, and sandpaper. Rasps are available in an assortment of shapes and sizes for plaster carving; they are, actually, varieties of files. They are constructed of steel and have fine to rough filelike ends, used for working the plaster.

The use of a fine-grained plaster is recommended for carving purposes, because this type of plaster yields a very compact plaster block, which is more satisfactory for carving. Particularly fine details may be achieved with a fine-grained plaster.

Steel chisels of the flat, pointed, and toothed types used in stone carving are occasionally employed for carving plaster, but care should be observed in their use, since plaster is a fairly fragile substance when compared with stone.

Wood chisels can also be used in cutting or carving blocks of plaster. The mallet blows should not be too hard and the chisel should not be permitted to become wedged in the plaster mass or a fracturing may result.

It is recommended that the plaster masses be kept moist while they are being carved with chisels, because a dry mass will chip and

[10] *The Chemical Formulary,* H. Bennett (Editor), New York, 1935, vol. 2, p. 26.

fracture ahead of the cutting edge of the carving instrument. How-
ever, the use of rasps, files, and sandpapers for rounding out and
finishing is more satisfactory on dry plaster.

All tools should be kept sharp and clean.

PREPARATION OF PLASTER BLOCKS FOR CARVING

Rough masses of plaster of Paris in rectangular, cylindrical, and
other forms may be cast in simple cardboard containers, the inner
surfaces of which have first been lubricated with an oil or petroleum
jelly or coated with shellac. The cast plaster block can be carved
while the mass is still soft, immediately after the setting, although
it is generally safer and more satisfactory to wait until it has hardened.

The use of cardboard or compressed-paper containers as negative
mold forms for the casting of rough plaster masses are superior to
more rigid mold forms, because they are more easily and quickly
removed from the plaster mass after the plaster has set. A compressed
paper mold can be torn away from the plaster form within a few
seconds, without danger of marring the cast mass.

MODELING WITH PLASTER

The rare Greek statuettes that were modeled in plaster had a core
of gypsum over which was applied a thin coating of a finer grade of
plaster. This layer was modeled with the fingers and with simple
modeling tools. The material used by the Greeks appears to have been
prepared differently from the plasters of today. It is quite possible
that a retarding agent was used, for the few Greek works in plaster
that we possess appear to have been worked as freely as a plastic
earth, with little fear by the modeler of being overtaken by a quick
set. From the time of the Greeks until the present day, plaster of
Paris has not enjoyed an extensive use as a modeling medium.

In modeling with plaster, there are two methods that may be used.
The form of the work may be built up in a solid manner, or it may be
constructed over a framework or skeleton. For practical purposes it is
best to build up a work over a framework, particularly if the project
is to be a large one. Small, compact pieces can be built up solidly and
as the free water evaporates from the plaster mass, the weight of the
work will decrease substantially.

The plaster should be applied after it is mixed and has begun to

thicken.[11] A subnormal plaster-water ratio or denser mix may be employed for the first application. Additional applications may be made with mixes of normal, more fluid consistencies than the initial mix.

In modeling with plaster, a composition consisting of plaster of Paris, tow, and glue is sometimes used. The mixture is fairly light in weight and it dries and hardens without significant shrinkage. After setting it can be filed or chiseled.

The procedure consists of laying a sheet of tow that has been soaked in plaster and glue water, over a core of loose and dry tow. The rough forms are fashioned while the masses are still plastic. After this has been accomplished and the material has set, modeling is begun with a mixture composed of finely shredded, chopped tow, plaster of Paris, and glue. For finishing, the tow is eliminated and a mixture of plaster of Paris and glue is employed.

STORING PLASTER

Plaster of Paris in powdered form is a fairly stable substance when it is kept dry. It must be carefully protected from dampness in the form of actual moisture or a humid atmosphere, with which it reacts in a hygroscopic manner.

If atmospheric moisture is absorbed, the plaster will lose its uniform powdered amorphous form and will become lumpy and virtually useless for purposes of casting.

Plaster that has been exposed to moisture will also set more rapidly than protected or fresh plaster. Although it is usually marketed in bags that are fairly resistant to moderate external moisture, since it is very sensitive to dampness, the precaution of transferring the contents of a freshly opened bag to an airtight glass jar or container should be taken. This is quite important if the plaster is not consumed steadily and over a moderate period of time.

Plaster-filled containers should be kept away from walls and not placed directly upon concrete floors.

If a quantity of plaster has been exposed to moisture and the exposure has been moderate, the controlled application of heat to evaporate the absorbed moisture may reclaim it for sculptural use.

[11] Immediately after mixing at a normal plaster-water ratio, the mix will be free-flowing. After a few minutes, it will start to thicken and acquire sufficient body to be used in building up form. As the time passes, the mix will become steadily thicker until it is no longer plastic, but dense and hard.

Testing Plaster

Stored plaster of Paris should be tested before it is used. Some sculptors employ a rather primitive test consisting of pinching a small quantity of the material between the fingers. The shape of the mass should be roughly held. If the material falls apart, it has probably been exposed to moisture and is not deemed desirable for sculptural use. To test for the presence of grit, a small amount of the plaster is rubbed between the fingers. In a fine plaster, no gritty impurities will be felt.

A more practical method of testing supplies of plaster of Paris before use is based upon setting qualities. A small quantity of the plaster is mixed with water and the time that is required for the setting together with the hardness that is achieved are noted. These factors are then compared with the results that were achieved during previous use of the plaster.

Reclaiming Plaster

Plaster of Paris is a very economical sculptural material and it is usually readily available. However, there are times when the sculptor may find himself temporarily without an immediate source of supply and he may be forced to postpone his work or to reclaim plaster for re-use.

Plaster that has been exposed to atmospheric moisture can be heated in a metal container over a low fire and stirred steadily until the material appears to boil. This treatment will evaporate moisture that has been absorbed from the air and will reclaim the substance for use as a casting material.

Plaster that has been used, such as old negative mold forms and old or broken casts, may also be reclaimed for use, although after treatment the resulting plaster is not entirely equal to fresh plaster in setting qualities and strength. The plaster is first broken up into small pieces and these are calcined in an iron vessel at a low and steady temperature to evaporate the bulk of the water of crystallization. The mass of plaster should be stirred constantly to insure an equalization of heat. For testing, a small quantity of the calcined plaster is ground up in a mortar and pestle and mixed with water. If the mix sets well in the usual time, no further calcination of the larger mass is necessary.

5

NEGATIVE MOLDS

THE shell-like impression into which the casting substance is poured is referred to as the *mold,* the *negative* or *negative mold,* the *mother mold,* or the *containing mold.*

Negative molds are of two varieties: those that are flexible and those that are rigid.

Flexible molds may consist of several substances, among which are glue or gelatine, rubber, and agar compositions. Flexible molds are often reinforced by supporting outer shells or casings of plaster of Paris.

The rigid type of negative mold is generally fashioned of plaster of Paris, and it may be either a simple unit of one or two sections, or a complex mold consisting of myriad sections or pieces. There are two kinds of rigid molds: the *waste mold* and the *piece mold.*

A waste mold is a negative mold that has to be broken up and destroyed or 'wasted' in order to remove or release the positive cast contained within its interior. It is the simplest form of a mold. The major advantage of the waste mold is that its use reduces in number or eliminates the fine lines or seams that result when a piece mold is used. These lines occur at the edges where one section of a negative plaster mold joins another. The major disadvantage of a waste mold is that only one positive can be secured, since the waste mold is chipped away or fractured in releasing the positive.

A piece mold is a negative mold that has been constructed in several sections or 'pieces.' (See Plate 17B.) The number of sections to be made are determined by the undercuts of the work to be cast, and sections are fashioned so that they may be easily removed without fracturing or injury to the positive cast, and reassembled as many times as casts are desired. A plaster of Paris piece mold can be kept indefinitely.

A positive cast or impression taken from a plaster piece mold is an

accurate reproduction of the original positive if the negative was carefully made, but it is invariably covered with fine plaster lines or seams resulting from the tiny spaces existing where the sections of the piece mold came together or fitted into each other. These lines should be carefully removed after the positive cast has dried.

UNDERCUTS

In the fashioning of negative molds and positives from a rigid material such as plaster of Paris, the major problems confronting the sculptor are undercuttings. An undercut is the portion of a three-dimensional object or mold that prevents the easy and safe removal of the impression or mold. (See Figure 4.)

SEPARATORS

Separators are of two types: (1) Area separators; (2) surface separators.

Area separators are also referred to as *fences* and as *mold dividers* and generally consist of either clay or thin strips of metal. Their function is to divide surface areas or sections of a three-dimensional object so that piece molds can be fashioned.

Surface separators consist of superficial pore-sealing substances or surface lubricants and function to facilitate the safe and easy removal of a mold or negative impression from an original or positive cast.

Area Separators: Area separators or fences are employed in fashioning sectional plaster of Paris negatives or piece molds, although they have also been employed in forming rubber and gelatine piece molds.

Assuming that a sculptor desires to fashion a plaster negative from a simple geometrical form such as a perfect sphere, the first step would be to study the shape of the mass and the nature of its surface and to decide how many negative sections or mold parts it would be necessary to fashion to care for the work adequately. A one-piece plaster mold would be impractical since it could not care for more than half of the object and yet be capable of being easily and safely removed from the sphere. If a thin dividing fence were constructed along the middle circumference of the sphere, dividing the form into equal halves, the negative mold could be adequately fashioned in two pieces or parts.

To make a plaster negative from a complex form, such as a head, the sculptor must first study the work, its surface, and its undercuts

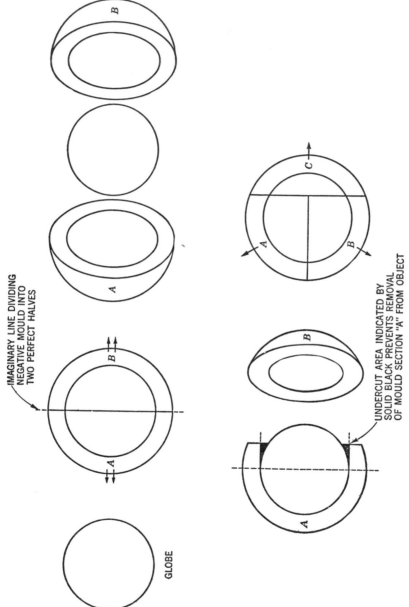

GLOBE

IMAGINARY LINE DIVIDING NEGATIVE MOULD INTO TWO PERFECT HALVES

UNDERCUT AREA INDICATED BY SOLID BLACK PREVENTS REMOVAL OF MOULD SECTION "A" FROM OBJECT

FIG. 4. THE MECHANICS OF CASTING WITH RIGID NEGATIVES SUCH AS PLASTER OF PARIS

A perfectly spherical object can be cast in a two-piece rigid mold if the line of separation does not reach beyond an imaginary line dividing the mold into two equal halves. Where undercuts are present, the negative mold generally has to consist of three or more units.

and projections, and decide on the basis of these how many pieces his negative mold will have to consist of in order to care for the entire mass satisfactorily. The dividing lines or mold divisions are then constructed on the model, with strips of clay or thin strips of brass, tin, copper, or iron.

Composition clay fences are of value when the positive model is composed of a hard substance, such as plaster of Paris, and can be prepared by placing a quantity of the clay on a flat surface. The mass is then flattened to a thickness of about $\frac{1}{4}$ of an inch, depending upon the nature of the work and the size of the piece-mold sections to be fashioned. The flattened strips are cut or sliced into widths and lengths which also vary in relation to the size of the work to be cast and the mold units. Small wedges of clay are frequently employed to bolster or support the fence strips in position on the model.

Metal fences are used extensively when the positive models are composed of soft materials such as plastic earth or composition clay. This type of mold divider can be fashioned from very thin-gauge hard sheet brass, copper, iron, or tin. The gauges generally used vary from about 36 to 38. The metal fence strips are cut from the sheet in required shapes and sizes and are pressed carefully into the yielding model along the lines of separation, to a depth of about $\frac{1}{4}$ of an inch. The metal strips should be imbedded so that they will not produce undercut areas between adjacent sections of the negative mold. The strips are generally cut in rectangular or oblong units. Brass and copper resist corrosion better than the tin or iron fence strips, although the presence of sulphur in some varieties of composition clay will cause the corrosion of copper or brass.

Surface Separators: Surface separators are used to facilitate the safe and easy removal of a mold or negative impression from a model or from a positive cast. Separators should serve the purpose adequately without slurring or clouding fine detail in either the negative impression or the positive cast.

Plaster from Plaster: In casting a plaster positive from a plaster negative, the superficial porosity of the containing mold must be either substantially reduced or entirely eliminated prior to filling the mold with the positive substance. An untreated plaster negative will absorb water from the fluid plaster positive material and may radically affect the physical strength of the positive cast, its surface texture, and its compactness. The safe removal of an intact positive

from the mold may also be endangered. In addition to eliminating the superficial porosity of the negative mold, a lubricating agent is frequently necessary to guarantee the easy and safe separation of the positive from the negative.

Lard and tallow have been used as separating media, but they have to be applied hot and frequently retain brush marks after cooling. The brush impressions are often recorded or reproduced in the positive cast.

A satisfactory preparation to employ in reducing the porosity of a plaster containing mold consists of a solution of 2 ounces of shellac to each pint of alcohol. One or two applications of this solution may be followed by the use of a lubricating oil. The application of oil should be very thin. A heavy application of a light-bodied oil may mix superficially with the fluid plaster and result in a soft and spongy plaster positive surface.

Another excellent formula consists of:

Parts by weight

Beeswax, white or yellow	1
Carbon tetrachloride	9

The wax is placed in the carbon tetrachloride and set aside for about two days to dissolve, after which it can be used.

Soap has been widely used as a separator, but the results achieved are not always uniformly satisfactory and experience is required for its successful application. The best varieties of soap to use are tincture of green soap, solutions of castile, and English Crown soap.

Clay-water has also been used infrequently as a separator, but it may cause a discoloration of the positive cast and its use is not to be recommended.

Hermann Prinz gives the following formulas in his *Dental Formulary:*

I

Parts by weight

Powdered shellac	10
Borax	5
Hot water (not boiling—150° F.)	100
Water-soluble aniline dye, enough to color.	

Put the ingredients into a bottle and shake well. The solution should be ready for use in two or three days.

II

<div align="right">*Parts by weight*</div>

Castor oil	3
Alcohol	1

Alcohol-soluble aniline dye, enough to color.

The purpose of the dye is not clear. It does not appear to be necessary or desirable, and its inclusion is not recommended because it may result in a stained positive.

Plaster from Plastic Earth: If a plaster negative is fashioned over an earth-clay model, the original should not be too dry. A thin layer of water may be sprinkled over the model before the application of the plaster negative material. This will prevent a too rapid hardening of the plaster owing to an absorption of water from the negative material by the plastic earth, and it will also function as a mild separator.

Plaster from Marble: Marble surfaces are generally given a wax coating before a plaster negative is fashioned. Bleached white beeswax is dissolved in turpentine and is brushed on the stone while hot. The coating can be removed later with a cloth moistened with pure turpentine.

Plaster from Raw Wood: Raw wood surfaces are frequently brushed with shellac before plaster negatives are fashioned. Alcohol can be used later to remove the film of shellac on the wood mass.

Plaster from Polished Wood: Polished wood is generally treated with a wax-turpentine solution, similar to that used with marble.

Plaster from Agar Molds: Plaster does not adhere to an agar mold and most casters do not employ separators.

Plaster from Skin: In making plaster impressions on skin, an oil or grease should be applied to the body surface, particularly if hair is present, however fine. Sweet oil, mineral oil, and petroleum jelly are some of the more frequently employed plaster-skin separators. Sweet oil is a good general separating medium, but the substance is rather costly, particularly when large works are cast and substantial surfaces are to be treated with lubricant.

AGAR

Agar is a vegetable gelatine secured mainly from marine algae native to the Pacific and Indian Oceans. The substance is a colorless

and amorphous solid that is soluble in hot water, in which it softens and liquefies.

A water-agar mixture melts at approximately 210° F. and remains soft until it cools at about 110° F. Because this cooling or hardening temperature is slightly above the normal human body temperature of 98.6° F., the material, which resembles gelatine in many of its physical characteristics, has been applied in fashioning flexible negatives from living flesh, without fear of injury to the flesh. (See Plate 18.)

An agar mold is flexible and can be employed in casting from moderate-sized forms possessing undercuts. However, an agar mold is physically weaker than a well-prepared gelatine mold and has to be handled quite carefully subsequent to fashioning. Plaster mother molds are indicated to reinforce agar impressions in much the same manner as they are used to reinforce gelatine negative molds.

While agar can be used as negative mold material to contain plaster of Paris, Portland cement, and magnesium silicate positive mixes, like gelatine, agar cannot be satisfactorily used as a containing negative for terra cotta, since it will not absorb significant amounts of moisture from the plastic positive material.

A pure agar and water mixture is too thin-bodied to adhere to curved surfaces satisfactorily and it also lacks sufficient cohesive strength to be used as negative mold material, so that body-strengthening substances must be added to the fundamental agar-water mix. In addition to this, the moist positive organic material is subject to attack by bacteria and the incorporation of suitable preservatives in the agar preparation is also necessary.

Agar-base negative mixtures are a recent casting development dating back to the First World War. The late Dr. Alphons Poller[1] was among the first to utilize agar as a negative mold material in fashioning molds from flesh. He developed a moulage system and subsequently wrote a book on the subject.

Poller's moulage compounds were patented and the trade names of his negative mold compositions 'Negocoll' and 'Dentocoll' were registered. There are several American products similar to these compositions and they are more economically priced. Among these commercial hydrocolloidal compositions are 'Form-all' and 'Plastico.'

[1] Poller, Alphons, *Das Pollersche Verfahren zum Abformen an Lebenden und Toten sowie an Gegenstanden.* Berlin, 1931.

FORMULAS AND PREPARATION

The American Museum of Natural History [2] gives the following agar formula:

To 6 oz. agar add 1 qt. water. When thoroughly soaked, boil in double boiler and add 3 lbs. glycerine. Continue cooking until water is well evaporated. Add a few drops carbolic acid. Allow to stand until evaporation is complete. The resulting rubbery mass should be cut into small cubes and is ready for use. Heat, as before, until liquefied and, after cooling somewhat, pour over the object to be cast. Harden the inner mold surface by coating with alum water before pouring hot wax into it. It may be used for casting objects in either wax or plaster.

Dr. Paul Gross experimented with hydrocolloidal compositions and developed the following formula [3] listed in an issue of the *Archives of Pathology*, together with directions for its preparation:

The negative mass consists of agar, magnesium soaps, absorbent cellulose wadding (cellu cotton), and water in the following proportions:

	Parts by weight
Agar	100
Oil soap	100
Magnesium sulphate	40
Absorbent cellulose waddings [4]	12
Water	700-800

(This is variable: see text)

The agar is heated in about 2000 cc. of water until it is completely dissolved. The cellulose wadding is macerated in hot water until the fibers have separated. It is then thoroughly stirred into the hot agar. The oil soap is next added, and when it is completely dissolved and incorporated into the agar mass, a concentrated solution of the magnesium sulphate is slowly poured into it. At the same time, the mass is vigorously stirred. This precipitates the insoluble magnesium soaps. The mass solidifies at about body temperature. The solid material is chopped fine, or, preferably, ground in a food grinder. Since this mass contains from two and one-half to three times too much water, it is spread out thinly on paper and allowed to dry

[2] Butler, Albert E., *Building the Museum Group*, New York, 1934, p. 27, Guide Leaflet No. 82, The American Museum of Natural History.

[3] Gross, Paul, 'A New Negative Mass for Making Accurate Plastic Reproductions,' *Archives of Pathology*, XIII, no. 6.

[4] Cellucotton from sanitary pads was used.

at room temperature to a state in which the crumbs are distinctly moist but no water can be expressed. The material is then ready for use.

Clarke [5] gives the following agar formula:

Agar (powdered)	4 ounces
Water	100 ounces
Borax or zinc oxide	1 ounce
Oxyquinoline sulphate	10 grains
Glycerine	1 ounce
Cellucotton	½ ounce
Cotton	15 grains
Rubber cement	4 ounces

Clarke recommends the use of powdered agar, since it requires the use of about ⅓ less water than does shredded agar. The inclusion of borax or zinc oxide in the formula serves to increase the colloidal binding power of the agar. Borax toughens the agar composition. Zinc oxide will color the mass white. The cellucotton and cotton fibers exercise a binding mechanical influence on the agar mass. The rubber cement also functions mechanically to increase the binding power of the agar mass in addition to increasing its consistency. It is recommended that synthetic rubber cements be avoided in compounding agar formulas. The oxyquinoline sulphate (Chinosol) has mild germicidal and fungicidal powers. The glycerine serves to keep the mass moist.

Clarke states that the rubber cement can be made by dissolving ½ ounce of caoutchouc (para rubber) in 25 ounces of benzene. The process requires about three days for complete dissolution. Clarke gives the following directions for mixing his agar formula:

Place the agar in three-fourths of the water (75 ounces if shredded agar is used), which should be at room temperature, in a double boiler and stir vigorously. Powdered agar mixes readily and should be stirred until all of the lumps have been absorbed. If the agar is shredded it will absorb all of the water but will not go into solution until heated. Heat is applied until the mass goes into complete solution.

The remaining one-fourth of the water is placed in a large-mouthed bottle to which is added the borax or oxide, cellucotton, cotton, preservative and glycerine. The bottle is corked and the contents are shaken vigorously until they are thoroughly mixed. The shaking in the bottle separates the cellucotton and cotton fibers and also mixes the other ingredients.

[5] Clarke, Carl D., *Molding and Casting*, Baltimore, 1940, p. 42.

After the agar and water have reached 100° C., or the boiling point, and have gone into complete solution, the second mixture is poured slowly into the agar, or first solution, with constant stirring. When these mixed ingredients have again reached 100° C. the mass is allowed to cool near the setting point and the dissolved para rubber or rubber cement which is very inflammable, is poured in slowly while stirring. The mass bubbles in evaporating the volatile liquid which was used to dissolve the rubber. It should not be replaced on the fire until the greater percentage of this chemical is removed by evaporation, otherwise it will ignite readily. The mass is now poured into an enamel tray to cool. (If the manufacture of this product is done on a large scale, the benzene may be recovered by condensation.) On cooling the composition will set, after which it is ground in a food chopper and *allowed to stand until the water has evaporated from it to a point where none can be squeezed from the mass when a ball of it is gripped in the hand.* On reheating the mass it is ready for use.[6]

Clarke recommends that the product be stored in airtight and wax-covered containers to prevent loss of moisture.

The glycerine and rubber cement are eliminated in an improved formula: [7]

Agar	4 ounces
Water	100 ounces
Zinc oxide	1 ounce
Oxyquinoline sulphate	10 grains
Cellucotton	½ ounce
Cotton	15 grains

AGAR FACE MOLDS

The procedure in making an agar face mold consists of first fashioning a simple outline impression of the face by bending a lead wire about the head, cheeks, and chin at the line where the mold will end. This wire outline is then placed on a sheet of cardboard and the shape is traced on the board, which is then cut with a scissors along the traced outline, and the inner portion is removed and discarded. The frame is then placed in position about the subject's head and secured to the face with small strips of adhesive tape. (See Plate 18.)

The agar is carefully heated for use in a covered double boiler so that no moisture will escape; it should be stirred at intervals during the melting. When the mass has cooled to just above body temperature (this can be tested by dipping a finger into the mass), it can be

[6] Ibid. pp. 43-4.
[7] Clarke, Carl D., *Facial and Body Prosthesis*, St. Louis, 1945, p. 79.

applied directly to the model. Separators are not required when agar compositions are used, as the material does not adhere to hair or skin.

The agar composition can be applied with the fingers or with a brush or spatula, beginning just under the chin and working upwards. The horizontal position of the subject and the cardboard frame will facilitate the application. When the nose area is reached, the material should be applied carefully around the openings, so that the subject can continue to breathe; or thin breathing tubes can be inserted into the nostrils and the nose area covered with the agar composition.

When a layer of agar about an inch in thickness has been built up over the face, a simple wire framework or cage is then placed over the agar mass to serve as a reinforcing structure and prevent the delicate mold form from breaking when it is removed. Strips of material, such as burlap, can also be used for this purpose, or a heavily bodied plaster mix can be applied over the agar impression to form a mother mold or casing.

The negative agar mold should be left in place over the model until the agar has thoroughly cooled. The cooling can be accelerated by the application of dry ice or by subjecting the agar mass to the air currents of an electric fan.

The completed mold is then removed, inverted carefully, and can now be filled with the positive material, generally plaster of Paris.

Used agar negative molds can be reclaimed for use by grinding the mass and storing it in airtight glass containers. Small quantities of water can be added to used compositions to compensate for any loss sustained in heating the material for use.

AGAR MOLDING A HAND

A hand can be molded in a one-piece agar mold by immersing the hand in the full vessel in which the agar composition has been softened by heat. The agar is naturally first permitted to cool to a comfortable temperature. If the hand is kept in the fluid agar composition a short time, when it is removed from the vessel it will be covered with a thin agar coating. Additional agar is then applied over this initial layer to build up a more substantial negative mass.

The agar mold can be reinforced with strips of cotton fabric. These strips may be dipped into the agar composition and then wrapped about the negative mass. When the agar negative has cooled to a fairly compact state, the hand can be carefully withdrawn from the

mold. If there is too much suction during this operation, a fine point can be inserted into the mold mass at intervals to permit the entry of small amounts of air, thus reducing the vacuum-suction.

If the mold 'catches' at the wrist and withdrawal of the hand becomes difficult without endangering the negative mold, the agar mass can be carefully sliced on each side. The cut portions are subsequently bound together with a long strip of fabric after the hand is withdrawn, and the mold will then be ready to receive the positive material.

GELATINE OR GLUE MOLDS

Flexible gelatine or glue molds are a comparatively recent casting media, dating back to about 1865. Both materials have been used extensively to form negative molds over models of plastic earth, plastilene, and wax. However, latex possesses many advantages over gelatine or glue as a negative material, and the sculptor who has worked with rubber molding compounds is not likely to return to the use of glue or gelatine.

A gelatine mold is occasionally referred to as a glue mold, but glue is actually an impure and cheaper form of gelatine and does not possess as much elasticity.

Gelatine is made by boiling organic tissue in water. The material is generally available in sheet form, in flakes, and as a fairly coarse powder. It is amorphous, white to amber in color, and transparent. It is quite brittle when dry and is soluble in hot water. Only the finest-quality gelatine should be used in fashioning negatives. The better grades contain less impurities and have greater water-absorption properties than do the cheaper forms of the material.

FORMULAS AND PREPARATION

Prinz gives the following molding formulas in his *Dental Formulary:*

I

Parts by weight

Carpenters' glue	20
Gelatine	20
Glycerin	85
Water	25
Cottonseed oil	20

Place the glue, the gelatine and the water in an enameled double (rice) boiler, let stand for twenty-four hours, heat until dissolved and add the glycerin and cottonseed oil with constant stirring.

<div align="center">II</div>

	Parts by weight
Carpenters' glue	200
Water	50
Soak the glue in water overnight, pour off the excess water and add:	
Glycerin	50
Melt over a low fire under constant stirring until the total mass weighs	250

Pure gelatine or glue can be used as a negative material without the addition of any other ingredient except water.

However, Fredericks, in his excellent manual,[8] recommends the use of glue and molasses in a proportion of 16 ounces of glue to each 14 ounces of molasses as a more elastic negative material than plain glue. The glue is broken into small pieces and permitted to soak in water for about 12 hours, after which the excess water is poured off and the mass is heated carefully over a small flame. The molasses is warmed separately and when it begins to boil is added to the hot glue and the mixture is briskly stirred.

The procedure in preparing gelatine for use as a negative mold material consists of first breaking the gelatine into small fragments, which are placed in a jar or glass vessel, and then adding sufficient cold water to completely cover the mass. These ingredients are then permitted to stand for about 12 hours or overnight; during this time the gelatine will slowly absorb water and soften. It can then be transferred to a double boiler and heated slowly until it is thoroughly melted. When the mixture is uniformly fluid, the mass should be permitted to cool to body temperature. Surface scum can be removed with a ladle. The gelatine should not be poured too hot. It should be tested before pouring by dipping a moistened finger into the fluid mass. If the heat can be comfortably endured, the material is ready for pouring.

[8] Fredericks, Frank Forrest, *Plaster Casts and How They Are Made,* 3rd ed., New York, 1927, p. 86.

Gelatine Molding from a Plaster Relief

The relief should be placed in a horizontal position, and a containing wall or fence of composition clay or wood constructed about it to contain the gelatine mass. All cracks between sections of the wall strips or between the wall and the baseboard should be completely sealed with the clay. The plaster model and the containing surfaces of the wall and baseboard are coated with shellac and an oil lubricant, or a warm and fluid mixture composed of equal parts of tallow and lard is applied over the dried shellac surface. The model is covered with a layer of clay about half an inch thick, and a larger cylindrical clay mass is set at the highest point of the model for a funnel or opening through which the gelatine will be subsequently poured. The clay mass is covered with a shell of plaster to form a casing. When this plaster casing has hardened it can be removed, cleaned, and treated with shellac. The clay thickness is now stripped off and the casing replaced in position over the original. The next step consists of pouring the gelatine to occupy the space formerly occupied by the clay.

The melted gelatine should be tested with a finger for warmth, and if this is just right it can be poured into the mold. After the gelatine has set, the mold can be turned over and the relief removed.

At this stage some casters sprinkle their gelatine negative with fine soapstone, which is brushed around and then knocked out. The inside of the mold is washed with a saturated solution of alum to harden the containing surfaces of the gelatine impression, and when this has dried an oil lubricant is painted on the inner surfaces of the gelatine negative. A thin plaster mix, constituting the initial positive application, is poured slowly into the mold. A brush can be used in applying this initial plaster, to make certain that the negative surface is completely covered, after which the mold may be fully charged.

If the gelatine mold is to be used for several positive casts, the plaster positive should be removed from its gelatine negative during the time between the initial setting and hardening of the plaster and the evolving of the heat of crystallization. If the plaster mass is not removed from the mold during this interval, the containing surfaces of the gelatine negative may be superficially melted by the heat given off by the plaster mass. Although disturbing the plaster at this time may lessen the strength of the finished cast, it is necessary and should be done very carefully and with a minimum of jarring.

The application of alum tends to reduce the 'burning' effect of the setting plaster upon the delicate gelatine mold.

If additional casts are desired, the gelatine mold can be painted with the concentrated alum solution, and re-oiled for each casting. Cold water can be used to mix the positive plaster material, since warm water tends to soften and melt gelatine.

Gelatine can be used repeatedly for negative molds providing that it is adequately dried out after each use. The moist substance has a tendency to become moldy, but the addition of a small quantity of carbolic acid will serve to prevent decomposition of the organic material.

Molding an Object in the Round

Assuming that a gelatine negative mold is to be formed from a plaster model, the caster proceeds to coat the plaster surface with shellac and to oil the surface lightly after the shellac application has dried. The model is then covered with a layer of composition clay from ½ to 1 inch in thickness. This thickness is governed by the dimensions of the model. The clay thickness occupies the space that will subsequently be filled with the gelatine, and it should be heavier where the mold seams are to come. Several extra conical clay masses are fashioned and these are placed on the clay layer at high points to serve as air vents when the gelatine is later poured into the mold.

A clay wall is built about the sides and over the top of the model, dividing the mass into halves, and a wide cylindrical mass of clay is placed on the top of the wall for a funnel opening through which the gelatine will subsequently be poured into the casing. The wall can be bolstered with triangular clay wedges placed on the back surface. Registration grooves can be cut into this dividing wall, or hemispheres made of composition clay can be stuck on the clay wall, so that the mold sections will fit securely and accurately together. A reinforcing shell, approximately ¾ of an inch thick is then made by pouring a layer of fluid plaster over half of the model. When this casing has hardened, the clay thickness can be removed if this is desired, leaving half of the model completed and the other half ready for the fashioning of the second portion of the reinforcing plaster casing; or the clay mass can be left intact to be removed later. Clay plugs for air vents are attached to the second portion of the mass, as was done with the first half, and the edges of the plaster casing, already completed, are covered with shellac and lubricant.

The second half of the casing is fashioned as was the first. After they are set, both sections are separated and the clay thickness is removed. The casing should be thoroughly cleaned, treated with shellac, and an oil lubricant.

The casing may now be reassembled. During this interval the gelatine should be heated in preparation for pouring. Make certain before pouring the gelatine that the mold is firmly bound and completely sealed, except for the pouring funnel or opening and the air vents.

As the gelatine is poured, these vents should be watched, and as the fluid gelatine rises in the opening and begins to run out of the vents, they should be plugged with clay. The mold should be filled to the top of the funnel opening. It is advisable to have some extra gelatine prepared, because the material tends to settle. After it has been poured, the mass should be checked at intervals for several hours. If the gelatine begins to leak from an air vent, the opening can be sealed more tightly with clay. The mass should be permitted to set and cool overnight.

When the gelatine has set, the front section of the plaster casing can be removed and the gelatine mold cut. The back casing can then be taken off, the gelatine sections carefully pulled away from the plaster model, and the original model removed. French chalk can be used to dust the external surfaces of the gelatine mold sections and the internal surfaces of the plaster casing. The containing surfaces of the gelatine negative can be painted with a hardening solution of alum and water, and the mold reassembled, bound securely with wire, and made ready for the casting of the positive.

A creamy plaster mix, prepared with cold water, is poured into the mold and the mold mass is turned in all directions, so that the fluid plaster will flow into all portions of the negative. Additional plaster is then added until the desired positive thickness is achieved. The plaster is then permitted to set, after which one section of the casing is removed and the gelatine mold lifted carefully from the positive. The external surface of the gelatine is again dusted with French chalk and the section is placed into its casing. This procedure is repeated with the other section of the mold.

In fashioning a gelatine mold from a composition clay model, many casters apply a thin layer of fine paper over the clay mass, or oil it. A clay thickness is built over this. 'Teeth' or pegs are occasionally inserted into the model to prevent a slipping or sagging of the gelatine mass.

KOROGEL

The B. F. Goodrich Company of Akron, Ohio, has developed an elastic and rubberlike material that can be used for fashioning flexible negative molds. The substance is known as 'Korogel' and it can be used in making molds that are to be charged with plaster of Paris, Keene's cement, or Portland cement mixes. It is used in much the same manner as is gelatine. It is not affected by water, and lubricants need not be applied to the containing surfaces of the negative molds between casts.

Korogel has many advantageous characteristics. It does not shrink, expand, or distort in use, and if the negative mold is set aside for long intervals it will not dry out or otherwise deteriorate. A negative impression composed of this material can be used for scores of casts. It can be remelted after the casting of the positives and re-used innumerable times without adding additional ingredients.

Korogel has to be melted and poured while it is fluid, and several precautions are necessary in preparing it for use. Enameled containers must be used for melting, since Korogel must not be permitted to come into contact with metal while it is being melted. As it should not be heated over 300° F., a thermometer should be used to see that the mass is not overheated.

The manufacturer recommends that melting be started with a small quantity of the material in an enameled vessel and kept over a low gas flame. When this has been melted, the rest of the material can be added, while the entire mass is steadily stirred with a wooden spoon or ladle to prevent burning at the bottom of the vessel. After it is melted, the heat source is extinguished and the fluid negative material permitted to stand without stirring to allow air bubbles to rise to the surface of the mass. The temperature of the fluid material is allowed to drop to approximately 250° F., or to the point where the material will just flow.

High points on the model should be well vented and the pouring opening or funnel fashioned at the top of the mold. The fluid negative material is slowly poured into the mold, after which the substance is allowed to cool thoroughly for several hours before the casing is opened.

Korogel has been used to form negative impressions from models of wood, metal, plaster of Paris, and Keene's cement. It is not recom-

mended to be used over models with low melting points, such as wax or composition clay, or for use over earth-clay models. Models composed of Keene's cement or plaster of Paris must be thoroughly dry before a Korogel negative is fashioned. Many workers with the material employ a separator over plaster of Paris or Keene's cement objects. A popular separator for this purpose is composed of equal parts by volume of French chalk and white petroleum jelly. This is applied in a thin coating and with a soft brush. Fine lubricating oil can also be used. The inner containing surfaces of plaster-of-Paris casings should be treated with the chalk and petroleum-jelly separator to prevent any possibility of the Korogel adhering to the mold.

Korogel is available in three degrees of hardness, designated as Korogel No. 1, No. 2, and No. 3. Number 1 is the softest variety, Number 2 is of medium consistency, and Number 3 is a harder kind.

The initial cost of Korogel considerably exceeds that of glue or gelatine.

PLASTER OF PARIS

For centuries man has consistently sought for a perfect casting medium, but while many materials have been employed and experimented with, no medium appears at the present time seriously to challenge the status of plaster of Paris as the most universally available and generally satisfactory rigid molding substance we have. While plaster of Paris has some serious limitations, the same limitations are often, paradoxically, the major virtues of the medium.

Plaster is one of the most inexpensive materials we have for the casting of negatives and positives. It is also used to reinforce or form the case or casing of agar, gelatine, and rubber negative molds.

PLASTER OF PARIS FACE MOLDS

The fashioning of a life mask in plaster of Paris is a rather disagreeable experience from the point of view of the subject, who has to recline quietly [9] with eyes closed during the application and setting of the plaster mold material. Tubes are inserted into the nostrils for breathing, although they may also be placed in the mouth, in which

[9] There is a tendency of the facial tissues to sag with gravitational pull when the subject is in a horizontal position. This phenomenon is particularly marked with older and obese persons. In order to avoid distortion, some sculptors prefer to fashion their impressions from an erect model, but this is very difficult and requires considerable experience.

case the nostrils are sealed with soft cotton to prevent the entry of the fluid negative material.

An experienced caster can fashion a face mold without the use of breathing tubes by leaving the nose for the final stage and carefully working the plaster around the nostril openings. Another, more precarious method, also involves leaving the fashioning of the portion about the nose for the final stages. The subject is told to take a deep breath and to hold it. A thickened plaster mass is used to cover the nose completely, and the subject is then instructed to exhale through the nose. The exhalation will produce holes in the plastic plaster over the nostril openings and the subject can continue to breathe through these passages while the plaster mold mass sets and hardens.

Care should be taken to protect the hair, eyebrows, and eyelashes. Before the application of the plaster of Paris, the head can be covered with a towel or a rubber bathing cap. The skin should be well oiled with petroleum jelly or with mineral oil. Eyebrows and eyelashes are most satisfactorily lubricated with petroleum jelly to prevent their being incorporated in the hardened plaster mold.

A normal plaster mixture should be used, in which the only ingredients are clean plaster and fresh water. The mixing water may be warmed to hasten the setting of the plaster and to eliminate the shock of a cold plaster mass placed on bare flesh.

If the positive is to be composed of untinted plaster of Paris, the mixing water for the negative mold can be delicately tinted with a small quantity of ordinary laundry bluing. If the positive mass is to be integrally colored, and this is the preferable procedure, the negative material is left uncolored. The difference in color between the negative and positive mass is necessary so that when the negative mold is chipped or carved away to release the positive, the sculptor can see where the negative stops and the positive surface begins. If both negative and positive were white or identically colored, the chisel or blade used to remove the negative might be driven into the positive mass.

After being mixed, the negative material should be allowed to thicken slightly to a creamy consistency, and then applied carefully to the lubricated face with a soft brush or with the fingers.

When the plaster mold has set, it can be lifted away from the subject and the containing surfaces of the mold are cleaned and retouched wherever necessary.

If the positive is to be of wax, the plaster negative should be immersed in hot water and then lightly coated with soap.

If plaster is to be used for the positive cast, a suitable separator or lubricant should be employed.

The positive may be cast solidly or as a shell. If it is to be cast in a shell form, a thin mix is poured into the negative mold and the mold is moved about from side to side so that the plaster will completely cover the inner surfaces of the negative. The excess plaster is then poured back into the container. The process is repeated until desired positive thickness is built up. Strips of burlap or gauze can be applied between layers to reinforce the positive mass.

If the positive is to be solid, the mold is filled with plaster, which is permitted to harden. Just before the positive material has set and while it is still soft, a curved wire can be inserted into the plaster mass to serve as a hanging hook.

After it has hardened, the entire mass is placed face up on a soft and cushioning surface and the chipping away of the negative mold can be begun. Light wooden mallets are preferable for use in the chipping process, and the blows struck with the chisels should be light and short. The chisels should not be used at right angles to the plaster mass, but should be applied obliquely and only a small amount of plaster removed at a time. The nose area and any other projecting surfaces are best left for last.

PLASTER CASTING A SIMPLE RELIEF

Assuming that the relief has no undercuts, it is placed on a flat surface, such as a wooden modeling board, and a wall of composition clay or wood is fashioned around the relief to contain the negative material within the area. (See Plate 17A.)

The height of the containing wall should exceed the height of the highest portion of the relief by about half an inch.

After the exposed surfaces of the relief and the inner sides of the containing wall have been treated with a separator, the plaster, which should be of a creamy consistency, is poured to cover the relief and to fill the area enclosed by the containing walls.

The thickness of the usual negative relief mold varies from half an inch to an inch, depending upon the dimensions of the relief and its nature. If the relief is wide and long, the negative may be reinforced while the plaster is still soft, by the incorporation of burlap strips and lacquered wire or metal rods in the negative mass.

When the plaster has thoroughly set, the negative mold may be removed and cleaned, retouched where this is necessary, and treated with lubricant. The mold will then be ready to receive the positive material.

Hollow Plaster Positives

Hollow plaster positives can be secured from piece molds by first treating the inner surfaces of the piece mold with shellac and then lubricating the dry shellac surface with an oil. The piece mold is carefully assembled and securely bound together. Cracks or spaces between the mold sections through which plaster might leak should be sealed with composition clay.

Fluid plaster of Paris of a creamy consistency is poured into the hollow interior and the mold mass is turned about in all directions so that the plaster will flow into undercuts and cover the entire internal surface of the negative. The excess plaster is poured out again and the process is repeated until the desired thickness has been formed. After complete setting, the mold sections are removed and the plaster positive can be retouched wherever this is necessary.

Plaster Waste Molds

A form that has been modeled in plastic earth or in composition clay does not possess a great deal of permanence and the fragile model must, therefore, be 'transferred' into another more durable material. The transition is effected by means of casting and the material generally used for constructing negative molds to care for medium to large works in the full round is plaster of Paris.

When only one copy or positive cast is desired from a medium to large-dimensioned, undercut clay model, and when the negative material is to be plaster of Paris, a waste mold is generally fashioned. The waste mold is usually made of two pieces or parts, although it may be composed of more pieces.

The procedure in forming a waste mold is to first fashion a composition clay or shim brass fence about the object, dividing it into two or more sections. Small conical clay projections are attached along the front edge of this fence to form registration holes so that the two parts of the finished waste mold will fit accurately together after the original is removed and the mold is assembled for casting the positive.

The first layer or application of the negative plaster material that comes into direct contact with the original should be fairly thin, and

the usual procedure is to tint this primary coating with laundry bluing or with water-color pigment that is added to the mixing water. Thus, when the completed negative mold is chipped away from the positive cast, the colored plaster will warn the caster of his proximity to the actual model, and greater care can be exercised with the mold-removing chisel.

The initial colored coating is applied thinly to one section of the mold with a soft brush so that it will cover all of the surface and penetrate into detailed areas.

After the first coating of tinted plaster has set and hardened, the external surface may be painted with a separator consisting of water to which has been added a small quantity of earth-clay. Enough earth-clay is dissolved in the water to thicken it slightly.

After the application of clay-water separator, the second coating of white, untinted plaster is applied over the model until the total waste-mold thickness is approximately ¾ of an inch.[10]

Irons are frequently incorporated in the final coating of plaster to reinforce the negative mold mass and to prevent it from fracturing when the clay model is pulled out of the mold. The irons assume particular importance when figures are cast.

The dividing clay wall may now be removed and the edges of the plaster mold treated with a lubricant, after which the remaining section of the waste mold is fashioned in the same way as was the first. When this has been accomplished and the plaster negative mass has set, the mold sections can be separated, the clay original removed, and the inner containing surfaces of the negative mold cleaned, treated with separator, and joined together again. The mold is now ready to be filled with the positive material, which is usually plaster of Paris, although cast stone mixes can also be used.

If a solid positive is desired, the mold is charged full and then tapped or vibrated while the inner mass is still fluid, to loosen air bubbles and to guarantee the penetration of the plaster into all portions of the negative mold.

A method used in producing hollow positives from small to moderate-sized waste molds consists of preparing a small quantity of fresh plaster, pouring it into the mold, flushing it about, and then pouring

10 This thickness is dependent upon the dimensions or size of the model. Small models can be cast with ½-inch plaster negatives, while larger models will require heavier molds about an inch thick. The waste mold should not be too thin nor should it be too thick.

it out again. The procedure is repeated until the desired positive thickness has been built up.

After casting, the entire unit, negative and positive, are left undisturbed until the positive mass has completely set and hardened. When this has taken place, the outer negative mold is carefully chipped away with a blunt chisel and mallet until the first colored negative application is reached, after which the chipping should be done more slowly and carefully until the positive mass has been released from its containing shell. This operation may be done with the mold mass placed upon an insulating material such as an old carpet. The chisel should be held firmly, on or near the blade, and the blows struck with the mallet should be quick and sharp. When the negative shell has been removed, the positive cast can be retouched wherever this may be necessary.

PLASTER PIECE MOLDS

Plaster piece molds are fashioned when more than one positive cast is desired of a medium to large work that has been constructed of clay. Piece molding a work in plaster is a painstaking task and the fashioning of an adequate piece mold for a complex and intricately undercut original may require many months of careful labor. (See Figure 4 and Plate 17B.)

The first step in piece molding a medium to large form in plaster of Paris consists of studying the plastic model and determining the number of pieces that will be necessary to make a complete and adequate waste mold, and also just where the lines of separation will be.

When this initial phase has been accomplished, thin pieces of brass, which are called 'tins' [11] are then set into the soft model to a depth of about ¼ of an inch, on the lines of separation. These tins are placed into the clay at an angle that will permit the easy and safe removal of small units of the mold without causing undercuts between adjacent mold sections.

Subsequent to the setting of the tins, dividing the entire mass into sections, the model is treated with a suitable lubricant and the fashion-

[11] The tins are made of very thin metal, such as 38-gauge shim brass, which can be easily cut with an ordinary scissors and bent with the fingers to conform with curves on the model. Tins are usually cut into relatively small rectangular units measuring 2 x 3 inches and 2 x 4 inches, but they can vary and be made either smaller or larger according to the nature of the work. Smaller units are used to divide detailed areas and rounded forms, while larger strips are employed in separating the broader, flat areas.

ing of the pieces constituting the negative mold is begun by carefully filling the areas enclosed by the tins with plaster of Paris.

The negative mold mass can be reinforced with lead pipe or with iron bars bent to conform to the shape of the model. The metallic supports are joined to the plaster mold by wrapping the iron or lead unit in strips of burlap or jute that have been saturated with fresh plaster mix, and these are held against the main plaster mass until they stick. The same support should not be joined to more than one piece-mold unit or the sections may become locked together and prevent the removal of single unit parts.

When this operation has been completed, the piece mold can be carefully removed from the plastic model, cleaned with water and a soft brush, and treated with separator.

The mold units are then reassembled securely and the negative is ready for use in casting the positive. A plaster mix of creamy consistency can now be poured into the mold, which is rotated or turned in all directions so that every surface is touched and covered by the fluid plaster. When this has thickened, additional plaster can be introduced into the mold until a hollow positive of desired thickness has been built up. The entire mass is then allowed to set thoroughly before the piece mold is carefully removed.

A strong solid plaster positive can be secured by fashioning a simple internal skeleton or armature from lacquered iron rods, around which is wound string or wire to catch the plaster. The piece mold is assembled about this structure; then when the mold is charged, the positive material will set firmly over the framework, forming a compact and very strong cast.

When the mass has thoroughly set, the burlap ties are chipped away, the external irons are removed, and the pieces or mold units are very carefully removed to release the positive cast, which may then be retouched wherever necessary. The mold units should be cleaned and set aside in a safe place for future use, if additional positives are later desired.

THREAD AND WIRE CUT MOLDS

Fine, strong thread or metallic wire is occasionally used as a means of dividing a simple plaster negative mass into piece-mold sections. (See Plate 19.)

The waxed or oiled thread or fine wire is carefully placed along

the line of desired separation, on the surface of the model, which is frequently composed of plastilene, and the plaster is applied over this. When the material has begun to set, the thread or wires are pulled, cutting through the yielding plaster negative mass and dividing the mold into the desired pieces or parts.

Some experience is required to judge accurately the precise moment in which to pull the threads and divide the negative mass. If the thread is pulled too soon the plaster may flow together and unite the mold parts firmly, thereby preventing the easy and safe removal of the negative. If too long a period is permitted to pass before the threads are pulled, the negative mass may become so dense that the mold-dividing threads will break under the physical stress before they can cut through the hardening plaster.

The author has employed dental floss, which is waxed silk thread, for mold-cutting purposes, with good results.

RUBBER MOLDS

The use of rubber as a negative mold material is a comparatively recent and welcome casting development. The rubber mold is far more pliable and elastic than glue, gelatine, or agar-agar negative molds, and is also more durable than any other flexible mold. Its pliability and elasticity make it possible for the sculptor safely and easily to take precise impressions from objects with high projections or deep, complex undercuts, and to cast from these flexible rubber impressions; its durability makes it possible for him to realize scores of positives from the same negative-rubber mold. A properly prepared rubber mold can be used for as many as a hundred positive casts; occasionally, even more.

The basis of all rubber mold preparations is *latex,* the fluid, water-soluble sap of the rubber tree. Latex, or liquid rubber, is an economical negative-mold material that compares very favorably in cost with fine gelatine. It is the material of choice when it is desired to cast from a small- to moderate-sized original, when the original has delicately modeled and intricate undercuts, and when fairly large editions of a work are desired.

Latex is generally available in a concentrated form, the consistency of which can be thinned with water. Ammonia is usually added to

the latex at its tropical source in order to prevent the coagulation and decomposition of the organic substance.

A rather crude rubber mold material can be made by using the basic latex together with cotton fibers as a filler, but it is not very satisfactory, as the mold is greatly distorted when it is removed. A finer compound can be produced by adding vulcanizing or gelling agents, an antioxidant, and a filler to the basic latex. The majority of commercial rubber mold preparations contain preservatives, fillers, vulcanizing ingredients, and antioxidants in addition to possible coloring matter. They may also contain plasticizers or softening ingredients to make the resulting rubber mold more pliable.

STABILIZERS

Rubber molding compounds generally contain an alkali such as ammonia to keep the rubber suspended in a colloidal state and thereby prevent coagulation of the particles. Soaps and casein solutions serve the same purpose.

PRESERVATIVES

Ammonia functions also as a preservative and serves to prevent the decomposition of the latex, which is an organic substance. The amount of ammonia added as a preservative to a latex is fairly small. Approximately 1 per cent may be added as a 5 per cent solution. Phenols are also frequently added to a latex for this purpose.

SETTING OR GELLING AGENTS

Ingredients such as magnesium sulphate and ammonium chloride are frequently added to the basic latex to stimulate setting or facilitate vulcanization. The proportion of gelling agents employed is approximately 1 per cent of the rubber solids.

FILLERS

Fillers are frequently added to the basic latex to make a more substantial-bodied molding compound. Among the important fillers used in latex formulas are the following ingredients:

Earth clay (China clay, Dixie clay)	Talcum
Whiting	Zinc oxide
Barium sulphate	Cotton fibers

VULCANIZING AGENTS

The addition of a vulcanizing agent to a latex formula serves to 'set' the negative mold and permits its removel from the object without distortion. It also prevents undue shrinkage in a rubber mold set aside for future use. It should be noted here that latex mixtures having a high water content will be more susceptible to shrinkage than those containing a small amount of water.

The best vulcanizing agent is sulphur in a dry and powdered form, such as flowers of sulphur. Zinc oxide and accelerators are also used. Vulcanizing ingredients should be dispersed before being added to the latex. They should never be added in a dry, powder form.

Self-curing compounds require the use of ultra-accelerators, but it is advisable even when these are employed to give at least a short heating period after drying.

ANTIOXIDANTS

Antioxidants are added to a latex mixture when it is desired to preserve the negative mold over a long period of time for future use in casting. The following ingredients are listed in *Latex in Industry:* [12]

1. Adol-alpha-naphthylamine (Age-Rite Resin)
2. Phenyl-beta-naphthylamine (Age-Rite Powder) (Neozone D)
3. Sym. di-beta naphthyl-p-phenylene-diamine (Age-Rite White)
4. Ditolylamines and petroleum wax (Age-Rite Gel)
5. Sec. aromatic amine mixture (Age-Rite HP)
6. Ketone-amine reaction product (Age-Rite Syrup)
7. Para-hydroxy-phenyl-morpholine (Solux)
8. Butyraldehyde aniline reaction product (Antox)
9. Acetaldehyde reaction product with phenyl-alpha-naphthylamine and phenyl-beta-naphthylamine (Nonox)
10. Acetone aniline condensation product (Flectol H)
11. Acetaldehyde aniline reaction product (VGB)
12. Phenyl-alpha-naphthylamine (Neozone A)
13. Diethyl-beta-naphthylamine (Neozone L)

FORMULAS

The following rather vague and generalized rubber mold formula is given in British Patent Specification No. 391,230, entitled *Improve-*

 [12] Noble, Royce J., *Latex in Industry,* The Rubber Age, New York, 1935, pp. 114-15.

ments in or Relating to a Process for the Production of Casting Moulds
of Rubber:

	Parts by weight
Rubber, as latex	100.0
Sulphur	3.0
Oil	6.0
Accelerator	1.2
Antioxidant	0.5
Soap	0.9
Casein	1.0

To each 100 parts of this dispersion medium is added 67 parts of
filler, such as dry, powdered plaster of Paris, to form a paste. The
model, if fashioned of plaster of Paris or composition clay, should be
treated with a separator before the latex compound is applied. Banana
oil can be used for this purpose. The paste should be applied thinly
and time should be allowed for adequate drying between applications.

Royce J. Noble gives the following formula [13] for negative rubber
molds:

	Parts by weight
Rubber, as latex concentrate	100
Sulphur	2
Zinc oxide	5 14
Filler	10-14
Color	3
Accelerator (PPD)	.8-1
Ammonia solution (5%)	44
Antioxidant	1
Stabilizer (casein sol. 10%)	5

To this mixture is added 18 parts of a solution consisting of:

Ammonium chloride	10%
Strong ammonia solution	10%
Water	80%

Sodium silicofluoride, ammonium sulphate or ammonium nitrate
can be substituted for the ammonium chloride.

The Revertex Corporation of America suggests the following for-
mula utilizing synthetic latex:

[13] Ibid. p. 267.

MOLDING COMPOUND

Solids by weight

Synthetic latex	100.00
Stabilizer	2.00
50% Filler, clay, etc.	20.00
50% curing dispersion	10.00

This formula can be adjusted to suit individual requirements with suitable pigments or coloring. The viscosity can be adjusted by the further addition of fillers. Stabilizers, fillers and curing ingredients are mentioned elsewhere in the text.

MIXING RUBBER MOLD MATERIALS

In mixing rubber mold materials, glass or enameled vessels should be used. Bowls of copper or alloys of copper, such as brass, are best avoided. The liquid ingredients are mixed first and the powdered ingredients then added in small quantities until all have been uniformly incorporated with the fluid mixture. An egg beater can be used to mix all of the materials thoroughly.

Many ingredients, such as earth-clay, barytes, zinc oxide, whiting, and plaster of Paris, have a coagulating effect upon the latex, and if they are to be used in formulating a rubber molding compound, they should be first wet or mixed with water containing an alkali such as ammonia. After this, the material may be added to the latex. The ingredients listed above should never be added directly to the latex in a dry, powdered form.

MAKING A RUBBER MOLD

A negative rubber mold can be made from virtually any plastic or rigid model of moderate dimensions. The first step in fashioning a rubber mold is to determine the line of separation on the model, and to mark this line on the plaster cast, metal, plastic earth, or composition clay model.

Separating Media: A separator should be applied to the model before the rubber molding compound is used. If a rubber mold is to be fashioned from a porous material, such as a plaster positive, the cast should be painted with a fine solution of shellac, lacquer, or varnish, which should be permitted to dry before the application of the rubber mold compound. A model made of earth-clay does not require the use of a separating material. Composition clay should be treated with a

coating of thinned shellac or lacquer, applied preferably in the form of a fine spray. An atomizer or air gun can be used for the application.

Mechanical Separators: Simple clay walls or mechanical separating fences can be built around the model. The work is first covered with flat strips of composition clay up to but not including the line of separation. If the model is of clay, tins can be used as fences or separators. A simply modeled work with moderate undercuts can be cast in a one-piece rubber mold, and mechanical separators will not be required. Many sculptors dispense with mechanical separators or fences, making heavy rubber negative molds from complex but moderately proportioned objects. When the rubber impression has set or hardened, it is cut along one side and peeled from the model. For the casting of positives, the rubber negative is sealed on the external surface with tape and the positive casting material is poured through the bottom or through an opening made by adding to the original model a cone-shaped mass of composition clay.

If a two-piece rubber mold is to be used, depressions or registration grooves should be cut into the clay separating wall, so that both halves of the rubber mold will fit perfectly together. Clay hemispheres can be set on the tins used as walls or separators to make similar registration holes. After the first half or section of the mold has been completed, these clay forms can be removed and the second half of the mold can be made.

Application of Rubber Compound: A thin application of the latex composition should be painted or sprayed on the prepared model for the first intimate and detailed negative impression. This first coating should be sufficiently fluid to penetrate into all areas of the object to be cast and to cover the surface of the model evenly. After this initial coating, fillers can be added to the latex material to bring it to a heavier, pastelike consistency. However, too much filler may cause a lumpy coagulation of the rubber compound. Many commercial rubber mold preparations are marketed in two units consisting of the *facing* material and the *backing* compound. The facing compound is thinner bodied and is used for the original applications or coatings, which are generally sprayed or brushed on the model. If a brush is used to apply a latex mixture, the brush should be thoroughly saturated with clean water and rubbed on a piece of bland soap before it is dipped into the latex material. This will prevent the compound from sticking to and coagulating in or near the ferrule, stiffening and binding the hairs of the brush and frequently ruining it for further

use. After each use the brush should be washed with water and hardened particles of the latex compound combed out. To ensure an even and smooth result, it is advisable to begin the latex application from the top of the object and to work down toward the bottom. The caster should take particular pains with the initial latex coating and should try to make the application smooth and bubble-free; this first coating determines the surface accuracy and smoothness of the positive impression.

The backing compounds are generally heavier-bodied, pastelike rubber compounds containing more filler, and are usually applied with a spatula to build up a heavily bodied negative mold.

If a uniform-bodied, thin latex compound is used throughout the process of building up an adequate-bodied rubber negative, many coatings will be required. Each coating should be permitted to dry thoroughly before the application of the next. On drying, the milky opacity or cloudiness of the rubber negative disappears and the rubber film or coat becomes translucent. The drying interval between the applications varies from about 15 to 45 minutes and is dependent upon the nature of the specific rubber compound being used. The initial coating should be permitted to dry longer.

If a latex mixture of a uniformly fluid and thin consistency is used throughout the fashioning of the negative mold, the mold can be more rapidly built up to a heavy thickness and reinforced by the incorporation of such material as strips of flannel, burlap, or silk in the rubber negative. These strips can be dipped into the fluid latex compound and placed on the mold being fashioned. When they are covered with a coating of latex, they become an integral part of the negative mold. Material should not be added to a rubber negative mold until two or three coats of pure latex compound have been applied over the model.

Negative molds should be built up to about ¼ of an inch, but the precise thickness depends upon the nature of the work being cast and its size.

Mechanical separators can be dispensed with in many cases by building up a heavy rubber negative and fashioning a heavier thickness of rubber material along the intended line of separation. After the rubber mold has set, a wet razor blade can be used to slice and divide the mold cleanly. For casting, rubber cement can be used to bind the seams of edges together.

After the rubber mold has been completed it should be permitted

to dry or set in place over the model for about two days. When the latex has thoroughly dried, and prior to the fashioning of the plaster reinforcing mold or casing, the external surface of the rubber mold should be washed with a weak, 25 per cent solution of hydrochloric acid in water, or coated with shellac or varnish. This procedure will neutralize the action of the ammonia in the latex composition, which might otherwise prevent the plaster of Paris, in intimate contact with the rubber, from setting.

After the latex applications have been completed, a plaster mother mold or casing should be made to reinforce and support the soft and yielding rubber negative impression. This casing can consist of one or more pieces, to be determined by the nature of the work that is to be cast.

If a simple rubber mold has been constructed, after it has dried adequately it can be easily removed from the model by cleanly slicing the latex shell with a razor blade. It can then be peeled from the original. Rubber molds may be used soon after drying, although the best procedure is to permit the mold to dry out and toughen for from 24 to 48 hours after the application of the last latex coating. The rubber negative tends to shrink on drying or setting and should not be removed from the model or cut until it has aged and toughened or been cured.

When an adequate-bodied rubber negative is removed from the original model or from a cast positive, it will return to its original shape. Tape or rubber bands can be used to hold sections of a mold together for casting positives.

Curing: Following the final application of latex, the mold can be placed in a warm environment to accelerate drying out or curing. The temperature should be between about 110° and 120° F. The interval required for curing varies with the nature or thickness of the rubber negative. A mold thickness of ¼ of an inch may require between 24 and 48 hours to cure adequately. To determine whether a rubber mold has been properly seasoned, a sharp pointed metallic instrument should be pressed into its heaviest portion. If the instrument springs back sharply and does not leave a mark, the mold is ready for removal from the model and for use as a containing negative.

The inner surfaces of the completed rubber negative mold should be carefully cleaned and coated with a shellac separator. A separating medium consisting of 10 parts of castor oil to 1 part of alcohol can also be used for this purpose.

Another solution that will prove satisfactory is 10 parts of glycerine to 1 part of alcohol.

DURABILITY

Rubber molds can be set aside for long periods of time without a marked deterioration of substance. If plaster of Paris is the material used in fashioning positive casts from a rubber negative mold, the heat evolved during the setting and crystallization of the plaster will not markedly shorten the 'life' of the specific rubber negative mold.

SULPHUR NEGATIVE MOLDS

Sulphur is very infrequently used as a negative material because it cannot be applied to flesh, to wax, or to clay models. It is also too brittle and fragile to be safely employed in casting large works, particularly works that possess undercuts.

The use of sulphur as a negative material is restricted to fashioning impressions from delicate reliefs, such as those on coins and medals.

The procedure in making a sulphur negative consists of first constructing a clay or thin metal containing wall about the object to be cast. The surfaces of the model and the inner containing surfaces of the wall are treated with shellac or an oil lubricant. The negative material is composed of:

Sulphur	8 parts
Fine iron filings	1 part

The sulphur and the iron filings are mixed together and melted. The mass is permitted to cool for a short time, and while it is still in a liquid state it is poured over the coin or medal and blown into cavities or depressions. After the mass has thoroughly cooled, the sulphur impression is lubricated with a grease and may then be filled with plaster of Paris to form the positive.

WAX MOLDS

Wax is rarely used as a negative material in sculpture. When it is used for fashioning negatives, it is employed to prevent any possibility of surface injury to a fragile or valuable original model.

In making a wax piece mold the surface of the original model should be dusted with a separator consisting of very finely ground

French chalk. Each finished wax piece or mold section must also be dusted with the talc separator and a plaster casing is required to contain the wax mold units. A mix composed of the following ingredients has been used for negative molds:

Beeswax	1 pound
Lard	1 pound
Linseed oil	½ pint

The ingredients are carefully and slowly heated over a low flame and a quantity of flour, about equal to the combined weights of the wax and lard, is added. The mass is thoroughly stirred.

Another wax negative formula consists of paraffin, olive oil, and whiting in the same proportions. The ingredients are melted together, poured on a flat surface such as glass, and kneaded until the mass is uniformly plastic.

Fredericks [14] writes of wax molds as follows:

Molds may be successfully made of wax, usually of small or delicate objects, as fruit, flowers, small animals, coins, medals, or of the hands and face. Take one part of rosin and three parts of white wax. Melt them in a hot water bath, as a glass jar placed in boiling water, and heat to the boiling point. Or melt paraffin wax (as a paraffin candle), and add a little sweet oil and whiting.

He recommends that flesh be greased before the wax is applied, and that the wax be permitted to cool to a bearable temperature. He continues:

Brush it on quickly to a thickness of about ⅛ inch, and, as it almost immediately hardens, an outer shell or case of plaster can be cast before the model feels compelled to move. Remove the case from the wax and the wax from the model, replacing it in the case at once to prevent warping or breaking, and make the cast as soon as possible.

Golden,[15] in the June 1926 issue of the *Journal of the American Dental Association*, describes his method of fashioning wax facial molds. In a later issue [16] of the *Journal* he condenses his original article and discusses other materials being used for the same purpose. His method consists of preparing a mixture of waxes that is applied

[14] Ibid. p. 93.

[15] Golden, E. H., 'Wax Spray Method for Facial Casts,' *Journal Am. Dental Association*, XIII, no. 6, 1926.

[16] Golden, E. H., 'A Study of Impression and Moulding Materials for Facial Casts,' ibid. xx, no. 7, 1933.

in the form of a spray to the patient's face in order to make a negative mold. His mixture, termed B-11, contains the following ingredients:

Paraffin	55%	(M.P. 51.7° C.)
Bayberry wax	20%	(M.P. 40.9° C.)
Carnauba wax	5%	(M.P. 84.8° C.)
Stearic acid	20%	(M.P. 69.9° C.)

Resulting melting point of mixture 52.97° C.

According to Golden, no preliminary treatment of the skin surface is necessary, but as a precautionary measure the application of a small quantity of petroleum jelly to hair is recommended. The spray was applied by Dr. Golden with a DeVilbiss type CB spray gun, but any good spray gun can be used for this purpose. The original layer of wax was applied with an air pressure of between 4 to 6 pounds. A higher pressure will result in an uneven deposition of wax. Over the first layer is applied a second layer that may be built up to a thickness of about ½ inch, and can be applied with a spatula. The wax application can be hardened by chilling with an ice bag if this is desired. The total wax thickness should come to about an inch, and a plasterof-Paris casing should be constructed over the wax negative.

Golden also gives the following formula, which can be applied with a soft brush rather than sprayed:

Bayberry wax	50%	(M.P. 40.9° C.)
Paraffin	25%	(M.P. 51.7° C.)
Stearic acid	25%	(M.P. 69.9° C.)

Resulting melting point of mixture
41.7-42.8° C. (Sayboldt test).

The wax mixture is applied with a soft brush while the mixture is in a liquid state, but not uncomfortably hot. The initial layer is a thin one, and is followed by the application of heavier layers with a spatula. The wax thickness is chilled occasionally with an ice pack and the entire mass is reinforced with a plaster-of-Paris casing.

METAL

SCULPTURAL USE OF METALS

THE word 'metal' appears to have been derived from the Latin *metal-lum*, meaning a metal or mine. It probably also stems from the Greek μεταλλάν, to search after.

Wood and stone are substantially older in sculptural use than are the metallic media, although the use of all these substances as materials of sculpture dates back to Antiquity. The discovery and early uses of metal are shrouded in the obscurity of prehistoric time, but it appears that Neolithic man first discovered metal and began to find practical utilitarian and artistic uses for the crude varieties native to his immediate environment.

POPULARITY

The reasons for the greatly increased contemporary use of metals in sculpture may be found in their physical properties, which are rivaled by no other group of materials. The majority of metals used for sculpture at the present day possess the following characteristics:

1. A high degree of hardness
2. Great rigidity or structural strength
3. Malleability
4. A generally high specific gravity
5. Metallic luster or reflection of light from the surface
6. Solubility in other metals when in a molten state, forming 'alloys' also possessing 'metallic' properties
7. A positive, but varying degree of physical resistance to elemental or atmospheric corrosion and subsequent destruction.

The metals and metallic alloys available today number many thousands, but those used sculpturally are relatively few in number. The most frequently used are listed below in an order roughly approximating their sculptural popularity and application:

1. Bronze
2. Brass
3. Copper
4. Iron
5. Lead
6. Aluminum
7. Pewter
8. The precious or 'noble' metals (for small works)
9. Stainless steel (rare use)

VARIETY OF USES

Metals are used sculpturally in three ways. First, they may be used as positive materials for casting purposes. Reduced to its elements, this involves a preliminary modeling of form in clay or some similarly plastic substance from which a negative impression or mold is taken. The molten metal or metallic alloy is then poured into the negative mold.

Metal may also be employed directly as a quasi-plastic *repoussé* medium and beaten or hammered into the desired shape, usually while the material is in a relatively thin sheet form. (See Plates 30A, 32, 33, 34B, 35, 36.)

A third sculptural use of metal is *wrought metal*. The basic form or mass is cast rough in a mold, and after this has cooled sufficiently to permit handling, the superficial surface form is achieved by hammering, chiseling, or tooling. A mass of metal may also be heated red and hammered into form on an anvil while the mass is hot and plastic. *Wrought bronze* and *wrought iron* are examples of these methods. (See Plates 31 and 38C.)

An important part of sculptural use of metal consists of intelligent selection of the specific metal or alloy best suited to the specific purpose. Some of the elements involved include the eventual environment of the finished work, the resistance of the metal or alloy to corrosion, the weight of the work as determined by size requirements, the cost involved, and the ease with which the metal can be shaped by casting, hammering, or both.

Casting is the most primitive and also the simplest means of getting a metal or metallic alloy into desired forms. The metallic substance is first heated in a crucible until it becomes molten, and it is then poured into a suitable negative mold, which may be placed either on the

surface of the ground and buttressed with sand or bricks, or in a pit dug into the earth to accommodate the mold. The pouring operation is referred to as *casting* or *pouring*.

Repoussé is the term applied to a process of shaping metal, which is usually in a relatively thin sheet form, into sculptural form by means of hammering or beating the design mass into relief from the back of the sheet, and then finishing the work by hammering or chiseling, or both, from the front of the sheet. The term is also used to describe the finished designs formed on a metal sheet by beating.

Many of the metals used sculpturally, including lead, copper, and bronze, can be wrought or shaped by means of hammering. The thickness of the sheet used, the depth of the relief desired, the malleability of the specific metal or alloy, softening by means of heat, and annealing are factors commonly involved.

A technique has been developed within recent years of utilizing paper-thin sheets of copper, which are shaped by means of hand pressure. A smoothly rounded metal or wood modeling tool is held between the fingers and pressure is applied to the metal sheet. This is a variety of modeling by means of pressure. The designs formed are invariably restricted to low reliefs, owing to the thinness of the metal used. This form of metalwork is generally classified as a variety of repoussé.

Sheets of metal in more substantial thicknesses are occasionally cushioned by a mold of wood, carved and shaped to approximate roughly the form desired, and the metal is then hammered into shape upon this. A sandbox or sandbag can also be used as a cushioning bed. Cushioning beds of asphaltum were used by the Sumerians in shaping their copper reliefs. The Greeks often employed a cement cushioning bed composed of ground brick and pitch in working sheets of bronze.

A popular bed composition consists of the following ingredients:

Parts by weight

Burgundy pitch	10
Tallow	½
Plaster of Paris	4

The pitch is first melted and, while it is warm, the tallow is added to it. The plaster of Paris is then dusted or sprinkled into the mixture and the mass thoroughly stirred. After the ingredients have been

mixed, the mixture is reheated, poured into a containing vessel, and allowed to cool and set. When work is to be begun on a sheet of metal, the surface of the bed composition is softened by the application of heat and the metal sheet is placed upon the cushioning mixture. The procedure generally consists of placing the front of the work directly upon the pitch bed, permitting the softened bed to cool and set, and then working the masses up from the exposed back of the sheet. The procedure is then reversed for the development of the other side and the application of the finishing touches, at which time the back of the sheet is set into the pitch bed.

The composition can be removed from the metal sheet surface with solvents such as kerosene or turpentine.

Among European folk arts were included techniques by which repoussé metal sheets were attached to cores of wood to produce sculpture in the round. There are also extant examples of Greek and Gothic sculpture in which bronze plates were riveted to wooden cores or bodies.

ANNEALING

When hammered repeatedly most metals become exceedingly brittle and they have to be 'softened' for further use by annealing. The process of annealing generally consists of heating the metal to a dull red heat and then allowing the piece to cool slowly in the air. Rapid cooling, such as results when a highly heated piece of metal is plunged into cold water, brine, or oil, causes most metals and metallic alloys to harden.

The majority of metals used sculpturally, with the exception of pure lead, pewter, and the noble metals, require annealing after a prolonged subjection to hammering. The annealing process removes internal stresses within the metal.

As a general rule, the harder a metal is naturally, the sooner will repeated hammering render it unyielding and ready to fracture.

Iron and steel can be annealed by heating to a red color. The metal should then be covered with cinders and permitted to cool slowly. Copper can be annealed by heating it to a dull red and then cooling it by immersion in water or slowly in air. Brass can be annealed by heating it to a red color and then immersing it in water. Zinc and tin can be heated in boiling water for several minutes and then allowed to cool slowly in air.

PHYSICAL CHARACTERISTICS OF METAL

HARDNESS OF METALS

The following table is based on the hardness of metals and alloys used in sculpture as measured by the depth of a scratch made on the metal by a diamond point mounted under a fixed weight.

1. Lead	5. Gold	9. Nickel
2. Pewter	6. Silver	10. Platinum
3. Tin	7. Zinc	11. Iron
4 Aluminum	8. Copper	12. Steel

DUCTILITY OF METALS

Ductility is a physical property possessed by many metals that permits the metal to be drawn out into threads or wire. This property is of particular significance in hammered or beaten sheet-metal sculpture and is not to be confused with malleability. Lead is quite malleable, but possesses low ductility. The metal is sufficiently soft to be easily shaped by hammering into desired forms, yet it possesses little ductility and may easily split if it is beaten too high or stretched too thin.

The metals used sculpturally are listed below in the order of their ductility:

1. Gold (most ductile)	6. Copper
2. Silver	7. Aluminum
3. Platinum	8. Zinc
4. Iron	9. Tin
5. Nickel	10. Lead (least ductile)

MALLEABILITY OF METALS

The sculptural malleability of a metal or metallic alloy is the property of that substance of being readily shaped into desired form by means of hammering.

1. Gold (most malleable)	6. Tin
2. Silver	7. Platinum
3. Lead	8. Zinc
4. Copper	9. Iron
5. Aluminum	10. Nickel (least malleable)

RESISTANCE TO CORROSION

The sculpturally used metals and alloys vary substantially in their ability to resist atmospheric and chemical corrosion. Some, such as iron and common steel, rust readily and thoroughly if they are unprotected and exposed to moisture. Aluminum and zinc corrode, but they form a protective film or coating in the early stages of their oxidation that tends to resist further, deeper destruction. The stainless steels have recently been developed to a point where they may be used without precautionary protective coatings as measures against atmospheric corrosion.

As a general rule, alloys resist corrosion better than the pure metals composing them.

The metals that resist corrosion best are the noble metals, such as gold, platinum, and palladium, which are immune to virtually all atmospheric corrosion factors.

The following table is rated on the basis of the corrosion resistance of metals to an industrial atmosphere such as that in New York City:

1. Iron	6. Copper
2. Zinc	7. Silver
3. Tin	8. Gold
4. Aluminum	9. Platinum
5. Lead	

MELTING POINT OF METALS

The melting point of a metal is the degree of temperature at which the metal passes or changes from a solid condition to a liquid. The structure of all solid metals and alloys are crystalline, being composed of crystalline grains rather than formed of one mass, in the way that glass is formed. The forms of these crystalline masses vary.

When heat is applied to a metal or alloy, the crystalline forms begin to break away and the metal expands and softens. When sufficient heat is applied, it melts and remains fluid as long as the temperature is above its melting point. When it cools down to its melting point, it begins to solidify and in most cases the metal or alloy contracts as it hardens.

When a metal is pure it passes from a solid to a liquid condition in a very narrow temperature range. The pure metals have one definite melting point. Alloys on the other hand have substantial and wide melting ranges.

ALLOYS

Alloys are metallic compounds that are prepared by the melting together of two or more constituent metals, until they form a fused, homogeneous mass, which is then permitted to cool. Occasionally, nonmetallic substances are added to a metal or metals to form alloys. An alloy has physical properties that differ from those of the component 'parent' metals.

In alloying nonferrous metals, the metal with the highest melting point should be melted first.

The physical properties of an alloy vary as the proportions of the elements constituting its ingredients vary. There are several thousands of possible alloy variations. Generally, an alloy may be said to be harder than any of its constituent metals. It is also usually less malleable and possesses a lower melting point than any of the 'parent' metals. Alloys are generally more resistant to corrosion than the metals that were used to form them.

Reasons for alloying:

1. To lower the melting point of the metal
2. To achieve additional strength and hardness
3. To increase resistance to corrosion
4. To alter color or appearance
5. To secure cleaner, sharper castings.

The proportions of the component metals or nonmetallic elements used in the formulation of alloys vary with the different manufacturers. It is, therefore, difficult to classify alloys precisely according to their specific physical properties.

ALUMINUM

Aluminum is a silvery white metal extremely light in weight. This may be an advantage or disadvantage, according to the nature and purpose of the piece to be made.

Aluminum can be cast and welded, is fairly malleable, and has a high tensile strength. It is excellent as a positive medium and may be cast in either a pure or alloyed form. (See Plates 23 and 25.)

The metal does not corrode to any great degree, since a protective oxide forms on the aluminum surface, forming a remarkable resistance

to the action of air even in the presence of heavy moisture. Aluminum may be regarded as permanent when used indoors, and when it is given a protective surface treatment, it is fairly permanent outdoors also. The ornamental aluminum spire on the Washington Monument has withstood for many years the effects of atmospheric corrosion, owing to the formation of a thin, superficial coating or film of aluminum oxide (Al_2O_3), which serves to protect the rest of the metal from further corrosion by the atmosphere.

There are many aluminum alloys available in which the aluminum content varies substantially. In some alloys, the aluminum is the principal constituent, while in other alloys aluminum is the minor metallic ingredient. Magnalium is an alloy containing approximately 90 per cent of aluminum and 10 per cent of magnesium. The alloy is lighter in weight than pure aluminum, and is more easily worked. In aluminum bronze the aluminum is approximately 10 per cent of the alloy, with the remaining 90 per cent consisting of copper. In appearance, it is similar to gold, while its strength approximates that of iron. It is not recommended for hammered sculpture.

Aluminum was discovered in 1825. It is fairly reasonable in price, although when it was first introduced in 1852 it sold for $545 per pound.

A few sculptors have experimented in the use of aluminum in sheet form as a direct sculptural medium, but the results have not been very successful. After repeated hammering aluminum requires annealing, for as the metal is hammered, it becomes strain hardened, and the annealing allows it to recrystallize and become soft and plastic again for additional working. The metal has a relatively low melting point (about 1220° F.) and the annealing process is a delicate and rather precarious affair. To anneal aluminum, the metal should be heated to a dull pink, but not to a dull red color. If the annealing is done in dimmed light, the color will be more readily observed. After annealing, the metal can be allowed to cool slowly at a normal room temperature.

Aluminum is annealed industrially in electric furnaces equipped with pyrometric instruments for measuring temperatures accurately. After annealing, aluminum does not require a pickling bath. The surface of the metal can be cleaned with a dilute solution of sodium hydroxide (lye), which should be used carefully because it is caustic to both flesh and metal.

The coloring of aluminum is a recent development. It is now pos-

sible to secure aluminum finished in colors ranging from pastel tints to pure, intense hues. The method of coloring consists of dyeing the color into the metal during manufacture.

ALUMINUM BRONZE

Aluminum bronze is produced by alloying copper with aluminum metal instead of tin. The substance is used as a positive casting material. Aluminum bronzes contain aluminum in a proportion rarely exceeding 10 per cent of the total alloy. The alloy is superior physically to ordinary tin-copper bronze, but it is substantially harder to work and finish. The tensile strength of the average aluminum bronze is approximately 65,000 pounds to the square inch.

ANTIMONY

Antimony is a rather brittle metal with a silvery luster. The metal is never used sculpturally in its pure form. It is occasionally alloyed in small quantities with lead and serves to form antimonial lead, a lead alloy with increased resistance to corrosion. The use of antimonial lead is restricted to the casting of positives, since the material is less tenacious than pure lead, and therefore cannot be used safely in sheet form for hammered work.

BRASS

The discovery and early application of brass is not accurately known. The substance appears to have been known to ancient peoples. It is mentioned in the Old Testament and by Pliny, but some scholars feel that the ancient alloy was, in reality, a variety of bronze and not actually a true brass. The name of the alloy stems from the Anglo-Saxon word *bræs*. During the early thirteenth century monumental brasses were produced in Europe. These were a variety of engraved memorials that began to supplant carved stone effigies. They were fashioned from sheet brass or *hard latten* and the design or forms were engraved on the metal. The English cut figures at the outline and inserted these metallic shapes into a similar outline fashioned in a stone slab, which served as a background and framed the brass engraving. Chisel-like tools and burins were used to cut the designs into the metal. Some examples bear vestiges of color in the incised lines and it is probable that a large proportion of the monumental

brasses received a similar treatment. The nature of the coloring matter is not known, but it is believed that a form of enameling was used.

Brass is an important alloy in sculpture and is composed fundamentally of copper and zinc. The color of the common alloy is a golden yellow. As the copper content is increased, the color of the resulting alloy becomes darker and richer. Alloys containing from about 15 per cent to approximately 25 per cent of zinc will resemble gold in color, and will be somewhat malleable. An alloy composed of 10 parts of copper to each part of zinc will have a reddish-yellow color. Working or hammering a brass will harden the alloy, and annealing must be resorted to in order to regain malleability.

As the zinc content of a brass alloy is increased markedly, the metal formed becomes increasingly hard and brittle and the color changes to a silvery white, finally turning to a gray.

Some confusion may arise from the term 'commercial bronze,' which is used industrially to describe some alloys of copper and zinc. These are, actually, varieties of brass.

The variety of brass known as 'fine casting brass' is composed of approximately 90 parts of copper, 7 parts of zinc, 2 parts of tin and 1 part of lead.

Brass is used today almost exclusively as a casting medium. However, it can also be used as a wrought medium and shaped with chisels and files. (See Plate 38D.) The alloy is substantially harder than copper and wears better. It takes a fine polish, and is superior to copper in its resistance to atmospheric corrosion, although the surface will readily tarnish if it is not protected by a wax, lacquer, or other protective treatment. Brass is almost invariably kept brightly polished, clean, and free from artificial patination, a practice Casson [1] attributes to the 'long domestic habit of keeping brass shining.' The practice has been carried over into sculpture and is applied by the relatively small group of sculptors who have used brass as a positive casting medium. The group includes Frank Dobson, the English sculptor.

MELTING AND PREPARING BRASS

The general procedure in preparing a brass consists of first melting a small quantity of scrap brass that has been mixed with some powdered charcoal. After the scrap brass has been liquefied, copper is

[1] Casson, Stanley, *The Technique of Early Greek Sculpture,* Oxford, 1933, p. 151.

added to the molten mass; when this has been thoroughly melted, the volatile zinc is introduced to the mixture.

However, the proportions of the ingredients in alloys prepared in this manner tends to vary with an accompanying variation in the physical properties of the resulting alloys, and for this reason many founders prefer to purchase prepared, standard ingots from reliable manufacturers, rather than to prepare their own.

BRONZE

Bronze appears to be the most extensively employed material of all the sculptural media. (See Plates 26-31.) Its great popularity is due primarily to the many excellent physical properties of the substance, among which are included a high structural strength, great physical permanence and resistance to atmospheric corrosion, ease of casting, and a fine, compact surface that takes an excellent finish or patina.

Bronze is essentially an alloy composed of copper and tin, although other metals in small quantities are occasionally added for reasons of appearance, physical strength, or increased resistance to corrosion. The major ingredient of a bronze is always copper, with the next metal in proportion being tin. The addition of tin to copper to form bronze results in greater strength, hardness, and durability than do zinc additions, which yield brasses. The percentages of the component metals vary according to the purpose to which the bronze alloy is to be applied, and as these proportions vary so do the physical properties and colors of the resulting bronzes differ. Bronze alloys range in color from a pure silvery appearance, resulting from a large proportion of tin in the alloy, through a delicate golden-yellow color, to a rich, coppery red. One ancient and very popular, warm-colored alloy consisted of 88 parts of copper, 10 parts of tin, and 2 parts of zinc. The tensile strength of the bronze is great, varying from 30,000 to 40,000 pounds per square inch.[2] It has a fine grain, a high resistance to corrosion, and takes an excellent finish. The brilliant color of the famed Corinthian bronze of Antiquity was probably due to the high copper content of the alloy, which was composed of about 90 parts of copper to each 10 parts of tin. The standard alloy adopted by foundrymen in this country and known commercially as United States

[2] The tensile strength of bronze exceeds that of all the nonmetallic media, including stone.

Standard Bronze is an alloy consisting of 90 per cent copper, 7 per cent tin, and 3 per cent zinc.

Within recent years aluminum has been alloyed with copper to form an aluminum bronze (see p. 133). The resulting alloy has a whiter color than ordinary bronze and a lower melting point. It resists corrosion better than copper-tin bronzes and has a higher tensile strength. A maximum of 10 per cent of aluminum is used to form the alloy.

Some sculptors occasionally add a small quantity of lead to a molten bronze mass to lower the melting point of the resulting bronze and also to soften it physically.

Bronze possesses the peculiar physical characteristic of shrinking and occupying less space than the aggregate of its constituent metals. It is possible that because of this shrinkage, which may be caused by an interpenetration of atoms, the alloy is much harder physically than either of its component elements, copper and tin. In modeling a work in clay for eventual casting in bronze, the sculptor should remember that the finished metal casting will be somewhat smaller than the original clay or plaster positive, since all sculptural metals shrink in casting; the model in clay has, therefore, to be fashioned a trifle larger to compensate for this shrinkage. This assumes importance where precise specifications are to be met.

When a bronze alloy is allowed to cool slowly it becomes quite hard and brittle. It may be kept soft and malleable by cooling the metal quickly after casting. Temperature affects a bronze alloy in precisely the opposite way that it affects steel.

The use of bronze as a casting medium permits detailed and intricate modeling, and its high tensile strength makes practical a lighter, freer, and more open design than would be possible in either wood or stone.

A bronze casting fills its mold completely when it is molten, and is therefore superior to pure copper as a casting material. The metal cools rapidly and it sometimes has to be poured through several openings or channels at once in charging a mold. The finished bronze may be regarded as a permanent metallic version of an originally impermanent or temporary material, usually a plastic wax or a plastic earth.

Contemporary bronzes are almost without exception mechanical reproductions, whose casting and finishing are often relegated to others by the sculptor.

HISTORICAL NOTES

Man first began to use bronze alloys several thousands of years ago in prehistoric times, originally employing the substance in the fashioning of utilitarian objects and then for objects of art. Both the Egyptians and the Myceneans were familiar with the alloy and used it frequently for their household articles and as an artistic medium. The later, Etruscan sculptors also used the material extensively, working their bronzes with extreme care and with a high degree of technical skill. The knowledge of the alloy and its utilization was, however, not restricted to the West. The Chinese excelled in the use of bronze as far back as 3000 B.C., and steadily perfected their technique through the centuries. During the Chou Dynasty (1122-249 B.C.) several treatises on bronze were written. It is stated in the *K'ao Kung Chi*, a work pertaining to this dynasty, but which may have been written subsequent to this period, that the proportions of copper and tin for the formulation of bronze alloys for specific purposes was concretely established. The work gives specific formulas for different bronze alloys.

Bronze was a favorite medium of the Greeks and during the richest period of Greek sculpture there were more statues produced in bronze than in any other medium. Of the total sculptural works of the Greeks the majority appear to have been executed in bronze. The small pieces were often cast solid, since this was the simplest manner of casting, but the weight of bronze together with the expense of the metal militated against casting larger works solidly, and many larger Early Greek bronzes were fashioned in sections of hammered sheets, which were then riveted together, usually over an inner supporting form of carved wood.

Many Greek marbles are copies or replicas of works originally executed in bronze. The bronze statues were used largely in the temples, whereas marble carvings were applied to porticos and placed in gardens.

Polyclitus, Myron, and Lysippus appear to have worked almost exclusively in bronze. Three other famous Greek masters, Praxiteles, Phidias, and Scopas, seem to have been interested more directly with stone carving, although they also modeled and produced bronzes.

The metal was highly valued for its physical properties and the ease with which it could be melted down and recast for coins and, particularly, for implements of war. This fact explains the relatively

small number of bronze statues that has survived to the present day. Greek bronzes, particularly the larger works, were seized and quickly melted down by the Roman, Turkish, Venetian, and other invaders who fought on Greek soil centuries ago. The smaller bronzes tended to survive this mass melting pot, however, and many museum collections of today possess a substantial proportion of them. This wholesale destruction of bronze sculptures and the consequently deceptive proportional relationship between the surviving Greek marbles and bronzes in public and private collections sometimes give the impression that the Greeks produced a great abundance of marbles and very few bronzes.

There were few bronzes produced during medieval times, but the Renaissance in Italy saw a revival of sculpture in this medium. After the Renaissance a decline set in during the seventeenth and eighteenth centuries. The advent of the nineteenth century saw the inauguration of many famous bronze foundries and large quantities of bronzes began to be produced. The medium began once more to assume great importance as a vehicle of sculptural expression.

The contemporary use of bronze as a sculptural medium surpasses any previous use of the material, but, paradoxically enough, the sculptors today who cast and work their own bronzes are very few.

It may be argued that if it is desirable for the sculptor to carve his stone and wood personally, it is similarly desirable for the modeler in clay to do his own bronze casting. However, most modelers have in mind the eventual reproduction of their work, whereas the carver in stone or wood does not. The lack of studio facilities together with the many technical difficulties entailed in bronze casting have been largely responsible for the extensive employment of professional bronze casters. However, the casting of small- to medium-sized bronzes is possible for the average sculptor if he works carefully and with an appreciation and understanding of the dangers involved in handling molten metal.

SECTIONAL BRONZES

Large Greek and Roman bronzes were rarely cast as a single unit, but were fashioned in parts or sections. These were subsequently soldered or riveted together. Kluge [3] has made an intensive study of

[3] Kluge, Kurt, *Die Antiken Grossbronzen*, Berlin and Leipzig, 1927, pp. 164 ff

the methods employed by the Greeks in joining parts of their bronze statues.

The large metal sculpture of the Greeks was intimately associated with wood carving, since sheets of bronze plate had to be riveted or anchored by nailing to another supporting substance such as wood. Eventually works were made so that the wood core could be easily removed, and riveting was followed by the soldering together of bronze parts, since this practice eliminated the surface blemishes caused by the riveting method.

It is interesting to note that while it is well known that the Greeks made use of solid casting, the lost-wax process (see pp. 146 ff.), and also of the practice of hammering sheets of bronze into shape over wooden *cores*, Kluge,[4] who has examined all of the large sixth-century Greek bronzes, feels certain that they were not cast by means of the lost wax process, but were cast into two-piece sand molds made from wooden originals. A core of casting clay was placed into the two-piece mold before pouring the molten bronze. The fitting of this core would naturally present great difficulties and there would be wide spaces between the core and the mold.

CASTING

Bronze can be poured only when it is in a molten and fluid state. Due to the white-hot, liquid condition of melted bronze, a mold is necessary to contain and shape the molten metal while it slowly cools and hardens. The negative mold should be composed of a refractory material sufficiently fragile to be easily removed from the cooled bronze positive, and possessing sufficient strength to resist the weight-impact of the heavy, molten bronze when it is poured into the containing form. The mold material must also possess a fine texture, so that it can register delicate detail and modeling, and also have sufficient porosity to permit the escape of heated, pressure-exerting gases formed at the time of pouring.

Mold Gases: Mold gases are formed by four fundamental factors:

1. Air present in the mold before the introduction of the molten metal or alloy
2. Gas emanating from the casting metal or alloy during cooling and hardening

[4] Ibid. Also Jahrbuch, 1929.

3. Steam or water vapor formed from the moisture present in the mold material
4. Gases formed by the burning of organic material in the core or negative mold material
 a. Hydrocarbons from the decomposition of organic binding material
 b. Carbonic oxides from carbonaceous or organic material in the facing compound and core mixtures.

Mold gases frequently cause 'blow-holes' and porous patches in the bronze positive.

Hollow Bronzes: Bronzes are cast in a hollow or shell-like form for several important reasons:

1. The practice is economical in terms of metal and cost, since it reduces the metal required for a casting to a minimum.
2. The weight of large works is very substantially reduced.
3. The practice prevents excessive metal shrinkage on cooling, with accompanying dangers of distortion and fracture. This is particularly important in casting large bronze masses.

Solid Casting: For the solid casting of small bronze statuettes, the Greeks employed a simple technique. The work was modeled in wax and incased in a containing negative mold composed of sand and earth-clay. When this investment material was dry, an opening was made and the entire mass was heated until the wax ran off. Vent holes were previously fashioned in the containing mold to permit gases and air to escape. After casting and the cooling of the positive metal mass, the negative mold was broken away and the bronze was removed and worked manually.

Types of Casting: There are two fundamental methods of casting bronze alloys, the sand-mold process (see Plates 20-21 and Figure 5) and the lost-wax or cire-perdue process. (See Figure 6 and Plate 23.) The principles involved are not new, but have been used from Antiquity. It is believed that bronze was originally cast in simple, single negative molds of stone. Piece molds followed and were used for the casting of simple, flat forms. The lost-wax process is thought to have been a subsequent development.

Both of the basic methods are used to secure castings that are almost invariably hollow, although they may also be used for obtaining solid castings, by eliminating the use of the core. However, in any

save small works, the weight and expense of the solid-cast piece becomes excessive and the results generally achieved with hollow, cored statuettes are superior to those secured by solid casting.

The lost-wax process yields a single bronze casting, since the original model is destroyed in the process, but the sand-mold method can be used to duplicate a work in bronze in almost unlimited numbers. However, intricate designs and finely detailed surfaces are most satisfactorily cast by means of the lost-wax process.

The methods of approach to bronze casting may be divided into two categories, the direct approach and the indirect.

The current methods of approach to the casting of bronze employing either the lost-wax or the sand-mold process are basically reproductive, *indirect,* and mechanical in character, rather than creative. Their extensive popularity is attributable to the relative simplicity of fashioning of the original modeled clay or plaster positive and then calling upon the foundry for casting and finishing or copying the work into metallic bronze.

Opposed to the general procedure of commercial casting is the practice of direct casting, which is an essentially creative method.

THE SAND-MOLD PROCESS

The sand mold was used centuries ago and is the method that is used industrially today. A very fine casting sand is necessary for the best results. The preferred variety, known as *French sand,* is an excellent type of specially prepared reddish-brown casting sand that has been imported from France.

The general procedure in the sand-mold process of bronze casting consists of first making a plaster positive of the original clay model. This plaster cast is treated with shellac to prevent an absorption of moisture from the casting sand, which is dampened and packed snugly and compactly against the plaster reproduction in fashioning the sand mold. (See Figure 5 and Plates 20-21.) Close-fitting steel or iron flasks or frames [5] are used to contain the casting sand, and these frames are constructed in sections that can be accurately fitted and clamped together. Three identically proportioned flasks are generally prepared for use in fashioning a sand mold for an object in the round.

A flask frame is first placed on a flat, horizontal surface and filled with French sand. The plaster form is then embedded in the sand on

[5] Wood is the most economical flask material and the easiest to fashion into shape, but it wears out quickly and readily burns.

its back and pressed into the yielding bed until the back portion of the plaster cast is submerged. The sand is next tamped down evenly about the model. A fine parting sand, consisting of powdered talc or silica, is then applied to the sand surface and the plaster surfaces remaining exposed.

The work should be carefully studied before the construction of the sand mold is begun. The dampened mold-forming sand may be

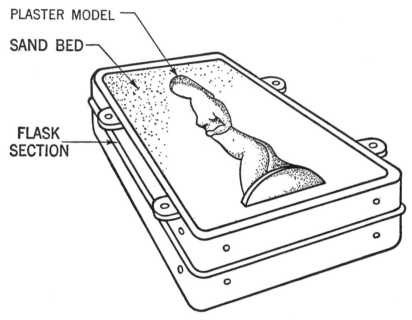

PLASTER MODEL

SAND BED

FLASK SECTION

FIG. 5. THE SAND MOLD

applied in small areas or sections if necessary and each piece-mold unit should be tamped and hammered gently and compactly against the plaster form. The sand impressions should be regarded as constituting sections of piece molds, and as many sections or pieces are made as are deemed necessary to care for all of the projections and undercuts in the specific sculpture.

The casting sand is applied over a small area and tamped compactly against the plaster model, after which the edges of the sand unit are trimmed smooth and clean with a knife. The completed section or sand-mold unit should be thoroughly dusted with the parting material before the next unit is fashioned. This procedure is repeated until the whole negative has been constructed for one side of the model; the entire surface is then dusted with parting material.

Next, a second flask section is placed over the first section and secured or pinned to it. An additional thickness of casting sand is then added over the negative sand mold to fill the space of the superimposed flask, and this layer is packed down securely. A heavy, flat board, employed to exert an even pressure on the sand mass, is pushed back and forth horizontally until the sand surface is perfectly smooth and the board lies flat and compactly on the sand mass.

The flasks are then clamped together by means of large wooden clamps and the entire mass is inverted. The initial sand bed in which the plaster model was partly submerged is now removed, and the process of fashioning a sand piece mold is begun again to care for the back of the model. When the back portion of the sand mold has been completed, another compact layer of sand is placed over the mold surface after the mass has first been dusted with parting sand. The sand layer can be reinforced by the incorporation of iron rods laid crossways and wired to the sides of the flask.

After the entire form has been completely piece molded with sand, the flask clamps are taken off and the flask section is removed, taking with it the outer sand shell, which comes away leaving the sand piece mold covering the plaster model. The compactly packed sand impressions are accurately reassembled in the metal containing flask. A third flask is placed over the flask still containing the embedded plaster form, and is also packed compactly with sand and securely clamped. The mass is then turned over, the top flask section taken off, and the process of removing the sand-mold sections from the plaster model is again repeated. When this phase has been successfully accomplished, the plaster model can be set aside. Long and thin needlelike pins can be placed through the sand-mold units to penetrate into the outer, supporting sand casing. These pins will securely hold each sand section in its proper place.

Grooves or channels have to be cut into the sand bed and along the edge of each mold part to provide gates and vents. A fairly wide channel is fashioned at the pouring end of the mold to serve as the funnel through which the bronze will eventually be poured to charge the mold. This main channel should connect with the other grooves or channels, which will function as ducts or gates for the passage of the molten metal into the mold and for the escape of air from the mold during the pouring operation.

After the channeling has been completed, the sand mold should be placed in an oven to dry and harden by exposure to heat.

An inner core is necessary for this type of casting, unless the work is to be solid—and this is not to be recommended save for very small castings.

One method of forming a core consists of shaping the moist sand over an iron and wire armature. Two long iron rods are used to suspend the core evenly within the negative mold. These rods are inserted at right angles to each other and are joined together with wire. The rods should be sufficiently long to project at both ends for several inches beyond the negative sand mold.

Over these rods a wire armature or framework is fashioned, along which are placed strips of waxed tape, to project at both ends of the central supporting rods. Moist sand is then pressed carefully all over the armature, until it reaches the approximate shape of the plaster original model. The core can be tested by fitting it carefully into the sand mold. If the core is not perfectly shaped it can be shaved down or built up until an accurate reproduction of the plaster model is achieved. This is then pared or shaved down to allow sufficient space between the core and the containing mold for the desired thickness of bronze. The core should be suspended uniformly between the sand-mold surfaces in order to secure a bronze casting of equal thickness.

For testing the accuracy of the pared core, small bits of sand, termed 'flies,' are added to the surface of the core mass at intervals of about an inch apart. The core is then placed gently in the sand mold, which is carefully closed and then reopened. If any of the tiny 'flies' have been crushed in the process, the core must be pared down at that point.

The 'flies' are next removed by very gentle brushing, the core is lifted by the ends of the main supporting rod and coated with graphite, and it is then placed on a layer of soft tissue covering a cushioning sand bed. The entire mass is then transferred to an oven and is allowed to bake overnight. The heat of the oven will bake the mold into a hard and compact mass and will also melt away the wax tapes, forming air ducts for the escape of the mold air and gases during the pouring operation.

Another method of fashioning the core consists of casting or packing the core material within the original plaster negative mold, and when this has dried and hardened somewhat, of shaving or sanding it down as much as is necessary to compensate for the desired thickness of the bronze casting. After they are fashioned, the core and

mold sections should be baked to harden the masses and to evaporate any moisture still present in the sand. While this operation is nearing completion, a fire may be started up and the bronze alloy prepared as described under *Lost-Wax Casting* (see pp. 140 ff.).

The core is suspended evenly between the inner surfaces of the sand mold by means of small pins or nails, and the metal flasks, which should join closely and compactly together, are then bolted and clamped. The space between the flasks at the joining edges should be sealed with a mixture of sand and plaster of Paris.

The finished mold is then placed on the floor or in a casting pit in its pouring position and is ready to receive the molten bronze, which is poured at a temperature well above its melting point. The crucible, with its melted metal contents, is then removed from the fire with tongs (see Plate 24), placed in the shank ring, and when in its proper position over the mold, tilted so that the fluid metal pours forth to fill or charge the mold spaces within the clamped metal flasks. The pouring of the molten metal should be continuous until the negative mold has been charged.

After the bronze has been poured and is hardened, the hot metal flask sections can be wedged apart with crowbars, and the outer sand mold fractured.

When the mass has cooled (the bronze positive hardens within a few minutes, depending upon the size or proportions and thickness of the casting, but takes a longer time to cool to a safe handling temperature), the inner-core contents can be raked out of the bronze shell. Metal supporting pins and the network of bronze gates can be sawed away with a hacksaw.

A dilute solution of nitric acid is frequently employed to clean a bronze after it is cast, but care should be observed in handling the acid, which is strongly caustic and destructive to organic tissue. In diluting a concentrated nitric or other acid with water, one should remember never to add water to acid or a violent reaction may ensue. The acid should be added very slowly to water. In any event, the immersion of the bronze in the acid should be brief and the metallic form should be thoroughly flushed with clean, fresh water after it is removed from the acid bath, to stop the corrosive action of the acid.

After the freshly cast bronze has been cleaned, the process of surface finishing may be begun (see *Cleaning and Retouching Bronzes,* and *Chasing,* pp. 168-9 and 169-71).

Good clean and sharp metal castings depend upon several factors, among which are the following:

1. The quality of the mold
2. The quality of the metal or alloy that is used
3. The skill and the care exercised by the caster in the preparation of the mold and in the casting.

In general, a fine-grained sand produces finer and smoother castings, but as the fineness of the sand grains increase, the less porous or permeable will be the resulting mold, and the permeability of the mold is an important factor in sand casting. Mold permeability is the result of several factors:

1. The degree of packing or ramming of the sand
2. The moisture content of the casting sand
3. The amount of earth-clay or loam in the sand mass
4. The fineness of grain of the sand particles.

The casting sand of a sand mold must be packed well in the flask and about the form, but not too compactly or a tight and hard mold will result. The sand must be packed sufficiently firm to resist the effects of the flowing, molten, and heavy metal and its pressure. For large, rough castings, green sand is frequently used. Loam or a mixture of loam and green sand is used for achieving finer castings. A fine powder consisting of finely pulverized and powdered brick dust can be used as a parting sand for dusting between the flasks before the sections are fitted into place.

Industrially, different metals are handled with different kinds of molding sands. A fine-grained molding sand is required for casting aluminum. The molding sand used for the casting of brass has to be finer grained than the sands used for casting iron. Brass has a tendency of 'eating' into the molding sand, and this tends to result in rather rough and blemished castings.

THE LOST-WAX OR CIRE-PERDUE PROCESS

The 'lost-wax' or *cire-perdue* process is the traditional method of casting in bronze. It appears from early bronzes that this method or one very similar to it has been used by sculptors for at least 5000 years. The ancient Egyptians employed the lost-wax method, casting over ash cores. The Greeks and the masters of the Italian Renaissance used it extensively in casting sculpture and jewelry. The famous Benin

bronzes were also produced by means of the lost-wax process, African knowledge of the method is believed to have been derived from the Portuguese in the fifteenth century.

The lost-wax method is infrequently used today because of the many technical difficulties involved in the preparation of the positive and negative molds and in the pouring operation; nevertheless, the results achieved by this type of casting are definitely superior to those generally secured by means of the sand-mold process. The sand mold tends to generalize form, whereas the lost-wax process reproduces minute detail and fine modeling. Benvenuto Cellini, in his Autobiography, describes these casting difficulties in detail in an account of the casting of his famous *Perseus*.

There are two fundamental problems in any casting method. The first is to achieve a minutely precise negative impression in a substance that will record and preserve the finest detail of the positive, resist the great weight-pressure of the descending molten metal at the time of pouring, possess sufficient porosity to permit gases to permeate it, and still be sufficiently fragile to be easily removed after the pouring operation without danger to the inner metallic positive casting. The second problem is to fill the negative mold completely with the selected metal or alloy.

The Indirect Method: The indirect method to lost-wax casting is more tedious and complicated than the direct, but it is frequently followed, particularly when a work has been originally modeled in clay. The process is lengthy and is definitely wasteful in terms of time and energy, compared with the process of working the wax directly over the core.

One indirect method consists of first preparing a gelatine piece mold from the original plastic model. Melted wax is painted on the inside of this negative mold in successive coatings until a thickness has been reached equal to that of the ultimate bronze casting. The gelatine mold may be removed and the wax shell retouched or modeled and any necessary details added. Wax plugs or tubes are attached to the waxen form to allow for the escape of air during the pouring of the molten metal, and to provide for the entry of the bronze. The core material is prepared of ground brick and plaster mixed with water, although an earth-clay formula may also be used for this purpose. The core material is gently tamped or poured into the interior of the wax shell. Small metal pins are then set into the wax, penetrating the core, and layers of fire-resisting clay or core material

are either poured or brushed over the wax to form the external core. This shell should be a heavy one and may be made with a mixture of 3 parts of plaster of Paris to 4 parts of silica, and sufficient water to render the mass plastic and of a creamy consistency. The outer shell is fashioned of successively applied coats of this material, applied in thin layers, each of which is permitted to dry thoroughly before another application is made.

The metal suspending pins should project through all of these layers and will serve to bind the mass securely. The finished mold, containing the wax-covered core, is then placed in an oven and heated, to melt away the wax and dry the core and outer shell thoroughly.

Before the molten bronze is poured into the negative mold, the mold should be wedged securely in the sand of the casting pit. Melted bronze or other nonferrous metallic material may then be poured to fill the narrow space between the core and the containing negative mold. After the pouring operation, the mass is permitted to cool slowly and then the outer shell is broken away and the core raked out. The bronze can then be cleaned and finished.

Another similar, but more lengthy and complicated version of the indirect method reportedly practiced at Antioch College is as follows: Assuming that the sculptor has modeled his work in clay, he then proceeds to cast from this and secure a plaster positive. The plaster reproduction is covered with a layer of clay about an inch thick, and another layer of plaster is fashioned over this. When the outer plaster shell has set and hardened, the whole is cut into sections and the clay layer is removed. The piece is then reassembled and an agar-agar composition is poured into the space vacated by the clay and allowed to harden. The jelled agar-agar is also cut into sections and each of these is fitted into its proper place in the assembled plaster negative mold and the plaster positive is set aside. The agar-agar shell, contained within the plaster negative, is coated on its internal surface with a layer of melted wax carefully applied with a brush. Additional melted wax may be poured into the mold to achieve a heavier deposition of the material. The wax is poured at a temperature of approximately 145° F. Since the temperature of the cooled agar-agar mass is substantially lower than that of the melted wax, the wax quickly cools and hardens. When the wax layer has reached a thickness of from $\frac{3}{16}$ to $\frac{1}{4}$ of an inch the process is stopped and the agar-agar and plaster shell are removed, after which the wax

FIG. 6. LOST-WAX CASTING

a. Metal skeleton. *b.* Core. *c.* Facing. *d.* Core vents. *e.* Mold body.
f. Sprue or main duct for the entry of the molten metal.
g. Ducts or gates branching from the main duct and joined to the model.
h. Main vent outlets from figure.
i. Vent outlets for core.
j. Small nails for anchoring the core in the mold body.

The gates and air vents in this representation of lost-wax casting are spread for purposes of clarity, and the mold is shown fairly thick because of this.

149

form is checked for flaws and imperfections and retouched or re-modeled wherever necessary. A specially prepared plaster-of-Paris mix is poured into the wax shell to form the core, and the outer portion of the wax form is covered with a heavy coating of the preparation through which wax tubes or plugs for 'gates' and 'vents' are run. The entire mass should be baked slowly to redness and sufficiently long to rid the plaster core and investment composition of its free moisture and any vestiges of absorbed wax. The main body of the wax during this heating will melt and run off, being 'lost.' The negative mold should be rammed up carefully in the sand of the casting pit to withstand the static pressure of the molten bronze positive material. Into the space vacated by the wax the molten bronze is poured, and when this has cooled the outer shell is broken away carefully and the inner core is raked out. Large and elaborate works may require weeks of preparation prior to the pouring stage by means of this method.

Direct Casting: A direct version of the lost-wax method consists of first fashioning a precise core of earth-clay or brick dust and plaster mixed with water and roughly shaped into the desired form. Over this core is applied a layer or layers of wax of approximately the desired thickness of the ultimate bronze. The wax thickness should, however, be greater than ⅛ inch, because if it is less the casting has to be done in a red-hot mold—a very delicate and rare procedure. The wax layer may be carefully worked and modeled and small metal pins placed through the wax and into the core to suspend it securely within the final encasing of a fine earth investment composition or a mixture of plaster of Paris and refractory materials. The vent openings and gates are fashioned of wax and incorporated with the modeled wax positive mass before the application of the casing or outer core, which should be applied carefully with a brush until a solid and substantial shell is formed. The mass is then baked at a high temperature for about a day to melt away the wax thoroughly and to bake the mold and core dry and compact. This 'burning-out' of the mold is of great importance. The mold must be heated to a redness all through. If the temperature is not sufficiently high and prolonged to rid the mass of all of the wax, including that absorbed in its pores, this may later vaporize when the molten bronze is poured and either blow the molten metal out or explode the mold, with definite danger to the caster. Subsequent to the burning process, the molten bronze can be poured to fill the empty space between the

core and the containing mold, formerly occupied by the thickness of wax. After the entire mass has cooled, the outer shell or investment is broken off and the core raked out. The metal pins are filed away and the bronze surface tooled or chased and polished.

The major advantage of the direct method of bronze casting is an economy of time and effort. The direct approach is also creative in nature, rather than reproductive.

There are four steps to be taken in fashioning a work for direct lost-wax casting prior to the pouring of the molten bronze:

1. The preparation of the core
2. The modeling of the wax form over the core
3. The application of the facing
4. The application of the negative mold investment material.

The method of direct casting developed by Johnston [6] eliminates the use of preliminary clay or plaster models. A refractory core is modeled, which is then covered with a wax thickness equal to that of the desired bronze casting, and the form and details are developed on this wax layer. A negative mold is fashioned over this and the wax is burned off, after which the molten bronze is poured to form the positive cast.

Johnston's procedure in constructing his model for heads consists of first building an armature of iron pipe screwed to a flange plate. This in turn is bolted to a wooden base or board. The pipe is covered loosely with paper and this is held in place with string so that the superimposed core may be easily removed later from the pipe. This practice also makes venting the core easier and tends to reduce the danger of cracking due to shrinkage.

A thickness of approximately one inch of coarse earth-clay core mix is built up about the armature and permitted to dry out partially, after which additional layers, approximately ½ inch in thickness, are added. Each of the layers is permitted to dry before the subsequent layer is fashioned. To guarantee a high degree of adhesion between the layers, which is of great importance, the dry core may be moistened with a creamy slip composed of crushed dry core and water containing a small amount of molasses in solution, before applying additional mix to the core mass. Fresh material in a wet condition

[6] Johnston, Randolph Wardell, *The Practice of Direct Casting*, Technical Studies in the Field of the Fine Arts, published by the Fogg Art Museum, Harvard University, Apr. 1940, vol. VIII, no. 4.

and of a sticky consistency may be applied with a spatula and the plastic mix modeled into this as it stiffens.

Any cracks that develop may be repaired by cutting away along both sides of the crack, roughening these sides, and painting the area with slip. While the slip is wet, a small quantity of very stiff core mix should be pressed into the cavity. This may be permitted to dry and the procedure is repeated until the crack is adequately filled.

The core may be removed from the armature upon completion and baked in a kiln or in an open fire. The heat should rise gradually or it may crack the core. After baking, the core is ready to be covered with wax.

Coating a Core with Wax: There are three ways in which a core may be coated with a wax thickness:

1. The wax may be modeled directly over the core. The disadvantage of this procedure lies in the fact that the wax thickness tends to vary with possible future difficulties arising in the actual casting operation, plus corresponding inequalities in the thickness of the resulting bronze casting.

2. The core can be dipped repeatedly into melted wax until a satisfactory wax thickness has been deposited upon the core. This procedure is particularly suited for small works up to about 12 inches. In dipping, care should be observed, because the wax deposition tends to be heavier on undersurfaces and on those portions of the work that enter the fluid wax first and leave the bath last. Borings can be made to check the thickness of the wax deposit. If an area is too heavy and uneven, the wax coating may be scraped manually to remove the excess. The temperature of the wax in this method is also of great importance, since a too-cool wax will build up unevenly. If the wax is too warm it may melt away the higher and more prominent portions of the work, deposited by previous dippings. It is advisable to melt the wax in a water bath contained in a large vessel. The liquid wax will float on the surface of the water and dipping can proceed without changing the containing vessel. A large work may be suspended from an overhead beam by means of block and tackle and lowered into the bath for wax coatings. If several dippings are necessary, each coating should be permitted to cool thoroughly before the work is redipped.

3. Sheets of wax of uniform thickness can be applied over the core and joined together by the application of heat. Fine steel tools

similar to those used by dentists are employed for this purpose. The working end of the tool is warmed over a low flame before it is applied to the wax.

After dipping or applying the wax by means of sheets, the sculptor can work it manually and scrape or carve it with sharp cutting tools. Many wax formulas may also be modeled by means of finger pressure. Upon completion, a piece can be polished with a fine sandpaper moistened with either gasoline or turpentine.

Fashioning of Gates and Vents: The gates and vents are fashioned of wax and joined to the work before its investment with the negative mold material. Several gates should be provided to convey the molten bronze into the mold, because the metal may otherwise chill and fill the form inadequately. (See Figure 6 and Plate 23.)

Tubes or rods of wax for vents and gates can be made by pouring a composition of melted paraffin and a small proportion of beeswax into hollow metal tubes and allowing the wax to solidify by cooling. When the wax is thoroughly hardened the tube should be gently and evenly heated and the wax rods may be pushed out with a wooden stick into cold water. Softening the wax rods by gentle heating will render them sufficiently flexible to be bent into desired shapes.

The wax rods for escape vents should be placed near the highest points of the work in its casting position to permit the ready escape of air and gases from the negative mold when the molten metal is poured.

Metal Supporting Pins: Metal pins are used to suspend the core evenly and securely within its containing negative mold. (See Figure 6.)

Ordinary nails or bronze pins or rods are used for this purpose. Bronze pins are preferable, since they have much the same appearance as the casting alloy: when the pins are cut and the bronze surface is finished, they do not present alien surface spots. The size of the pins should vary with the size of the work. For a small to medium bust about six pins are required, each being approximately three inches in length.

The pins should penetrate the wax and core material, and project sufficiently from the wax surface to be covered and firmly held by the negative investment material, which is applied later. Small holes may be drilled through the wax and into the core for the insertion of the nails or pins.

Application of Negative Mold Material: After the wax-covered core, with its wax rods or plugs for 'gates' and 'vents' has been completed, and the metal suspending pins are in place, a negative mold material is carefully brushed on the work. The first coating should be fairly thin and should completely cover the wax surface Additional, heavier layers may be applied by hand until the desired thickness of the containing mold is achieved. The entire negative mass may be reinforced by the incorporation of iron rods in the plastic investment material.

Upon completion of the negative, the mold mass is placed in a kiln or furnace and baked slowly to a high heat to burn out completely all of the wax contained within the negative.

MELTING AND POURING BRONZE

After the wax has been burned off, the core, now free within the containing negative mold, is suspended in an empty space by the metal pins previously inserted in the mass, and is ready for the pouring of the molten bronze. Small works may be cast in bronze with a minimum of equipment. Out-of-doors casting is best, since ventilation and ample space are assured.

A wood fire should be started up and gradually covered with coke. As this becomes red, fresh coke may be added until a 'bed' is built up about 8 to 10 inches in depth. The crucible [7] is placed in the center of this bed and surrounded to its rim with coke. The metal or metals may be added to the crucible at this stage and, when they have been liquefied, a layer of fine charcoal bits should be introduced into the crucible, which is then covered. To achieve a bronze or other alloy, the metals should be melted in the order of their individual melting points, starting with the one having the highest melting point.

After it is melted, the molten bronze mass should be superheated well above its pouring temperature to compensate for the loss of heat that occurs during the interval between the measuring of the tempera-

[7] Crucibles are numbered from 1 to over 400 and have a capacity of approximately 3 pounds per number. A #20 crucible would, therefore, hold about 60 pounds of bronze. It is advisable to 'temper' or anneal a new crucible by heating it *slowly* in a fire to about 600° F., and permitting it to cool naturally, away from cool drafts. In charging or 'loading' a crucible, the metal should never be dropped or wedged into the vessel, which is physically fragile. A crucible should be quite dry when it is placed in the furnace.

ture of the molten mass before the pouring operation and the trans
portation of the molten metal to the pouring site.

An iron rod or skimmer may be inserted into the molten mass and
withdrawn, for testing purposes. If the metal is too close to its melting
point it will chill and stick to the iron rod. The hotter metal will run
off and leave the rod clean.

The temperature of the molten mass can be more accurately tested
with a pyrometer. If a pyrometer is not available, the temperature of
the molten mass may be roughly judged by its color, which should
be close to a white heat. Some founders advocate that common art
bronze alloys be poured at a temperature close to about 2200° F.,
which is approximately 400 degrees higher than the melting points
of the alloys. However, alloys vary in their melting temperatures as
the proportions of their ingredients vary. The ideal or proper tem-
perature at which a specific alloy should be poured would be the
lowest temperature at which the melted alloy would thoroughly and
uniformly fill the mold. Pouring at this lowest temperature would
also minimize shrinkage.

It is, however, extremely difficult to specify precise pouring tem-
peratures for alloys. A knowledge of the melting temperature of the
alloy employed, together with experience, is required to determine
the proper pouring temperature, and the molten mass should be super-
heated by at least 100° F., above its melting temperature.

To bring a bronze alloy to its pouring temperature and then to
remove it from the furnace, skim it, and pour the mass into the mold
is poor technique, and may result in faulty castings because of the
gases imprisoned in the molten mass, which have little time in which
to escape.

Superheating the alloy will compensate for the temperature loss
that occurs during transportation of the crucible from the furnace.
It will also permit the molten metal to remain in a clean atmosphere
while a substantial proportion of gases can escape from the mass as it
slowly cools to the desired pouring temperature.

When the metal has been melted and has reached the desired tem-
perature, the furnace may be uncovered and the caster, protected by
goggles, a heavy apron, and leggings, may proceed to lift the crucible
with tongs and to place it down carefully in the center of the shank
ring. A small amount of dry sand or asbestos should be placed on

the floor area before putting the crucible down, to serve as an insulation between the hot crucible and the flooring. At this point the surface of the molten bronze should be skimmed of floating scum, and any additional lead,[8] tin, or zinc may be added. The surface may be reskimmed if necessary. Following this, the crucible is lifted once again and the molten metal is poured into the negative mold. After the pouring operation, the entire mass should be left untouched for several hours to cool.

INGREDIENTS IN WAX FORMULAS

The substances generally used in compounding wax formulas for metal casting are as follows:

Beeswax is an insect wax secured by melting and refining the honeycomb of the bee, *Apis mellifera, Apidae.* Beeswax, the foundation of most wax formulas, is stable both physically and chemically. It varies from white to a yellowish brown color. The whiter varieties are generally bleached. By itself, the material is too hard and short to be modeled or carved. The wax adds smoothness and unity of mass to a formula. It is partially soluble in alcohol, ether, acetone, and chloroform, and has a melting point of 144-7° F., 62-5° C.

Burgundy pitch is an aromatic, oily rosin secured by the distillation of species of European pine. The material, similar to common rosin in its physical contribution to a wax formula, has superior physical body and is less brittle than rosin.

Carnauba (Brazil wax) is a hard wax with a color ranging from yellow to yellow-green. It adds hardness, structural strength, and brittleness to a formula, but it shrinks greatly. It is soluble in hot alcohol, ether, turpentine, hot oils, and alkalies. The wax has a melting point of 183-8° F., 84-6° C.

Ceresin (cerosin, ozokerite, mineral wax, earth wax) is a refined ozokerite. It varies in color from white to yellow. The substance is an odorless solid, similar physically to paraffin, but tougher and with little shrinkage. It is soluble in alcohol, benzene, naphtha, chloroform, and hot oils, and has a melting point of 142-73° F., 61-78° C.

[8] Lead is almost insoluble when it is added to a bronze alloy and if it is used, its use should be kept to a *very small* percentage of the total mass. The lead distributes fairly uniformly in the form of small units or drops in the bronze mass and is a source of weakness in an otherwise strong metallic body.

Cocoa butter may be added to a wax formula in place of lanolin. It functions primarily to prevent a hardening of a wax mixture in cold weather.

Halowax is a synthetic wax with a high melting point. It is a strong and hard material and imparts a milky opaqueness to a cool wax formula. A disadvantageous characteristic of the substance is that handling it frequently results in a dermatitis.

Lanolin (wool-fat, wool-grease, *adeps lanae*) is a purified grease secured from the wool of sheep. It is an amorphous, opaque substance with a slight odor and a color that varies from white to a yellow amber. It imparts plasticity and softens a wax mixture and is a useful addition to a mix in cold weather. It is soluble in ether and chloroform.

Lead linoleate [lead plaster, $Pb(C_{18}H_{31}O_2)_2$] is a yellowish white paste, soluble in acids, and quite poisonous. The substance is similar to lead oleate in its contribution to a wax formula.

Lead oleate [$Pb(C_{18}H_{33}O_2)_2$] is a white paste used to increase the plasticity and ductility of a wax formula. It is highly poisonous and a maximum of 1 part of the ingredient should be used to each 16 parts, by weight, of waxes. The paste is composed of equal parts of olive oil, lard, and lead monoxide. The lard and oil are melted together and the lead monoxide stirred to a heavy creamy consistency in boiling water. While both mixtures are warm they are mixed together thoroughly. The paste is soluble in alcohol, ether, and turpentine.

Paraffin is a white, odorless, semiopaque material secured from petroleum. It is used primarily to thin or to dilute a wax formula. It improves the carving qualities of a wax mixture and tends to reduce its stickiness. It should not be used too freely in a composition that may require a prolonged period for completion, since an excess of paraffin in a mix may cause a sagging of the wax mass with a resultant distortion of form. Paraffin is soluble in ether, benzene, olive oil, warm alcohol, and turpentine, and has a melting point of 118-45° F., 48-62° C.

Petroleum jelly (petrolatum) is a light yellow to amber, semisolid amorphous substance. It imparts softness to a wax formula. Its melting point is 113-19° F., 45-8° C.

Rosin (common rosin, colophane, gum colophony) is a brittle, transparent solid secured by the distillation of turpentine. The color varies

from light amber to a dark reddish brown. It increases the ductility of a wax composition and lowers the melting point. Since it imparts a stickiness to the formula, it should be used sparingly. It is soluble in amyl and methyl alcohol, ether, and carbon disulphide, and softens at 160-76° F., 70-80° C.

Tallow (suet) is a solid, unctuous substance, which varies in color. It is made from solid, organic fat. When fresh it is a 'short' substance. Old tallow is best for use in wax compositions and imparts a plasticity and softness to the mixture. The substance is susceptible to oxidation and may become rancid. Fine qualities may be relatively high in price.

Venice turpentine is a yellowish, heavy liquid with an aromatic odor. It may be used as a substitute for Burgundy pitch or rosin in a wax formula. Less of it is necessary than either rosin or pitch to impart a corresponding ductility. It is soluble in alcohol and ether.

The ideal wax composition for use in bronze casting would possess the following properties and characteristics:

1. Economy
2. Ease of preparation
3. Ability to be melted away without leaving a resinous residue behind to contaminate the mold and the eventual bronze
4. Wide working temperature range
5. Ductility when warm
6. Hardness when cold with a minimum of brittleness
7. Light in color and opaque to semiopaque when cool
8. Low coefficient of expansion
9. Physical durability.

WAX MIXTURES

The compounding of wax compositions is a delicate and exacting procedure. Some of the variable factors involved include the individual requirements of the sculptor, the type of work to be undertaken, and the fluctuating daily and seasonal conditions of temperature and humidity. The individual ingredients may also vary substantially in their physical and chemical qualities, depending upon their natural sources or the manufacturers.

It is interesting to note that Alfred Lenz omitted rosin in his wax formulas after much experimentation, having become convinced that the substance carbonized and left an undesirable contaminating

residue in the negative mold. The formula he used extensively for lost-wax casting is as follows:

THE ALFRED LENZ MODELING WAX FORMULA [9]

	Parts
White beeswax	100
Paraffin	100
Druggist's lead plaster [10]	50
Petroleum jelly	50
Cocoa butter	25
(Add if needed in cold weather)	
Lanolin	10

The ingredients of the Lenz formula are melted over a water-bath or in a double boiler and as much ammoniated mercury is added as the mixture will suspend after repeated melting. This modeling wax will flush out at approximately 180° F.

To rid the wax formula of unsuspended particles and to minimize thereby the possibility of defective casting resulting from carbonization of the single solid element in the wax, Lenz permitted his formula to cool and solidify, and then, by warming the containing vessel slightly, removed the mass of wax and cut away the bottom portion. The upper mass was then remelted, cooled, and the procedure repeated.

Lenz frequently tinted his waxes, experimenting with different colors in an endeavor to reduce to a minimum the tendency of the material to reflect light. Reduced reflection would also reduce eyestrain and accentuate form.

Working Waxes: Working waxes for bronze casting may be applied in sheet or rod form or modeled. The working qualities of many formulas are improved by repeated melting and cooling. They should be strained occasionally while in a melted condition through a clean, fine-mesh cloth. The following formulas are listed by Johnston in his excellent article [11] on direct casting (all parts by weight):

[9] Lenz, Hugh F., *The Alfred David Lenz System of Lost Wax Casting,* National Sculpture Society, New York, 1933, p. 10.

[10] Druggist's Lead Plaster, U.S.P. formula:

Lead monoxide	1000 grams
Olive oil	1000 grams
Lard	1000 grams
Boiling water	sufficient quantity

[11] Ibid. p. 222.

FORMULA W1

Beeswax	16
Lead oleate	1

(A hard, stiff wax suitable for very small work)

FORMULA W2

Beeswax	16
Paraffin	16
Lanolin	1
Lead oleate	1
Venice turpentine	1

(Softer and more ductile than W1)

FORMULA W3

Beeswax	24
Tallow	7
Ceresin	16
Carnauba	8
Paraffin	8
Lead oleate	5

FORMULA W4

Beeswax	1
Paraffin	1
Ester rosin [12]	1

(A cheap, simple mixture that works well in warm weather)

Dipping Waxes: The following formulas [13] are for waxes designed basically for 'dipping' rather than 'working,' since they cut and scrape evenly. The dipping waxes are physically brittle, whereas the working waxes are ductile and plastic.

FORMULA H1

Beeswax	8
Paraffin	16
Ceresin	21
Carnauba	16
Halowax	8

(A hard, opaque, white wax, with strong shrinkage)

[12] Rosin may be esterified by adding 10 per cent glycerine, which hardens and toughens the rosin.
[13] Johnston, op. cit. p. 223.

FORMULA W5

Beeswax	1
Paraffin	1
Ceresin	1

W5 is a transparent, yellow foundation wax. If the successively applied layers of this wax have a tendency to separate in dipping, Johnston recommends the addition of a little rosin or Venetian turpentine to the formula.

MODELING TOOLS FOR WAX

Lenz [14] fashioned his own tools for fine modeling from lignum vitae wood and aluminum. These tools were shaped with files and smoothed or finished with emery cloth.

Wax-modeling tools should be well balanced and both ends shaped for use. Wood tools can be dipped into melted paraffin wax or treated with oil to reduce their tendency to pick up wax as they are used. If they are dipped into paraffin, the excess should be rubbed off manually with a clean cloth.

Metal tools can be fashioned from old dental instruments that have been resharpened or reshaped. Occasionally warmed or hot metal tools may be required during the shaping of the wax form.

Lenz suggests the use of a pair of binocular lenses in modeling faces and other detailed portions of small figures or statuettes.

CORE AND MOLD MATERIALS FOR LOST-WAX CASTING

There are two fundamental types of binding materials used in the fashioning of cores and negative molds for lost-wax casting: (1) Earthclay; (2) plaster of Paris.

The use of plastic earth or clay as a mold-binding material has two advantages. The substance yields a stronger negative mold and it is safer to use than are the plaster mixtures, which contain water of crystallization and free water, thereby requiring thorough drying by exposure to prolonged heat.

However, plaster-bound negative molds, which are used extensively at present, enjoy the advantage of being more easily and quickly fashioned over the model than are clay bound molds.

While both the plaster-bound type of negative mold material and

[14] Lenz, op. cit. p. 13.

the earth-bound type have been used for centuries, the earth- or clay-bound mold antedates the use of the plaster-bound negative. Both the clay and the plaster types of negative molds are described by Benvenuto Cellini, although he refers to the use of plaster molds only for the casting of silver objects on a small scale.

Contemporarily, plaster is employed extensively and almost to the exclusion of earth-clay for this purpose.

Plaster Core and Investment Mixtures: Plaster of Paris is the fundamental binding material in plaster-bound cores and investments. While pure plaster has been used,[15] it is liable to cracking and a chalky disintegration during the baking and casting processes. For this reason other ingredients are usually added to the basic plaster to increase the physical strength of the core or investment and to compensate for any weakening of the plaster upon exposure to heat. There are several specially prepared refractory plaster mixtures that are commercially available for the casting of nonferrous metals and glass.

Some of the substances added to plaster of Paris to form core and investment mixtures are earth-clay, calcined earth-clay, reclaimed and pulverized calcined plaster, pulverized quartz or silex, asbestos fibers, and glue size, in addition to the occasional inclusion of organic matter.

Earth-clay is sometimes used with plaster because of its physical reaction to heat. While a plaster mass will tend to chalk and to break down when it is exposed to a high heat, earth-clay will gain in strength in firing and will compensate for the loss of physical strength of the plaster. This material should be employed in moderate proportions, however, not exceeding about 15 parts of the total volume of the formula. It should be thoroughly incorporated into the other ingredients of the formula by mixing.

Calcined earth-clay is also referred to as *grog*. The material can be prepared for mixes by pulverizing fired earth-clay or pottery, firebrick, or ordinary red building brick. It can be safely used in quantities of about 50 per cent of the total volume of the other ingredients.

Calcined plaster has been successfully used as a strengthening in-

[15] Lenz evolved a method of utilizing pure plaster of Paris as a facing material. However, his investment body, which was applied over the facing, consisted of an equal mixture of plaster and silex, together with the inclusion of a small quantity of asbestos fiber.

gredient in mold and core formulas. Lenz[16] mentions his successful use of an investment compound consisting of:

	Parts by weight
Dental plaster	1
Burnt and crushed (used) investment	3

Asbestos and pulverized quartz or silex are also frequently added to plaster-bound core and mold formulas as refractory materials. The asbestos fibers tend to increase the strength of the mold, to lighten the mold-weight, and to increase its porosity. Asbestos can be used up to about 50 per cent of the total volume of the mix formula. Pulverized quartz is frequently substituted for the calcined earth-clay in a plaster-bound mold formula.

The addition of glue size functions primarily as a retarding agent for the plaster of Paris. This ingredient should be added to the mixing water used in compounding the specific formula.

Leonardo da Vinci gives the following formula[17] for bronze casting in which plaster is combined with organic matter to form the mix:

To Cast Bronze in Plaster

Take to every 2 cups of plaster 1 of ox-horns burnt, mix them together, and make your cast with it.

Equal parts of plaster, asbestos fibers and calcined earth-clay, brick dust or ground quartz can be used for fashioning cores and negative investments. The ingredients should be measured by volume and mixed together while in a dry state. Sufficient water is used to render the mixture pastelike in consistency and the paste is applied compactly.

For the initial core mass, a plaster mixture may be used without the addition of glue or any other plaster-retarding agent. As the core is built up and slowly assumes form, the work should progress more carefully and slowly; a retarding agent may be introduced into the mix in small quantities to enable the sculptor to work more carefully and over a prolonged time.

A core formula used by Johnston[18] for several works is as follows:

[16] Op. cit. pp. 17-18.
[17] Richter, Jean Paul, The Literary Works of Leonardo da Vinci, New York, 1939, II, p. 13.
[18] Op. cit. p. 215.

FORMULA P1

	Part by volume
Dry asbestos	1
Plaster	1
Potter's flint or silex	1

The dry ingredients are first mixed together in a container and are then slowly sifted into water and stirred to make a thick paste. The formula is applied with a spatula or trowel. The fingers should not be used. This mix can also be used for the facing if it is mixed to a thinner consistency and either jarred or vibrated to rid it of imprisoned air bubbles.

The following stronger mix is also given. This is, however, more difficult to rid of air bubbles:

FORMULA P3

	Parts by volume
Fire-brick grog (through 60-mesh)	2
Plaster	1

Prior to the application of the facing compound, Johnston recommends that the modeling wax form be washed with either a thin solution of soap and water or with some alcohol. This practice serves to draw the plaster into all details. A small stiff brush may be used for the application of the creamy paste. It should be brushed carefully over each portion of the work to a minimum thickness of ⅛ of an inch before a fresh area is worked upon, to guarantee adherence to the mass and to prevent a flaking and incorporation of bits in the subsequent bronze casting.

The body of the mold may be fashioned with the following plaster mixture:

FORMULA P4

	Parts by volume
FF plaster	2
Fire-clay, finely ground	1
Asbestos floats	1
Crushed fire-brick (through 8-mesh)	1
Silex, or fine silica sand (through 40-mesh)	1

(These can be tumbled together, dry, in a barrel before using)

A simpler mixture is also given:

FORMULA P5

	Parts by volume
Fine, clean sand	2
Plaster	1

These ingredients may be shaken together into water in which a small quantity of glue size has been dissolved. The mass is thoroughly stirred until of the consistency of a stiff cream if the formula is to be poured. If the application is to be made by hand, the consistency of the mix should be that of a stiff paste

Clay-Bound Mixtures: For the formulation of clay-bound core and negative mold mixtures many substances can be used. Clay is, naturally, the major ingredient of a clay-bound formula. Organic matter, such as manure, cloth and hair clippings, and straw, has been frequently added to the basic earth-clay, because this organic material chars during the mold-baking process and the residue tends to reduce the oxidation of the molten bronze when it is poured to charge the mold. If the organic substance is of a fibrous nature, such as straw or cotton fibers, it will also serve to impart additional physical strength to the negative mold. The addition of asbestos fibers will similarly serve to strengthen a negative mold formula.

Johnston [19] gives the following ingredients of various clay mixtures for use in fashioning cores and molds:

Clay, to bind the other materials together and give plasticity.

Organic matter, such as charcoal dust, chopped straw, and other vegetable fibre, hair clippings, cloth shearings, manure, loam, *etc.* The fibres strengthen the mould while it dries. Later, being charred in the baking, they give porosity and leave a carbonaceous residue that tends to reduce the oxidation of the molten metal. The tannic acid from the chopped straw is beneficial in strengthening the clay itself.

Asbestos, short fibre, or 'floated,' lightens the mould and gives tensile strength and porosity.

Mineral fillers, such as fine sand, sifted ashes, crushed old clay moulds or bricks, *etc.,* give compressive strength and lessen shrinkage.

Crushed baked plaster moulds, called 'luto,' give a certain amount of plasticity and porosity to a clay mix, while weakening it. This weakening

19 Ibid. p. 211.

is sometimes desirable: clay may fire so hard that it is difficult to remove from the casting. (In many Oriental bronzes the cores are not removed.)

Johnston [20] prepares the clay mixtures by throwing into a barrel organic matter in the form of cotton rags, chopped straw, jute sacks, cotton mattress stuffing, hair clippings, and so forth, together with a small amount of fine sand and earth-clay. The mass is kept in a damp state 'for several months (or years),' and the fermentation is stimulated at intervals by the addition of substances such as old cider or whey. After the fibers have rotted and broken down substantially, a 'slip' is stirred into the mass. The slip is made in approximately this manner:

Dry New Jersey ball clay, crushed, 2 parts by weight. (Fire-clay or local blue clays may be used instead, but will be less plastic and take less sand.)

Luto, 1 part by weight (formula P1). If no luto is available, use silex or ashes (through 60-mesh). Ground charcoal in place of part of the luto (or ashes) will improve the mixture.

These are shaken into hot water and stirred thoroughly to make a thick cream, which is rubbed through a $\frac{1}{8}$-in. sieve.

This paste is permitted to age a little and is then mixed with an equal volume of fine sand or ashes. For foundation work the sand or ashes should first be screened through a 16-mesh. A finer screen of about 40-mesh should be used for finishing. After screening, the material is mixed and beaten with a heavy rod until the mass is plastic. If the mixture is not sufficiently moist, a small amount of water may be added. The mixture may be tested in several ways. If the substance cracks after being applied to an iron armature or to a dry core, it contains an excess of earth-clay, although occasionally this phenomenon may also indicate an excess of luto. Insufficient earth-clay may cause the material to be crumbly in working or may result in physical weakness and easy fracture in a piece that has been exposed to red heat and cooled.

Johnston also describes a simpler mixture [21] which has proved to be satisfactory in small applications:

Mix the clay to a slip with hot water; work into it dry asbestos, until it is plastic. Dry a piece, heat to redness, cool, and test for shrinkage. If it is too hard, or has too much shrinkage, use more asbestos; if too crumbly, use more clay.

[20] Ibid. p. 212.
[21] Ibid. p. 213.

Facings: The facing is the term applied to the first layer of the mold investment material that touches the modeled wax form. It is best to apply earth-clay facings thinly and carefully. Benvenuto Cellini [22] recommended the following facing cream.

Tripoli powder (gesso of Tripoli)	4 parts
Burnt ox-horn cores	2 parts
Iron filings	1 part

The ingredients are finely ground together and mixed with liquid manure, which has been first washed and sieved.

Two formulas used and recommended by Johnston [23] are:

FORMULA F1

	Parts by volume
Kieselguhr	4
Ground charcoal	2
Iron filings (very fine)	1

FORMULA F2

Windsor Locks sand or French sand, mixed to a smooth cream with whey containing a little clay, molasses, and flour.

Johnston had some difficulty with kieselguhr facings, since they frequently cracked. However, in a later article,[24] he gives the following improved facing formula:

FORMULA F3

Calcined kieselguhr	4 ounces
Kaolin	1 ounce
Molasses	1 tablespoonful
Water to make a thin cream.	

An interesting fragment from the writings of Leonardo da Vinci presumably describing lost-wax casting with plaster-bound cores and investment is recorded by MacCurdy: [25]

[22] Ashbee, C. R., *The Treatises of Benvenuto Cellini on Goldsmithing and Sculpture,* Edward Arnold, London, 1898; 'On the Art of Casting in Bronze,' ch. I, p. 112.

[23] Op. cit. p. 213.

[24] Johnston, R. W., *The Direct Casting of Figures,* Technical Studies in the Field of the Fine Arts, Fogg Art Museum, Harvard University, April 1941, vol. IX, no. 4, p. 198.

[25] MacCurdy, Edward, *The Notebooks of Leonardo da Vinci,* New York, 1939, p. 1020.

. . . the cold will have sufficient thickness to touch the plaster, and you pour out the rest and fill with plaster and then break the mould, and put the iron pins across, boring through the wax and plaster, and then clean the wax at your leisure; afterwards put it in a case, and put a mould of plaster over it, leaving the air holes and the mouth for the casting. Through the mouth turn the mould upside down, and after it has been heated you will be able to draw out the wax contained within it; and you will be able to fill up the vacuum which remains with your liquefied material, and the thing cast will become hollow. But in order to prevent the plaster from becoming broken while being rebaked you must place within it what you know of.

C.A. 352 r.c

CLEANING AND RETOUCHING BRONZES

All bronzes require cleaning and retouching after the casting has been completed, the metallic form removed from the mold, and the core raked out. Metal supporting pins have to be filed away and the bronze surface invariably needs cleaning to remove the blackened surface or 'fire-skin.' Where the lost-wax process was employed, the rods and vents or gates, now solid bronze, have to be sawed off slightly above the surface of the bronze casting, after which they may be beaten with a chasing hammer or tools, carved, or filed smooth. Occasionally, a bronze surface will be marred by surface cracks together with defects resulting from air bubbles in the molten metal which cause small craterlike holes or swelled surface 'blisters.' The ancient Greeks frequently added small bronze patches to fill such holes and these additions were then filed and chased.[26] When the areas involved were extensive, the piece was usually remelted and recast.

Fresh bronzes are generally cleaned and polished by means of burnishing or friction. Some sculptors make use of acid baths for the initial surface cleaning of the bronze. Either of these methods, if employed, should be used carefully and conservatively. Cleaning a bronze by means of scraping with files and chisels is a coarse method and it is not recommended. Rubbing with coarse abrasives and brushing with stiff wire brushes are also crude and dangerous procedures, particularly where fine surface modeling is present. Pickling a bronze in a dilute solution of nitric acid is a method used by some sculptors for the removal of dirt and 'fire-skin.' The bronze is immersed in the

[26] An acetylene torch can be used to melt small bits of bronze for filling holes in a bronze surface.

acid solution,[27] which eats away the superficial metal. When the work is removed from the solution it should be dipped in an alkaline bath to neutralize any further corrosive action of the acid, and the piece is then flushed liberally with clean water and dried.

Bronzes have sometimes [28] been bathed in or washed with a strong, heated solution of brown potash and water, in proportions of from ½ to 1 pound of potash to each gallon of water. The method is a harsh one and it is not to be recommended.

'Fire-skin' may be removed by rubbing the work with steel wool, which is available in several grades, varying from very coarse to very fine. Leonardo da Vinci gives us an interesting, if crude, method of polishing a cast. 'You should make a bunch of iron wire as thick as fine string and scrub them with it with water, but keeping a tub beneath so that it may not cause mud beneath.' [29]

A small quantity of water thrown on a freshly cast, hot bronze, soon after its removal from the mold, will cause a blowing off of a proportion of its 'fire-skin.' The remainder may be removed manually by means of tools, fine wire brushes, or steel wool, after the piece has cooled sufficiently to be handled freely.

CHASING

A perfect surface is rarely achieved in bronze casting. The surface results with the lost-wax method are generally superior to those secured by means of the sand-mold process, but almost all castings have to be finished or chased after their removal from the mold. If a good mold is prepared carefully and the bronze is a good alloy and is poured at the right temperature, an almost perfect surface can be attained. It should be remembered that good negative molds are necessary to secure good, sound bronzes. After casting, bronzes may be filed and hammered or chased for finishing.

Chasing is a process of mechanically finishing or tooling a bronze or other metal surface. It is also used to add fine details to a finished bronze. The principles of chasing have been used for many centuries in the East and in the Old World. A substantial number of Chinese bronzes have an extremely fine surface tooling or chasing. Chinese

[27] In the dilution of a concentrated acid with water, it should always be remembered that the acid should be added slowly to water, and that water is never added to a concentrated acid. Concentrated and dilute nitric acid are both highly caustic and must be handled carefully.

[28] The solution will completely eat away and dissolve aluminum and zinc.

[29] MacCurdy, op. cit. p. 1020.

bronze casters of the best periods were extremely skilled. Some of their bronzes appear to have been cast with such perfection that there was little necessity for the use of chisel and file. Their technique and methods were so proficient that paper-thin castings were achieved.

The tools required for chasing may be purchased or fashioned by the sculptor either from tool steel, which may be secured from hardware stores, or from small steel tools called *nail sets*. If nail-set tools are used it will be first necessary to remove or draw out the temper, prior to shaping the ends by means of filing into the desired forms. This removal of temper is not necessary for tool steel, because it is not hardened when it is marketed. The tips of the nail sets should be placed in the flame of a gas burner or other source of strong heat and allowed to become quite hot, after which the tool is removed with pliers and allowed to cool slowly in the air. After cooling, the end may be shaped and then tempered into the necessary hardness. Subsequent to tempering, the tools should be cleaned and polished with fine emery paper.

Steel chasing tools may be fashioned from square lengths of cast steel varying from $\frac{3}{8}$ to $\frac{1}{4}$ of an inch in diameter. These are cut into 4 or 5 inch lengths with a hack saw. The metal is annealed by heating to a bright red and then allowed to cool slowly in air. The ends may be shaped by heating and then hammering or forging, or the tools may be shaped by grinding or filing.

The striking ends of the chasing tools should vary. Some should possess round or ball-like ends, and some should be flat, with slightly rounded edges to prevent sharp edge lines from marring the bronze surface when the tool is used for chasing. They may also be shaped in oval, circular, and rectangular forms.

The striking surfaces of chasing tools are generally polished perfectly smooth, but a mottled or finely pitted tool will occasionally prove of value. This may be made by beating the striking surface of the chasing tool, which is held securely in a vise, with an old file, or hammered with a sharp, fine-pointed steel tool.

Chasing tools are held with the striking surface pointed at the area to be chased and the end is struck with a small, light mallet. This is repeated patiently until the entire surface area has been finished.

Hack-saws, files, cold chisels, burnishers, gouges and burins, and chasing hammers are also used in working and finishing a bronze.

To temper steel tools, the finished chasing tool is heated until it

becomes cherry-red and is then plunged into water up to a depth of about ½ inch from the striking end. The cooled portion should be rubbed to expose the clean bright metal under the superficial oxidized film and then reheated. The color or temper changes should be closely watched as the heat is carefully applied. When the initial pale straw tint appears at the striking end, the tool should be placed quickly again into water up to a depth of about ½ to ¾ of an inch from the striking end of the tool and then the entire tool may be immersed in the water to cool off. If the resulting tool is too brittle, it may be tempered a deeper color.

WROUGHT BRONZE

The practice of many commercial foundries to file and chisel or grind away a bronze casting wantonly in order to smooth and finish the work has led some sculptors to demand that the unfinished or rough cast, as it is removed from the mold after pouring, be returned intact to them for finishing. The crude, unrefined casting is then cleansed and worked upon by the artist in his studio. A high degree of perfection may be achieved by the sculptor working and hammering directly upon the metal. Bronze finished in this manner is called wrought bronze. (See Plate 31.)

Once more the bronze assumes the dignity it enjoyed during the times of the Greeks, when the bronzes were never released from a studio until they had been worked over and out, chiseled, gouged, and beaten into form in a direct, sculptural manner.

Saul Baizerman's procedure in working with bronze as a sculptural medium consists of first making sketches and drawings and then carving the form to perfection in a block of plaster of Paris. This is then cast in bronze and the surface form is developed by means of hammering. There is no recourse to the usual filing and chiseling, and areas that are inaccessible to the hammer are reached with a fine punch.

The method results in a metallic solidity and 'a sense of metal comparatively rare since the Chinese.' [30]

REPOUSSÉ

Sheets of bronze are rarely used today as wrought or repoussé material, but the alloy can be heat-treated when it is in sheet form

[30] London *Times,* 1924.

until it is quite malleable, and it can then be shaped by the use of hammer and punch.

The Greeks employed a rather primitive but practical method of hammering thin sheets of bronze into shape over wooden forms or cores that supported the metal and served also as a mold form.

A cement cushioning bed composed of a mixture of pulverized brick and pitch was also used. The metallic sheet was placed on this cushioning bed and beaten into sculptural form with hammers and punches from the back of the sheet. The pitch mixture yielded to the beaten forms and tended to prevent holes from being punched through the sheet. After the work was completed from the back of the piece, the pitch was heated and melted off the front of the relief and applied to the back, and the shaping of the final form was completed on the face of the work.

The *Siris bronzes* [31] in the British Museum are supreme examples of the skill attained by the Greek sculptors during the fourth century B.C., in hammering sheets of bronze into sculptural form. (See Plate 30A.) The reliefs are fashioned very high and the heads are almost detached from the background, yet the metal was not fractured by the punch despite the fact that these areas are almost paper-thin.

COPPER

Copper is believed to have been the first metal used by primitive man. Historically, the Chaldeans employed it as early as 4500 B.C. It was used by the Egyptians, and *via* Egypt its use is believed to have spread to Europe. The Sumerians in the ancient Near East used copper as a positive casting material for small figures and fashioned high reliefs, approaching sculpture in the full round, from thin sheets of the metal. These reliefs were hammered into sculptural form over wooden cores covered with asphaltum, which modeled into shape. When the hardening effects of the addition of tin to copper were discovered, the resulting bronze alloys were employed largely in the making of instruments of war.

One of the most important properties of copper from a sculptural point of view is its high degree of malleability. Pure copper is quite soft. The metal is softer than bronze and is more readily shaped by the hammer. It possesses a great tenacity or physical strength and

[31] Brönsted, P. O., *The Bronzes of Siris Now in the British Museum*, London, 1836.

is highly resistant to corrosion in dry air. In the presence of moisture
or humidity there is a superficial formation of green carbonate. Copper
is occasionally used in a relatively pure form in place of bronze as a
casting material, but there is some difficulty in the pouring of pure
molten copper, since the metal is somewhat sluggish and does not
flow as readily as does bronze. The specific gravity of the pure metal
is approximately 8.89 at 68° F. Copper has a warm, deep reddish
color, takes a brilliant polish, and is highly resistant to the majority of
corroding agents. It is the foundation of all bronzes, brasses, and
nickel-silver alloys.

WORKING AND ANNEALING

The cost of copper as a sculptural material is fairly moderate and
only the best quality, high-purity metal should be used for sculptural
purposes. Sheets of copper with pitted, brittle surfaces should be
rejected.

Sheet copper is a more stubborn material to work with than is
sheet lead, since the copper does not yield as precisely or as sym-
pathetically to hammer blows, so that there is frequently a com-
promise between the realization of the original concept and the
resistance of the metal. The warm, glowing color of copper and its
durability compensate for the difficulties involved in shaping it into
sculptural form. (See Plates 32 and 33.)

The choice of sheet thickness for repoussé work should be gov-
erned by the particular requirements of the work to be undertaken.
The relative ease of working and the proportions and size of the
contemplated sculpture are some of the factors that should be con-
sidered.

In hammering copper, the edges of a large sheet should be taped
before work is begun, because the edges are usually quite sharp and
hammer blows may cause the sheet to spring away or to bound for-
ward. If the sheet of metal is held or supported with the free hand,
the edges of the metal sheet may cause deep gashs in the flesh.

With low reliefs in sheet copper, small difficulties are encountered,
but as the depth increases, the difficulties of working the sheet also
increase.

The tools required for working copper as a hammered medium are
fundamentally the same as those used in shaping sheet lead. Sandbags
can be used for the preliminary shaping of the copper sheet in much

the same manner as they are used in lead sculpture. The sandbags may be fashioned in rectangular, oval, or circular shapes. The covers of the bags should be constructed of heavy, strong leather and filled with a fine variety of sand.

Copper, when it is used as a repoussé medium to be hammered into form, occasionally has to be annealed or softened by exposure of the sheet to a high degree of heat as the hammered work progresses, because the metal steadily hardens and eventually becomes quite brittle under repeated hammer blows. Pure copper may also become brittle with age, due to molecular changes within the metal, and sheets to be used for hammering may require annealing prior to their use.

In annealing copper, the metal is heated to a dull red color and is then either permitted to cool slowly in the air or is dipped into cool water after it has partly cooled. Natural, slow cooling is the preferable procedure, particularly if the sculptural forms or masses have been developed, else there may be an unequal contraction resulting from the rapid cooling and the stress may cause a distortion of form or cracking of the sheet.

The heat required for annealing a copper work will discolor the surface of the metal with the formation of superficial black oxidation scales or blisters. The copper surface must be thoroughly cleaned of this copper-oxide formation after the annealing or the oxide scales may become incorporated into the metal body by subsequent hammer blows when work is resumed, and the final surface will be rough and spotted. Plunging the heated work into cold water will remove a large proportion of the oxidation scales, but is not recommended if the forms have been highly developed. Cooling or quenching copper in cold water after annealing does not result in any appreciable hardening of the metal.

The method employed by Saul Baizerman in working sheets of copper into sculptural form consists of 'modeling' the metal by pressing, twisting, and hammering relatively thin, but adequate sheets of copper from both the front and the back. The sheet thickness that is employed, even for very large or heroic forms, is approximately $\frac{1}{16}$ of an inch, and the metal used is pure copper, which is secured completely soft.

The copper sheets, which are usually shipped from the mills in a rolled form, have first to be straightened out and the initial sculptural

shaping of the masses is then achieved by means of manually twisting and turning the metal sheet. All of the final shaping is accomplished by means of two metal hammers, reshaped by the sculptor to meet his particular requirements.

The hardness developed in the copper sheet from repeated hammer blows is exploited as a shape-retaining factor and the metal is never annealed. The artist's conception continually evolves as the work progresses and is adapted to material changes of shape and hardness. It is important, however, in working sheet copper sculpturally, that the artist have a detailed conception of what he wishes to accomplish and the means by which the forms will be achieved before beginning to shape the sheet.

Although it is a difficult medium, sheet copper possesses great sculptural possibilities. Sculptors can use the material to develop very delicate and finely detailed low reliefs to almost full-round forms.

CLEANING COPPER

For cleaning purposes, particularly after annealing, a 'pickle bath' is necessary. A glazed or nonporous earthenware or glass vessel should be used to contain the bath or acid solution, which consists of:

<div align="center">

Sulphuric acid 1 part
Water 8 parts

</div>

The containing vessel should be sufficiently large in width, length, and depth to accommodate the specific sheet. The work is submerged in the bath for approximately five minutes. If the containing vessel is too small to accommodate the sculpture, the acid solution can be swabbed on the copper sheet with a stick covered at one end by a thick piece of cloth. The swabbing is continued until all of the scales have been removed, and the metal should then be washed thoroughly with clean water and dried with a soft cloth. It can also be dipped in or swabbed with the acid solution and then scrubbed with a fine abrasive such as powdered pumice, using a small, stiff brush for the purpose. The piece should then be washed thoroughly with clean water, and dried. If the copper sheet is not washed after its removal from the acid solution, the metal striking surfaces of the shaping hammers may become covered with a layer or coating of copper. During the process of shaping a sheet of copper by constant hammering, frequent annealing and cleaning are required.

COPPER-NICKEL ALLOYS

Copper-nickel (see Plate 37B) alloys possess great physical strength and are highly resistant to corrosion. When nickel is added to a brass or bronze, there is a marked increase in the toughness of the resulting alloy. When nickel is present in a copper-nickel alloy in excess of 20 per cent, the resulting alloy is white or silvery in color. The use of the alloy is restricted to the casting of positives. A familiar copper-nickel alloy is the United States five-cent piece, consisting of copper 75 per cent and nickel 25 per cent.

Monel metal is an alloy of copper and nickel containing approximately 65 per cent nickel, 28 per cent copper and about 7 per cent in impurities of iron, manganese, and cobalt. It is harder than either pure copper or pure nickel and is stronger structurally. The alloy is highly resistant to corrosion, possesses a pleasant silvery appearance, and can be used as a casting medium.

German Silver is also referred to as nickel-silver. (See Plate 37D.) It is a brass alloy composed of from 10 to 30 per cent nickel and from 5 to 50 per cent zinc, the balance consisting of copper. The name is derived from the silvery appearance of the alloys. They possess a high resistance to atmospheric corrosion and are used as positive casting materials.

GOLD

Pure gold is the most malleable of the sculpturally used metals and is also one of the heaviest, having a specific gravity of 19.2. Its extremely high ductility, malleability, and attractive appearance led to its early and extensive utilization as an art medium. It was employed in ancient times by many peoples, including the Egyptians, the Etruscans, and the Assyrians, but its rarity and expense virtually prohibit its sculptural employment today save for very small, hollow statuettes, for coinage purposes (coins and medals), and for jewelry.

Gold has most frequently been shaped into sculptural form by means of casting, although the metal can be worked manually as a wrought medium or carved. The metal contracts greatly after casting, during cooling and solidification.

The purity of gold alloys in jewelry is expressed in terms of carats. A carat is a unit of $\frac{1}{24}$ part, so that 14 carat gold would consist of 14 parts of gold and 10 parts of copper. Pure gold is 24 carat, but since this is much too soft for practical use, other metals in small

quantities, generally copper or silver, are added to harden it. An alloy consisting of 90 per cent gold and 10 per cent copper is that generally used for manufacturing coins.

IRON

Iron is most malleable and, therefore, is most plastic when it is in a heated or glowing state. It can then be hammered and welded or shaped by twisting and turning. When ordinary cast iron is heated to a redness and hammered, it will crumble under the hammer blows, and large fragments may fracture from the mass. Malleable cast iron is a fairly soft variety, which can be distorted physically with greater safety than can either the white or gray cast-iron varieties. The metal has a moderate degree of resistance to corrosion. When wrought iron is heated to redness and hammered, it works fairly easily.

When fluid and molten iron cools and solidifies it shrinks and contracts greatly, so that when it is used as a positive casting material, the resulting impressions will tend to be blurry.

Pure iron has a high melting point and low fluidity when it is in a molten state, so that when pure iron is used sculpturally, it is almost invariably wrought and not cast. (See Plates 37F, and 38A and C.)

LEAD

Pure lead is a silvery-gray metal with a soft and delicate appearance, a high degree of plasticity, and great weight. The surface of the metal readily tarnishes upon exposure to the atmosphere, but the rest of the lead body, protected by the superficial tarnish, possesses great resistance to the corrosive effects of the atmosphere. Lead is the softest of the many metals used in sculpture, and is also the least tenacious. The former quality allows it to be easily fashioned when it is in thin sheet form. Its almost complete lack of elasticity necessitates extreme care and a delicacy of handling, which is of particular importance in the final stages of execution, when it is very easily broken if stretched too thin.

The use of lead as an art medium dates back many centuries. Small statuettes and reliefs of lead were fashioned by the Greeks. The Spartans made use of the metal as a positive casting material for their votive figures in the sixth century B.C., and the Romans employed it extensively as a medium for their garden ornaments, vases, and

statuary. Its use in the fine arts steadily declined through the succeeding centuries and flickered feebly in the nineteenth century.
There has been a contemporary revival of the use of lead as a sculptural medium, owing in large measure to the highly successful application of the metal to architectural and garden sculpture. Lead is
singularly appropriate for use in garden sculpture because of its delicate texture and soft appearance, which blends beautifully with
foliage and the surrounding countryside. It also possesses great possibilities for use as a medium for relief panels in architectural
sculpture.

Lead possesses physical properties that permit it to be worked in
two fundamental manners. It may be used as a direct sculptural
medium and hammered or beaten into form (see Plates 34, 35 and
36), or it may be used as a plastic positive material and poured into
suitable negative molds, after having first been reduced to a molten
state by the application of heat exceeding its melting point of approximately 621° F. (327° C.). A combination of the two basic methods
is a third possibility. The work can be cast in the rough, in either a
solid or hollow form, and then finished by means of hammering. A
work thus fashioned is referred to as 'wrought lead,' as opposed to
cast or hammered lead.

Lead has a fairly low melting point and can be cast with simpler
facilities than those required for many of the other metals and alloys
used sculpturally, particularly bronze. (See Plate 38B.) The high temperatures necessary to melt bronze are generally unattainable by the
average sculptor, who has limited studio facilities, so that recourse to
a commercial foundry is usually necessary.

A disadvantageous characteristic of lead when it is used as a casting medium is the considerable contraction or shrinkage of the metal
as it cools and solidifies. This shrinkage is approximately $\frac{5}{16}$ inch
per foot. The shrinkage tends to be less noticeable on a small casting, which cools and solidifies quickly, than it would be on a large
casting.

NEGATIVES FOR CASTING

Molten lead should never be poured into an unprepared, ordinary
plaster-of-Paris negative mold, because plaster crystallizes in setting,
and the water of crystallization remains incorporated within the
hardened plaster mass. There is also invariably present, particularly
in a fresh plaster cast, a substantial quantity of free water in excess

of that which was required for crystallization, and this evaporates slowly from the surface of the plaster mass. When molten metal comes into direct physical contact with the inner containing surfaces of a plaster negative, the free water and water of crystallization are rapidly converted into steam by the concentrated and intense heat, setting forth tremendous energy in the form of pressure resulting from rapid expansion. This may result in a violent bubbling forth and expulsion of the molten lead from the plaster negative, showering hot metal several feet about the room. The confining space of the negative mold serves to intensify the phenomenon. Plaster must be used with caution. The negative mold mass should be heated or calcined for several days over a high and constant temperature in order to evaporate slowly from the mass the bulk of its free water and water of crystallization. Plaster is often mixed with various refractory materials before it is used as a negative substance for the casting of molten metal. A relatively high water ratio is also recommended in order to produce a negative mold with maximum pore space. The mold must be thoroughly calcined before the molten metal is poured into it.

The use of a wooden negative mold for the casting of lead is not recommended, since the intense heat of the molten lead mass is sufficient to char and set fire to the containing walls. This is particularly true of large castings and those that are cast solid.

The finest and most suitable types of negatives for the casting of lead are the refractory plaster molds, the earth or clay-bound molds, and the sand molds (see pp. 141-6). Bronze molds are occasionally used commercially for the casting of lead articles, and make possible unlimited editions of a specific work.

CASTING

For pouring, the lead is first melted in a heavy iron or steel crucible. Impurities will rise to the surface in the form of a thin scum, which should be removed with a metal ladle. Long-handled tongs and shanks are used to transport the crucible with its molten contents to the negative mold and to pour the metal. If the negative mold is of the sectional plaster variety, it should be firmly bound together with wire and secured to a rigid base or partly buried either in a sandbox or in the earth for anchorage. There is no appreciable deterioration of metal in melting either lead or an alloy of lead, provided however the temperature does not exceed approximately 752° F. (400° C.).

It may be noted here that the majority of alloys of lead have lower

melting points than pure lead metal. There are some exceptions to this, as in the case of an alloy of lead and calcium, but for sculptural purposes the rule holds.

PURITY

Lead for casting does not have to be entirely free from metallic impurities, for these may impart additional structural strength, and may, therefore, actually be desirable. Some sculptors add tin metal in various proportions to the molten lead for a lighter and more silvery appearance and for additional hardness. The result of this mixture is an alloy of lead, which is referred to as pewter.

However, the lead secured for use as a medium to be shaped by hammering should be relatively free from metallic impurities. The impurities should not exceed 1 per cent of the metal mass and they should be distributed homogeneously throughout the entire mass, since the presence of other metals, particularly tin, zinc, and antimony, if localized within a specific area, might result in a hardening and an eventual cracking of the piece in that region after repeated hammer blows. High purity lead requires no annealing, although it can be easily annealed if it is desired. The annealing of lead begins at about 158° F. and increases with the rising of the temperature to approximately 480° F. To anneal, the work is placed in a container of water which is heated to the boiling point (212° F.). Virtually every other metal, with the exception of the noble metals, require softening after being subjected to the hardening effects of prolonged hammering. This applies also to metallic alloys.

The presence of other metals, uniformly distributed in a lead mass and constituting an alloy of lead, serves to harden the lead and render shaping more difficult and also more precarious. As the proportion of metallic impurities is increased the danger of brittleness and subsequent fracture similarly increases.

The sheet lead secured by the author for his personal work varies from 98.8 to 99.9 in purity. This relatively high degree of purity is especially desirable for sheet lead to be used as a direct medium and shaped by means of hammering.

On the basis of my experiments with several varieties of lead in varying degrees of purity, I have found that the finest variety for use as a direct medium is that which is known as, or conforms to the standards of, chemical lead. The specifications of chemical lead, according to the American Society for Testing Materials, are as follows:

	Maximum	Minimum
Silver	.020%	.002%
Copper	.08%	.04%
Arsenic+ Antimony+ Tin	.002%	
Zinc	.001%	
Iron	.0015%	
Bismuth	.005%	
Lead by difference	99.9%	

The small copper content of this type of lead serves to increase the resistance of the lead to corrosion and also to strengthen it physically.

The variety known as corroding lead is an especially pure form, being composed almost entirely of pure lead and analyzing between 99.94 and 99.99 in purity. Corroding lead, while purer chemically than chemical lead, does not possess as desirable physical properties for use as a sculptural medium. It is much softer than chemical lead, but does not resist corrosion as well, or possess its structural strength.

Antimonial lead is a lead containing a relatively high percentage of antimony, which may vary up to 10 per cent by weight of the total alloy mass. When alloyed with lead, antimony apparently retains its natural brittleness, being tempered substantially by the lead and serving to harden it, but nevertheless, imparting to the union its undesirable fragility and brittleness. The variety used in my experiments contained 6 per cent antimony, but there is reason to believe that all antimony-lead alloys behave sculpturally in a similar manner. The alloys possess a beautiful silvery appearance, but, unfortunately, cannot be used satisfactorily for direct sculpture. Antimonial lead is markedly stiffer than chemical lead and is therefore more difficult to shape by beating. The material has a tendency to crack in large and irregular fractures after being hammered only slightly. This type of lead alloy has possibilities for use as a casting medium, and, in a more restricted sense, as a wrought medium. It has a lower melting point than pure lead and may be annealed in a baking oven at a maximum temperature of approximately 400° F. (204° C.).

Tools

The tools required for direct sculpture in lead are few in number and are relatively inexpensive. They consist largely of ball pein hammers of assorted sizes. These do not have to be secured in a new

condition; however, the striking surfaces of each of the hammers should be carefully examined and if there are any scratches present, they should be ground or sanded off. The contours of the striking ends may, similarly, be reshaped by grinding to meet the sculptor's individual requirements. Wood mallets are frequently useful for the initial shaping or rounding out of large areas. (See Plate 34A.)

Chasing or finishing tools can be fashioned from discarded dental tools of surgical steel, and frequently prove of value in finely detailed works. Occasionally, a sandbag may be required as a supporting framework for large and consequently heavy pieces.

When lead in any form is being worked, whether for casting or for shaping by means of hammering, the regular use of a glove is strongly recommended for the free hand. While there is a very real possibility of the entrance of lead in small quantities into the system through the mouth, there is no absolute proof whether lead is absorbed through the unbroken skin. However, since there is such a possibility, it is advisable to wear protective gloves rather than risk lead poisoning. The lead surface should be handled as little as possible while working. Both hands may be protected by gloves, or a glove may be used to cover and protect the free hand while the other hand holds the shaping hammer. The precaution of using gloves and washing after work cannot be emphasized too strongly.

Sheet lead is the form generally used for direct sculpture, and can be secured in any practical thickness. That within a thickness range of between $\frac{1}{16}$ inch and $\frac{3}{8}$ inch is best for general work. For small pieces in low relief, the $\frac{1}{16}$ inch may be used, but it must be carefully worked, particularly with the higher areas, since the lead stretches very thin as it is beaten into form. The heavier thickness of $\frac{1}{8}$ inch is safer to use, and is also more substantial to work with, although this thickness also restricts the size of the piece. For larger and more monumental works, it is advisable to use the heavier thicknesses between $\frac{3}{16}$ inch and $\frac{3}{8}$ inch. Thicknesses greater than $\frac{3}{8}$ inch are rarely necessary and are not recommended, except in special instances where the sculptor finds it desirable to sacrifice ease of execution for additional weight and structural strength. The cost of sheet lead also increases proportionally with the thickness of the sheet and its resultant weight. In working the heavier thicknesses of $\frac{5}{16}$ inch and the $\frac{3}{8}$ inch, larger ball pein hammers are required and heavier blows are necessary. These weightier thicknesses are indicated for pieces up to 6 feet in height.

| THICKNESS | | APPROXIMATE WEIGHT |
| | | *Pounds to* |
Inch	*Millimeters* [32]	*the square foot*
1⁄16	1.587	4
1⁄8	3.175	8
3⁄16	4.762	12
1⁄4	6.350	16
5⁄16	7.937	20
3⁄8	9.525	24
7⁄16	11.112	28
1⁄2	12.700	32

PROCEDURE IN HAMMERED SCULPTURE

On beginning a relief in sheet lead, one should first cleanse the metal surface with powdered soap and water. The drawing may be sketched very lightly upon the sheet of lead with a chalk of soft consistency. (See Plates 34B and 35.) Some sculptors resort to a few simple guide lines; others prefer to refer to a small clay or plaster sketch for guidance and comparison. A few prefer to work freely and without preliminary drawings on the metal surface. If it is decided to sketch directly upon the lead sheet, do not press hard with the chalk or crayon or the surface of the metal may be marred.

Occasionally either a scriber or scratch-awl is used for scratching the outlines of a design upon the lead sheet, but if anything higher than a low relief is to be undertaken, it is not advisable to use these tools. The scratches are permanently inscribed on the metal surface, and it will be found that as a relief progresses, the proportions of the drawing will change and become distorted due to the unequal stretching of the lead sheet, so that the design will have to be redrawn to compensate for the rounding out of the forms.

The best manner of working sheet lead is to hammer from both the front and the back of the sheet. It is a beautifully plastic medium, sufficiently soft to be readily shaped by blows, and yet possessing a solidity and permanence of form. The lead sheet can be placed upon a cushioning sack filled with fine sand for the development of the primary masses. After the initial rounding out of the forms by blows from the front and back of the sheet, the sculptor can make further use of the sand-filled sack for support to the back of the lead piece,

[32] The equivalent of one inch is 25.4 millimeters.

while further shaping and finishing are carried on from the front of the work.

The base of a large and heavy sheet of lead may be placed on a table or work bench and the upper portion held upright by a rope and pulley arrangement attached to an overhead beam. The lead sheet can be easily lowered or turned about by this device.

The initial stages are easily and quickly achieved, usually within a few hours with a simple, moderate-sized work. Complex and larger pieces may have to be worked with greater care and may, therefore, require more time.

TREATMENT

Lead lends itself to extremes of treatment when it is employed in a direct manner, varying from a rough, broad handling, to a fine and delicately finished surface, with a range of relief from the very low to the very high, approaching the full round.

Lead reliefs may be worked very high, since the metal is soft and yielding when in sheet form; but, as stated before, some caution should be observed with the thinner sheets. As a general rule, the heavier the lead thickness, the greater or higher the relief possible. Heads and figures can be fashioned in sheet lead so as to constitute sculpture closely approaching the full round.

As long as the design is in a fairly low to medium relief, few difficulties will be experienced, but as the relief becomes deeper and approaches the full round, the technical problems increase proportionately and the task will become more difficult.

In the process of shaping a sheet of lead into sculptural form, there is a natural pull and stress of one area upon another. This is of particular importance during the initial stages of the work as the high, larger masses are beaten into their desired shapes. The sculptor should be constantly on the alert for a subtle buckling and for a distortion of form of areas adjoining the portion or region being worked upon.

In working a head in sheet lead, particularly a small head, care should be taken with the fashioning of the nose, since this is usually the highest point of the sheet and there is a tendency of the lead to thin out at the tip of the nose and to split.

The same area should not be struck too many times or it may thin dangerously. To avoid excessive thinning, regions that are to be raised by hammering should be beaten up over a broader area and higher

than they will be in the finished sculpture. To complete the work, the raised areas are beaten down to their final position.

Extremely fine detail is not recommended for lead sculpture intended for an outdoor site, since the metal is quite soft and a fine surface finish may wear away fairly quickly upon exposure to the elements. The proper treatment for outdoor lead sculpture is dependent upon the specific climate of the site in which the piece will eventually be placed. Generally, the treatment indicated is a broad and almost severely simple handling. Because of the nature of the medium, a good rule to adhere to in lead sculpture is to keep the forms simplified, with sharp shapes subdued and compact.

For meticulous surface finishing or delicate modeling of form on a hammered lead work, the use of a candle is recommended. All other light sources should be extinguished, and the candle should be moved about, below, above, and on the sides of the work for critical judging and final touches.

Work upon a solid mass of lead is not advisable because of the weight of the metal, which has a specific gravity of approximately 11.34 and a consequent weight per cubic foot of about 708.75 pounds. In addition to the tremendous weight, it is most difficult to shape a solid mass of lead. Herculean blows are necessary, and even these have but a superficial effect, with little or no influence upon the internal compact mass.

Backing-up a Finished Relief—Mounting

After a work of lead is finished, but before backing it up with concrete, one can, if desired, first apply a small quantity of soft solder in small and separated areas on the back or internal surface of the lead sculpture. This will provide an intimate anchorage for the cement backing, which will embrace and adhere to the projections. If a lead work has sufficient undercuts to retain the cement backing, the application of solder may be unnecessary, except, of course, possibly to reinforce portions that have been beaten thin in the process of shaping, such as the tip of a nose.

Concrete is the material of choice for use in backing up lead sculpture, which thereby achieves additional structural strength and is protected against distortion resulting from an impact or heavy pressure. Concrete also serves to stabilize lead sculpture and thereby eliminates the necessity of anchoring it to a base.

A mixture of 1 part of cement to 3 or 4 parts of sand, with sufficient clean water to render the mass plastic, can be used for backing up a lead relief.

The free lime in a cement mix will react chemically with the unprotected lead surface with which it comes into direct physical contact; but this action is generally superficial and of short duration since it is invariably stopped by the evaporation of moisture from the concrete after setting and aging. As a precautionary measure, a protective coating of lacquer should be applied to the inner surface of the sculpture before the application of the cement mix. This will substantially mitigate the chemical reaction between the cement and the lead. If two or three coatings of lacquer are applied to the lead, the possibility of caustic reaction should be entirely eliminated.

Under normal conditions the free lime in a cement mix will continue to react with the lead until the lime is completely carbonated. The time interval required for complete reaction varies from six to twelve months.

The concrete backing of pieces designed for outdoor sites may be waterproofed. After setting and aging, the concrete is saturated with successive coats of paraffin dissolved in a volatile solvent such as naphtha. The first application should be allowed to dry thoroughly before the succeeding coats are applied. As many applications are made as are deemed necessary to fill the pores of the concrete mass thoroughly with the dissolved paraffin and thus protect it against the penetration of moisture.

In a large lead work, rods of iron or steel may be used to reinforce the cement backing mixture. These can be inserted into the cement backing while the mass is still soft and yielding, or a skeletal framework can be constructed within the lead form and then filled in and covered with the plastic cement.

I have seen an isolated instance in which metal rods, together with a fairly thin shell of plaster of Paris, were used to reinforce a large bust fashioned of sheet lead. The sculptor's idea was probably to have a lightweight backing material, but since any work fashioned of lead is going to be heavy by virtue of the fundamental nature of the material, and since the weight of plaster, which is approximately 145 pounds per cubic foot, closely approaches that of set cement (which comes to about 180 pounds per cubic foot) it appears that the sculptor misjudged the material that would have proved most suitable for the purpose.

It is quite questionable whether plaster of Paris should be used as a backing material for lead sculpture, particularly in view of the relative physical fragility of plaster as compared with the structural strength of cement

The patina or surface finishing of the lead work should take place after the form has received its concrete backing. A piece intended for use indoors can be backed up and mounted on its base prior to the application of the patina.

If a lead sculpture is to be mounted on a wooden base, the use of a wood that has been well seasoned, waxed, and polished is recommended. Green oak and any wood containing organic acids should be avoided. The wood should also be free from insect larvae, which might injure the work.

If it is deemed desirable to fix the lead sculpture securely to its base, one or more holes should be bored into the waxed and polished wood base and an iron or steel rod then inserted into it. This should be perpendicular to the top surface of the base and should project from it. The diameter of the rod, the number of rods necessary, and the length of the portion projecting from the wooden base are determined by the size of the lead sculpture, its resultant total weight, and the basic balance or weight distribution of the work.

The sculpture is next placed in its correct position on the base and the back of the piece may then be filled in with concrete, which should cover the projecting rod and hold it securely on drying.

If a lead work contains undercuts, the concrete on hardening will hold securely to the lead form, and the rod penetrating both the base and the cement backing will prevent these from separating, thus achieving a compact and solid unit.

The mounting procedure can be reversed, and the lead work first backed with concrete into which, while the mass is still plastic, may be inserted the rod. This is permitted to extend from the backing and a hole is then drilled into the wood base to accommodate it.

Blocks of polished or unpolished stone may also be used for bases on which to mount lead sculpture. The drilling of holes in a stone block for the supporting metal rod is accomplished by means of star drills, which are available in several sizes.

Many lead works require no base. They stand firmly without the additional support a base would supply. To very large pieces a base might prove a massive and bulky addition. Frequently a head or bust

fashioned from a sheet of lead will assume a somewhat curved shape at the base of the sheet and this generally serves admirably to balance the work.

CLEANING A FINISHED WORK

The completed lead piece should be thoroughly cleaned by gentle, circular rubbing with a fine steel wool and a powdered soap plus just enough water to liquefy the soap. Soaps with a fine pumice powder content can be used. After cleaning, the piece should be washed thoroughly and repeatedly with clean water to remove any remaining vestiges of soap. The result at this stage will be a shiny, sparkling surface. Gloves should be used on both hands during this operation, both for protection from the lead and also from the fine steel-wool splinters, which are equally dangerous. If rubber gloves are available, they should be used in preference to cloth gloves, which are quite porous.

PATINA OR FINISH FOR LEAD

If a cloth is used with powdered soap for cleaning, rub well, and then allow the soapy suds to remain in contact with the lead surface for a short time. After this interval, rinse the suds off with clean water, but do not rub the lead surface. A dull finish will then be present and the mass will darken slightly in the air.

Lead may be finished with a dull natural surface, or it may be polished either entirely or in selected areas for purposes of accent. Exposure to the air will, in time, result in a natural dull surface patina resulting from oxidation, but this is often streaked with large discolorations from the chemical action of impurities absorbed by rain as it descends through the atmosphere. A polished area can be preserved and protected for some time by the use of a thin film of oil or wax rubbed into the specific area during the final finishing process. A soft cloth that will not shed its fibers can be used for this purpose.

Another finish for lead, which may also be applied to pewter and aluminum, gives a beautiful dark gray, dull finish. The metal surface is first rubbed with a soft cloth moistened with dilute muriatic acid, after which a small quantity of linseed oil is rubbed over the surface with fine steel wool. A somewhat similar antique finish can be secured without the use of acid by applying a small quantity of powdered graphite and linseed oil to the lead surface and rubbing with fine

steel wool. Dilute muriatic acid is, actually, a dilute hydrochloric acid, and some care should be exercised in using the chemical. If the liquid acid gets on the hands, they should be quickly flushed with water. An alkaline solution or soap will also neutralize the caustic effects of the acid. The room should be kept well ventilated while the acid is being used and the fumes should not be inhaled.

Highlights may be brushed on a lead work with steel wool; further accenting can be attained by the application of an earth color mixed with a small quantity of linseed oil or wax and used sparingly. Color accents are of little or no value if the surface of the lead work has been very meticulously and smoothly finished, particularly if the piece is to be eventually placed outdoors. The surface finishes just described are chiefly suitable for sculpture intended for use indoors.

Lead is easily corroded when it is placed out-of-doors in regions that are highly industrialized. The atmosphere is apt to be heavily charged with carbon dioxide gas. Rain, in falling, tends to absorb some of this and a dilute carbonic acid bathes the piece of sculpture. Eventually a lead work may be converted into a white, earthy-looking mass of brittle basic carbonate, beneath which will be left a very thin film of lead metal.

Pure natural water has little or no corrosive effect on lead. Minute quantities of dissolved salts tend to form a coating that generally serves to protect a lead mass against substantial damage.

As a routine precautionary measure, all lead pieces should receive a lacquer or wax treatment before outdoor exposure.

Lead is a relatively inexpensive material, easily worked and fairly permanent when properly treated, and it should enjoy a more extensive use in sculpture. When it is employed by a sculptor with an understanding of its capacities and limitations, together with a respect for these physical properties, it possesses a charm and a simple dignity rivaled by no other medium.

NICKEL

Nickel is a silvery metal that may be used sculpturally as a casting medium. It is highly resistant to atmospheric corrosion and takes a very high polish. The metal has been used extensively as an alloying substance and as an electroplating material. Used as an alloying ingredient, it yields the familiar nickel-silver and Monel metal.

PALLADIUM

Palladium is a rare white metal, possessing a close general resemblance to platinum. The metal is lighter in weight than platinum and is both malleable and ductile. It takes a very high polish and is unchanged on exposure to the atmosphere, unless it is subjected to heat, at which time it will oxidize superficially and become first blue and then white again as the heating is continued and the oxide decomposes. The metal has a melting point of about 2831° F. It is of limited value to sculptors because of its rarity and great expense. It has recently been used as a medium for fashioning cast medals (in limited editions), since it is quite hard, lighter in weight than platinum and only slightly heavier than silver, and resists tarnishing.

Palladium is also used in the manufacture of jewelry. The palladium used for medals and jewelry is an alloy of palladium and ruthenium, both of which are noble metals in the platinum group. The element is rarer than gold.

PEWTER

Pewter is an alloy composed of lead and tin and it is closely related to lead in its sculptural properties. It is generally made up of 4 parts of tin and 1 part of lead, plus occasionally copper, antimony, and zinc in small quantities. The alloy is more expensive than lead.

The presence of tin and the traces of other metals in smaller amounts in the pewter tend to result in a slight and almost imperceptible hardening of the pewter mass as it is hammered. This hardening may sometimes reach the stage in which the pewter would require an annealing, particularly if the tin content is extremely high or is localized within a specific area, in which case a hardening and resulting cracking might take place.

The melting point of pewter is so very low that it can be annealed in a kitchen oven, but this has to be done with extreme care. The alloy has a more silvery appearance than lead and has also slightly more body and permanence.

Pewter is quite soft and is worked in much the same manner as is lead. The physical properties of the alloy are similar to lead for sculptural use as a casting medium, although the alloy has a lower melting

point and is harder than lead. (See Plate 37A.) Pure lead is safer to use for hammered work than is pewter, particularly in medium to high or full reliefs.

PLATINUM

Platinum, a metal that is rarer than gold, derives its name from *platina*, the Spanish diminutive of silver. The metal is softer than silver and very heavy, having a specific gravity of 21.4. Pure platinum wears easily and iridium is usually added to it to harden it and also to increase its elasticity. It is highly malleable, but because of its great expense its use is restricted to medals and jewelry, and very rarely for coins.

In using platinum or palladium for medals, the original model is first cast in a hard bronze, and by means of a reducing machine a small steel die is cut of the precise size of the medal. With this die the copies are struck.

SILVER

Silver is a white and lustrous metal with a high melting point and a specific gravity of 10.5. The metal has been used for sculptural and utilitarian purposes for many centuries and by virtually every people.

Pure silver is very soft and is easily worked as a wrought medium. However, because of its great softness, pure silver has to be hardened for practical use by the addition of another metal, usually copper. It is frequently employed as a positive casting medium for small sculpture.

Sterling is the term which is used to indicate any silver that has the purity required for the English sterling shilling: 925 parts of pure silver in 1000 parts of total alloy.

STEEL

Many varieties of steel have been developed, particularly within recent years. They are generally more plastic materials with which to work than is cast iron, but are far too hard to be readily shaped by means of hammering. Mild steel, when heated to redness and hammered, will work well, but will be more difficult to shape than wrought iron. When cast steel is heated to redness and hammered, it will work well, but with some difficulty. When alloy steels are heated to redness

and hammered they are very difficult to work and some varieties may fracture under the impact of the hammer.

The stainless steels have great structural strength and a very high degree of resistance to corrosion. They have been used sculpturally as a casting medium within recent years.

TIN

Metallic tin is a silvery white metal with corrosion-resisting properties. It is rather weak, or brittle, for sculptural use as a hammered medium, although the metal may be employed as a positive casting material. (See Plate 37C and E.) Its use in repoussé is restricted to very small works, because of its fragility and lack of much ductility and malleability.

Tin forms very important alloys, and is one of the elements constituting bronze, pewter, and solder.

Tin plate is commonly referred to as tin, but is, actually, composed of iron or steel sheets that have been cleaned and softened and then covered with a very thin layer of pure tin.

Tin is not recommended for repoussé, except in very thin sheets for small works, which have to be worked with great care.

WOOD'S METAL

Wood's metal is rarely employed sculpturally although the material could be used as a casting medium because of its low melting point. However, lead and pewter are definitely superior physically for use as either direct or indirect media. Wood's metal is an alloy composed approximately of 25 per cent lead, 50 per cent bismuth, 12.5 per cent tin, and 12.5 per cent cadmium, by weight. It melts at about 160° F. (71° C.), which is extremely low for a metallic substance.

ZINC

Pure zinc is rarely used in sculpture, as a direct or indirect medium, because the material is not a satisfactory one with which to work. The substance is quite brittle in its cast form, and is useful in sculpture only as a possible alloying ingredient in the formation of alloys such as the brasses.

7 SURFACE TREATMENT OF METALS

BIDRI

BIDRI is a form of surface decoration of metal that is similar to niello. The process is practiced in India. The base ground used is composed of an alloy formed from zinc with a small proportion of copper and lead. Shallow designs are traced in the surface of this ground and filled with thin silver plates. The surface is smoothed and the bidri ground is permanently stained a deep black by the application of a paste consisting chiefly of ammonium chloride and potassium nitrate. The result is a rich contrast of brilliant silver and jet black.

BRONZING

By means of bronzing, an antique metallic effect can be imparted to another substance such as ivory, plaster, wood, brass, or copper. It is achieved by applying thin leaves of beaten bronze to the surface of the copper or other metal with a size. A paste is occasionally used for this purpose and is composed of finely divided particles of bronze mixed with a binding paste.

A bronze powder may be made of equal parts of white tin oxide and powdered sulphur. These ingredients are mixed together and melted until the mass appears a flaky, yellow powder.

Another formula for bronze powder consists of powdering the finely laminated alloys of copper and zinc and adding a small quantity of oil to the powdered mass to prevent oxidation.

Stannic sulphide (SnS_2) is commonly known as *mosaic gold* or *bronze powder* and is frequently employed in bronzing. Twelve parts of tin (by weight) are first dissolved in 6 parts of mercury. A brittle amalgam will result and this is powdered and then mixed with 7 parts of sulphur and 6 parts of sal ammoniac (ammonium chloride). This mixture is then placed in a long necked glass flask and heated gently in a sand bath until the 'rotten-egg odor' (hydrogen sulphide) no longer is given off. As the odor decreases the temperature is slowly

raised to a dull redness until no further fumes are noticed. The bronze powder or mosaic gold will be found on the bottom of the flask in the form of beautiful yellow scales or flakes.

DAMASCENING

Damascening is a form of inlaying or surface decoration of metals. It consists essentially of cutting a design into a copper, bronze, iron, or steel ground and leaving the depression slightly undercut. The inlaying material—generally gold, although other metals can be and have been used—is fitted into the cavities and pressed into depressions. The damascened areas are then smoothed and polished.

ELECTROPLATING

Electroplating dates its origin from the beginning of the nineteenth century. By means of this process thin and uniform films of metals such as copper, silver, gold, cadmium, chromium, tin, and nickel can be deposited on the surfaces of other metals or on prepared non-metallic objects by the use of an electric current that passes through a metallic salt solution. (See Plate 2, A and B.)

Anodes composed of the metal that is to be deposited are suspended in the metallic salt solution, and as the current passes through the solution, metal will be dissolved from them and an equivalent amount will be deposited on the cathodes, or objects to be plated, with little or no loss to the solution.

The process of electroplating has been used sculpturally, but largely as a means of camouflaging plaster of Paris, wax, and wood in imitation of metallic materials. The student is cautioned to always bear in mind the fact that electroplating is a delicate and very often a dangerous activity, since deadly cyanide compounds are frequently employed in plating formulas.

In order to achieve the finest metallic deposition, the object to be plated must be adequately prepared before its immersion in the electroplating solution. Metallic objects should be perfectly clean and free from rust, and since the finished plated surface will reflect the nature of the original surface, particularly if the plating is of the usual, thin type, they should be carefully polished and buffed before immersion in the plating tank.

In order to electroplate a porous object such as a plaster cast, the

pores of the plaster mass have to be first sealed and then given a surface capable of conducting an electric current, before the object can be plated. This surface preparation may be accomplished in several manners. The plaster model can be warmed and then treated with linseed oil; it can be immersed in melted paraffin wax; or it can be painted with shellac or lacquer to render it waterproof.

Plaster casts are frequently heated for several days over a moderate temperature before being immersed in linseed oil or treated with melted wax or lacquer, in order to rid them of free moisture.

In immersing a cast in oil or wax, it should be left in the fluid material until air bubbles cease to evolve from the pores of the plaster. Wax can also be applied by painting the melted material on the plaster surface with a brush. If oil is used for the pore-sealing treatment, the oiled cast should be heated moderately to accelerate the oxidation of the oil, which will harden to a dense and nonporous firm. A plaster cast can be prepared in less time with wax than with oil, since the wax hardens on cooling and the wax-treated object requires only a gentle rubbing or buffing to be smoothed sufficiently for the plating bath.

After the pore-sealing treatment has been completed, the oiled, waxed, or lacquered surface is brushed with a fine graphite powder and the surplus powder is wiped away with a soft cloth. A fine metallic bronze or copper powder can also be used for this purpose in place of the graphite. If graphite is used, some workers recommend that the graphite-treated cast be immersed in a solution consisting of 4 ounces of graphite to 1 pint of water for a few seconds, and then placed under clean, running water to wash away any surplus. The solution can also be painted on the work.

Small objects can be electroplated with relatively simple and inexpensive equipment. A glass jar, such as a small aquarium tank, can be used as the plating tank and the electroplating current can be secured from a storage battery.

Assuming that a plaster object is to be plated with copper, the plaster mass is first treated to reduce its porosity and to achieve a surface capable of being electroplated.

The plating solution is prepared by first measuring water [1] in quart units and pouring these into the glass tank. Two or three quarts should be sufficient for small objects. Sulphuric acid, in proportions

[1] Distilled water can be used for small objects, if desired.

of between ½ and 1½ ounces of acid to each quart of water that is used, is then added to the tank water. About 6 ounces of copper sulphate to each quart of water is then dissolved in the acid-water mixture and the plating fluid is ready to be used.

A sling of fine copper wiring can be arranged to hold and suspend the object to be plated in the solution. A sheet of copper is also suspended in the tank and attached to the positive wire leading from the storage battery; the negative wire is attached to the plaster cast, which can then be immersed in the plating mixture. The process of electroplating will start as soon as the properly wired object is placed in the plating fluid. All of the connections should be made before the work is suspended in the solution.

The object to be plated will soon assume a pink, coppery color. Too high a voltage will cause it to take on a dark color, and too low a current will slow the plating operation and result in a crystalline surface instead of a smooth plating.

A rheostat and voltmeter can be attached to the circuit and the rheostat adjusted so that the voltmeter at the beginning of the plating operation reads about 5 volts. This is maintained for several minutes and is then adjusted so that the voltmeter reading is about 1½ volts.

The time required for plating a plaster object that has been treated with metallic powder varies from about 15 to 30 minutes. An object that has been treated with graphite will require from about 30 minutes to an hour and a half. Heavier platings will naturally require a longer time.

The following table gives the amperes required for plating with different metals:

AMPERES REQUIRED TO PLATE ONE SQUARE FOOT

Solution and metal	Average amperes
Brass (cyanide)	2 to 3
Bronze (cyanide)	2 to 4
Chromium (CrO_3)	150
Copper (cyanide)	5
Acid copper (sulphate)	70 to 90
Gold (cyanide)	1 to 5
Nickel (sulphate)	5 to 20
Silver (cyanide)	2 to 3
Zinc (cyanide)	10 to 20

ETCHING

Employed as a means of surface decoration of metal, the process consists of covering the surfaces to be etched with a protective ground, into which the design to be etched is drawn or scratched with a sharp steel point, exposing the metallic surface to be attacked by the acid or mordant. A scriber or etching point can be easily made from a steel dental tool ground to a sharp point.

The acid can be locally applied to the exposed areas, or the entire piece can be bathed in an acid bath. The latter procedure is that most commonly used.

GROUNDS

Black asphaltum varnish can be used as a protective etch ground. It is most efficiently applied with a brush. Beeswax is also frequently used. It is melted and applied over the entire surface of the slightly warmed metal.

ACIDS OR MORDANTS

The simplest mordant for etching brass, copper, or bronze consists of equal parts of nitric acid and water. If the reaction is too intense, the solution is too strong and more water should be added.

FORMULA II			FORMULA III	
Potassium chlorate	1 ounce		Ferric chloride	2 ounces
Hydrochloric acid	5 ounces		Water	3 ounces
Water	40 ounces			

For iron and steel the following formulas can be used:

FORMULA I			FORMULA II	
Nitric acid	1 part		Hydrochloric acid	2 parts
Water	2 parts		Water	1 part

INLAYING

Inlaying consists of the insertion or incrusting in one substance of another material physically different in color and texture, for purposes of decoration and ornamentation.

Bronzes have been inlaid with gold and silver by hollowing out

areas in the bronze and slightly undercutting the hollowed areas to hold the inlaying material, which is generally laid in wire form and worked over by hammering.

NIELLO

Niello is an ancient form of metal surface decoration that has been generally applied to silver or gold, although it can also be applied to copper. The process consists of filling engraved designs with a black composition consisting of silver, lead, copper, and sulphur. These ingredients are incorporated or fused by means of heat. The design in the metal can be cut or etched, and it should be made fairly deep and slightly undercut to hold the inlaying material securely. The finished design appears as a black drawing upon a metal background.

A formula for niello enamel, which is not a true enamel, consists of the following ingredients:

Silver	3 parts
Copper	2 parts
Lead	1 part
Flowers of sulphur	

The three metals are fused together by means of heat. The alloy is then powdered by filing the mass with a coarse file. The filings are mixed with about twice their weight of flowers of sulphur, and the entire mixture is remelted. When the mass is cool, the block is ground into a powder in a mortar and pestle.

The cavities to be filled with the niello powder should be thoroughly clean and dry. A weak acid can be applied to the cavities to clean them. When they have been adequately prepared, the niello powder is loaded into the spaces and fused by exposure to the heat of a Bunsen burner or other source. The heat should be applied to the underside of the metal mass and care should be taken not to overheat it.

After the niello is fused, a fine-toothed, dull file can be used to level off the surface, and a fine emery cloth can be employed for finishing purposes.

To make the niello flow into the cavities more easily, approximately 5 per cent by weight of finely powdered ammonium chloride can be added to the mixture.

THE PATINATION OF METALS

Patination is the process of artificially and superficially coloring or changing the appearance of a metal or metallic alloy. The patina, or adhering coat, is almost invariably the result of chemical corrosion, although it may also be caused by the electrodeposition of another metal, or by a superficial application of a colored and generally opaque lacquer, paint, or enamel. The coating of a clean and generally polished metal object with transparent, clear lacquer is used by some modern sculptors to protect natural color.

There are, therefore, four fundamental manners by means of which the surfaces of metallic objects have been and can be changed in their physical appearance or treated to retain their natural appearance:

1. The exposure of the metallic object to the corrosive effects of chemical fumes or baths
2. Electroplating the metal object with other metals
3. The surface application of opaque color in the form of lacquer, paint, or enamel
4. The application of transparent coatings of colorless lacquer, as a color-protection measure.

The colors produced by exposure of the metallic object to chemicals are most frequently thin surface films of either oxides or sulphides. Occasionally, they may be a combination of both of these, and, less frequently, they may be nitrides or phosphides.

Atmospheric corrosion also affects almost all metals to a varying degree and frequently results in patination.

The patination of metals is a highly specialized art and one difficult to accomplish according to any set formulas. Two sculptors or craftsmen making use of the same fundamental formula may secure markedly different results.

The finished products resulting from the application of various patina formulas depend upon various factors, among which are included the following:

1. Temperature control
2. The purity of the ingredients employed
3. Working utensils

4. The care exercised in the preparation of the formula
5. The method of application.

ALUMINUM

Aluminum can generally be superficially colored only gray or black, although the integral coloring of aluminum in delicate tints by chemical additions to the molten aluminum mass prior to pouring is a recent industrial development.

To color an aluminum surface gray, the metal should be rubbed with a soft cloth moistened with a dilute solution of muriatic acid. A few drops of linseed oil is then applied, after which the metal surface is rubbed with a fine steel wool, resulting in an attractive, dull finish.

A *black* finish can be achieved by a bath consisting of the following ingredients:

Caustic soda	4 ounces
Calcium chloride	1 ounce
Water	1 quart

The water should first be heated in an earthenware container. The caustic soda is dissolved in the heated water and the solution is stirred, after which the salt is added. The temperature of the bath should be kept at about 200° F. The aluminum is immersed in this bath for about 15 minutes, after which it is removed, rinsed with clean water, and immersed for a few seconds in a second solution consisting of:

Hydrochloric acid	1 quart
White arsenic	4 ounces
Iron sulphate	4 ounces
Water	1 quart

After the work is removed from the second bath, it should be thoroughly rinsed with clean warm to hot water.

BRASS

Brass can be patined in several colors:

'Antique': The brass surface is covered with an aqueous solution of antimony chloride or caustic antimony, which is permitted to dry. The solution will produce a dark, 'antique' effect.

Blue: Brass can be patined blue by the use of the following:

Sodium thiosulphate	2 ounces
Lead acetate	1 ounce
Water	1 pint

The solution is applied warm to hot.

Brown: A brown patina can be achieved with brass by the use of the following solution, which is applied cold:

Ferrous nitrate	2 ounces
Sodium thiosulphate	2 ounces
Water	1 pint

Green: Brass can be patined green by the use of the following solution, which is applied cold:

Ammonium chloride	16 grains
Potassium bitartrate	48 grains
Sodium chloride (common salt)	96 grains
Copper nitrate	2 ounces
Water	12 ounces

Another formula for the production of a green patina for brass is as follows:

Iron sulphate	½ ounce
Copper sulphate	½ ounce
Ammonium carbonate	½ ounce
Water	1 quart

After this solution is applied, the brass object should be dried and lacquered for preservation.

BRONZE

Bronzes have been gilded with gold, notably by the Greeks; silvered, embellished by the use of enamels, inlaid with other metals by Egyptian, Assyrian, Greek, and Persian sculptors, electroplated, and camouflaged by artificial chemical or acid patination. (See Plates 1B, 2A and B, and 29B.)

Many contemporary sculptors prefer to retain the clean, golden natural color of the metal in their bronzes and to avoid artificial patination. They feel that the coloring of a bronze should be achieved by means of alloying other metals with the bronze base formula and

that the bronze should be treated as metal and kept clean and polished. However, the majority of modern bronzes invariably receive an artificial chemical or acid patination. Unpatined bronzes possess a clean and wholesome beauty and it is regrettable that so few sculptors are conscious of this. The fine attractive texture and color of a bronze is very rarely exploited for its own sake.

If a bronze is left unprotected from elemental oxidation or corrosion, its fresh, clean, and shining surface generally begins to tarnish superficially within a short time interval. A natural bronze surface may be preserved in several ways. The casting must first be thoroughly cleansed. After this, the bronze may be polished and a good floor wax rubbed gently over the surface with a soft cloth or piece of chamois. A work thus treated should be dusted regularly. A solution of beeswax dissolved in turpentine can also be used as a protective coating for bronze. This solution dries quite quickly and is fairly protective. It may be applied two or three times each year if desired or necessary. A naked bronze surface may be more completely preserved by another method involving the application of a protective coating of lacquer. This is a delicate process that results in a bright and glossy but protected metallic surface. The bronze surface is first thoroughly cleaned and a clear metal lacquer of fine quality is applied thinly and evenly with a soft and wide brush. It is important that the working environment in which this process is performed should be relatively dust free and that the bronze be thoroughly clean. The casting should be heated slightly to make the lacquer flow evenly and easily over the metal surface. The sculptor must work quickly because the lacquer solvent evaporates rapidly.

Lacquer can be removed from a piece of bronze sculpture by either boiling the work in a strong solution of washing soda and water or by dissolving the hardened lacquer coating with lacquer thinner, a highly volatile and inflammable liquid. This latter method of removing a lacquer coat is preferable since the first is quite crude and highly caustic.

In ancient times bronzes were frequently buried in the soil and thus acquired rich patinas by chemical reaction with the materials constituting the individual earth. The so-called 'antique finish' or patina is a comparatively modern development that stems from the Italian Renaissance, and is based upon the unearthing and observation of old bronze statues and statuettes that were corroded and colored by oxidation and decay. During the Renaissance many ancient

bronzes were recovered from the earth and the sea, and all of these were discolored from exposure. This chemical corrosion-coloration or accidental patination of ancient bronzes resulting from long burial or immersion was imitated in many of the bronzes then produced by the Italian craftsmen and the practice continued through the succeeding centuries, receiving great impetus from the French Romantics of the nineteenth century. The sculptor Barye (1795-1875) developed many types of bronze patinas, but none were pleasant to the eye.

Many of the rich and beautiful red, green, brown, and bluish patinas on Chinese bronzes are the result of 'aging' by burial in the earth, but the patination of a bronze by means of burial is not recommended. It is unscientific and uncontrollable and a work may suffer greatly from the treatment. The metal buried in the soil for lengthy periods of time may be slowly and completely changed into nonmetallic and fragile compounds.

The Chinese and Japanese produced bronzes that were highly orna-mental, with veined, clouded, and mottled patinas of yellow, brilliant red, and browns, and delicately minute mottled ornamental effects. However, if patination is desired, a uniformly consistent patina is preferable to mottled patinas, which might actually detract from the form of the sculpture.

Patinas today are generally secured by means of the application of liquid solutions of chemicals or acids in the form of baths or thin surface coatings, or by means of exposure of the piece to chemical fumes, and they consist largely of artificial, dull chocolatelike finishes or shiny greens of a sickly and corrosive appearance.

There are three fundamental methods used to apply the chemical solution and thus achieve a patination. One coarse type frequently used by French sculptors and workmen requires heating the bronze surface with a blow torch held in one hand while the other hand is used to apply the acid or other solution to the surface of the heated bronze. The work is occasionally washed with clean water to prevent too potent a concentration of the solution resulting from the evapora-tion of water by the high temperatures involved, leaving behind the concentrated chemicals. However, high-temperature processes are re-garded by many authorities as not only dangerous to apply, but ruinous, since they frequently destroy the art object. A second method of patination eliminates the use of heat and involves the application of solutions to the cold metal surface. A third method involves the

exposure of the bronze to chemical fumes and is the least injurious to a bronze casting of all three methods.

Greens: The majority of greens are achieved by the application of chlorides, particularly by means of solutions of sal ammoniac (ammonium chloride) and hydrochloric acid. The use of these chemicals and other chlorides in achieving a green bronze patina is not to be recommended, because they corrode the bronze metal dangerously. Fink and Eldridge [2] particularly caution against the use of chlorides, having found that these chemicals are among the most destructive of salts to copper and some of its alloys. They found that thin sheets of copper that had been treated with a thin coating of ammonium chloride and then exposed to a humid atmosphere became quickly pitted because of the continuous corrosive chemical action of the salt, and that only minute quantities of chlorides are required to convert substantial masses of copper into malachite and azurite in the presence of atmospheric humidity and carbonic-acid gas.

The highly important research of Fink and Eldridge lends scientific substantiation to the aesthetic convictions of the contemporary sculptor who feels that metal should be exploited as metal, and not subjected to corrosive chemical action for surface coloring.

A green to blue-green patina with a rather powdery surface texture, referred to by the ancients as *ærugo nobilis,* is produced by burying the work in the earth.

ANCIENT GREEN

Ammonium chloride	1 part
Cream of Tartar	3 parts
Sodium chloride	3 parts

These ingredients are dissolved in 12 parts of boiling water, to which are added 8 parts of copper-nitrate solution.

'ANTIQUE' GREEN

Ammonium chloride	½ ounce
Copper sulphate	3 ounces
Water	1 quart

After the application of this solution, the piece should be rinsed with cold water, then with hot water, and dried.

[2] Fink, C. G., and Eldridge, C. H., *The Restoration of Ancient Bronzes and Other Alloys,* The Metropolitan Museum of Art, New York, 1925, pp. 42-5.

Apple Green

Ammonia	4 fluid ounces
Sodium chloride	5 ounces
Ammonium chloride	5 ounces
Acetic acid	1 quart

Yellow-Green

Ammonium chloride	15 ounces
Copper acetate	8 ounces
Water	1 quart

Blue-Green

Sodium thiosulphate	¼ ounce
Ferric nitrate	2 ounces
Water	1 quart

Apply, after heating to a boiling point, with a wide brush.

Renaissance Black: The bronze is first covered with a solution of copper nitrate, which is permitted to dry slightly, after which the piece is heated carefully over a smoking straw fire until the desired color is secured. The bronze should be turned slowly while it is being smoked. After being smoked, the bronze surface should be cleaned with a solution of ammonium chloride and then placed in a container and covered with sand, which is saturated with milk at two-day intervals. After about 14 days have passed the bronze should be removed, covered with fine chalk, and reburied in the sand, repeating the applications of milk as described above for a period of 2-3 weeks. The bronze can then be removed and the surface permitted to dry, after which it can be lightly brushed to remove any adhering particles of sand.

Deep Blue to Black

The application of a solution consisting of the following ingredients will result in a blue to black patination:

Ammonium sulphide	2 ounces
Water	1 quart
Solution used cool to cold	

Brown: Varieties of brown may be secured by means of the following formula:

Barium sulphide	1 ounce
Potassium sulphide	¼ ounce
Ammonia	2 fluid ounces
Water	3 to 5 quarts

Patination by Means of Fumes: The patination of a bronze surface by exposure of the bronze to the effects of chemical fumes is preferable to the use of processes involving chemical baths or corrosive coatings. Fumes are far gentler to a bronze than are the other methods and the chemical action necessary to achieve a patina by means of fumes is milder and more superficial.

Fume patinas are generally produced by first moistening the clean bronze surface with fresh or distilled water and then placing the object to be patined into a box or cabinet, on the floor of which is placed a vessel containing the chemical solution producing the patina-producing fumes. The cabinet is then closed to prevent the escape of the fumes and to preserve the concentration within the container.

A procedure recommended by Fink and Eldridge [3] consists of exposing the bronze to the fumes of concentrated acetic acid and concentrated ammonia. The two chemicals are contained in separate vessels which are placed in a cabinet together with the bronze object, and the container is sealed. The time required for the production of a good patina by this method varies from about 10 hours to 30 hours, although in some cases longer periods may be required. The procedure results in the production of a blue-green to green finish.

Another type of fume-patination that results in an 'antique' green patina consists of placing the bronze object in an air-tight container into which are also placed two glass vessels. One vessel is filled with pure water and the other with hydrochloric acid. The cabinet is opened at intervals and bits of marble or chalk (calcium carbonate) are added to the hydrochloric acid. The pure water will slowly evaporate and will increase the concentration of moisture in the enclosed cabinet atmosphere. The addition of calcium carbonate to the acid will cause the generation of carbon dioxide. Exposure of the bronze to the fumes should continue for several days and will result in a rich green patination.

Fink and Eldridge [4] achieved good results by exposing bronzes to the concurrent attack of ammonia and acetic-acid fumes. The patina achieved was an attractive blue-green.

[3] Ibid. p. 40.
[4] Ibid. p. 39.

Fume patinas are generally quite thin and delicate and may be protected by the application of a lacquer or a solution of beeswax.

COPPER

Sculptures in copper intended for indoor exhibition are often given a variety of finishes or patinas by pickling the work in various solutions.

The exposure of a copper work outdoors will generally produce a bright but irregular green patina. Heating the metal over a gas flame will cause the formation of beautiful oxides, but these colors are generally impermanent and are frequently quite irregular.

Green: The exposure of a copper work, contained in a sealed cabinet, to the fumes of spirits of ammonia will produce a green patina.

LIGHT GREEN

Vinegar	1 pint
Ammonium chloride	125 grains
Sodium chloride	125 grains
Liquid ammonia	¼ ounce

The sodium and ammonium chloride are first dissolved in the vinegar or acetic acid and the liquid ammonia is then added to this solution, which is applied cold. The solution can also be used for the green patination of bronze.

A method of copper and copper-alloy patination recommended to the author by Colin G. Fink consists of cleaning the surface of the object very thoroughly, with grease solvents and hand soaps. After it has been thoroughly cleaned, it is placed under a bell jar in which there is a dish containing a concentrated solution of ammonia. The object is kept here for about a week, depending upon the room temperature.[5]

When the surface has become blue, the piece is transferred to a second bell jar, in which there is a dish of glacial acetic acid. Within a comparatively short time a dark green patination appears. The dish of acetic acid may be removed and the object permitted to remain under the bell jar for about 24 hours more and then allowed to dry exposed to the air.

The dark green acetic-acid patina will change to a light green patina, characteristic of malachite.

[5] The higher the room temperature, the shorter will be the time required for exposure of the work to the fumes, since the heat accelerates the chemical process.

When the malachite has formed over the surface satisfactorily, the article may be sprayed with a solution of beeswax dissolved in benzol. This is applied with an atomizer. If the work is to be exposed out-doors where the beeswax might be removed by bees and hornets, it is recommended that the spraying medium consist of a solution of paraffin wax in gasoline.

Brown: A brown patina can be produced by the application of a paste composed of the following ingredients:

Ammonium carbonate	3 parts
Copper acetate	1 part
Tartaric acid in vinegar	1 part
Salt (sodium chloride)	1 part

BROWN TO BLACK

Potassium or Ammonium sulphide	1 ounce
Water	1 pint

This solution is applied cold

Black: A black finish can be achieved by immersion of the copper work in a solution consisting of the following ingredients:

Sodium chlorate	10 parts
Caustic soda	5 parts
Potassium persulphate	10 parts
Water	75 parts

Verde antique:

FORMULA I

Acetic acid	1 ounce
Copper nitrate	4 ounces
Water	1 quart

The copper should be thoroughly cleaned before immersion, and then moistened with water. The solution is applied warm.

FORMULA II

Ammonium chloride	1 ounce
Calcium chloride	1 ounce
Copper nitrate	1 ounce
Water	1 quart

Iron and Steel

Iron and steel can be patined a blue-black by the application of a hot solution composed of 10 grains of sodium thiosulphate to each ounce of water. The process requires an exposure of between about 10 to 15 minutes.

Silver

Silver has been made to simulate bronze, just as bronzes have quite frequently been made to simulate silver, with much needless effort, since the logical procedure would be to use the metal desired directly as a casting medium.

The patination of silver is the result of the formation of sulphides, the chemicals generally used being sodium sulphide, calcium sulphide, ammonium sulphide, and potassium sulphide. Any of these salts can be used in a proportion of ½ to 1 ounce of salt to each gallon of hot water.

An 'antique' patina for silver can be achieved by the exposure of the silver object to ammonium sulphide fumes or by the immersion of the piece in a solution of one of the above-listed sulphides.

Tin

Tin can be colored with a black patina by immersing the object in a bath composed of the following ingredients:

Copper chloride	4 ounces
Antimony chloride	1½ ounces
Hot water	1 quart

The tin object is kept in the bath until the desired patina is achieved, after which it should be removed from the bath and rinsed in hot water.

CLEANING BRONZE OR BRASS

A bronze or brass work can be cleaned by the use of a 5 per cent solution of acetic acid, saturated with common table salt. The salt is added to the acetic acid until the solution will no longer dissolve any more. It is then ready for application.

After the work has been cleaned with the salt solution, it should be washed with water, polished, and lacquered lightly, or waxed.

POLISHING METAL

The sculpturally used metals can be polished manually or by means of machines equipped with buffing wheels. The commercial practice consists of mechanically polishing and buffing the metal, leaving the finished object with a very high and even luster. Some of the materials used for buffing wheels include fine metallic wire, wood, leather, muslin, felt, and cotton, their use being determined by the nature of the material to be polished, the type of abrasive to be used, and the degree of finish desired. The speed of the wheels or their revolutions per minute (R.P.M.) is another important factor.

In polishing metal by means of buffing wheels and abrasives, the abrasives are the actual polishing agents. These also vary according to the metal to be polished, the stage or nature of the polishing, and the finish that is desired. They include emery powder, silica, tin oxide, and rouge.

A very fine steel wool can be used for manually polishing a metallic form. This is followed by the application of a small quantity of linseed oil in the second stage. A finer abrasive consists of a paste composed of oil and a fine flour emery.

For the final stages of polishing, a chamois skin can be used to apply a fine buffing powder or jeweler's rouge, and the finished work can be lightly waxed with a soft flannel cloth to prevent or retard natural oxidation and discoloration. Banana oil has been used and recommended for protecting a polished metal surface, but it has not proved as satisfactory a protective substance as has wax or lacquer.

LACQUERING METAL

The lacquering of a metal surface is fundamentally a protective measure that serves to prevent superficial oxidation and the consequent loss of finish, polish, or color of the metal or alloy so treated. There are two types of lacquering, hot and cold.

Cold lacquering requires experience. The process consists of applying lacquer evenly to the clean and cold metal surface with a soft, wide brush. In hot lacquering the metal to be lacquered is heated to a moderate, comfortable warmth and the lacquer is applied quite quickly. After the application of the lacquer, the metal is allowed to cool slowly.

A metallic surface should be thoroughly cleaned and the metal washed with alcohol to remove any vestige of grease before the application of the lacquer.

A clear lacquer can be made by mixing the following ingredients:

Alcohol	1 quart
Shellac	1½ ounces
Gum sandarac	1 ounce

These ingredients are thoroughly mixed and permitted to stand for about a week, after which the solution should be poured into clean metal or dark glass containers, tightly sealed, and stored in a cool place for later use. The lacquers used for metal are invariably crystal-clear to amber, but they can be tinted delicately with color.

8 STONE

STONE is the traditional material of the sculptor. It was one of the first durable substances to be used by prehistoric man in his early attempts to represent form in three dimensions. From then on to the present day, when permanence, workability, and an attractive appearance were desired of a sculptural material, stone was frequently chosen as the medium.

An extensive variety of stones is available for sculptural use. They vary in hardness from soft alabasters, capable of being carved with knives, to dense, chisel-resisting granites, and present as well a dazzling variety of textures and colors. The determining factors in the selection of a type of stone for carving should be its suitability to the concept and its durability with reference to the ultimate site of the work.

The stones commonly used in sculpture include varieties of the sandstones, limestones, marbles, granites, and related igneous rocks.

The hardest, most uniform and compact stones belong to the igneous formations. The softer varieties are generally more porous stones and may be of sedimentary formations. The heavier sedimentary stones are usually the more durable varieties, since the weight generally indicates that the grains of the stone are more compactly cemented together, whereas the lighter types are more porous.

ORIGINS

Rocks fall into three major divisions, according to their origin: those that have been formed by the action of fire—the igneous rocks; those that have been formed by the action of water—the sedimentary stones; and those igneous and sedimentary varieties that have been radically changed physically or metamorphosed by natural forces— the metamorphic rocks.

The trade or commercial use of the term 'stone' includes all forms

of stone except the marbles. The term is also applied generally to a detached portion or fragment of a rock mass or deposit. Stones are usually quarried in large, rectangular blocks.

IGNEOUS

Igneous rocks are formed by the cooling and solidification of subterranean molten masses as they approach the surface of the earth. The chemical nature of the mass, plus the rate of cooling, determines the nature of the resulting rock formation. Masses cooling slowly and at great depths usually form the coarser-grained varieties. Those cooling more rapidly form the finer-grained stones, such as basalt. The igneous varieties include diorite, aplite, syenite, gabbro, basalt, diabase, rhyolite, and obsidian.

SEDIMENTARY

Sedimentary rocks are also referred to as 'stratified' forms, and are the result of deposition of sediment in successive layers or strata. The ingredients of a sedimentary formation are the result of erosion, over very long periods of time, by the chemical and physical action of water and the elements on rock formations. Erosion is an extremely slow process, embracing countless centuries, and many factors contribute to it. Heat and frost cause alternate expansion and contraction of a rock mass, which results in numberless surface fractures. Acid-forming gases in the atmospheric moisture have a slow, dissolving action. The chemical and physical action of surface and subterranean streams tends to wear away the areas with which they come in contact, for the erosive power of flowing water bearing sediment is great. The action of rain over long periods of time is another very mild factor in the slow wearing down of rock over periods of centuries.

When a rock mass is eroded, small particles of stone are carried away by flowing water and are eventually deposited in river beds or larger bodies of water, such as lakes and oceans, into which the rivulets and streams ultimately empty. Far out at sea these particles are intermingled with the skeletal remains of innumerable varieties of organisms, including both minute and large shellfish. The skeletal structures of the small animals are made up largely of calcium carbonate, which is the predominating ingredient of limestones. The majority of limestones and sandstones used by the sculptor have been formed in this way.

Metamorphic

Igneous or sedimentary rock formations that have changed radically during their existence are called metamorphic. The major factors in the formation of metamorphic rocks are pressure, heat, and chemical reaction. Great pressure and heat, deep in the bowels of the earth, may sufficiently soften the original rock mass and change its physical nature so substantially that a form radically different from the original rock will result. Extreme pressure may also cause a recrystallization of the formation. The metamorphic rocks include quartzite, gneiss, schist, slate, marble, and soapstone.

GRANITE

The precise derivation of the term 'granite' is not accurately known. It may have been derived from the Latin *granum*, meaning a seed or grain, because of the granular texture of the stone. Another possibility is the Italian word *granito* (grain), referring to the vari-colored grains. The term granite is used today to distinguish any entirely crystalline, unstratified, granular rock mass of igneous origin, made up principally of quartz and a potash feldspar.

All types of granite are hard and compact, varying in individual texture or coarseness. There are fine-grained, medium-grained, and coarse-grained varieties. The greater the quartz content of a granite, the harder the stone will be, and the difficulties experienced in carving it will be correspondingly increased.

Granite has been extensively employed as a medium for outdoor decorative and monumental sculpture, for it is one of the most durable stones and is highly resistant to the destructive forces of the elements. The sculptural suitability of a specific variety of granite is governed largely by its physical properties, the nature of its constituent minerals, and their arrangement. The best possible quality should always be used, as in any other stone selected for sculptural use.

Because granite is a very hard and physically compact material, it is quite difficult to carve. Some varieties are fairly brittle and tend to shatter under the chisel, while others have interlocking grains that make them extremely difficult to work. In carving granite, the sculptor should avoid delicate projections or deep undercuts. Although it is possible to achieve fine detail and delicate modeling, it is quite difficult to do so and the nature of the medium demands a broad treat-

ment. Forms should preferably be kept rounded and compact rather than sharp, angular, or projecting. (See Plates 47B, 48A, and 49C and D.) Egyptian sculptures in this material are excellent examples of how the medium should be worked.

The granites take a very high polish but defects within the specific stone may become apparent with polishing.

DOMESTIC VARIETIES

The finer-grained, uniformly colored, and compact varieties of granite are to be preferred for sculptural use. The color of a particular variety of granite depends to a great extent upon the color of the feldspar it contains, since feldspar is usually the most abundant mineral in a granite. Feldspar occurs in gray or white, pink, and red tints, and the resulting varieties are similarly colored. However, the presence of other minerals, such as quartz and hornblende, in significant quantities may markedly modify the coloring effect of the feldspar. The presence of abundant biotite or hornblende, evenly distributed in fine grains through a granite mass, may cause a near-black color. In medium-grained granites the average sizes of the crystals of feldspar are about a quarter of an inch in diameter. Granites in which some of the feldspar crystals are substantially larger than the rest are called *porphyritic granites*. Some varieties also receive their names from their most abundant ferro-magnesian mineral constituent, i.e. *hornblende granite* or *biotite granite*.

Varieties of granite are produced in many states in America. The eastern seaboard and the western states are the major areas of production. There is very little granite quarried in the central areas of the country.

Vermont is one of the largest producers of granite in this country. There are many varieties of Vermont granite, ranging in color from very white to light and dark gray. The Barre granites (light Barre and dark Barre) are all very hard and compact, fine-textured stones that are highly durable and can be used safely for outdoor sculpture. These granites are quarried by several companies, but the quality and textures are very similar, the principal difference being in the colors, which range from light to dark gray. The weight of Barre granite is approximately 165 pounds per cubic foot. Newark pink is a fairly coarse-grained, pinkish gray variety; Kirby mountain, a blue-gray, fine- to medium-grained. The Hardwick granites are even- and fine-grained to medium-grained varieties, blue-gray in color. Vermont gray

is medium-grained and a light gray. Derby gray is a fine-grained, blue-gray granite. Bethel white granite is white to blue-white, with a medium to coarse texture. Cabot granite is a fine- and even-grained, dark blue-gray variety.

Maine granites vary from a medium white or gray to a dark gray color, although there are also some light and dark pink types.

New Hampshire produces medium white or gray to dark gray and pink varieties of granite, which have been used sculpturally.

Massachusetts produces light and dark gray and pink varieties. Quincy granite polishes to a dark, steely blue-gray. It is one of the hardest varieties and is excellent for statues that are to be exposed outdoors. (See Plate 49D.)

Minnesota produces pink, red, gray, and black granites. The deep red Minnesota granites are preferred by many sculptors to other varieties. St. Cloud gray granite is a fairly uniform and mottled variety of blue-gray mixed with gray and black. The stone is very compact.

Rhode Island granites have a reputation for their fine-grained textures. The colors vary from a light bluish-white and blue-gray to pink and red. The industry is largely located in and near Westerly. The stones produced have been extensively used for monuments and, occasionally, for sculpture.

North Carolina produces light gray and pink varieties of granite. Balfour pink granite is probably the hardest and most durable that is produced in the South.

Pennsylvania produces Bonnie Brook black granite, a jet black variety. Coopersburg granite is gray to dark gray and has been frequently used for sculpture.

Missouri quarries a fairly attractive dark red variety, near Graniteville. The monumental stone is marketed as 'Missouri Red.'

Texas produces a small amount of block granite, a light to dark gray, fine- to medium-grained variety, secured from Llano County. Burnet County quarries produce a course-grained red granite used for building. An attractive red variety, suitable for monumental use, is quarried near Fredericksburg, Gillespie County.

Foreign Varieties

Scotch granites have an excellent reputation. They are available in grays, reds, and light blues, and are generally mottled varieties.

Ireland produces some gray and reddish varieties.

Swedish granites are primarily of dark colors or black, although medium, light, and mottled varieties are also produced. The stones are generally excellent.

Finland has quarried and exported to the United States red, gray, and black granite varieties, which have been used largely for structural purposes.

CONSTITUENTS OF GRANITES [1]

Essential Minerals

Quartz $\left.\begin{array}{l} \\ \\ \\ \\ \\ \end{array}\right.$
Orthoclase
Microcline
Albite } Feldspar Group
Oligoclase
Labradorite

Assessory Minerals

Characterizing Accessories

Muscovite } Mica Group
Biotite
Hornblende
Pyroxene

Microscopic Accessories

Sphene
Zircon
Garnet
Rutile
Apatite
Pyrite
Pyrrhotite
Magnetite
Hematite
Ilmenite

Secondary Minerals, caused by Weathering and Alteration

Chlorite	Muscovite	Calcite
Epidote	Kaolin	Hematite
Limonite		

LIMESTONE

Limestones are composed principally of calcium carbonate ($CaCO_3$, the mineral *calcite*). When more than 10 per cent of a limestone is made up of magnesium carbonate, the variety is referred to as a *dolomitic limestone*. When a limestone contains as much as 45 per cent or more of magnesium carbonate, it is called *dolomite*. The term

[1] Adapted from Hawes, G W., *The Building Stones of the United States and Statistics of the Quarry Industry*, George P. Merrill, ed., Tenth Census Report, 1880, vol. x, p. 16.

dolomite is generally applied to varieties containing the double carbonate of lime and magnesia ($CaCo_3MgCO_3$) in large amounts. They are composed chiefly of the calcareous skeletal remains of shellfish and minute animals. Recent theory suggests that chemical precipitation is an important element in their formation.

Limestones may be physically microcrystalline or coarsely crystalline. They generally have a somewhat 'sandy' or granular appearance.

Limestone has been used as a carving medium since the beginning of recorded history. The Egyptian sculptor's models were generally carved in limestone. (See Frontispiece.) These models were made by trained sculptors, either for apprentices to copy for practice and study, or as a master guide for work on a statue or piece of relief sculpture.

The density of limestones varies from fragile, natural chalks, formed by the shells of the minute animals classified zoologically as the Foraminifera (protozoans), to compact, crystalline stones, which are frequently classed with the marbles because of their high degree of physical compactness and their ability to take a high polish.

Limestone has an average hardness of approximately 3. When pure, it is fairly soft and can be scratched with a knife. It is easily carved, except when silica is present.

The limestones are generally softer than the marbles and, therefore, easier to carve.

The degree of luster to which a limestone can be polished varies according to the porosity or spacing of grains in a specific variety. The more compactly cemented the grains are, the finer will be the finish that can be achieved. As a group, limestones do not take a high polish, because of their physical structure, which is less compact than that of marble. Many varieties cannot be polished, while others yield only a slight luster when they are rubbed with polishing abrasives. They are often smoothed by means of rubbing with a very fine variety of sand mixed with water.

The weights of limestones vary from about 167 to 171 pounds per cubic foot. The heavier, less porous varieties are best for sculptural use.

Limestones are generally a gray to buff color, although they may also be cream, yellow, blue, red, green, brown, and tinted black. The buff color is usually owing to the presence of iron oxides. Tinted varieties may oxidize and change in color, because of unstable iron impurities within the mass. For example, blue limestones may change to a yellowish or brownish buff color. The presence of sulphur may

also cause color changes. The whitest varieties of limestone are the purest and are frequently classified with the marbles.

Care should be exercised in selecting limestone for sculptural use and only 'select' or 'statuary' grades should be purchased. Statuary limestone is generally buff, and is the finest variety in graining, uniformity of color, and texture.

While there is a great deal of limestone produced in this country (it is present in almost every state), only a small percentage of what is quarried is fit for sculpture. Oölitic limestone is usually excellent for sculptural use; it generally carves easily and is quite compact, but takes a very poor finish, as it is too rough. Lithographic stone is an extremely fine-grained limestone that is quite dense and of a homogeneous crystalline structure.

The tools used for carving marbles of soft to medium consistency can also be used for carving the limestones. Bushhammers should be used only on the very hard and compact varieties, and even then should be applied carefully and without too much force.

Domestic Varieties

Alabama produces an oölitic limestone of quite uniform texture, but it is occasionally veined. It is quarried in the northwestern section of the state. The colors vary from a light to medium gray to buff. Alabama limestone is slightly harder to carve than Indiana limestone.

Indiana limestone is frequently referred to as Bedford stone, Bedford limestone, and 'oölitic limestone,' because of its resemblance to the roe of a fish. The spherical grains or 'oölites' are believed to have resulted from the precipitation of calcium carbonate in sea water. Select varieties of Indiana limestone are very fine-grained, with the grains approximately $\frac{1}{25}$ of an inch in diameter. They are the choice of domestic limestones and compare favorably with imported European varieties.

Indiana limestone can be secured in buff to gray colors and is an attractive, fairly soft, and easily worked stone. It is similar to many sandstones in that freshly quarried blocks are generally easier to carve, whereas the longer the block is out of the earth and exposed to the air, the harder it becomes to work sculpturally. Freshly quarried and carved Indiana limestone is also susceptible to the action of frost, unless it is well seasoned before being exposed. The AA, buff, statuary grade is an unusually fine and uniformly grained type and is the best of the many Indiana varieties for sculptural use.

Kentucky produces an oölitic limestone that is quarried in Warren County. The stone is similar in color, texture, consistency, and durability to Indiana limestone. In the selection of blocks, the presence of small pyrite impurities should be looked for, since these may cause a brown staining of the stone mass upon outdoor exposure.

Minnesota produces many good near-white to buff varieties of limestone. The limestone quarried at Kasota is strong and will take a good polish.

Missouri limestones are generally compact crystalline varieties, commonly classified with the marbles.

Texas produces a good light buff to cream-colored oölitic limestone, which has been used sculpturally. The stone is quarried in Williamson County.

Arkansas and *Wisconsin* also supply sculpturally acceptable varieties of limestone.

Foreign Varieties

French limestones are preferred by many American sculptors to domestic varieties: particularly Caen stone (anglicized and pronounced 'Kane'), which is a beautiful, soft, buff-colored oölitic limestone quarried near Caen, France. (See Plate 47F.) It is the finest limestone produced in France, is easily carved, has a fine grain, and is only a trifle more fragile than Indiana limestone. It is not recommended for use outdoors.

Euville, Normandeaux, Lotharinge, and Peuron are other fine French limestones that have been used for carving purposes.

Cuba produces a fine buff-colored limestone similar in appearance to varieties of Indiana limestone, but having a much finer graining and being softer and easier to carve.

SANDSTONE

Sandstones are fairly porous stones of sedimentary origin, which vary markedly in compactness and durability. They are composed of fine grains of sand (quartz, silica) bound together, in varying degrees of firmness, by a cementing material. The compactness and consequent usefulness of a sandstone depends upon the type of material cementing the grains. Quartz is the strongest cementing substance, but other binding agents, such as iron oxide, earth-clay, and calcite, a crystalline form of calcium carbonate, are also found.

The harder varieties consist of almost pure quartz and are fre-
quently used as grindstones for sharpening tools. Some forms of sand-
stone are extremely fragile and can be easily crumbled between the
fingers. The silica particles in sandstone vary in size with different
varieties and the graining within a single block can vary substantially.
One may come upon a very hard spot of a soft area while working a
block, so that the control of the chisel is very important in carving
sandstones. The pure siliceous sandstones are the most durable, but
they are also the hardest varieties and the most difficult to carve.

The quartz grains of a sandstone are very hard, but the ease with
which a variety may be carved is determined by its cementing sub-
stance and relative porosity. The grains of some varieties are quite
weakly bound together and portions may fracture off with only a
slight impact, but those that are welded together by quartz as the
cementing material (quartzite or siliceous sandstone) are quite diffi-
cult to carve.

The degree of cementation is an important factor in determining
the degree of polish a variety will accept. Many types will not take
a polish because the grains are plucked out in the process.

Freestone is the term applied to a sandstone that can be carved
with uniform ease in any direction. It is formed when fine grains of
sand, almost invariably of a uniform or consistent size, are deposited
by water in specific beds.

Most varieties of sandstone are quite porous. Their porosity varies
greatly, but the pore spaces between the granules are in most cases
quite fine. When it is quarried, sandstone frequently contains a quan-
tity of moisture or *quarry water* in its pores. In many instances the
quarry water contains dissolved mineral matter. After quarrying, this
moisture tends to evaporate slowly and the minerals in solution are
deposited on the sides or walls of the pore cavities. This serves to
harden the stone. A freshly quarried block will therefore carve more
easily than will a block that has been exposed to the air sufficiently
long to have lost most or all of its quarry water.

A carving from a recently quarried block should not be placed out
of doors in low temperatures, since cold sufficient to freeze the quarry
water might wreak havoc with the piece. Because of the porosity of
most forms of sandstone, even a well-seasoned piece should not be
placed outdoors unless it has received a precautionary pore-filling or
sealing treatment.

Sandstones may be secured in gray, yellow, buff, red, brown, green, and black. Many kinds receive their names from their colors, i.e. bluestone, brownstone, and redstone. (See Plates 47C, 48G and H, and 49E.) Impurities are responsible for the colors, and therefore the purest types are white. Pure calcareous and siliceous varieties range in color from white to a pale yellow.

Two forms of iron oxide are responsible for most of the red forms of sandstone. The presence of *hematite* (Fe_2O_3) colors the stones red to dark brown. Another iron oxide, *limonite* ($2Fe_2O_3.3H_2O$), causes shades varying from buff to brown. While these iron-oxide forms are fairly stable, iron sulphides and carbonates are unstable, and oxidation resulting in changes in color may occur after the block has been carved. This color alteration may be uniform, or it may result in an uneven or spotty surface.

Gray varieties generally owe their color to the presence of earth-clay or shale.

DOMESTIC VARIETIES

There are abundant and widely distributed sandstone deposits in almost all of the United States. Some varieties are suitable for carving, but a large proportion either are too hard or unsound for satisfactory carving or are absorbed for building purposes. Uniformity of coloring and structure should be the decisive factor in the selection of a sandstone for sculptural use. Stratified blocks should be avoided.

Ohio is the leading producer of sandstone in this country, supplying more than 50 per cent of the total American commercial output. Varieties range from fine- to medium-grained and are available in blue, gray, buff, and variegated colors. Berea sandstone is an extensively quarried Ohio variety. Ohio sandstones are regarded as the most durable domestic varieties.

Connecticut: Portland brownstone is a fairly uniform, medium-grained, brownish-red sandstone, once quarried in Portland, Connecticut.

Kentucky: Rowan County is an extremely fine-grained variety capable of taking a fine finish.

Pennsylvania Waynesburg stone has been used by some sculptors for carving.

Wisconsin Dunn County or Dunville stone is a fairly good, fine-grained, buff to cream-colored sandstone.

England: Sandstones are extensively quarried in *England* for structural purposes, but many of the varieties produced, such as the Devonshire and Cheshire sandstones, are also excellent for sculpture.

France produces a large amount of sandstone, some of which is excellent for sculptural use, but it is almost entirely employed locally for building purposes.

Canada is a large producer of sandstone, much of which is used locally for building construction.

MARBLE

Marble is more extensively used today by sculptors than any other form of stone. (See Plates 47D, 48B, and 52A.) It is softer and therefore easier to carve than the igneous rocks, and is more durable than the limestones and other sedimentary formations.

The use of fine-grained, creamy-white native marbles by the ancient Greeks inaugurated a tradition in the use of fine white marbles for stone sculpture. This practice was continued by the Romans and perpetuated by the extensive use of fine white Carrara marble during the Renaissance in Italy. The Romans first worked the famed Carrara quarries about the year 283 B.C. and used the marble sculpturally and architecturally in the rebuilding of Rome during the time of Augustus. Michelangelo used to visit the Carrara quarries to select choice blocks and was largely responsible for the greatly stimulated use of the Carrara marbles as a sculptural medium. Its popularity steadily increased during the succeeding centuries, until few sculptors thought in terms of any other variety of stone. During the latter part of the nineteenth century the established standard for sculptural marble was the Carrara. Within the past decade sculptors have manifested a more wholesome diversity in their choice of stone for carving.

Marbles are generally close-grained, compact stones capable of taking a high, smooth polish. This latter characteristic is responsible for the name, which is derived from the Greek μάρμαρος, meaning 'shining stone.'

Marbles are of metamorphic origin and are the result of the transformation of dolomite or limestone by various natural forces, such as pressure, heat, or chemical action. They are, therefore, closely related in a chemical and geological sense to limestones, although they differ

structurally. Marbles are occasionally referred to as crystallized limestones. Chemically, a marble is the same as a limestone, with the exception that in a limestone the carbonates are granular, whereas in a marble they are crystalline. The finer-grained, compact varieties are the best for carving. The finer types consist of an almost pure calcium or magnesium carbonate in crystalline form.

There are three major groupings of marble:

1. *Calcite forms:* These consist of between 95 and 100 per cent of crystallized calcium carbonate or calcite grains.
2. *Dolomite forms:* These are composed of crystallized dolomite ($MgCO_3.CaCO_3$) grains in proportions of approximately 55 per cent calcium carbonate and 45 per cent magnesium carbonate.
3. *Mixed forms:* These are made up of a mixture of both calcite and dolomite in varying proportions.

The specific gravity of calcite is 2.7, whereas the specific gravity of dolomite is 2.9, so that dolomite varieties are naturally slightly heavier.

Pure calcite or dolomite varieties are white. The colors, which range from a pure white to a jet black, are the result of impurities, which may be uniformly distributed throughout a block, or may be present in streaks or spots. Impurities, in varying degrees, are present in all varieties of marble. Those most commonly found in marble are:

1. Silica, in the form of silicates or free quartz particles
2. Iron oxides, such as *hematite* or *limonite*
3. Pyrite (Ferrous sulphide)
4. Aluminum silicates (clays)
5. Manganese oxide
6. Organic substances in small quantities.

Veins and other markings on marble are generally caused by one or more of the impurities listed above. Pink, red, and reddish-brown colors are caused largely by the presence of manganese oxides or hematite. The cream, yellow-ochre types usually have fine traces of limonite impurities.

Some of the factors to be considered in choosing a block of marble for sculptural use include:

1. The life [2] of the stone
2. The compactness of the block

[2] See 'Live stone,' in Glossary.

3. Freedom of the mass from veins or clouded areas
4. Uniformity of texture and fineness of graining
5. Purity of color.

The finer grades of both foreign and domestic marble are the higher-priced varieties, but for sculptural use these should be secured in preference to cheaper blocks. Stones are usually priced according to their quality, although costs of transportation and tariffs on imported varieties affect prices. The Tariff Act of 1930 placed a duty of 65 cents per cubic foot on rough marble blocks imported into this country.

DOMESTIC VARIETIES

Since most marbles are the result of metamorphism, they are generally found in mountainous regions. In this country the notable deposits are in the Appalachian belt of the eastern states.

Alabama marbles are finer-grained than the majority of the Georgia and Vermont varieties. Most of the Alabama varieties are white, some are translucent, and all are fairly pure, consisting of from 98 to 99 per cent calcium carbonate. Alabama produces one of the very finest white marbles in the United States. It is both attractive and durable, although occasionally dark streaks will mar an otherwise perfect stone. Madre Cream is a creamy-white, hard, and very fine-grained Alabama marble. Cream Blanc is also creamy-white, hard, and fine-grained and is excellent for sculptural use. Some of the creamy-white varieties have a close resemblance to Carrara marble, but frequently they have veining that renders them useless for carving purposes. Alabama marbles have a low porosity of approximately 0.5 per cent, according to U.S. Bureau of Standards tests.

California produces White Columbia, a snow-white, fine-grained variety somewhat similar in color and texture to Carrara marble.

Colorado Yule is a fine quality marble that varies in color from a pure white to white with gray clouds. It is fine-grained and excellent for carving, but it is not highly durable outdoors. White Colorado is a fine-textured, pure-white variety that is used for sculpture.

Georgia marbles are among America's finest sculptural marbles. They all have a similar and rather obvious crystalline and sugary texture, but, unfortunately, blocks are frequently mottled with iron pyrites in brittle flakes. The sculptor must also expect occasionally to encounter deep-seated blemishes. There are several beautiful varieties that take a very high polish and are generally used for com-

pact sculptural designs. Georgia marble can be roughly classed into four color groups—white, gray, pink, and creole.

Kennesaw marble is white with gray patches. White Georgia, Amicalola, and Southern are other white varieties. Silvery Gray is a light-gray variety generally free from veins and marked clouds. Light Cherokee is another light-gray marble, but is frequently veined and clouded. Etowah is one of the most beautiful of pink marbles. Its color varies from a rich, light salmon to a deep reddish pink. The clouding or veining of this variety is not uniform, but the clear, perfect blocks are among the most attractive of American marbles. Creole is mottled and occasionally blemished by clouded patches. The color varies from white to gray with black or blue-black veining. Mezzotint is gray with dark-gray markings.

The average weight per cubic foot of Georgia marble is 180 pounds. The abrasive hardness of the stone is halfway between ordinary white Vermont marble and Tennessee marble. Georgia marble is cut in the same manner as any other compact, crystalline marble. Its interlocking crystalline structure results in a stone of great physical strength and density. The absorption of water is very low. One hundred pounds of Georgia marble will absorb approximately .09 per cent of water.

Illinois: Athens marble is a fine-grained, light-colored, recrystallized limestone generally classed with the marbles.

Indiana: Wellington Cream is a creamy-buff, hard variety of Indiana limestone with fine perpendicular markings. It takes a good polish and is generally classed with the marbles.

Tennessee is the largest producer of marble in the United States. The Tennessee varieties are excellent, compact stones that may be used outdoors. They are extremely hard—undoubtedly harder than any other American sculptural marble. The stones are therefore difficult to carve and to polish. Many sculptors compare Tennessee marble to granite, but, while the marble is tough, I have not found it equal to any granite in so far as carving difficulties are concerned.

Tennessee marble is an excellent sculptural stone. It is almost pure, consisting of approximately 99 per cent calcium carbonate, and because of its compactness, it resists abrasion. The Tennessee marbles have a very low porosity. The average pore space, according to U.S. Bureau of Standards tests, is approximately 0.5 per cent. There are both fine and coarse varieties. T. Nelson Dale [3] has divided Tennessee marble into six groupings, based upon their colors, as follows:

[3] Tennessee Geological Survey Bulletin 28, *Marble Deposits of East Tennessee.*

1. Gray
2. Faintly pinkish gray
3. Pink { a. light
b. medium
c. dark
4. Fine dark red
5. Coarse dark red
6. Variegated

Vermont marbles are fine-grained, but are not too durable outdoors. There are reddish, greenish, bluish, creamy, and mottled-white varieties. Vermont white marble is regarded by many sculptors as a fine sculptural marble.

FOREIGN VARIETIES

Belgium produces many varieties of veined and colored marble, but is best known as the source of the world's finest black marble, *Noir Belge* or Black Belgian. It is a comparatively hard marble and is regarded very highly by most sculptors. (See Plate 52A.) The stone is fairly compact, takes a beautiful polish, and is quite durable, but it is treacherous to carve and fractures very easily. There are four grades of the stone marketed, but only the best grade should be used for carving. The finest grade has no veins or other markings and polishes to a jet black, brilliant surface, but, unfortunately, it also has a tendency to fracture in large, curved masses. Many direct sculptors secure contrasting textural effects by leaving portions of the surface unpolished after using the point or bushhammer. While Black Belgian is being carved, the fine particles of stone floating in the air yield a strong odor similar to that of hydrogen sulphide or rotten eggs. It is interesting that many experienced workers with the stone superstitiously regard Black Belgian as poisonous, and they take special pains to avoid skin scratches from the sharp fragments that break away during the carving process. After working with the stone, they wash thoroughly and use antiseptics on all abrasions. My attempts to secure positive, scientific confirmation of this belief have been unsuccessful: it does not appear that an abrasion from Black Belgian marble is any more or less dangerous than a similar cut or scratch from any other variety. I have worked with the stone and have not experienced any harmful physical effects.

France produces more varieties of marble than any other country, but much of the production has been absorbed and used within

France and her exports have been less extensive than Italy's. There are possibly as many as 250 varieties of marble quarried in France. Blagore,[4] in 1888, listed 240 varieties, and others have undoubtedly been discovered and quarried since that time.

Many of the colored French marbles are mottled, veined, or striped. The best white French statuary marble is the fine-grained, compact variety known as Saint-Beat. This stone is usually available in fairly large blocks and is highly regarded by French sculptors.

Greece: The Greek marbles are considered by some carvers to be the best in the world for sculpture, superior even to the fine Italian Carrara. The finest grade is called 'statuary.' The Parian and Pentelic (see Plate 48B) marbles are the most famous of the Greek marbles. Although both varieties are fairly hard, they respond beautifully to the chisel. Parian marble is somewhat coarser-grained than either Pentelic or Carrara and has a bluish tint, but both the Pentelic and Parian marbles are fine-grained, compact stones with no cleavage lines. Pentelic is snowy-white and close-grained and it frequently contains minute specks of iron that impart an additional beauty to the stone, particularly if slight oxidation takes place and changes the color to a golden or tannish-brown. Parian marble comes from the island of Paros; Pentelic, which was used for building the Parthenon, is quarried on Mount Pentelicus, near Athens.

Istrian marble, which is found on the Istrian peninsula and on some of the Dalmatian islands, is a large-grained, buff marble that compares favorably with the Greek marbles.

Italy: Carrara marble was used by Michelangelo for many of his carvings and is the best known of all marbles. It consists of small, irregularly shaped crystals of calcite fitting compactly together, and the penetration of light to an approximate depth of one inch results in a waxy or translucent appearance. Because of the soft, translucent nature of Carrara, it is difficult to achieve delicately modeled and subtle forms. Colors vary from snow-white to creamy-white with a bluish cast, but, unfortunately, sculpture in the latter color appears lifeless. A block may occasionally show 'pinholes.'

Approximately 10 per cent of the marble quarried at Carrara is of a statuary grade. The best grade is the Italian Statuary White, which is fine-grained and translucent.

Most of the Siena marbles are veined. Siena Unie, a bright yellow variety, appears to be the only one with little or no marking.

[4] Blagore, G. H., *Marble Decoration*, London, 1888.

There are many other beautiful marbles quarried in Italy, but most of the varieties exported to the United States are the veined or mottled types (see Plate 47E), which are of value to the building trades but are not desirable for sculptural use.

Canada: Marble has not been extensively quarried in Canada and little of what is produced is exported. There are a few quarries situated in Quebec Province. The majority of Canadian marbles quarried today are spotted, mottled, streaky, or patchy. There are, however, deposits of crystalline limestone varieties in the Maritime Provinces.

Other Countries: Many South American countries, notably Argentina, Colombia, Ecuador, Guatemala, and Venezuela, have deposits of fine marble. Some of these deposits have not yet been worked commercially, and much of what is produced is absorbed locally.

There are many other fine statuary-grade marbles quarried in Europe, Asia, Africa, and South America, but the production of many varieties is frequently low, and what is quarried is used locally. The costs and difficulties of transporting stones from remote districts are other factors that keep many beautiful marbles from our markets. Many deposits of statuary-grade marble have not yet been worked commercially.

BOULDERS

Boulders are loose and generally rounded, hard rock fragments that have been loosened or have broken away from parent bodies by natural forces, such as water, frost, or glacial action. They may be composed of any of several ingredients, including granite, gneiss, limestone, or sandstone, or they may be a conglomerate. They are, however, frequently of igneous origin and are abundantly distributed throughout the world. These generally rounded, free rock masses lying on the surface of the ground in fields and meadows have been occasionally used for sculpture, notably by John B. Flannagan and by William Zorach. (See Plate 47B.)

Boulders are worked in the same way as other similarly constituted stones.

MISCELLANEOUS IGNEOUS

OBSIDIAN (No Grain: Glassy)

Obsidian is a hard and brittle natural volcanic glass composed predominantly of silica in combination with other substances, such as

iron, calcium, potassium, and sodium. It is the result of molten rock masses that poured forth out of boiling subterranean furnaces and cooled too rapidly for their elements to combine into the various mineral forms. This vitreous volcanic rock is generally black or a very dark gray, although occasionally it is green, brown, or reddish and is sometimes spotted or striped. Obsidian has been used since ancient times for sculptural and decorative purposes. It was used extensively by men of the Stone Age, who tipped their weapons with the hard, natural glass.

Obsidian is found in the western part of the United States, in Mexico, Peru, Siberia, Iceland, Italy, and other countries. It takes a brilliant polish, and is, like glass, extremely brittle and grainless, breaking in perfect conchoidal fractures, so that it cannot be safely carved with chisels. Shaping has to be done by careful abrasion rather than by pulverization. The Egyptians are believed to have used sand bores for working the substance, and emery for the polishing.

Basalt (Fine-grained)

Basalt is a hard and tough igneous stone. It was frequently used by the ancient Egyptians as a sculptural medium for portraits. There are many varieties, ranging from almost glassy forms to fine-grained, compact types, and it is widely distributed geographically; Oregon, Washington, and Idaho have extensive deposits in this country.

Basalt is slightly easier to carve than granite, although both of these igneous forms are very hard, chisel-resisting materials. It is a beautiful stone for sculpture and takes a fine surface polish, if one has sufficient energy and patience to work it. The polishing serves as a superficial protection to work exposed outdoors.

The tools required for carving are fundamentally the same as those used for shaping the granites into sculptural form. The thickness of the chisels and the degree of tempering necessary are identical.

Diabase (Fine-grained)

Diabase is not a true granite, but it is a very hard and compact igneous rock generally classed with the granites and referred to as a 'black granite.' A typical diabase is a fairly fine-grained, crystalline, granular rock without quartz and composed principally of triclinic feldspar, a constituent of many igneous rocks, such as diorite and gabbro. Pyroxene, iron oxide, and sometimes apatite, a native phos-

phate of lime, may also be present. The composition of diabase is similar to that of basalt, but the grain is coarser. Diabase varies in color from dark green to near-black. The specific gravity of the stone is approximately 3.12.

Diabase is tough and durable if it has not been physically weakened or decomposed by long exposure to the elements. It is difficult to carve and requires great patience to polish manually. The tools for carving and the tempers required are essentially the same as those used for sculpture in granite.

Some varieties of diabase are popularly known as 'greenstone,' but are not to be confused with the metamorphic, soft stones also referred to as 'greenstone.'

DIORITE (MEDIUM-GRAINED)

Diorite is not a true granite, having a triclinic feldspar and no quartz, but it is generally classed with the granites and is referred to as a 'black granite.' It is of igneous origin and is very hard and compact. There are many varieties of diorite, which vary in color from a common gray to a dark gray, near-black. The stone is heavier than granite and it is quite difficult to carve and to polish. The tools required for carving are fundamentally the same as those used for granite.

Diorite has been used as a sculpture medium since Antiquity, and many Egyptian carvings in this material have been discovered.

PORPHYRY (MEDIUM-GRAINED)

Porphyry is rarely used in contemporary sculpture. It is a volcanic, fine-mass rock with scattered, coarse crystals. The colors vary from red to green. The difficulties of securing the stone, which is imported from Greece and Egypt, together with the comparative rarity of large, flawless blocks have caused it to be generally ignored by sculptors. It is a difficult material to carve and polish. The stone was used by the ancients, particularly by the Romans, for decorative and sculptural purposes.

MISCELLANEOUS SEDIMENTARY

TRAVERTINE

The travertines and calcareous tufa are related to the onyx marbles, but are microcrystalline and generally classed with the limestones.

They are composed of almost pure calcium carbonate and are the result of precipitation from springs. The majority of travertines are quite porous with large pores and cannot be highly polished. There are pink and white varieties, which closely resemble marble.

The travertines were formerly imported from Italy, but deposits have been recently discovered in America. They are only infrequently employed in sculpture.

ONYX MARBLE

A precipitated inorganic form of calcium carbonate, mentioned under alabaster (pp. 238-9), sometimes referred to as Mexican onyx (see Plate 48C, cave onyx, or onyx marble, is found in many caverns in the form of stalactites and stalagmites. A stalagmite is a deposit formed on the floor of a cave by the calcium carbonate precipitated from water seeping through the roof rock. A stalactite is formed like an icicle on the roof or side of the cave in a conical or cylindrical shape.

Mexican onyx or onyx marble is not a true variety of onyx, since onyx is essentially a silica form. Neither is it a true limestone. It is commercially classified with the marbles.

Blocks of onyx marble are not always sound, and the material should be worked very carefully. Mexican onyx is a relatively fine-variety of onyx marble and takes a fairly good polish. The material has been worked successfully and on a heroic scale in the 38-foot-high Peace Memorial erected at City Hall, St. Paul, Minnesota. This piece was designed by Carl Milles.

Mexican onyx is secured from Mexico and derives its name from its source. The Arizona marbles are all onyx varieties.

SLATE

Slate is infrequently used by sculptors today because of its physical fragility, its tendency to fracture in flat plates on being struck, and the difficulty of securing it in sound blocks. Hard slate was used sculpturally by the Egyptians. It can be worked well with files, rasps, and abrasive stones, but chisels should not be used. The material has a generally low porosity. Cracks, ribbons, and knots of flintlike siliceous materials are occasionally encountered in masses of slate. There are violet, green, and gray-to-black varieties. It is quarried largely in Pennsylvania, Maine, Vermont, Maryland, New York, and Virginia.

African Wonderstone

African wonderstone is a dark gray, slatelike stone of sedimentary origin. (See Plate 48D.) It is a very compact variety of shale composed of earth-clay substance. The stone is imported from Africa, but it is believed that there are deposits of similar material in the United States.

African wonderstone is generally available in fairly large blocks.

MISCELLANEOUS METAMORPHIC

Serpentine

Verde antique' is a term commonly applied to marbles that are green in color and that consist largely of serpentine, a hydrous magnesium silicate. The serpentines or verde antiques are capable of taking a polish and are classed commercially with the marbles, although the serpentines have been largely derived from altered dark igneous rocks. The stones are generally veined and are highly decorative, but flaws are abundant and fairly hard blocks of serpentine may contain veins or pockets of soft steatite. Unless the sculptor can secure a thoroughly sound block, which must nevertheless be worked patiently and carefully, it is best to avoid this group. (See Plate 48F.)

Talc

Talc is a magnesium silicate of the same family as serpentine, although it differs from serpentine in its physical properties. Its powder is also referred to as talcum and, in its compact forms, as steatite and soapstone. The term 'soapstone' is applied to the dark, compact variety that gives a 'soapy' or 'greasy' smooth sensation when it is touched with the fingers. It differs from talc in its coloring impurity and is usually regarded as a metamorphic stone formed from former igneous rocks of a high magnesium content.

Steatite has a fairly high specific gravity of approximately 2.8. It takes a fairly good polish and is similar in appearance to marble. The color varies from white to light gray, and yellow to green. Impurities are responsible for the green, which is the most common variety of the mineral.

Steatite is easily cut or carved with a knife and is fairly permanent for indoor sculpture if precautions are taken to prevent abrasion, since the mineral has a hardness of about 1 and it can be easily scratched

with the fingernail. Small blocks of steatite are generally of a uniform consistency. Large masses can be divided by sawing with an ordinary saw. Fine chisels and knives can be used for carving, and discarded dental implements, which have been reshaped by grinding, can be used as supplementary tools. Although steatite carves easily, care should be taken in 'cross whittling' or cutting against the grain. It is an inexpensive medium and is generally available.

Talc is excellent for small to moderately sized sculptures. It has been extensively used for many centuries and by many peoples. The Egyptians used steatite for fashioning amulets. The Assyrians made cylinder seals from talc, and it was used by the ancient Chinese and by the American Indian for ornaments, images, and utensils.

GREENSTONE

Greenstone is a relatively permanent, green-colored stone of metamorphic origin and is related to soapstone. It consists largely of actinolite and chlorite and is fairly durable, but has not been used extensively for sculpture.

Deposits have been worked at Lynchburg, Virginia.

MISCELLANEOUS MINERALS

JADE

Jade has been used for artistic and utilitarian purposes since Antiquity. Prehistoric knives and carvings fashioned of jade have been found in ancient ruins, and it was used in the New World by the early Mexicans, but its source has never been discovered.

Jade is the general term applied to two distinct mineral forms: nephrite and jadeite. Nephrite, the more common variety, has a hardness of 6.5 and is, therefore, almost as hard to carve as quartz. Jadeite has a hardness of 6.5 to 7, closely resembles nephrite, and is worked in much the same way. Their colors vary from white to deep green.

Jade is very difficult to work and requires great patience. It is used extensively in the East, particularly by the Chinese, who prize it highly. Despite the great difficulties in carving jade, they are very proficient in working it intricately and elaborately. Chinese carving of jade is a grinding operation, consisting of the application of friction by means of drills. Merrill [5] mentions a carving of white jade,

[5] Merrill, G. P., *Stones for Building and Decoration*, 3rd ed., New York, 1910, p. 349.

which is now in the Indian Museum, London, that took three genera-
tions of workers eighty five years to complete.

Nephrite jade has been found in many regions, including China,
Turkestan, Siberia, Alaska, Canada, British Columbia, and New Zea-
land. The most extensive deposits of nephrite are in the Mogaung
district of northern Burma. A large mass of jade, weighing over 7000
pounds, was discovered in 1902 in New Zealand. There are two
known deposits of the mineral in the United States, in Wyoming and
in California. Huge boulders have been found in Wyoming in recent
years, and many have been purchased for shipment to the Orient
for carving.

LEPIDOLITE (LITHIA STONE)

'Lithia stone' or lithium stone is a popular term for lepidolite, a
compact mass of fine-grained lithium mica or lithium ore. The stone
comes from very old rocks and is found in Africa, Australia, Brazil,
and in this country in Maine, Connecticut, and California. It is very
rarely used sculpturally. (See Plate 47G.)

Lithium stone varies in color and in its physical compactness. It
is frequently a delicate lilac-violet interspersed with white and dark
gray to black impurities. Occasionally large masses of quartz will be
found incorporated in the stone. Samples I secured from Chaim Gross
were not uniformly bodied; they were very fragile in areas and
crumbled away under slight stress. The stone has a hardness that
varies between 2.5 and 4. It is very soft and easily worked.

QUARTZ

There are many different forms of quartz, which is one of the most
common minerals in the earth. It is present as an important constituent
of igneous rocks having an excess of silica, such as granite, and it
occurs in metamorphic forms, such as schists and gneisses. The more
important varieties used in sculpture or of potential value as sculptural
media, and not included elsewhere in this book, are listed below.

Rock crystal has been used for centuries as a minor sculptural
medium, notably by the Myceneans, the Romans, and the early
Renaissance sculptors, but it is rarely used today, having been almost
entirely superseded by glass. Rock crystal is a hard, brittle, and single-
crystal variety of quartz. It is generally colorless and transparent and
is often of igneous origin.

Its chief source is Brazil, where it has been mined extensively in recent years.

There are deposits in the mountains of Japan. It is also found in the granitic rocks of central Japan, the Swiss Alps, India, Arkansas, and in other parts of the world. Brilliant, tiny crystals are occasionally encountered in cavities in blocks of Carrara marble.

The Japanese method of working rock crystal is simple and appropriate. The stone is very carefully chipped with a small steel hammer, which is pointed at one end and flat to slightly curved on the other. This tool is applied carefully and delicately slowly to pulverize the brittle material.

Rock crystal can be polished to a high and beautiful luster. For polishing, a finely powdered emery is mixed with water to form a paste and this is applied manually with a clean cloth or felt. A finer abrasive is then employed for the final polishing. The Aztecs used a finely divided hematite (rouge) for the final polishing of rock crystal.

Rose quartz is a coarsely crystalline variety of quartz, very difficult to·work and best ground into shape with abrasives, manually or with machines. It varies in color from a pale pink to a deep rose. The color may fade somewhat on being exposed to light.

Smoky quartz is also called Cairngorm Stone. It is a coarsely crystalline variety of quartz, difficult to shape into sculptural form.

Amethyst is a blue-violet variety of quartz, which is usually included with the precious stones. It has been used in the past as a medium for intaglios. The Egyptians utilized it as a gem stone, and the Chinese carved it. Amethyst is widely distributed.

Agate is a variegated variety of quartz with concentric or curved bands of varying texture, and a frequently unattractive color, which is generally masked artificially when the material is used commercially. It has been employed for small sculpture and for fashioning utilitarian objects. Moss agate is a variety of agate whose decorative appearance militates against its use as a sculpture medium.

Aventurine is a coarsely crystalline variety of quartz, with brilliant scales of mica or hematite. The mineral is generally yellow to brown in color, although green is also known. The term is also applied to certain iridescent feldspars.

Chalcedony is a general term applied to fibrous varieties of quartz, which break with splintery fracture. The forms are usually translucent with a waxlike luster. They are compact structurally and have a hardness of about 7, making them fairly difficult to carve. Carnelian is a

red chalcedony that was employed by the Greeks and Romans for intaglios. It is found in several places including India, Brazil, Siberia, and Florida. Sard is a rich brownish-red variety of carnelian.

Flint is a dull and frequently dark-colored granular variety of quartz. The substance is quite hard and breaks with a conchoidal fracture. It was employed by prehistoric man for fashioning implements. It is rarely used today for sculpture.

Jasper is an opaque, impure, and compact variety of quartz that occurs in many colors: dark green, brown, yellow, and occasionally black or blue. It takes a fairly good polish. Jasper was used by Chinese sculptors for carving small figurines.

Bloodstone or heliotrope is a dark green mineral with red nodules distributed through its mass. It is a form of jasper. The material was used during the Middle Ages as a sculptural medium, but it is not employed for this purpose today.

FLUORITE (BLUE JOHN)

Fluorite (CaF_2) is a transparent to translucent mineral which varies greatly in color. There are light green, yellow, blue, blue-green, rose, violet, white and brown varieties. 'Blue John' is a type peculiar to Derbyshire, England, which has been used for fashioning ornaments. It resembles lapis lazuli, and is occasionally referred to as 'litoslazuli' or 'lithos lazuli.' However, these terms are never used by mineralogists. Fluorite is available in large masses in Cordoba Province, Argentina. It is also found in Switzerland, Norway, southern Illinois, and Kentucky. The American Indian used varieties secured near Rosiclare, Illinois, for ornamental carvings. The mineral has a hardness of about 4.

Hesketh has worked this material with small points and straight chisels (flats), $\frac{1}{4}''$ to $\frac{1}{2}''$ in width. The temper employed was for hard stone. The points were used at first, with a light hammer, to rough out the forms, and then the flats were employed. Final polishing was achieved by rubbing, while wet, with carborundum bricks. Highlights were secured with jewelers' rouge applied on wet felt.

MALACHITE

Malachite is a translucent or opaque bright green stone (a hydrous carbonate of copper) with a hardness of 3.5 to 4. There are large deposits of the mineral in Soviet Russia and it is also found in Australia and Arizona. Large, solid blocks about 3 feet thick have been secured.

It has been used for ornamental purposes but is generally too decorative for sculptural use. The mineral takes a good polish, but one that does not endure for long.

LAPIS LAZULI

Lapis lazuli is a rare and costly semi-precious translucent stone. It has a hardness of about 5½ and takes a good polish. The mineral is of metamorphic origin and occurs in crystalline limestone. It is regarded as being an intimate mixture of several minerals, and not a homogeneous mineral. The more abundant mineral, lazurite, gives lapis lazuli its rich, deep azure to greenish-blue color.

Lapis lazuli has been used since ancient times for small ornamental objects and for inlaying purposes. Finely ground and mixed with gum arabic or oil, it supplies the painter with a beautiful blue pigment. Large vases fashioned of lapis lazuli are in the Vatican Museum, Rome.

The source of the finest quality is Afghanistan, although it is also found in Siberia, China, Chile, and California, and is produced artificially today. Substantially sized masses of the natural mineral are occasionally available.

RHODONITE

Rhodonite is a pink to rose or occasionally brown mineral, consisting mainly of magnesium silicate, and it is related to jadeite. It has been employed as a gem stone. Rhodonite is found in large masses in Soviet Russia and has been used by the Russians for fashioning decorative objects. Much of this beautiful material is too ornamental for sculptural use.

GYPSUM

Alabaster is a collective term used to denote two mineral forms—one, a hydrous sulphate of lime or hydrous calcium sulphate ($CaSO_42H_2O$), and the other, a carbonate of lime. The term alabaster used by the ancients is a misnomer for onyx marble, a carbonate of lime variety (pure white calcite or crystalline $CaCO_3$), which is, actually, a member of the marble family, and has a hardness of about 3. This is a banded, waterlaid deposit used by the Egyptians and the Assyrians, and its color varies from a pure white to tints of yellow and red.

'Modern' alabaster was also used in ancient sculpture and is the

kind usually referred to today when alabaster is mentioned. It is a soft hydrous sulphate of lime, with an average hardness of about 2, and can be easily scratched with the fingernail or with a knife. The substance is fairly soluble in water and its use is therefore restricted to indoor sculpture. It is a beautiful but physically fragile medium, and carvings of it must receive every protection against physical abrasion and exposure to excessive moisture or heat.

Pure varieties of gypsum alabaster are snow-white and fine-grained. It is also available in delicate tints of pink, and clear and veined whites, which are capable of taking a high polish. Some are occasionally contaminated by iron oxide, which causes brown veins and 'clouds' in the mass. The uniformly clouded or pure white varieties are preferable for sculptural use. The veined kinds should be rejected. The coarser varieties of calcium sulphate or gypsum alabaster are generally calcined to make plaster of Paris.

Italy produces a fine alabaster that is excellent for carving.

Alabaster varies in translucence. The more opaque varieties may be used for portraits and detailed forms, but the translucent ones are unsuitable because of the inevitable obscuration of form. However, alabaster is generally treated in a broad manner, since finely detailed work is not entirely consistent with the nature of the very soft and generally translucent substance. (See Plate 49A and B.)

There is an Italian method for reducing the translucence of alabaster, which also results in a hardening of the substance. After it is carved, the piece is immersed in a container of cold water that is heated slowly and carefully almost to the boiling point. The container is then removed from the fire and the water allowed to cool slowly. The alabaster hardens, loses much of its translucence, and becomes similar in appearance to the slightly translucent Italian Carrara marble. The procedure is a very delicate and dangerous one, because if the temperature is not carefully controlled, the resulting mass will have a dull, dead, and chalky appearance.

Satin spar is a fibrous form of gypsum with a silky luster. It can be very easily shaped into sculptural form.

POROSITY AND OUTDOOR EXPOSURE

Stones with a high degree of porosity are generally not desirable for outdoor use, particularly in damp, cold, and changeable climates. The density or moisture resistance of a stone is a major factor govern-

ing its durability. The penetration of moisture, together with subsequent freezing and thawing, is the initial step in the disintegration of a stone mass. The finer the pores are, the greater will be the dangers to which the block is subjected upon exposure to freezing temperatures. The sculptor should seriously consider the climate to which his finished work will be subjected when he selects stone for monumental friezes, commemorative statues, or garden sculpture. If the climatic or environmental conditions are carefully and intelligently studied before selection, the need for preservative and restorative measures will be considerably lessened.

The porosity of stone varies with different types as follows:

Origin	*Type*	*Porosity*
Sedimentary	Sandstone	Porosity varies from approximately 1% to 10%.
Sedimentary	Limestone	Porosity varies from approximately 1% to 5%.
Metamorphic	Marble	Usually quite compact, with a low degree of porosity.
Igneous	Granite	Many varieties have a porosity of less than $\frac{1}{1000}$%.

THE WEATHERING AND PRESERVATION OF STONE

The scientific study of the effects of weathering on stone and of the methods of preservation is comparatively recent. While all forms of stone are perfectly durable and permanent when exhibited indoors under normal conditions of temperature and humidity, their durability varies markedly when they are placed outdoors. All varieties are affected by atmospheric or elemental action. The degree of dissolution and disintegration depends upon the compactness and porosity of the specific type and its chemical composition.

Sedimentary and metamorphic varieties, the limestones, marbles, and dolomites, are basically carbonates and are subject to changes by chemical and physical action. In a temperate climate, chemical action is frequently the greatest danger to this group. Quartzite, on the other hand, is very insoluble and durable.

The greatest dangers to the dominantly silicate igneous varieties are chemical weathering and heat and cold, which cause alternate expansion and contraction of the rock surface. Chemical weathering is probably the more important. Heat and cold are overrated as factors.

Stone-affecting agents can be roughly divided into two major

groups, which not infrequently supplement or activate each other: chemical forces and physical forces. Some of the agencies destructive to stone are:

1. Heat and cold—frost
2. Wearing and abrasion by wind-borne particles
3. The physical and chemical action of water
4. Acid-forming gases in the atmosphere
5 Fire (which is destructive to all varieties).

1. Heat and cold are physical factors. Every stone expands on being warmed and contracts on cooling. Volume changes vary with the structural composition of the specific stone. In temperate climates, with alternating seasons of winter and summer and cool nights following warm days, the continued expansion and contraction of a statue placed outdoors may progressively weaken its physical structure. All sculptural stones are made up of either minute crystals or fine heterogeneous grains cemented closely together. Variable expansion due to heat causes a movement and strain between the particles. As a piece cools, contraction takes place and, as this process is repeated, fine fissures or surface cracks may result. The infiltration of water with dilute acids finally results in the formation of new salts possessing a greater volume than the original substance, and a solution of some constituents. The outer surface of a stone tends to react more than the inner mass to heat and cold changes.

The physical action of frost is responsible for a great deal of stone destruction. Moisture in fine surface fissures exerts a considerable pressure upon freezing, resulting in larger fissures and eventual cleavages. No stone can long withstand this pressure, for, on freezing, water increases in volume by approximately 10 per cent. The more completely filled and saturated the pores or fissures in a stone may be with water, the greater will be the danger to the block upon freezing. The danger of frost is particularly great in a freshly quarried and recently carved block of porous stone, such as 'unseasoned' limestone, which still contains quarry water.

2. Wind-borne dust particles and fragments of solid matter are erosive agents, whose destructive force varies with different regions and seasons.

3. The solubility of most varieties of stone in pure water is slight. However, rain in urban areas is not so pure as is commonly supposed. As it falls, it absorbs dust and dirt particles from the atmosphere. The

dust and dirt particles increase its abrasive physical action, which is extremely mild, but may prove of some importance over a period of centuries.

4. The concentration of acid-forming gases in the atmosphere is greatest in industrial areas. Carbon dioxide and sulphur fumes (containing sulphur dioxide) react to a limited degree when absorbed by moisture and form dilute solutions of carbonic acid and sulphurous acid [6] when absorbed by the falling rain. During a shower or storm an exposed statue is bathed by these solutions. Mild solutions of carbonic acid exert a slow solvent action on some stones. The calcium carbonate and magnesium carbonate of which marbles and limestones are largely composed are affected by carbon dioxide in solution. The larger the pores of a limestone or marble, the greater and quicker will be the damage wrought. Sandstone grains, cemented by calcium carbonate, are similarly affected. Carbonic acid will also attack alabaster and cement sculpture. It is interesting to note, however, as Loughlin [7] points out, that carbon dioxide gas, even in a damp atmosphere, has no corrosive effect on limestone, and that only when the gas is dissolved in water, does it exert a very slow solvent action which, under ordinary conditions of weather, would require about 450 years to corrode two-fifths of an inch of limestone surface.

Weak solutions of sulphurous acid similarly attack marble, limestone, dolomite, sandstone, and, to a very slight degree, granite. Dilute sulphurous acid will also react with magnesium carbonate to form magnesium sulphate or Epsom salts. This reaction is accompanied by a volume change of approximately 1.5. Fortunately, the salts thus formed are soluble in water and are generally dissolved before their expansive energy can do any significant damage to the stone.

5. Excessive, concentrated heat, such as that emanating from a wood fire, will cause considerable physical expansion of a stone mass with great danger of cracking. Intense heat will also cause chemical changes in many varieties of stone. When marble is burned, it is converted into lime.

$$CaCO_3 + heat \rightarrow CaO \ (lime) + CO_2 \uparrow$$

[6] This question appears to be in the theoretical stage. H_2O plus SO_2 yields H_2SO_3 or sulphurous acid. However, it is believed by some that sunlight acts as a catalytic agent, yielding a sulphuric acid. Bowles, in his book *The Stone Industries*, New York, 1939, p. 350, discusses the acid formed as sulphuric acid.

[7] Loughlin, G. F., 'Indiana, Oolitic Limestone; Relation of Its Natural Features to Its Commercial Grading,' *Contributions to Economic Geology*, 1929, Part 1, U.S. Geol. Survey Bull. 811, p. 113.

Many fine marble statues, possibly numbering in the thousands, are lost today because of this simple chemical reaction. Barbarian invaders and peasants in Europe reduced numerous marble statues to lime by means of wood fires in order to make mortar for building purposes.

One of the fundamental purposes of a stone preservative is to prevent the access of atmospheric moisture and rain water into the stone body. The ideal preservative would be a fluid preparation that would penetrate into the surface pores of a stone and, as the volatile solvent vaporized away, would leave the dissolved, solid protective matter in the pores. Several applications might be required, depending upon the size and abundance of the pore spaces in the specific stone mass. This ideal preservative would also possess long-term properties. It would not tend to react chemically to the injury of the stone structure, and it would have no staining or discoloring effect.

Kessler [8] found that fatty oils, heavy petroleum distillates, and insoluble soaps are the most efficient waterproofing materials, and that finely pored stones are more difficult to waterproof adequately. Paraffin was the most satisfactory material in terms of waterproofing ability and durability.

It is interesting to note that the obelisk, or 'Cleopatra's Needle,' in New York City's Central Park was treated with a mixture of paraffin and creosote dissolved in turpentine. The material was applied by warming the stone surface and applying the mixture hot. The obelisk, which was brought to New York from its original Egyptian site, apparently suffered more during a few winters here than in the many centuries it stood in the comparatively mild, dry, and uniform Egyptian climate. The paraffin treatment appears to have satisfactorily checked the ravages of rain and occasional frost.

THE DURABILITY OF MARBLE ON OUTDOOR EXPOSURE

Marbles vary in their resistance to atmospheric action. Since marble is almost wholly composed of a pure calcium carbonate or calcium magnesium carbonate, it is quite sensitive to the chemical action of the elements. Some varieties may change slightly in color because of the effects of the sun. A high concentration of atmospheric impurities,

[8] Kessler, D. W., *Exposure Tests on Colorless Waterproofing Materials*, Bureau of Standards Tech. Paper 248, 1924, 33 pp.; *A Study of Problems Relating to the Maintenance of Interior Marble*, Bureau of Standards, Tech. Paper 350, 1927, 91 pp.; *Bibliography on Weathering of Natural Stone*, Proc. Am. Test. Mat., column 31, part II, 1931, pp. 804-13.

such as soot and smoke particles, near industrial centers is particularly injurious to marble. Carbon dioxide in the air will form a dilute solution of carbonic acid when it is absorbed by rain and will slowly corrode a marble statue. Water or moisture may also penetrate into the pores, entailing dangers of a slow, progressive chemical dissolution or structural disintegration upon freezing. 'Low porosity in exterior marble is desirable, as pore spaces permit infiltration of water which may cause disintegration by freezing. Porous stones also collect soot or soil particles and therefore are not satisfactory when exposed to excessive smoke or dust.'[9]

The harder and more compact varieties of marble are generally used for outdoor sculpture. They should be fine-grained, uniform throughout the block, free from substantial impurities, and of a low porosity. The finer the graining and the lesser the porosity, the smaller will be the danger from frost. In America the finer marbles, such as Parian and Carrara, have a relatively short life (approximately 20 years) when they are exposed outdoors.

THE DURABILITY OF IGNEOUS STONES ON OUTDOOR EXPOSURE

In general, the igneous varieties of stone appear to wear better upon exposure to the elements than do the sedimentary and metamorphic varieties. The limestones are the least durable of these groups. However, within each classification there will be found a decided variation in weathering qualities, owing to a variation in the composition and the cementing material binding the material particles together.

Many of the igneous stones have a rather mixed nature. The fine-grained, uniform, and compact varieties of granite, with little porosity, wear very well.

The amounts of water absorbed by 100-pound units of various American granite varieties are as follows:

Mt. Airy granite	.25
Barre granite	.294
Milford granite (Mass.)	.340
Westerly granite	.340
Concord granite	.371
Hallowell granite	.405

[9] U.S. Bureau of Mines, Information Circular 6313.

Llano granite	.42
Winnsboro granite	.44
Bethel granite	.470

These figures are based primarily upon findings of the Bureau of Standards and the U.S. Geological Survey, Washington, D. C.

9 SCULPTURE IN STONE

TOOLS AND EQUIPMENT

THE stone-working hand tools of today are simple in an almost primitive sense. Increased knowledge in the utilization of fire and metal has given us our steel hammers and stone-cutting chisels, but these are essentially primitive in nature. Pneumatic drills, powered by electricity, are modern mechanical developments, but they are all based on the original and fundamental hand tools.

The stone-working tools of prehistoric man were apparently fashioned out of stone or flint, a hard variety of quartz. These were shaped and sharpened to a chisel-like edge on one end, while the rest was left in a rough condition to fit conveniently into the fist. The stones to be carved were undoubtedly shaped by friction and careful, minute chipping. It is possible that the visualization of familiar forms was influenced by the natural shapes of the stones.

Surviving examples of ancient stone-working tools are very rare. Ancient tools that have been discovered in Egyptian quarries [1] consisted of approximately 88 parts of copper and 12 parts of tin, forming a hard bronze alloy. While this alloy is not sufficiently hard for carving all stone, particularly the igneous varieties often employed by the Egyptians, increased hardness is believed to have been imparted by hammering the metal or by the addition of phosphorus to the molten metal.

The Egyptians used both copper and bronze chisels, as well as drills, in carving their soft stones. For the harder stones the drills were occasionally fed with emery powder. The preliminary dressing was done with stone hammers.

The eminent archaeologist Sir Flinders Petrie has made a careful study of ancient instruments. [2]

[1] Lucas, A., *Ancient Egyptian Materials*, London, 1926.
[2] Petrie, Sir Flinders, *The Pyramids and Temples of Gizeh*, London, 1883, ch. 8; 'Mechanical Methods of the Egyptians,' *Anthropological Journal*, 1883; *The Arts and Crafts of Ancient Egypt*, London, 1909; *Tools and Weapons*, London, 1917.

Many authorities believe that in Antiquity copper was made almost as hard as tool steel by a method of heat treatment. The treatment has been referred to as 'the lost art of hardening copper.' It is quite possible that an explanation may lie in the fact that some of the copper tools contained natural impurities, which imparted additional hardness, or that the copper was cold forged, so that the result was a substantially harder form of copper. However, the question is controversial, and the 'lost Egyptian art of hardening copper' is referred to as a myth by Lucas, who states that the 'only secret of hardening copper the ancient Egyptians knew was to hammer it.'[3]

Desch[4] demonstrated by experiment that copper with an initial Brinell-scale hardness of 87 could be raised to a hardness of 135 by means of hammering.

The stone-working tools of the early Greeks[5] were similar to those used today. They made use of the *boucharde* or bushhammer, the point or punch, the claw or toothed chisel, a very narrow-edged flat chisel, drills, files, rasps, saws, gouges, and abrasives. (See Plate 39.)

THE POINT

The point or punch (see Plate 39e) is an extremely important stone-carving tool, used primarily during the roughing-out stage of carving to remove large masses of stone, and later to remove smaller masses and expose the final concept. (See Plate 40.) This tool can be, but rarely is, used from the first stages of carving down to the final surface finishing and smoothing. Tools with large, substantial diameters are used at first, since the initial blows, intended to remove large masses of stone, are necessarily heavy. As the carving progresses, these tools are gradually replaced with finer and more delicate points.

Points should be held firmly but should not be clutched too tightly. The tool should be pointed at the stone and held firmly enough so that the area aimed at will be struck, but it must have enough freedom so that the point can bite into the stone with the full impact of the hammer blow. Points should never be forced or permitted to become deeply wedged within a stone, or the chisel may fracture, leaving the tip buried securely within the block.

Points are usually applied initially at right angles to the surface or

[3] Lucas, A., *Ancient Egyptian Materials and Industries*, 2nd ed., London, 1934, p. 172.
[4] Desch, C. H., 'The Tempering of Copper,' in *Discovery*, VIII [1927].
[5] Casson, Stanley, *The Technique of Early Greek Sculpture*, Oxford, 1933.

at fairly acute angles. (See Figure 7.) As the carving proceeds, the angle of application becomes more oblique. Only rarely is the point held at right angles to the stone surface after the block has been 'roughed out,' because when the carving blow is struck at that angle, there is danger of fracturing the stone and destroying its crystalline structure to a considerable depth. This danger bears a direct relation

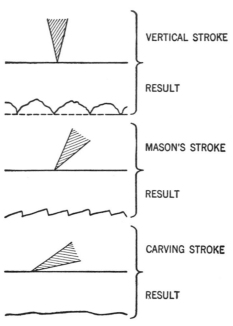

VERTICAL STROKE

RESULT

MASON'S STROKE

RESULT

CARVING STROKE

RESULT

FIG. 7. ANGLES OF APPLICATION OF THE STONE-CARVING POINT.
(After Casson.)

to the force of the blows dealt the chisel; the lighter hammer blows will minimize the danger of fracturing, although they will also prolong the time required for carving. An angle of approximately 45° is generally employed for carving.

Pointed chisels are very easily fashioned. Octagonal rods of tool steel should be cut into desired lengths by means of a hack saw. The striking end of the tool is then heated until it glows, and hammered on an anvil to a rough point. After the chisel cools, it can be ground smooth and pointed on a grindstone. The blunt, freshly cut chisel blank can also be shaped directly to a point by means of grinding the striking end on an abrasive wheel.

After shaping, points should be tempered for the type of stone that is to be carved. If the sculptor tempers his own tools, he must remem-

ber that the tempering should be restricted to the cutting end. If both
ends are tempered, when the chisel is struck with the metal hammer
the impact will be very sharp and the tool will bounce away. On the

FIG. 8. MUSHROOMING OF CHISEL END

other hand, if the end receiving the impact of the carving hammer
is too soft, it will quickly 'mushroom.' (See Figure 8.)

THE CLAW OR TOOTHED CHISEL

The claw or toothed chisel appears to have been used sculpturally
for over 2500 years. Evidences of its use have been discovered in
Greek sculpture of the sixth century B.C.

The toothed chisel is similar to the flat chisel, except that its cutting
edge consists of a straight, serrated row of flat to pointed teeth. (See
Plate 39f.) The tool is used fundamentally for the removal of succes-
sive layers of superficial stone and for the roughing-out or blocking-
out of the main forms of the design after the initial use of the pick
or point. Coarse chisels with wide, well-spaced teeth may be used at
first, followed by finer chisels with smaller and more numerous teeth,
more closely spaced, as the carving advances.

The total width of the cutting head or surface of a toothed chisel
rarely has need to exceed $\frac{7}{8}$ of an inch or a full inch. For finer cutting,
smaller sizes are naturally indicated.

The teeth of a claw chisel can vary greatly in size and in number.
A chisel with teeth $\frac{1}{32}$ of an inch in width is an extremely fine-cutting
tool and its use results in a very finely abraded surface. Chisels with
teeth up to $\frac{1}{8}$ of an inch in width are used more frequently for gen-
eral carving and shaping. The teeth can be pointed in order to pene-
trate deeply into the stone, or they can be blunt for superficial cutting
or shaving of the surface.

Toothed chisels are frequently used in place of bushhammers for

the softer varieties of marble and for the sandstones and limestones.

Michelangelo appears to have made use of both fine- and medium-toothed claw chisels. The use of the claw chisel for the final stages of stone carving is excellently illustrated by Michelangelo's unfinished stone sculptures, and a study of these will be of value to the student sculptor. (See Plate 40.)

To fashion a claw chisel, a rod of tool steel is first cut to the desired length with a hack saw. The striking end is heated until it glows and it is then placed on an anvil and beaten flat. When the metal has cooled, the flattened portion can be ground to a straight edge on a grinding wheel. If desired, the sides of the striking end can also be shaped by grinding. Triangular files are used for dividing the straight edge into cutting teeth. These teeth can be left flat or blunted, or they can be sharpened and pointed by widening the v-shaped incisions with the triangular file. After having been shaped, the tool should be tempered for the stone to be carved.

THE FLAT CHISEL

'Flats' (see Plate 39g) were rarely used in early sculpture because the ancients employed copper or bronze for their chisels, and a flat, sharp cutting edge would have blunted and been rendered useless very quickly. With the application of iron to tools, flat chisels could be made that would retain their cutting edges for reasonably long working periods. The flat chisel was frequently employed as a principal tool for working the softer varieties of stone, and especially for carving low reliefs, a form of sculpture for which this instrument is particularly suitable.

The flat chisel is employed at an oblique angle to the surface and will remove more material in a given time than will a punch. It is used today largely as a surface-finishing tool for the sandstones, limestones, and marbles.

A study of Michelangelo's nearly finished stone carvings shows that he worked in a manner similar to the Greeks and did not make much use of the flat chisel, proceeding from the use of the claw chisel to finishing stone abrasives.

Flat chisels are very easily fashioned from lengths of tool steel in the same way as toothed chisels. One end of the steel rod is first heated until it is glowing and is then beaten flat with a hammer over an anvil. When the metal length has cooled it can be shaped by grinding and then tempered for use.

CHISEL SIZES

For fashioning chisels, rods of tool steel should be cut into lengths with a hack saw. It is advisable to cut the chisel blanks 1 to 2½ extra inches in length, since the occasional fracturing of a point, a mushrooming of the end receiving the hammer blows, and repeated sharpening will slowly shorten the total length.

A 6-inch chisel can be used for close and careful finishing. Eight inches is a good general chisel length. Larger chisels of 9, 10, and 10½ inches are occasionally used for the preliminary shaping of a stone mass.

The diameters of stone-working chisels should vary according to the nature of the carving and the type of stone that is to be worked. For the preliminary carving of a rough stone mass, thicker tools are indicated. For the finishing stages, delicate chisels are generally employed. The harder varieties of stone naturally require heavier tools than the softer types.

Chisel diameters of ⅜ and ½ of an inch are best for general stone carving. For fashioning one's own chisels, rods of octagonal or square tool steel should be secured in diameters of $5/16$, ⅜, ½, ⅝, and ⅞ of an inch. The $5/16$-inch size can be used for making delicate tools suitable for finishing marbles, limestones, and sandstones. The ⅜, ½, ⅝, and ⅞ of an inch diameters can be used for fashioning heavier tools for carving hard marbles and igneous varieties of stone.

Octagonal tool steel is more easily gripped while working than is the square type, but many granite workers prefer the square variety.

THE BUSHHAMMER

The *boucharde* or bushhammer, as it is commonly called, is a tool that is essentially a multiple-point or multi-pick. (See Plate 39a.) The hammer invariably has two striking ends, each of which is geometrically divided into equally spaced, parallel rows of metallic teeth, which have been cut or filed into the metal. The teeth may vary in number from four to several hundred. As the number of teeth in a given surface increases, the size of the individual steel tooth decreases and is more closely fitted against the adjoining teeth.

The striking force of a bushhammer is theoretically divisible by the number of teeth in the working end, each of which carries a proportionate share of the force. Assuming that a single-toothed tool, such

as a pick or punch, is driven with a 10-pound force, the full 10 pounds will be transferred to the single striking point. If a bushhammer, carrying a similar 10-pound force, has four teeth, each tooth will, theoretically, bear about 2.5 pounds of the force.

The bushhammer is used for wearing down or uniformly reducing a stone surface by progressive, broad pulverization. The sculptor enjoys a great degree of control over both the tool and the area being worked upon. The bushhammer stuns a stone superficially to a less degree than the point or pick. When a flat surface is struck with a bushhammer, rows of sharp indentations are left by the steel teeth, and, as the blows are continued, layers of the stones are successively removed. Light tapping with the boucharde will remove material in thin layers.

The bushhammer is a very useful and fairly rapid tool, which may be employed from the coarse, initial roughing-out stages almost to the very delicate or final stages of the carving. As the work progresses, the hammers should be replaced with others having increasingly finer and more numerous teeth. The pitted, granular surface resulting from the use of the bushhammer is generally removed by using the flat chisel.

The bushhammer is of particular value in working with granite and other hard, igneous varieties and is used today primarily as a hard-stone tool. The boucharde can also be used satisfactorily for working the harder varieties of marble, such as Parian, Georgia, and pink Tennessee. Pentelic marble has a tendency to flake readily, and bushhammers should be used very carefully on this variety or not at all. The use of the bushhammer on the softer types of marble, the limestones, and sandstones is not recommended, although the tool has been used carefully on some of these stones with satisfactory results. The fundamental danger with the softer stones is that of too deep pulverization.

The Egyptians made extensive use of the bushhammer for the preliminary dressing or wearing down of the surfaces of hard, igneous stones, such as granite and basalt. However, the tool did not enjoy a great degree of popularity with the Greek sculptors.

There are two methods of making bushhammers:

1. The teeth of a bushhammer can be cut with a chisel after the head or striking end of the tool-steel blank has been heated to a glowing temperature and is soft. This method is generally used commer-

cially, but it is not recommended. The author's experience has been
that the use of the chisel tends to weaken the structure of the base
area of the tool, and that when the finished hammer is applied to a
stone, the teeth adjoining the weakened area will readily fracture
away.

2. A boucharde can be fashioned by manual sawing and filing. (See
Figure 9.) This method is preferable to the one outlined above. The

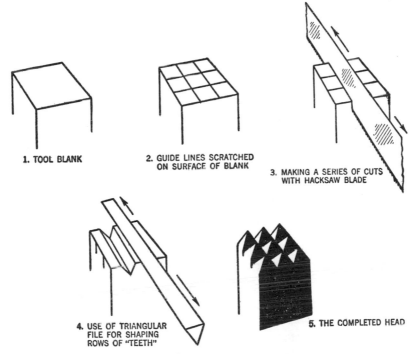

1. TOOL BLANK

2. GUIDE LINES SCRATCHED
ON SURFACE OF BLANK

3. MAKING A SERIES OF CUTS
WITH HACKSAW BLADE

4. USE OF TRIANGULAR
FILE FOR SHAPING
ROWS OF "TEETH"

5. THE COMPLETED HEAD

FIG. 9. MAKING A BUSHHAMMER HEAD

bushhammer blank should first be securely gripped in a metal vise.
Sets of equidistant parallel lines, intersecting at right angles, are cut
on the face of each striking end by means of a hack saw. V-shaped
grooves are then fashioned by the use of triangular files, dividing the
striking end into parallel rows of sharp, pointed, pyramidal teeth.

Holes to accommodate hammer handles can be punched in the
bushhammer head with a punch press after the steel has first been
annealed. If the sculptor does not have facilities for punching the
handle opening, the bushhammer head should be taken to a black-
smith.

The Bush Chisel

The bush chisel is similar to the bushhammer in its effects upon a stone surface, except that the area covered by the bush chisel is generally smaller, since the chisels are more delicately fashioned. There is, however, with the bush chisel, the advantage of a greater degree of control over the surface being worked upon.

Bush chisels are held and used in much the same way as points or chisels. The tool is grasped with one hand and pointed at the stone surface, while the other hand holds the carving hammer and delivers the blows, which pulverize and slowly reduce the surface area.

Bushhammers and bush chisels should be cleaned at frequent intervals by inserting hack-saw blades between each line or set of teeth and drawing the blade lightly back and forth several times in the long grooves.

A bushhammer should be cleaned frequently to remove particles of stone and stone dust that may become wedged between the interstices separating the teeth. The pressure of the packed debris is increased with the impact of the bushhammer upon a stone mass, and the additional stress may cause teeth to fracture off at the striking end.

The Pick

The pick is a pointed hammer generally mounted on a short wooden handle and used in much the same manner as the boucharde. (See Plate 39c.) Some picks are pointed on one end and rounded on the other, but many sculptors prefer to use both as working ends.

The pick cracks and chips away masses of stone and is of value in removing large fragments during the early stages of blocking out the initial forms. When the pick is originally applied with force and at right angles to the stone, the blows crack or flake-fracture large areas of the block and considerable amounts of stone can be quickly removed.

The pick is particularly applicable to marbles, but it should be used with care because it is apt to stun the crystalline structure of a marble to a considerable depth, depending upon the force of the blow and the angle of its application. It is initially applied at right angles to the stone and the angle of application is gradually changed as the work progresses, since right-angled blows may cause a deep-seated fracturing of the crystalline structure. The force of the blows is also reduced as the carving progresses.

To fashion picks, tool-steel blanks are heated until glowing and the ends hammered on an anvil to rough, tapering points while the metal is hot and plastic. After cooling, the points can be finished on a grindstone. Holes for hammer handles are fashioned in the same manner as are bushhammer openings. Picks should be tempered, as are chisels, for the specific stone on which they are to be used.

MALLETS AND HAMMERS

Metal striking or carving hammers should be fashioned of untempered tool steel. The hammer heads employed for stone sculpture usually vary in weight from 2 to 4 pounds, and they are generally mounted on short wooden handles. (See Plate 39.) Sculptors occasionally wind thin strips of leather around the handles so they can be more firmly grasped.

Wooden mallets are frequently used for cutting the softer types of stone and also for the lighter, finishing phases of carving, when fine, narrow chisels are employed.

ABRASIVE TOOLS

Abrasive tools have been used since the time of the Egyptians, and they are used today by virtually every sculptor during some phase of the stone-carving process. (See Plate 39d.)

Abrasive tools are finishing tools and are of two basic types: (1) metallic rasps and files, and (2) stone or mineral abrasives.

Rasps and files are made of metal. The cutting teeth of files are fashioned by lines made in the metal surface. Rasps are filelike tools with sharp, pyramidal projections or teeth, which are formed by indentations made in the metal with triangular points while the rasp blank is hot and soft. Rasps are frequently used for wearing down small areas and for delicately finishing surfaces, although many sculptors prefer to use a very narrow, flat chisel for the final surface finishing. The use of rasps and files results in attractive stone finishes, although striated markings are invariably left by these tools. There are many types of rasps and files available, ranging from those with very fine teeth or cutting edges to coarse tools that can be used for the rapid abrasion and shaping of broad areas. They are also used on woods and plaster for wearing down and shaping surfaces.

Stone abrasives have three functions: cutting, smoothing, and polishing. Coarser-grained, hard stones are employed for cutting; medium stones are for smoothing; and fine and comparatively soft abrasive

stones and powders are used for polishing. Emery is the hardest abrasive used in sculpture. It was used by the Egyptians to feed their stone-carving drills and by the Greeks for cutting detail and grooves and for the final surface smoothing of their carvings. Synthetic emery is available in a variety of shapes and sizes. Carborundum, or silicon carbide, is another very important abrasive frequently used for shaping and smoothing. The material was discovered in 1891 by Acheson and is available today in a great variety of shapes and sizes. Sandstones are frequently used as abrasives for the softer stones. Fine emery cloth, sandpaper, and chunks of solid pumice are also used for shaping and finishing stone surfaces.

PROTECTIVE GOGGLES AND MASKS

Sculptors should use protective goggles and masks while carving stone. Masks can be bought from chemical supply houses. Their use prevents the inhalation of fine particles of stone dust, which should be particularly avoided when carving silicates, as silicosis may develop.

Goggles protect the eyes from sharp, flying particles of stone and are very necessary during the initial roughing-out stages, when picks and points are frequently employed and when the blows struck have sufficient force to send fragments of stone flying through the air with great velocity. Goggles are also very important when igneous stones and the hard varieties of marble are carved.

PNEUMATIC TOOLS

Pneumatic tools are used for two fundamental purposes:

1. To lighten the physical labors invariably entailed in stone carving. Results are achieved with a pneumatic drill with a minimum expenditure of muscular energy.
2. To reduce substantially the time required for carving a stone sculpture. Markedly quicker results are secured with a pneumatic drill than by the manual use of hammer and chisel.

The force of the blows delivered by a pneumatic tool are supplied by compressed air, while the instrument proper is guided by hand.

Both heavy and delicate interchangeable carving chisels are available for pneumatic drills. Fine tools are used for delicate carving; heavy tools for the preliminary rounding out of the stone mass and for harder types of stone.

The pneumatic drill is of more significance in carving the harder, igneous varieties of stone, such as granite, than it is for cutting sandstone, limestone, and the average varieties of marble. It can be quite useful in the preliminary stages of carving a rough stone block, when the major forms are rounded out by the initial removal of large external masses of stone.

The disadvantages of pneumatic drills are as follows:

1. Pneumatic equipment is expensive when compared with the cost of hand tools.
2. The control of a pneumatic tool is usually not as delicate as that secured with hand tools. This is particularly true in the finishing stages of stone carving, since pneumatic drills are generally somewhat bulky and heavy.
3. The health hazards entailed in using the pneumatic drill are substantial.
 a. Stone fragments broken off during carving are driven into space with greater force by the pneumatic drill than by manual tools.
 b. The pneumatic chisel charges the air with a greater concentration of fine stone dust than do manual tools.
 c. The vibration of a pneumatic tool, particularly after prolonged use, apparently affects the blood vessels of the hand and arm, frequently impairing the circulation and resulting in 'white fingers' or 'pneumatic hammer disease.'

The effects of prolonged, repeated percussion on the circulatory system of the hands was first reported in 1911 by Loriga of Rome. Cottingham,[6] at the request of the Journeymen Stone Cutters' Association, made an important investigation in 1917 on the effects of the pneumatic chisel upon stone workers in the Indiana limestone belt. Another excellent report,[7] sponsored by the government and published in 1918, was made by Dr. Hamilton. These have been several since that time, the most recent of which is one by Gurdjian and Walker.[8]

[6] Cottingham, C. C., Stone Cutters' Journal, 32:5, May 1917.
[7] Hamilton, Alice, A Study of Spastic Anemia in the Hands of Stonecutters, in Bulletin 236, U.S. Department of Labor, Bureau of Labor Statistics, Industrial Accidents and Hygiene, Series no. 19, 1918, p. 53.
[8] Gurdjian, E. S., and Walker, L. W., 'Traumatic Vasospastic Disease of the Hand (White Fingers),' Journal of the American Medical Assoc., 125: no. 10, 3 Nov. 1945. See also Telford, E. D., McCann, M. B., MacCormack, D. H., '"Dead Hand" in Users of Vibrating Tools,' in Lancet, 2:357-88, 22 Sept. 1945, p. 359.

The Star Drill

The star drill is a long metallic rod with a fluted end, used primarily for drilling holes in stone for mounting purposes. (See Plate 39h.) The method employed consists of the progressive pulverization of the localized spot by means of repeated hammer blows on the drill, which is held between the fingers. As the hammering progresses the drill is slowly revolved between the thumb and fingers. Water should be used occasionally to flush the hole and wash away the pulverized stone, which might otherwise clog the opening and wedge the tool. It is important to keep rotating the drill in the hole as the blows are struck, for if the drill is kept in one position, it may become securely wedged in the opening and snap off.

Star drills are available in a variety of sizes, ranging from very delicate drills for fashioning small openings to tools that may be used for large borings. The drill invariably makes an opening slightly larger than the diameter of the drill, so that if an opening an inch in diameter is desired, the drill should have a diameter of a trifle less than an inch.

After holes are drilled, metal rods are inserted into the openings. A rod should project from the work far enough to fit into a corresponding hole in the stone or wood base block selected for the mounting.

Tools for Granite

The tools required for carving granite and other hard, igneous stones should be thicker and heavier than those employed for carving the limestones and marbles. They also have to be specially tempered.

Chisels for granite carving should be from 9 to 10 inches in length and should be fashioned from square tool steel. The type of tool steel called 'Peerless' is an excellent, high-grade steel for making granite carving tools. The chisel diameters should vary and should include ½-inch chisels, ⅝-inch chisels, ⅞-inch points, and ⅞-inch chisels.

Tempering

The process of regulating hardness in tool steel is called 'tempering.'

When hard steel is heated, the metal is softened and its brittleness is reduced. If the glowing steel is quickly cooled or 'quenched,' it will become hard and somewhat brittle because of internal stresses. This

brittleness can be overcome by reheating the metal and cooling it slowly.

The tempering of tool-steel, stone-carving implements is done quite scientifically. The tool is first heated to 'draw out' whatever hardness the metal may possess. This is accomplished by placing the shaped working end of the tool into a high degree of heat and keeping it there until it becomes a glowing red. It should never be heated beyond a cherry or bright red color. If a white heat is reached, the metal may 'burn' and be rendered useless.

The tool is then plunged into cold water, and this quenching will cause the metal to become very hard. However, since very hard steel is too brittle for most carving purposes, some of the hardness has to be removed. The degree of hardness to be retained will vary according to the purpose for which the instrument is intended. To remove some of the hardness, the tool is placed over a low heat and carefully warmed. As the heat is applied, the steel will change color, or oxidize.

Temper Colors: If the surface of a piece of steel is polished clean with a fine emery cloth and then heated slowly, color changes will be observed on the metal surface. A pale straw color will first appear, succeeded by a darker straw color. This will change to a bronze or brown, followed by a reddish violet, which in turn will change to a blue, and finally to a dull red. At the dull red stage, all hardness will have been removed. The tempering operation can be terminated at any stage by removing the metal from the heat and quickly cooling or quenching it in water.

Temper colors are due to the formation of a thin oxidation scale on the metallic surface. This can be easily removed manually, if it is desired, by rubbing or polishing.

It is very important to temper tools under conditions of natural daylight, because temper colors are deceptive under artificial light and will tend to appear in a softer range. Temper colors will also vary somewhat with the metal or type of steel alloy employed, so that the following table may be regarded as a general one:

COLOR TEMPERING SCALE

Approximate degrees F.	Color of oxide
400	light straw
435	straw
470	dark straw
510	bronze-brown

Approximate degrees F.	Color of oxide
540	violet
575	dark blue
630	light blue

Judging the temperature to which a piece of polished steel has been subjected by the color of the oxide film formed upon it is, at best, a somewhat crude approximation. However, while this method has been superseded industrially by the introduction of modern pyrometric instruments, which accurately measure the precise temperature of the furnace or the work being treated, judging temperature by temper colors is satisfactory for sculptural purposes.

The uniform tempering of an entire steel body is accomplished industrially by the use of oil, salt or brine, or lead baths. It is also achieved in hot-air tempering furnaces in which the steel is heated to the correct temperature and then removed and cooled quickly by oil or water quenching or allowed to cool slowly in the air. However, the advisability of uniformly tempering stone-carving tools is questionable.

A method employed for point hardening consists of heating the tool to about 2 inches from the striking end, and cooling it by immersing approximately 1 inch of the tip in water. The end is then quickly polished and, as heat from the major body mass of the tool travels toward the point, temper colors will appear. When the desired color or hardness is reached, the tool is quickly plunged into cold water.

The sculptor should always remember that as the temper hardness is increased, the brittleness of the tool will also increase and that it will therefore fracture more readily when used on hard stone. Finishing chisels or 'flats' can be tempered quite hard, since they are used chiefly for surface finishing and not for carving.

The temper color required for carving tools for marbles varies. The soft marbles require a bluish-violet tempering. Tools for carving the harder types of marble are generally tempered to a gold color. The temper color for granite is a very delicate straw to near-white.

The Care of Tools

Tools should be kept sharp and clean. Points and flat chisels can be sharpened by the use of an abrasive sharpening stone. Bluestone is frequently used for this purpose, with water as a lubricating agent.

The untempered ends of working chisels will frequently begin to mushroom (see Figure 8) after repeated hammer blows, and the sharp, irregular, overhanging edges should be ground off on an abrasive stone or wheel.

METHODS OF APPROACH TO STONE CARVING

There are two fundamental methods of approach to the art of carving in stone: the direct method and the indirect method. However, there are many variations or modifications of each of these two basic methods and these are extensively practiced by contemporary sculptors. (See Plates 42 and 43.)

INDIRECT APPROACH

The indirect method of stone carving involves the use of previously prepared three-dimensional models, built up in most cases of plastic clay and then cast in a more durable substance, such as plaster of Paris. The casts are then utilized as master models from which to take points or otherwise copy. The clay model is generally constructed in the size desired for the finished stone work. After the work is cast in plaster, it is usually assigned to a professional carver, who, with the assistance of a pointing machine, proceeds to duplicate the original model in stone. Occasionally an indirect sculptor may personally point a work, or have his studio assistants or students do this for him.

The indirect approach is essentially a mechanistic process employed for the reproduction in stone of a work designed and fashioned in another medium. Herein lies the danger that a substantial degree of spontaneity and vitality will be lost in reproduction. The indirect method is also used in mechanically enlarging from a smaller model or reducing from a larger model, and is the precise opposite of the direct method of carving.

The indirect method very often necessitates a substantial waste of stone, since the professional carver or sculptor is primarily concerned with a reproduction of a specific size, and generous allowances for waste are invariably made in securing a block for the individual work.

Another cause of waste peculiar to the indirect method is the practice of designing a work wholly in terms of clay, with little regard for the nature of the eventual stone version and the compactness of design required by this medium.

There are several reasons for indirect sculpture:

1. The physical aspect of carving stone is one of the major factors responsible for the indirect method. Indirect sculpture is physically economical for the sculptor, since the months of carving that a piece frequently entails involve considerable hard work. It definitely requires a high degree of patience. With some indirect sculptors, sheer indolence and the 'hobby' or avocational attitude are very real factors.

2. The indirect method is also materially economical, since the risk generally involved in freely carving the stone block is eliminated by mechanical instruments. Mistakes can rarely be rectified in stone carving, and when the total cost of a stone sculpture in terms of time, energy, and financial expenditure are considered, indirect sculpture is the more economical and easier course to follow.

3. Lack of basic technical knowledge and personal confidence is an important element responsible for a substantial number of indirect sculptors.

The disadvantages of indirect sculpture are:

1. The process of modeling a work, casting it in plaster, and then either carving indirectly from it or sending it out to be carved generally entails a greater expenditure of time than if a piece were carved directly.

2. The copying model is almost invariably composed in a material different from that in which the final, permanent reproduction is fashioned. The qualities of the ultimate stone or wood are not present in the original clay model, nor are they, naturally, present in the finished copy.

3. It is definitely difficult to retain vitality in a work when it is reproduced mechanically from clay or plaster into stone or wood, particularly since most indirect sculptors have a meager knowledge of, and experience with, wood or stone.

4. The effect of a work depends to a great extent upon the lights and darks or the play of shadows. The effect of opaque clays cannot be adequately achieved in a reflecting and very often partly transparent stone surface, such as many marbles possess.

During the latter half of the nineteenth century, and extending into the first part of the twentieth, virtually all stone sculpture was produced by the indirect method of carving, and the majority of these pieces were executed by commercial firms and individual stone cutters hired by the sculptor.

The sculptor during this period was fundamentally a dilettantish modeler, who quite frequently did not even fashion the preliminary plaster cast from his clay original. There is an amusing anecdote related by some direct sculptors regarding a sculptor whose most recent work was criticized by a friend as having deteriorated substantially from his previous creations. The sculptor accepted the criticism passively, merely remarking remorsefully that his marble carver had recently passed away and that he had since been forced to do his own work!

A large number of sculptors today, unfortunately by far the great majority, do not carve directly. Some do not carve at all, developing their concepts in partial or full-sized clay models, casting from this or having the work cast for them, and then turning it over to a professional stone carver for the final version. Others instruct their stone mechanics to reproduce their clay or plaster work in stone to within a thin layer or film of the final surface, and this minute thickness is then worked by the sculptor.

The contemporary tendency in serious stone sculpture, however, is again toward the direct method. The movement was revived in France, and has been substantially stimulated by the great and wholesome tendency toward functionalistic design.

Direct Approach

Direct carving or *taille directe* is by its very nature an essentially creative process, resulting in a freer and more wholesome result than that generally achieved by means of the indirect method. (See Plate 42 and Plates 50 and 51 for direct carving in wood.) Direct carving appears to have been the original method of working in stone. It was first employed by prehistoric man. The Egyptians and Assyrians and, later, the sculptors of Archaic Greece practiced this method of stone carving.

The most capable and significant of our contemporary sculptors are all direct carvers. The so-called academicians are fundamentally modelers who practice the indirect method, and the sculpture-by-proxy group receives its supporters from this cluster, whose exhibits are often remarkable for their uniformity of carving and slickness of finish, all too frequently the handiwork of but a few professional cutters or stone mechanics.

The direct sculptor in stone has a profound respect for his material, which is his primary interest. He feels that there must be a minimum

of wasted stone, and that, therefore, the form or forms must, as it were, fit rather compactly against the shape of the block as it came to the studio from the stone yard or quarry. There is a definite preference on the part of the direct sculptor for the rough and irregularly shaped block. Since the shape of the crude stone block largely determines the nature of the work with many direct sculptors, they may purchase a block of stone and allow it to remain untouched in the studio for many months, while mentally developing and evolving the concept of the work to be eventually carved, as suggested by the rugged, crude form of the block. After the problem has been thoroughly thought out, the actual process of carving is begun. These preliminary steps may occasionally be reversed, and the sculptor may first develop a concept and then search for a block of stone suitable for the undertaking. There is a complete and direct personal control of the work when the sculptor handles his material from the inception of the piece to the final finishing stages. The completed sculpture invariably retains the strength of the original concept.

The procedure in direct carving is quite simple. Few tools are required and these, for stone sculpture, consist of a sculptor's hammer, a few chisels, and possibly a pick, together with one or more bush-hammers of various sizes. The general forms are blocked out simply, and the outer layers of the stone mass are removed gradually and evenly, until the form or concept remains. The form or forms may be modified or altered somewhat as the work progresses, but major changes are not always possible. The method is actually a slow process and one requiring great patience. It permits considered deliberation and a continuous, constructive evolution of the final forms. A capable artist who makes use of this method can produce a well-evolved sculpture, achieving the impression that the creation was released from its superficial stone shell.

A direct carving is invariably complete as an organic whole during any stage of the work, from the rough beginnings to the final finishing stages. The method is an analytical process and one that is basically functionalistic. The material determines the design and imposes its individual limitations. There is little waste and the final results possess greater vitality and wholesomeness than the results achieved by means of the indirect method.

Some substantial criticism has been directed against the sculptor who respects his medium to the extent of desiring a minimum of wasted stone, and who adapts his concept to imperfections that are

uncovered within the block as the work progresses. The critics main-
tain that the rough shape of the stone as it comes to the sculptor is
accidental at best, and that he is therefore handicapped, since the
medium should be controlled by the sculptor, rather than the reverse.
They claim that the shape of the stone block, together with stratifica-
tion, veinings, and other markings caused by nature or accident,
should not result in any modification of form or adaptation of con-
cept to conform with the restrictions of the stone block, but that the
sculptor should control the medium and disregard limitations of
shape, structural weaknesses, and so forth.

Many indirect sculptors regard carving a block of stone from the
rough beginnings to the final stages as wasteful in time and energy:
some leave the coarser and more manual initial hewing of a rough
block to assistants; others hire pointers and carvers for everything
save, in rare instances, the final touches. They compare their practice
to that of the architectural designer, who conceives the project, plans
and renders it on paper, but sees no necessity for mixing mortar and
laying, or supervising the laying of, each brick.

Another popular criticism of the direct approach holds that the
sculptor, having no recourse to mechanical reference to models, in-
fuses the carving process with a fear of failure that hampers the hand
and fetters the imagination.

Many of the great sculptors of the past made use of small studies
in wax before they carved the stone block. Michelangelo often made
preliminary wax sketches, which may logically have been fashioned
in order to capture and make concretely three-dimensional the mental
concepts he had. (See Plate 44A.) It is also possible that he used
preliminary models to work out his compositions before carving on
a grand scale was attempted in stone. It is known that wax studies
were often used by him as a working guide. Vasari relates that
Michelangelo often utilized a method of working in which 'one takes
a figure made of wax or other firm material and immerses it in a vessel
of water: the figure is then gradually raised, displaying first the upper-
most parts, the rest being hidden, and as it rises more and more the
whole comes into view.' This is based upon the credo of the direct
sculptor, that the form lies dormant or 'sleeping' within the confines
of the stone mass. One of Michelangelo's sonnets maintains that the
sculptor never invents anything that does not lie concealed and rest-
ing within the block of marble, and that no hand that is not animated

by the spirit will extract from the block what lies concealed within, covered and hidden by a superfluous film or shell of stone.

> The best of artists hath no thought to show
> Which the rough stone in its superfluous shell
> Doth not include: to break the marble spell
> Is all the hand that serves the brain can do.[9]

Michelangelo made a small three-dimensional sketch of the *David* before carving the stone block. The study was about a tenth the size of the marble block and was carefully worked out in detail. There are, in addition, several wax fragments of limbs for the *David* in the Victoria and Albert Museum at South Kensington. Some supposedly authentic clay models for the Medici Tombs are in Germany. In 1925, seven models were discovered in an attic of St. Peter's,[10] two of which are draped torsos apparently intended for buttresses in the dome, and five are complete figures of Prophets. The models are not very large, being approximately two feet high, but they possess monumentality, and it appears perfectly reasonable to assume that Michelangelo intended to carve huge statues of these. Some scholars seriously consider the possibility of Michelangelo's having prepared and used full-sized models.

In some instances it appears obvious that Michelangelo carved directly into the stone without recourse to models. A study of his *Slaves* will reveal that the raw blocks of stone suggested the forms contained within. The basic shape of the stone blocks as they came to him from the quarry was retained.

Another Renaissance figure, Benvenuto Cellini, advocated working out problems of form in wax before attacking the stone block.

To succeed with a figure in marble the art requires a good craftsman first to set up a little model about two palms high, and in this model he carefully thinks out the pose, making his figure draped or nude as the case may be. After this he makes a second model of the size his marble is to be; and if he wants it to be particularly good he must finish the large model much more carefully than the small one. If, however, he be pressed for time, or if it be the will of his patron who needs the work in a hurry, it will suffice if he complete his big model in the manner of a good sketch, for this may be quickly done, whereas the working out in marble takes a long time. True it is that many strong men have gone straight for the

[9] Sonnet xv, 'Rime,' quoted in Symonds, J. A., *Life of Michelangelo*, 2nd ed., London, 1893, vol. 1, p. 110.
[10] These were discovered by Monsignor Cascioli, director of the Museo Petriano.

marble with all the fury of the chisel, preferring to work merely from a small and well designed model, but, notwithstanding, they have been less satisfied with their final piece than they would have been in working from a full size model. This was noticeable in the case of our Donatello, who was a very great man, and even with the wondrous Michelangelo, who worked in both ways. But it is perfectly well known that when his fine genius felt the insufficiency of small models, he set to work with the greatest humbleness to make models of the size of his marble; and this we have seen with our own eyes in the Sacristy of St. Lorenzo.[11]

Leonardo da Vinci advocated similar preliminary steps, although his instructions were much more mechanistic and precise, and therefore basically indirect in nature.

If you wish to make a figure of marble make first one of clay, and after you have finished it and let it dry, set it in a case, which should be sufficiently large that—after the figure has been taken out—it can hold the block of marble wherein you purpose to lay bare a figure resembling that in clay. Then after you have placed the clay figure inside this case make pegs so that they fit exactly into holes in the case, and drive them in at each hole until each white peg touches the figure at a different spot; stain black such parts of the pegs as project out of the case and make a distinguishing mark for each peg and for its hole, so that you may fit them together at your ease. Then take the clay model out of the case and place the block of marble in it, and take away from the marble sufficient for all the pegs to be hidden in the holes up to their marks, and in order to be able to do this better, make the case so that the whole of it can be lifted up and the bottom may still remain under the marble; and by this means you will be able to use the cutting tools with great readiness.[12]

A 43 r.

Da Vinci's method is the forerunner of the mechanistic, indirect movement in sculpture, although the actual practice of pointing appears to have had its primitive beginnings in Greece, when the demand for sculpture became so great that mechanical, time-saving devices were developed.

Eric Gill wrote:

It is not desirable to make exact models in clay, because the sort of thing which can be easily and suitably constructed in clay may not be, and

[11] Ashbee, C. R., *The Treatises of Benvenuto Cellini on Goldsmithing and Sculpture*, pp. 135-6.

[12] MacCurdy, Edward, *The Notebooks of Leonardo da Vinci*, New York, 1939, pp. 1018-19.

generally is not suitable for carving in stone. . . Modeling is a process of addition; whereas carving is a process of subtraction. The proper modeling of clay results in a certain spareness and tenseness of form and any desired amount of 'freedom' or detachment of parts. The proper carving of stone results in a certain roundness and solidity of form with no detachment of parts. Consequently a model made to be full size of the proposed carving would be, if modeled in a manner natural to clay, more of a hindrance than a help to the carver, and would be labour, and long labour in vain. . . The finished work is not a piece of carving but a stone imitation of a clay model.[13]

However, in a later article he states that the use of clay models for stone carving is a 'technical matter' and is a 'matter of personal convenience or preference.' [14]

THE CARVING AND TREATMENT OF STONE

Each variety of stone, each block, and each carving presents problems peculiar to itself, so that it is practical to indicate here only general carving procedure. In stone carving, as in wood carving, there are no short-cuts or paved roads to traverse. The sculptor must supplement factual knowledge with practical studio experiences.

The physical qualities of the medium, such as hardness, texture, color, and permanence or durability, should be taken into consideration in determining the treatment of the work. These elements partially determine the possibilities and limitations of the specific medium.

Stones vary in color from the transparent, colorless, rock crystal to stones ranging from a pure, dazzling white to a jet black. Many are uniformly colored throughout the block, and these are preferable for sculptural use to those that are mottled, striped, or veined.

The texture of a stone is its superficial, surface appearance as determined by the size of the grains or units composing the variety and the arrangement or compactness of these units. The porous types, such as most of the limestones and sandstones, generally present a rough and pitted appearance. The marbles and igneous varieties appear more compact and crystalline. For sculptural purposes uniformity of texture, as well as uniformity of color, is desirable.

[13] Gill, Eric, *Sculpture, An Essay on Stone Cutting*, Sussex, 1924, pp. 26 f.
[14] Gill, Eric, 'Eric Gill Compares Modelling and Carving,' *Architectural Design and Construction*, vol. III, no. 6, April 1933, pp. 212-15.

Stone is a hard and weighty material, and designs in this medium must of necessity be compact. The harder the stone, the more massive or broader the treatment it demands, entailing a simplification of form and design. The softer stones, such as most of the limestones and many of the marbles, allow for a very realistic treatment and detailed modeling. However, some of the very soft and translucent varieties are also treated in a broad manner. The size of a stone carving should also be in keeping with the subject matter or the nature of the work.

A block of stone should first be tested with the metal carving hammer for 'life,' and then wetted down to show up possible cracks, streaks and veins, or stratification. A dull texture usually indicates inferior, weathered stone. A block suitable for sculptural use should be 'alive.' The stone should yield a clear, ringing sound when struck with a sculptor's metal stone-carving hammer. A blow on 'dead' stone will give an absorbed, dull thud. Fresh fractures should always appear bright and clean.

If the block proves to be satisfactory, it should be placed upon a sturdy floor stand and the carving can be started. Lifting a heavy block of stone into place alone and by sheer muscular effort is not recommended, regardless of how powerful one happens to be. A block of stone is most satisfactorily lifted into place by means of a studio pulley arrangement. If this is not available, assistance should be secured and the block very carefully worked up an inclined plane or tilted carefully back and forth while planks are slipped beneath to raise it slowly to the desired height. The block can then be transferred onto the floor stand by placing small round rods beneath the block and carefully rolling it into place.

A block can also be mounted on a large wooden barrel that has the top still in place. Barrels with iron bands circling the top, waist, and base and reinforcing the staves are excellent for this purpose. Sturdy modeling stands are also used for supporting stone blocks during the carving process. Both floor stands and studio floors should be sufficiently strong to sustain the blocks to be carved.

The majority of sculptural stones can be cut in all directions. However, the sculptor will frequently discover that a block of stone will be easier to carve in one direction than in another. It should be carved uniformly from all sides, in a consistent and equal manner and against the direction in which the individual block scales or

cleaves. If it is desired, the rough design can be chalked on the stone mass before the carving is begun.

Granites are quite difficult to carve and polish, since many of the ingredients of a granite are either equal to or harder than ordinary steel. Feldspar has a hardness of 6 and quartz of 7, while steel varies between 5 and $5\frac{1}{2}$. The other igneous varieties generally used for carving are similarly difficult to carve, but their physical nature, demanding compact designs with little projection, serves to contribute additional physical permanence to the work.

Alabaster, sandstone, limestone, and marble are softer materials and are more easily carved, although some varieties are quite hard.

The hand tools used for carving vary with the personal requirements and preferences of the individual sculptor and with the nature of the stone to be carved. In carving, the impact of the hammer blow to the chisel is transferred to the area to which the sculptor directs his cutting edge or point. Heavier-diametered and suitably tempered tools are invariably indicated for the hard, igneous varieties, and thinner, more delicate tools for the majority of marbles, limestones, and sandstones. Heavier tools are also frequently employed for the initial roughing-out stages, and finer tools are used for finishing purposes.

Picks and points are generally used for the initial roughing out of the masses, followed by the gradual introduction of the bushhammer as the work progresses. As the carving develops and layers of stone are removed, heavier bushhammers should be replaced with lighter ones having finer teeth, and the blows should be less vigorous than they were at first. If the blows struck with a boucharde are extremely heavy, there is the danger of a deep-seated pulverization and weakening or actual fracturing of the stone mass.

Toothed chisels are frequently employed after the use of points and also in conjunction with the point in the secondary stages of roughing out the form. Many sculptors, during this secondary stage, work to within $\frac{1}{2}$ to $\frac{1}{4}$ of an inch of the final surface contour.

Flat chisels are used almost entirely for finishing and are quite frequently supplemented and succeeded by abrasive stones. There are a few sculptors who have successfully and exclusively employed points throughout the carving process, finishing the surfaces with abrasive stones.

The surface finish of a stone carving should be regarded as an important design element. The free-standing figures of the Greeks,

which were intended to be viewed from all sides, were generally uniformly finished. Those to be viewed frontally and from the sides had backs that were frequently left unfinished. Most of the stone sculptures of the Renaissance were consistently finished. The tendency in contemporary sculpture is to vary the surface finish, and an entire carving is rarely finished or polished uniformly.

While the majority of ancient sculptures were invariably colored superficially, this practice gradually died out, and today painting stone sculpture or gilding marble with gold is regarded as undesirable and artificial. However, some contemporary sculptors, notably Eric Gill, have experimented with the possibilities of painting portions of stone sculpture. (See Plate 48F.)

POINTING

Pointing is a mechanistic method of copying from a three-dimensional model. The model generally consists of plaster of Paris, and the substance that is used for reproduction is generally stone, although the pointing of wood and, less frequently, ivory, is also practiced. (See Plates 14B and 43.)

Professional pointing is a definitely undesirable and mechanical means of securing reproductions. It is undesirable because of the wholly uncreative and devitalizing nature of the process and the invariably lifeless or very 'slick' product that results from it. A work almost invariably loses life when it is reproduced by pointing, even in those very rare instances where the sculptor does his own marble pointing, because all too frequently he is subjugated by the machine.

Although pointing dates back many centuries to the time of the Greeks, it was not until the time of Canova that the pointing machine was perfected. There is evidence that during the Late Hellenistic period the Romans used a primitive version of the pointing machine, and this mechanical device may partly account for the large number of Roman copies of Greek sculpture. However, it appears that the Romans took only a few major points. The current practice is to take hundreds of points for a head; occasionally the number of points taken runs into many thousands for life-sized figures.

Probably during the Renaissance in Italy the practice first came into being of hiring professional craftsmen or *formatore* to reproduce in stone works that had been originally modeled in clay. Clay had been used extensively before this, but as a medium in its own right and not as a substitute for the direct carving of stone. The material

was employed either as a substance to be baked hard and permanent (terra cotta), or as a transitory medium for eventual bronze or other metal casting.

The professional stone carvers required a means of mechanically measuring points on the original and transferring these measurements to the stone block, and the pointing machine made its appearance.

The pointing machine is a movable instrument consisting of an upright rod, frequently constructed of hollow tubing, on which are attached adjustable rods set in movable sockets, so that points can be taken in all positions.

The process of pointing consists of marking with pencil all projections and recessions or 'points' on the model, which is generally a plaster cast, and making position measurements with the adjustable rods of the pointing machine, which are capable of measuring at intervals a fraction of an inch apart. The machine is repeatedly transferred from the model to the rough stone mass and is placed in precisely corresponding positions. The pointing rod indicates the depth of the points marked on the original model or cast, and holes are drilled into the stone mass to the depth measured by the rods of the pointing machine. The superficial stone is then chiseled away between several of the drilled holes until the full depth of the point holes are reached.

The initial pointing is sometimes of a rough nature, but when the crude stone mass begins to assume the desired dimensions or form, finer pointing is employed.

Hand pointing is also used in carving stone. For this a 12- to 14-inch pointed steel rod and a wooden mallet are employed for boring the small holes in the stone mass.

Enlarging

The problem of enlarging a small work in relief or in the round to larger dimensions has confronted sculptors since Antiquity, and many methods and devices for doing so have been developed through the centuries. There is available today an extensive variety of elaborate mechanical instruments for enlarging small works to heroic dimensions, and for reducing large models to small and even minute size, as in the case of medals and coins.

The Egyptians made use of a rather simple working device, which may logically have been employed for enlarging reliefs. Their

method consisted of dividing their small design into squares,[15] and also dividing the surface of the larger wall area into proportionately larger squares. The design could then be readily transcribed. (See Plate 46 for method of enlarging by squares.)

While the Egyptians frequently carved their free-standing figures directly in the stone, it is believed that they occasionally enlarged small works by means of a system of linear markings upon the small model and the larger stone mass.[16]

There is no evidence that mechanical methods of enlarging were used by the Greeks, and no actual mention of this is made in the literature.

During the Renaissance in Italy (see Plate 45B), several methods of enlarging were employed and some of them have persisted to the present day. One method, described by Benvenuto Cellini, consists of enlarging by framework or chassis.[17]

Vasari mentions a relatively simple method [18] that was used for transferring from full-sized wax or clay models to stone, or for proportionately enlarging. The method, actually a simple version of enlarging by chassis, involves the use of two carpenter's squares, each consisting of two straight lengths of wood joined at right angles to each other. The leg of one strip is placed horizontally upon the table while the other leg projects vertically. One 'square' is used for the model and the other for the copy. Measurements may be taken from the upright portion of the 'square,' which should be calibrated for greater accuracy.

Enlarging by Chassis: A method long employed for enlarging a small work consists of fashioning two frames or chassis—one for the small model and the other for the enlarged copy. (See Figure 10.)

The small model is first firmly fixed to its pedestal or modeling stand. If a modeling stand is used, the revolving top should also be made fast. A larger stand is employed for the proposed enlargement.

A wooden top frame is constructed for the small model from four strips of smooth, seasoned wood, about half an inch thick, and these

[15] Mackay, Ernest, 'Proportion Squares on Tomb Walls in the Theban Necropolis,' *Journal of Egyptian Archeology,* IV, 1917, pp. 74-85.

[16] Edgar, C. C., 'Sculptors' Studies and Unfinished Works,' vol. 31 of the *Catalogue Général des Antiquités Egyptiennes du Musée du Caire,* 1906; see 'Introduction.'

[17] Ashbee, C. R., *The Treatises of Benvenuto Cellini on Goldsmithing and Sculpture,* p. 141.

[18] *Vasari on Technique,* trans. by L. S. Maclehose, New York, London, 1907, § 48, p. 151.

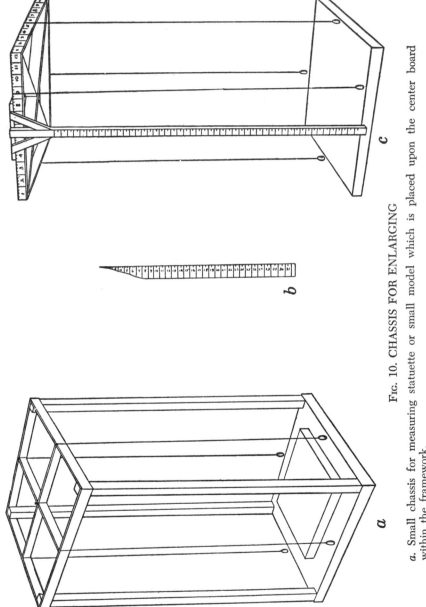

Fig. 10. CHASSIS FOR ENLARGING

a. Small chassis for measuring statuette or small model which is placed upon the center board within the framework.
b. Pointing stick used for taking 'distance in' measurements.
c. Large chassis with a hanging rule that is used for taking 'distance down' measurements.

are joined together at perfect right angles. One long and two short lengths of wood are then arranged so that they cross in the center and join each pair of frame corners. A projecting screw or nail is fixed to the central point where the struts cross.

A proportionately larger frame is prepared for the enlargement. Both small and larger frames should slightly exceed the maximum dimensions of the sculpture. The smaller frame is supported by four equally long, upright wooden posts, carefully joined at right angles to the frame top and to the base on which the model rests. The larger frame is fashioned of heavier lengths of wood and may be reinforced at the corners. Uprights may be used to support the larger frame, although, because of possible interference with the modeling or carving, it is often suspended firmly in place over the stand and armature or stone mass by means of overhead attachments to a beam, wall, or roof.

Equal linear divisions are marked off on the sides and along the top edge of the small chassis, and v-shaped niches are cut along the upper edge of the frame with a sharp knife or triangular file. The top edge of the larger frame is similarly calibrated and notched. Assuming that the desired enlargement is to be made four times the size of the small model, an inch on the small frame will be equal to four inches on the larger chassis. After the frames have been carefully calibrated, they are placed in position and tested with a spirit level for perfect horizontality.

Four plumb lines are now fashioned, one for each side of the frame, by attaching lead weights to long pieces of string or cord and tying the ends of these strings to the nail or screw set at the point where the wooden supporting struts cross inside the overhead frames. The plumb lines can be moved along each side of the frame and set in the cut notches.

A T-shaped tool (T-square) is prepared for each frame by joining a long strip of wood at right angles to a smaller piece. The instrument rests upon the frame top and is employed in lifting and moving plumb lines and for taking 'distance down' measurements. The vertical length of this tool should reach a little below the top of the base stand and should be carefully calibrated along its length.

Two pointing sticks are also required, one for the small model and the other for the proposed enlargement. These may be made from thin lath strips that are tapered off at one end to form a point. Each stick is calibrated along its flat surface from one end to the other. A

headless nail may be set firmly into the tip of the pointing stick to serve as a durable and firm point surface.

If the enlargement is to be of clay, an armature should be erected on the larger stand under the large frame. If stone is to be used, the block should be set in position on the large stand.

Measurements may be taken from the small model by adjusting the T-square on the horizontal frame, fitting the plumb line into the proper notch, and then using the pointer to gauge the distance from the plumb line. In taking measurements or points with a pointing stick, it is important to hold the stick perfectly level and at right angles to the plumb line. A small level, attached to the pointing stick, is frequently found to be a valuable aid.

We shall assume, for purposes of illustration, that a point position on the small model is as follows: front side, plumb line in notch $5\frac{1}{2}$; 'distance down' on the vertical rule, 11; 'distance in' from the plumb line, measured horizontally with the pointing stick, $4\frac{1}{2}$. These measurements are now multiplied according to the size of the desired enlargement, say $4\times$, $5\times$, or $6\times$, and a corresponding point is located for the larger copy. If the copy is to be in clay, the mass is built up over the armature until the form reaches the tip of the pointing stick; then a small wooden peg is imbedded in the mass to mark the point position. Each point taken on the small model should be marked with a small pencil dot or cross.

If the enlargement is to be of stone, holes are drilled at the points and to the approximate depth indicated by the pointing stick. The full depth should not be drilled, but a thin layer of stone left for the finishing phase of carving. When enough points have been taken, the carving is begun and the superfluous stone removed to the depth of the drilled holes.

The small model may also be marked with parallel horizontal lines an inch or so apart, and dots made along these lines at regular intervals. A spirit level should be employed to insure accuracy. Pointing may proceed systematically from one line to the next.

After locating the point from the front of the work, measurements are taken from the sides. The process is carefully repeated until sufficient points have been taken to permit the beginning of free modeling or carving. At this stage, the tops of the stands should be able to revolve freely so that the work can proceed from all sides.

In order to reduce by means of the chassis, the entire procedure is reversed.

Proportional dividers (see Figure 11) are compasses that may be used to enlarge or to reduce. The instrument is most frequently composed of metal, although it may also be made of wood. The tool consists of two channeled arms of equal length, both ends of which are tapered to sharp points. A setscrew is used to hold the two arms to-

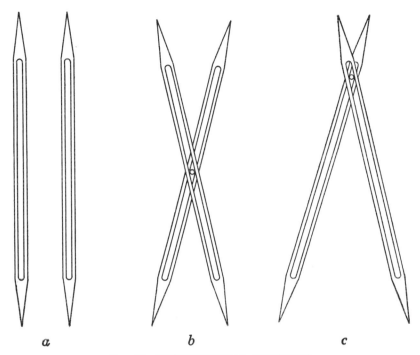

a b c

FIG. 11. PROPORTIONAL DIVIDERS

a. The two channelled arms of the dividers.
b. Setscrew fixed midway between the ends of the arms.
c. Dividers adjusted for a 4 × enlargement or reduction.

gether and to adjust the dividers. If the setscrew is in the center of the channels and the divider arms are opened, the distances between the measuring points at both ends will always be equal to each other. As the setscrew is moved toward one end of the dividers, the space between the points at this end will decrease, while the space between the points at the other end will proportionately increase.

If a drawing is to be enlarged, the dividers are adjusted to the desired scale of enlargement. Measurements are taken with the smaller end of the dividers and transferred with the larger end. Regardless of how far apart one pair of points are separated, the other

pair will increase or decrease proportionately, at the fixed scale, until the setscrew is moved.

SPLITTING OF STONE

Blocks of stone can be divided or split mechanically by the use of metallic wedges. A line is first laid out with a straightedge and chalked on the stone, and a series of holes are drilled along it to a depth governed by the block thickness. These holes, laid out at intervals of a few inches, should be approximately ¼ to ½ an inch in diameter and about 6 inches deep.

Metallic wedges, or 'plugs,' and 'feathers' are inserted into the holes and lightly tapped in succession until the block is split. The 'feathers' are half-round pieces of soft iron or steel and a pair of these is used for each hole. 'Plugs' are small steel wedges that are placed between the feathers.

The tapping must be done uniformly and one wedge must not be struck more frequently or with a greater force than another. It is good practice to begin at one end of the dividing line and to work toward the other, continuing the tapping until the fracture appears.

POLISHING

Polishing consists of physically smoothing and making a surface more lustrous and brilliant by means of continuous, fine abrasion. Polishing also serves to bring out the full beauty and richness of the color and texture of a stone.

Many ancient statues were uniformly and highly polished. As far as is known, however, the earlier Greek sculptors did not polish their marbles, but finished their carvings with a smooth surface. From the fourth century B.C. the surfaces of Greek statues often appear to have been polished. Michelangelo frequently polished areas of his sculpture to the highest possible luster to achieve desired highlights. This is particularly apparent in his *Moses*.

Many contemporary direct sculptors carefully juxtapose polished areas against rough, unpolished surfaces for contrasting textural and naturalistic effects and for decorative purposes. The practice also places important emphasis upon the nature of the stone. An entire carving is rarely smoothed or polished uniformly. (See Plate 41B.)

Stone carvings can be quickly polished by using machines, but experience is required in their use and great care and control have to be

exercised or delicately carved and detailed areas may be rapidly ground away and destroyed.

Polishing a stone surface manually invariably requires a considerable expenditure of time and energy, but it is a safer and therefore more satisfactory procedure than machine polishing. The general procedure consists of soaking down the stone block with water and then applying abrasive stones, such as carborundum, in descending degrees of hardness. Softer or gentler abrasives, such as tin oxide or putty powder, are used for finishing purposes. The sculpture should be kept wet while it is being polished. Some sculptors make use of a simple mechanical arrangement, consisting of a metal container, such as a tin can, punctured on the bottom and suspended over the work. The vessel is filled with water, which slowly drips onto the highest part of the carving and lubricates the rest of the stone surface.

For the initial smoothing of a surface, particularly for the hard, igneous varieties, carborundum stones (Silicon carbide, SiC), varying from the fairly coarse to the finer-grained forms, are used. While carborundum powder can also be used, it is quite wasteful. When carborundum is used in a chunk or solid form rather than as pulverized or powdered grit there is maximum utilization. The stone surface is worn as smooth as possible with the carborundum and is then rubbed with fine emery powder, using small pieces of water-moistened felt or cloth. Putty powder or alumina can be used for the final polishing.

Buffing is then applied to the final polishing in finishing a carved stone surface. In buffing marble, the surface is first saturated with water, and a fine variety of soft sandstone is rubbed evenly and carefully over the stone, care being taken to control pressure and direction. Putty powder, applied with a soft moistened cloth or felt, is generally the final abrasive-polishing agent after the use of the sandstone. Oxalic acid is sometimes used, but it is not as satisfactory as putty powder and is very poisonous.

Physical abrasion, while it takes more time and energy, is preferable to harsh, chemical-corroding agents in finishing a stone carving. Hand polishing is hard and tedious work, but it possesses the advantages of greater control and a minimum danger of polishing away, and thereby destroying, a delicately modeled surface.

Alumina (Aluminum oxide, Al_2O_3), a white, amorphous powder, can also be used for the final polishing of a marble in place of tin

oxide or putty powder. It is a very gentle abrasive and is the so-called 'Italian marble polishing powder.'

After it is polished, the finished carving should be flushed several times with clean water and rubbed between flushings with a soft, clean cloth.

Marbles are generally polished with soft sandstones as the primary and secondary abrasives. After the sandstones, gentle tertiary abrasives, such as putty powder or alumina, are used.

Belgian black marble can be polished by using emery cloth for the initial smoothing. A fine variety of pumice powder mixed with a lubricating oil is then employed. As a final abrasive-polishing material, putty powder or alumina is applied with soft cloth or felt moistened with water. This method will result in a jet-black, mirror-like surface.

A small bit of wax may be rubbed into the surface after polishing to bring out the full, natural color of the stone. It should be applied conservatively. If too much is used, the surface may become stained. Plato mentions the use of Punic wax as a means of achieving more brilliant marble surfaces.

It is not always practical to polish the surface of a stone carving very highly if the work is to be eventually placed outdoors, since in many climates the surface polish of a stone carving is not very durable. However, a protective application of wax will increase the resistance of a polished stone surface to the effects of weathering.

Cleaning

A polished stone surface will stain and accumulate dirt less readily than will an unpolished surface and is, therefore, much more easily kept clean.

Some of the factors responsible for the soiling and staining of stone sculpture placed outdoors are:

1. Smoke-polluted atmospheres. This factor is particularly important in urban, industrial areas.
2. Wind-borne grime and soil
3. Plant growth (mosses and lichens)
4. Capillary action. This factor generally involves the staining of the base portion of a stone carving by the capillary action of solutions carried upwards from the earth.

Some ignorant and merciless 'restorers' make use of exceedingly harsh methods when they are entrusted with a stone-cleaning assignment. The so-called 'restoration' of the famous Elgin Marbles is an example of the really brutal and vicious methods that can be used by professional restorers. Statues were reworked with chisel and mallet, resulting in an entirely new product, and were quite callously sand-blasted and scrubbed with wire brushes.

One of the crudest and most vicious methods of 'cleaning' a stone carving involves the application of a blowtorch to the surface of the carving. The intense heat causes superficial, scaly fragments of stone to fracture off.

The use of highly caustic acids are also crude and dangerous cleaning methods and are best avoided. Hydrofluoric acid and hydrochloric acid have been used for this purpose. However, the Indiana Limestone Quarrymen's Association recommends the use of oxalic acid for removing stains from limestone. For rust marks, smoke, oil, and other stains that are less than a year old and are not dried deeply within the stone, the Association recommends washing the surface with a solution consisting of 2 pounds of oxalic acid and 1 gallon of water. The solution is permitted to soak into the stone, after which a thin ($\frac{1}{16}$-inch) layer of a paste, composed of 3 pounds of chloride of lime and 1 gallon of hot water, is applied to the surface. This paste is allowed to remain on the stone for about a day and is then washed away by thoroughly saturating the statue with repeated drenchings of warm water. If the stains are not entirely removed, the Association recommends that the paste be re-applied.

The use of sodium hydroxide (lye) is another dangerous procedure that should be avoided. This substance is highly caustic and eats away carbonates. It is useful only as a means of destroying plant growth, such as mosses and lichens, but even then only a very mild solution should be employed, consisting of from 2 to 3 tablespoons of lye to 1 gallon of water. The stone is flushed with water and the solution is applied with a stiff bristle brush. This is followed by thorough saturation of the stone with clean water and drying with a soft, clean cloth.

A stone carving should be handled as carefully and as gently in cleaning as living flesh. The water for cleaning and flushing purposes should be fairly pure and moderately warm or tepid to cold. Scrubbing brushes should have bristle hairs. Metallic wire brushes should never be used. Scrubbing or brushing should always be gentle and

controlled. Fine abrasives, such as marble dust, putty powder or tin oxide, alumina, finely pulverized volcanic ash, and fine liquefied soaps or soap powders that are not excessively alkaline in content should be used for removing superficial dirt accumulations. The general procedure consists of first saturating the surface with tepid water, after which a wet brush or cloth is dipped into the selected abrasive or soap (or both) and is used to scrub the surface. The stone should then be thoroughly and repeatedly flushed with clean water to guarantee that no vestige of the soap remains.

Kessler [19] suggests several interesting methods of removing stains from marble carvings. Marble stains usually penetrate into the surface of the stone and vary in intensity and color according to the porosity of the specific variety. Green and brownish stains from copper or bronze can be removed by the use of 1 part of ammonium chloride to 4 parts of powdered talc. The two ingredients are mixed dry and liquid ammonia water is added to form a paste, which is applied as a poultice. Iron stains on marble can be treated with a mixture of 1 part sodium citrate and 6 parts of water. To this is added an equal volume of glycerine. The ingredients are mixed together and whiting is added to form a paste, which is applied to the stained area and permitted to remain for several days.

Oil stains on marble are treated with a mixture of equal parts of acetone and amyl acetate. A heavy piece of flannel is saturated with this solution and applied to the stained area. A piece of glass or a slab of marble should be placed over the flannel and the cloth should be moistened several times with this solution.

Grease stains can be treated with a paste consisting of a mixture of Fuller's earth, a clay rich in magnesia, and water. This paste is spread over the stained area and is permitted to remain in contact with the stone for several days, after which it should be washed away with clean water and the area gently polished.

REPAIRING

In cases where superficial particles of granular stones, such as limestone and sandstone, have been loosened, the application of silica in the form of an alcoholic solution of silicon ester appears to be the most satisfactory reparative substance. In the presence of moisture

[19] Kessler, D. W., *A Study of Problems Relating to the Maintenance of Interior Marble*, Bureau of Standards Technical Paper 350, Washington, D. C., 1927, 91 pp.

the solution decomposes: the silica is deposited and the volatile ethyl alcohol evaporates. The silica serves to cement the loose grains of the stone. Some experience is required in the application of the material.

Kuhlmann's Process: A solution of silicate of potash or soda is brushed into the stone surface. The carbon dioxide in the atmosphere will react with the solution and some of the constituents of the stone and form a hard, binding surface.

Ransome's Process: A solution of sodium silicate is applied to the stone surface until this has been thoroughly saturated. It is permitted to dry and another solution of calcium chloride is applied in the same way. The two solutions will react and produce an insoluble silicate of lime, which will bind the stone particles together and also fill the surface pores.

Boiled linseed oil is occasionally applied to a stone surface as a pore-sealing material, which also serves as a rather weak binding agent. One or two coats of the oil are brushed well into the clean surface. The oil soaks into the stone and tends to intensify or to deepen the color of the stone. It has to be carefully applied or the stone may become patchy or stained.

10

WOOD

NATURE OF WOOD

Wood has been, and still is, abundant in most parts of the world, and one would naturally expect wood carving to be one of the oldest forms of sculpture. Wood has been used extensively and by almost every people as an artistic medium for over 5000 years.

Physically, wood is fibrous, but usually quite compact and durable. It is comparatively light in weight and not as structurally homogeneous as are most of the sculpturally used metals and stones. The durability of wood is important to the sculptor, since a high degree of resistance to atmospheric humidity and the effects of temperature, together with a resistance to cracking or splitting, are desirable.

Wood is composed of cell structures or fibers, the nature of which determine the hardness or softness of the variety, the ease with which it can be carved, and its porosity. The weight of woods varies almost daily with the moisture content.

Both hardwoods and softwoods are used sculpturally. (See Plates 53 and 54.) Hardwoods are secured from exogenous trees having broad, flat leaves. These include varieties of oak and chestnut. The softwoods are secured from trees with narrow, resinous leaves, and include pine and hemlock. Generally, the close-grained woods are the hardwoods and these are, naturally, more difficult to work than the softwoods, but they possess the redeeming characteristics of almost invariably being more durable, taking higher polishes, and yielding more sculptural pleasure in working.

An extensive variety of domestic and imported woods, varying from soft to very hard, are available for carving. The domestic woods are usually more economical in terms of price. Many of the imported woods are fairly costly and some types are only occasionally available, frequently in only small blocks or planks.

'Heartwood' is the term applied to the core of the wood, which is generally darker and more uniformly colored than the external wood. The hardness and density of the heartwood depend upon the variety.

Some types are softer externally, while others have a denser exterior with a softer heartwood.

Knots in wood are the result of branches.

VARIETIES OF WOOD

The following list is by no means complete. There are many other types of wood in existence, some of which have been used in native carvings. However, not all of these are generally available. The references given in the bibliography may be consulted for additional varieties.

Acacia is a rare wood from the Near East, very infrequently used for carving.

African Blackwood, see *Ebony*.

African Bubinga, see *Rosewood*.

African Cedar, see *Bosse*.

African Ebony, see *Ebony*.

African Mahogany, see *Mahogany*.

African Walnut, see *Walnut*.

Almique is a reddish-brown wood imported from Cuba and the Guianas. It is hard, compact, and heavy, and takes a fine polish.

Amaranth wood or Purpleheart is a rich, violet-colored, tropical hardwood imported from the Guianas. It is close- and even-textured and is generally available in plank form. Planks vary from approximately 1 to 6 inches in thickness, 10 or more inches in width, and from 6 to 21 feet in length.

American Mahogany, see *Mahogany*.

American Walnut, see *Walnut*.

Applewood is a close-grained, rather soft wood, suitable for delicate detail and taking a good finish. The imported varieties are superior to the commercially available domestic types. Applewood is generally available in small logs of a maximum diameter of about 10 inches and a length of about 36 inches. (A log is a tree trunk with the bark removed and the branches lopped off.)

Ash heartwood varies from a light to a dark gray-brown. There are several varieties, generally heavy, hard, and brittle open-grained woods of intermediate durability.

Australian blackwood is a close-grained, rich reddish-brown wood, frequently attractively figured. It is imported from Australia and Tasmania.

Avodire is a very light-colored African hardwood with a beautiful figuring. It is largely used for decorative purposes and is generally available in plank form.

Ayous is an African wood similar to Avodire, but is softer and possesses a more marked graining. It is usually available in large logs.

Balsa is characterized chiefly by its extremely light weight and its softness. The wood is very easily cut, preferably with a thin blade, but it is rarely used sculpturally because its surface is so easily marred and the mass destroyed. Balsa is commercially available in planks and blocks.

Balustre, or Balaustre, is a brilliant orange-colored wood imported from South America. Logs vary in size up to about 8 inches in diameter and 8 or more feet in length.

Basswood or linden is a fairly common American softwood with a straight, close grain. It is light in weight, compact, and is quite easily carved. The color of the heartwood varies from a creamy white to a medium reddish brown. It has little durability when used under conditions favoring decay.

Beechwood is a tough, strong hardwood with variable qualities of durability. The heartwood is of a reddish color. The wood takes a fine polish, but has a tendency to check during seasoning.

Bethabara is an oily, fine-textured, and very hard dark brown wood that comes from the Guianas.

Birch is available in many varieties. The wood is generally not very durable. Red birch is light, hard, and strong, with a reddish-brown heartwood. Yellow birch is the same as red birch, but with a generally lighter heartwood. White birch is a soft variety that is not highly durable. Northern yellow birch is a vari-grained, fine-pored hardwood, harder and heavier than gumwood. The pores of this variety are finer than those of mahogany, but not so fine as the pores in gumwood. Its durability varies.

Bird's-eye maple, see *Maple*.

Blackbean is an Australian wood, also referred to as Moreton Bay Chestnut. It is hard and heavy and resembles teakwood. The color is light to dark brown with lighter colored streaks.

Black Walnut, see *Walnut*.

Bosse is a delicately figured, light-pink African wood, also referred to as African Cedar and Pequa, or Piqua. It is infrequently used for carving.

Boxwood is a very fine-textured, light-colored, tough hardwood with no grain limitations. The wood is generally a deep yellow color. It is a good wood for carving, but is usually available in only relatively

small pieces or small logs. Turkish boxwood, which is usually avail
able in small, round pieces up to about 8 inches in diameter, is
superior to the West Indian variety.

Brown Ebony, see *Ebony.*

Braziletto or Brazilwood is a South American variety of wood, generally
available in small logs up to about 5 inches in diameter. It has been
used for making violin bows.

Brazilian Rosewood, see *Rosewood.*

Brazilian Satinwood, see *Satinwood.*

Brazilian Walnut, see *Walnut.*

Bubinga, see *Rosewood.*

Butternut is also referred to as 'white walnut,' although it is softer than
walnut and differs in color. It is a minutely pored, coarse-grained,
light wood of medium hardness. It carves easily and satisfactorily,
but does not wear well. The color of the heartwood is a grayish
brown that darkens on exposure. Butternut is quite compact struc-
turally and is capable of a very high polish.

California Sycamore, see *Sycamore.*

Camphor Wood is an exotic, scented, tropical hardwood imported from
Formosa and Borneo. It is generally available in plank form, ap-
proximately 4 inches in thickness.

Canaletta or Canalette is a Venezuelan wood that has an attractive color
and figuring. It is rarely used for sculpture.

Canary Wood, see *Satinwood.*

Capome or Capomo is a light-colored, Central American wood that is in-
frequently employed for carving.

Cashew wood is very rarely used by the wood carver. It is believed that
the sap of the tree is irritating to the skin.

Cedar is a durable, scented soft wood. Red cedar is a fine-grained, soft,
light wood, easy to carve, but rather brittle. White cedar varieties
are generally soft, weak woods. Spanish cedar is not a true cedar
variety, but the wood is favored by some sculptors for carving. The
colors of cedar vary from a yellow to a deep brown. Alaska cedar
is a hard, yellow variety.

Cherrywood is a close, and straight-grained wood with minute pores. It
has a reddish color similar to mahogany and is excellent for wood
carving. The wood can generally be secured in logs a foot or more
in diameter. Wild cherry, or wild black cherry, has a light to dark
reddish-brown heartwood. It is a light, fine, straight-grained hard-
wood, which is quite compact structurally and carves well. It is
frequently used for fine wood carvings.

Chestnut is a light, soft, coarse-grained wood. It is susceptible to a check-
ing and warping in drying and has to be very carefully seasoned.
It is fairly durable and easily split. The heartwood is a grayish-
brown color. Chestnut is becoming scarce owing to chestnut blight.

Cocobola is a reddish-colored tropical wood imported largely from South
America. It is very hard and dense and is fairly difficult to carve.
Some people are allergic to it and develop water blisters and a
swelling of those parts of the flesh touched by the dust or shavings.
Large blocks of cocobola are very frequently hollow because of
internal decay. Small pieces of the wood are generally quite com-
pact. It is widely used for making knife handles.

Coffeewood, see *Ebony*.

Coromandel, see *Ebony*.

Cuban Mahogany, see *Mahogany*.

Cypress wood is a close, straight-grained, durable wood, which is fairly soft
and light-weight. It is easily carved and has a delicate, resinous odor,
but is not very strong physically. The heartwood is brownish and
is durable even when used under conditions favoring decay.

Degame, see *Lemonwood*.

Dogwood is a fairly straight-grained, pinkish-white, hard and heavy variety,
available in small logs of from about 3 to 4 inches in diameter and
about 4 feet in length.

Eastern Oak, see *Oak*.

East Indian Rosewood, see *Rosewood*.

East Indian Satinwood, see *Satinwood*.

East Indian Walnut, see *Koko*.

Ebony is a dense, smooth-grained, heavy, tropical hardwood, quite ex-
pensive and difficult to secure in substantial sizes. (See Plate 54B.)
It is generally jet-black, but there are also reddish and greenish
varieties. The finest variety is the African Gaboon ebony, which is
rather difficult to carve and is usually available in small logs ap-
proximately 8 inches thick and 40 inches long. Macassar ebony, or
Coromandel, comes from the Dutch East Indies. This variety can
occasionally be secured in logs a foot or more in diameter and 7 or
more feet in length. Macassar ebony is considered by many wood
carvers to be inferior to African ebony. Brown ebony, which is
also referred to as Coffeewood and South American Grenadilla, is
similarly considered inferior to the African variety. Brown ebony
is usually available in logs a foot or more in diameter and 6 or more
feet in length. Ebony from Ceylon frequently attains a diameter
of 2 feet and a length of from 10 to 15 feet. Mozambique ebony
is a term applied to a dark violet or plum-colored hardwood that
is also known as African Blackwood or Grenadilla.

Elm is a medium-weight but tough hardwood, difficult to work and only occasionally used by wood carvers. The color varies from a light to a dark brown.

English Sycamore, see Sycamore.

Epplewood or Ipilwood is a beautiful tropical wood imported from the Philippine Islands. This exotic variety is, however, poisonous to some carvers, who, when exposed to it, may develop a nasal congestion and the symptoms of hay fever.

Gaboon ebony, see Ebony.

Goncalo Alves is a light brown, beautifully figured South American wood, generally available in large logs. It is not very frequently employed for wood carving.

Grenadilla, see Ebony.

Gumwoods are light, small-pored, southern hardwoods, which are plentiful but frequently difficult to carve. Many varieties exhibit a tendency to warp, shrink, and check in seasoning. Southern red gum is a good carving variety that is also fairly durable. The color varies from a grayish brown to a reddish brown.

Hard Pine, see Pine.

Harewood, see Sycamore.

Hickory is a very strong, white to brown hardwood.

Holly is a fine, close-grained, compact, and moderately hard light wood, which is fairly easily carved. The heartwood is creamy white in color with a tendency to spot or to darken on exposure. The wood is frequently very difficult to secure.

Honduras Mahogany, see Mahogany.

Honduras Rosewood, see Rosewood.

Imbuya is a brown wood imported from Central and South America. It is occasionally called Brazilian walnut because of the similarity of its color to walnut. It is softer than black walnut and is usually available in logs and thin planks.

Ipe or Ipi is a Brazilian wood rarely used for carving.

Ipilwood, see Epplewood.

Iron Mahogany, see Lignum vitae.

Italian Walnut, see Walnut.

Jacaranda, see Rosewood.

Kewazinga is a Gaboon wood related to Bubinga. The French group these two woods together and refer to them as African Rosewood.

Kingwood is a dark violet brown, South American hardwood, streaked with light and dark yellow markings. It is usually available in small logs.

Koa is a light-weight exotic wood, native to the Hawaiian Islands. It is quite hard and durable and has an attractive grain.

Koko or East Indian Walnut is a hard, dense, close-grained tropical wood imported from Burma. It is dark brown and is usually available in log form.

Lancewood is a fairly rare wood, similar to Lemonwood but physically stronger and more resilient.

Laurel, see *Sassafras.*

Lemonwood, also referred to as Degame, is a yellowish or creamy-white hardwood that is sometimes used for carving. Cuba is the major source of this wood, which is generally available in logs about 12 inches in diameter and 12 feet in length.

Letterwood, see *Snakewood.*

Lignum Vitae is undoubtedly the heaviest, hardest, and densest commercial variety of wood there is. (See Plate 54A.) It is frequently referred to as iron mahogany and iron wood. The extreme hardness of lignum vitae makes it exceedingly difficult to carve, and many sculptors emphasize the hard nature of the wood by a rough, broad treatment, securing rugged and stonelike effects. The wood is close-grained and compact, but is somewhat brittle in carving, and occasionally soft spots may be encountered. It has a fine grain and takes a very high polish. Lignum vitae heartwood varies from a light olive green to a deep brown or near-black. Young specimens of heartwood are usually a rich yellow-brown; older specimens approach black. The wood is secured principally from two species, *Guaiacum sanctum* and *Guaiacum officinale.* A third species, *Guaiacum arborium,* supplies a similar wood.

The lignum vitae trees are gnarled, low-growing trees, reaching a maximum height of about 25 feet and a maximum diameter of approximately 1½ feet. The wood is imported from Cuba, Puerto Rico, the Bahamas, Nicaragua, and South America. Some is secured from semitropical Florida. It is generally available in logs about 3 inches to 1½ feet in diameter and up to 10 feet in length. It is fairly expensive.

Limewood is a smooth, even-textured, light-colored wood, excellently suited for carving.

Live Oak, see *Oak.*

Linden, see *Basswood.*

Macacauba is a Brazilian wood, also known as Brazil Padouk, Maca wood, Monkey wood, and Quira. It is rarely used sculpturally.

Macassar Ebony, see *Ebony.*

Macaya is available in many varieties. It is a coarse-grained but hard and durable wood, the most common species of which flourishes in and is secured from Mexico. It is infrequently used for carving.

Madrone is a beautiful wood, which comes from our Pacific Coast. It is also known as Madroña and Madrono. It varies in color from a light pink to a fairly deep, intense red.

Magnolia wood is similar to Yellow Poplar. It is not very abundant and is infrequently used for carving.

Mahogany is a fairly inexpensive hardwood, which enjoys an excellent reputation among sculptors. (See Plate 54D and 54F.) It is strong, of medium weight, and has great beauty and durability. It is excellent for carving, but requires experience and care, since it is somewhat brittle and has a tendency to splinter. Raw, unfinished mahogany varies from an ocherish color to a golden brown. The natural color of the finished wood is a warm, reddish brown. Mahogany pores vary from medium to large and are generally well spaced but frequently conspicuous. The wood is fine grained and has a smooth, silky appearance when it is well finished. It is capable of taking a very high polish. Mahogany is highly resistant to atmospheric humidity and there is a minimum of danger of its warping, swelling, or shrinking. It is also highly resistant to mold and decay, even in tropical climates.

Mahogany trees frequently grow to a tremendous size, occasionally reaching between 6 and 10 feet in diameter and 150 feet in height. It is a tropical wood, secured mainly from the West Indies, Central and South America, and Africa. There are several varieties, ranging from soft woods to hard types, but only three commercially important species. The West Indian *Swietenia mahogani* is marketed as Cuban, Santo Domingan, or Spanish mahogany. Another species, *Swietenia macrophylla*, grows in Honduras, Mexico, Guatemala, Nicaragua, Panama, and northern South America. Honduras mahogany carves like walnut. The principal African species, *Khaya ivorensis*, comes from the Gold and Ivory coasts, Nigeria, and near-by regions of equatorial West Africa, and is known collectively in America as African mahogany.

Santo Domingan mahogany is one of the hardest and heaviest varieties. The wood is rich and close-grained with a silky texture. When freshly cut, it is a yellowish white, but changes to a golden brown or a deep reddish brown. The wood is quite difficult to carve. Cuban mahogany is densely grained and is regarded by many sculptors as the hardest and heaviest variety of mahogany. African mahogany is one of the softest varieties. The wood has larger pores than American mahogany and is luxuriously figured with stripes, mottles, and exotic swirls. When freshly cut, it is a pinkish color, which changes to a pale golden brown. African mahogany carves very well. Tropical American mahogany is gen-

erally straight-grained and more mellow in appearance than West
Indian mahogany. The wood is yellowish white to pink when freshly
cut, but changes to a rich, golden brown. Peruvian and Amazon,
or Brazilian, mahogany comes from the upper Amazon regions of
Brazil and Peru.

Philippine mahogany is not a true mahogany. The name is applied
to at least a half-dozen species of the dipterocarp family. Most of
the woods referred to as Philippine mahogany are fairly soft and
carve well, but they possess the undesirable qualities of losing color
or bleaching on prolonged exposure to light. The woods are fairly
plain, with larger pores and a coarser appearance than mahogany.
They are generally given a mahogany finish and weakly resemble
true mahogany.

Mahogany is plentiful and is generally available in planks, blocks,
and large logs.

Majagua is a hard, green to blue-gray, Cuban wood used primarily for the
manufacture of baseball bats.

Makore is also known as Makori, Makora, and African Cherry. The wood
is beautifully figured and is sometimes available in log form.

Malabar, see *Rosewood*.

Malacca wood is best known by its use in the manufacture of canes. It is
very rarely used sculpturally.

Maple is available in several varieties that are classed with the hardwoods,
although some maples are soft. It is a close-grained wood with a
fine, compact texture. Bird's-eye maple refers to an ornamental
graining found mostly in the hard varieties. The heartwood of maple
varies from light brown to reddish brown.

Mountain Laurel, see *Myrtle*.

Mountain Oak, see *Oak*.

Myrtle wood is secured from a variety of mountain laurel. It has a brown
heartwood and is fairly hard, heavy, and strong. The wood takes a
fine polish and is fairly good for carving, but it is difficult to secure
commercially.

Narra is a Philippine wood related to the Andaman Islands' Padouk. It
has a yellow to reddish-brown color and is not always available
commercially.

Northern Yellow Birch, see *Birch*.

Oak is a hard, tough, close-grained, durable, and beautiful wood, but un-
fortunately all varieties are subject to warping and checking in sea-
soning. The woods are capable of taking a high polish and are not
very subject to insect attack. Oak is excellent for general carving
and is ideal for broad, strong designs. There are many varieties,
only some of which are good for carving. Oak can be roughly

divided into three major groups: white oak, red or black oak, and
live oak.

White oak is strong, hard, and heavy and takes a good polish,
but care has to be exercised in seasoning or a serious checking may
result. Red oak is heavy, strong, porous, and hard. It may similarly
check in drying. The wood is quite coarse and is not as good as
white oak for carving. Live oak is strong, close-grained, and hard.
Southern oak is heavy and close-grained. Western oak is also hard,
heavy, and close-grained. The Eastern or Mountain oak varieties
are generally considered the best for carving purposes. Oak heart-
wood varies from a creamy white or yellow to a dark brown. The
color of most varieties can be darkened with concentrated ammonia.
Oak wood is very frequently finished by waxing or oiling.

Okoume is another name for Gaboon Mahogany. The wood is soft and
light-weight and is a light reddish-brown color.

Olivewood is an excellent carving wood, with a rich, greenish-brown color.
It takes detail very well.

Padouk, African Padouk, or Corail is a deep-red wood used largely for
decorative purposes.

Paldao or Dao wood is a very fine wood imported from the Philippine
Islands. It is similar to walnut in color and figuring and is generally
available in large logs.

Palisander, see *Rosewood*.

Palo Blanco means 'white wood' and the name is applied to many woods of
different species. The true Primavera (see p. 294) is quite durable,
whereas the others tend to buckle and warp markedly in drying.

Palosapis is also known as Bella Rosa and Bayott. It is a fine and beautiful
Philippine wood of a light color, with a pinkish striping.

Partridge Wood is known commercially as South American Grenadilla and
Coffeewood. It is a dark, hard, heavy wood, with light brown,
featherlike markings. It is sometimes available commercially in fairly
large sizes.

Paper Birch, see *Birch*.

Pearwood is a light, close- and even-grained wood that is fairly soft and
carves well, permitting delicate detail. The imported varieties are
superior to the domestic. The wood is generally available in lumber
form. (See Plate 53A.)

Pequa, or *Piqua*, see *Bosse*.

Pernambuco is another name for Brazilwood, a rich, bright red South
American variety.

Philippine Mahogany, see *Mahogany*.

Pine is a light-colored and even-grained softwood. There are about forty
varieties of pine in the United States. Some of these are quite soft,

others are of medium hardness, and many types are quite rosinous. The colors vary from a straw-white to a reddish brown. The wood carves easily and is frequently recommended as a 'first wood' for students just beginning to carve. It is often treated in a broad manner. Soft pine is a pale, yellowish-white, clean, and easily worked, but not very strong wood, relatively free from knots and rosin. It is usually available in large pieces. Sugar pine is an excellent, uniform wood, commercially available in fairly large pieces. Hard pine is strong and rosinous.

Plane Wood, see *Sycamore.*

Plumwood is occasionally used for carving. The wood is quite soft and permits a delicacy of detail. Imported plumwood is superior to the domestic varieties.

Poplar is a soft, light, and durable wood, which is easily carved. The heartwood varies from a light yellow to brownish color. Yellow poplar is fairly soft but difficult to carve, since it seems to grip the chisel. It is a fragile wood that does not wear very well and bruises quite easily.

Primavera or white mahogany is a tough, dense, blond or creamy white, hard tropical wood, which carves well and is fairly durable. It has a beautiful graining resembling that of mahogany. It is imported from Mexico and Central America and is usually available in logs up to about 8 inches in diameter.

Purpleheart, see *Amaranth.*

Red Birch, see *Birch.*

Red Cedar, see *Cedar.*

Red Oak, see *Oak.*

Redwood or Sequoia is an aromatic and quite compact wood, with a coarse to fine texture and a straight to curly parallel graining. The wood is light in weight and not too strong, but it is soft and easily worked, takes a good polish, and is fairly durable. Redwood is not used extensively for carving. The color of the heartwood varies from a cherry to a reddish brown.

Rosewoods are even-textured, smooth, scented, tropical hardwoods. Bubinga is a red-colored, fine-figured, durable and hard African variety, quite durable and usually available in very large logs. It is also called Bois de Rose d'Afrique, African Rosewood, and Faux Bois de Rose du Congo. Brazilian rosewood, also known as Palisander and Jacaranda, is an extremely fine, rare, and expensive variety. It is an even-textured wood with a beautiful appearance. The color is reddish brown streaked with black or yellow. Huge blocks, planks, and logs of this wood are generally available. East Indian rose-

wood, also known as Malabar, has a striped graining. Its color varies from pale yellow to red or deep violet. Honduras rosewood is a light-colored variety. Madagascar rosewood, also referred to as French rosewood, is imported from the Island of Madagascar, off the coast of East Africa. It is a bit lighter in color than Brazilian and East Indian rosewood, and the average size of the logs is smaller.

Sabicu wood is a tough and fairly strong hardwood imported from Cuba. It has a dark-brown, coppery-tinged heartwood, which is sometimes faintly streaked. It is not used extensively in this country at present, either for furniture or for carving purposes.

Sandalwood is a yellowish, hard and close-grained, scented tropical wood, which takes a good finish.

Santo Domingan Satinwood, see *Satinwood.*

Santo Domingo Mahogany, see *Mahogany.*

Sassafras is secured from several varieties of trees of the laurel family. The wood is light, soft, slightly aromatic, and quite durable, but it is not strong and has a tendency to check in drying.

Satinwood is an exotic, scented wood with ornamental graining. Brazilian satinwood is a light yellow, hard variety. It is sometimes called canary wood because of its yellow color, which is marked with dark streaks. East Indian satinwood is a fine, decorative wood with a golden color and varied graining. It is usually available in large logs. Santo Domingan satinwood is generally regarded as the finest of the satinwoods. It is beautifully decorative, with a lustrous golden color.

Sequoia, see *Redwood.*

Snakewood is also known as Letterwood. It is a tropical wood imported from Dutch Guiana. The wood is hard and durable and has a warm reddish-brown color with dark spots that occasionally resemble reptilian markings. The wood has a bitter taste and is believed by the natives of the regions in which it grows to be a specific remedy for the bite of the venomous hooded serpent, or cobra. The variety is frequently available in logs with a maximum diameter of about 8 inches.

Sneezewood is a South African wood, having a yellowish color that deepens to dark brown toward the center. Fine dust particles of this wood frequently irritate the nasal membranes and cause sneezing.

Soft Pine, see *Pine.*

South American Grenadilla, see *Ebony.*

Southern Oak, see *Oak.*

Southern Red Gum, see *Gumwood.*

Spanish Cedar, see *Cedar.*

Spanish Mahogany, see *Mahogany.*

Sugar Pine, see *Pine.*

Sycamore is a light-weight, close-grained hardwood. It permits a delicacy
of carving, but is fairly difficult to work. The heartwood is generally
a reddish-brown color. Plane wood is secured from the plane tree,
a variety of sycamore. California sycamore is a brittle variety, diffi-
cult to season. English sycamore, or Harewood, is actually a variety
of maple. It is a light-colored, fine-grained, figured wood and is
generally available in the form of thin planks. The wood has a
tendency to warp and crack in seasoning. (See Plate 1C.)

Teakwood is physically suggestive of oak, but it is lighter and more uni-
form. Its color varies from a yellow to a golden-brown. The wood
is quite hard, possesses great physical strength, has a good, even
graining, and carves nicely. Teakwood is durable and possesses an
oily component that repels insect pests. There are two varieties:
Asiatic or Indian teakwood, and African teakwood. Indian teakwood
is the kind generally referred to when teak is mentioned. Asiatic
teakwood includes teak from Java, India, Burma, Siam, and Ceylon.
Burmese or Siamese teakwoods are fairly soft and of a medium con-
sistency. They are very durable woods with low shrinkage and swell-
ing factors. Burmese teak carves easily but quickly dulls the chisels.
Teakwood is generally available in logs, blocks, and planks. After
it is carved, the wood darkens slightly to a light chocolate-brown.
It can be waxed or oiled.

Tigerwood, see *Walnut.*

Tulipwood is a light-colored, Brazilian wood with streaks of red and yellow.
It is usually available in small log form.

Turkish Boxwood, see *Boxwood.*

Vermilion Wood is a very rare Indian wood that resembles ebony in its
working qualities. The name is derived from its beautiful wine-red
color.

Walnut is one of the finest of the sculptural woods and requires the use of
very sharp tools. (See Plates 53C and 54C.) Close-grained walnut
is the best variety for carving. The wood is very hard, often requir-
ing wood-carving mallets. Its fine, tough grain permits a delicacy
of detail. American walnut is an excellent, hard wood for carving
purposes. It has beautiful graining and texture. The grain is gen-
erally quite fine and open, with a straight to slightly curly figuring.
It also has uniformity of mass, is very durable, and takes a high
polish. The color varies from a medium to a dark brown. American
walnut is more open-grained than limewood and should be carved
carefully. The wood is generally available in logs a foot or more in

diameter. Italian walnut is a hard, close-textured, beautiful variety suitable for delicate and detailed wood carving. Black walnut is a strong, heavy, hard variety that carves well and takes a high polish. The heartwood is a rich, chocolate-brown and is quite durable even when it is used under conditions favoring decay. African walnut, or Tigerwood, is a golden-brown variety with figured graining. It is usually available in the form of large logs up to 3 feet in diameter.

Linseed oil darkens walnut, but wax has little effect upon it. Occasionally oxalic acid is used commercially to bleach walnut to a lighter tone, but this practice is not recommended for the sculptor, particularly since natural walnut has a really beautiful color. A raw and untreated walnut carving has a very pleasant and attractive appearance.

Western Oak, see *Oak.*

West Indian Boxwood, see *Boxwood.*

White Birch, see *Birch.*

White Cedar, see *Cedar.*

White Mahogany, see *Primavera.*

White Oak, see *Oak.*

White Walnut, see *Butternut.*

Wild Black Cherry, see *Cherry.*

Wild Cherry, see *Cherry.*

Yew is a hard and very fine-grained wood, which has been used extensively for archery bows. It has also been employed for wood carving.

Yellow Poplar, see *Poplar.*

Zebrano, see *Zebrawood.*

Zebrawood, also known as Zingana and Zebrano, is a tropical wood imported from Africa. The name is derived from its striped graining. It is generally available in the form of very large logs.

WEIGHT

The weight of wood varies considerably with moisture content. Green or fresh wood possesses the largest quantity of moisture and is, naturally, substantially heavier than normal, air-dried wood. Artificially dried or heat-dried wood is lightest in weight. The approximate weights of some varieties in terms of pounds per cubic foot, in a normal air-dried condition (without artificial heating), is given as follows: [1]

[1] Compiled from several sources.

Aspen	26	Maple, average	35
Balsa	7.5	Oak, average	45
Basswood	26	Pearwood	48
Beech	43	Pine, average	34
Birch, average	41	Plumwood	50
Butternut	26	Primavera, white mahogany	36
Cherry, black	36	Redwood	27
Chestnut	30	Rosewood, Brazilian	50
Cocobola	75	Honduras	70
Ebony, Indian	73	Satinwood	65
East African	62	Snakewood	68
Hickory, true	51	Sycamore	33
Lignum Vitae	78	Teakwood	45
Mahogany, African	35	Walnut, black	38
West Indian	25	white, butternut	26
		Zebrawood	65

SCULPTURE IN WOOD

Tools

Chisels: There are hundreds of different shapes and sizes of wood-carving tools, but the student should secure a relatively small working kit, consisting of a few fundamental instruments together with one or two mallets, and add to his equipment as he learns to employ his basic tools. The choicest wood-carving tools are made of fine steel and are well tempered and balanced. The sculptor should always purchase the finest possible tools. The English wood-carving tools enjoy an excellent reputation because of the quality of the steel, their balancing, and their tempering.

Chisels have straight cutting edges, are available in many sizes, and function in two ways. (See Figure 12.) The sharp cutting edge cuts into and separates the wood along a specific path, while the bevel and thickness of the chisel serve as wedges and force the wood apart. The cutting and splitting action may occur simultaneously, or one may rapidly follow the other. The smaller the wedge angle or bevel on the chisel, the easier will be the carving. Low-angled chisels are indicated for carving the softwoods, while tools having higher angles are used for the hardwoods.

Chisel handles should be made of a good quality wood because

they have to take a great deal of abuse in the form of mallet blows. Ash wood is frequently used for chisel handles and is excellent for this purpose. Tool handles should be tested manually to make certain that the chisels are securely held. If they are loose, they can be glued and the chisel tang pressed firmly into the open space of the handle. The shoulder of the chisel should fit compactly against the handle ferrule.

Many professional wood carvers vary their chisel handles so that no two cutting tools have similar handles. This practice saves time during the carving process, since the tools can frequently be recog-

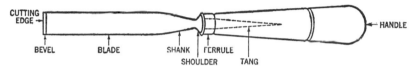

FIG. 12. WOOD-CARVING CHISEL

nized by their handles and little time is spent in picking up and selecting the one required for the particular carving job.

Gouges are tools with curved cutting edges. There are many varieties of them. Gouges that have their bevel on the outside are called 'outside bevel gouges'; those that have their bevel on the inside are 'inside bevel gouges.' Gouges with bent shanks are used for deep cutting.

Care of Tools: Wood-carving tools should be kept clean and as sharp as razors. When tools are not in use, they are most adequately protected by being lightly oiled and kept in a dry place. If it is possible, wood-carving instruments should be wrapped in soft, clean cloths before they are stored away. Many wood carvers hang their tools on wall racks to protect the cutting edges when the instruments are not in active use. (See Plate 9B.)

Rust can be treated when it first appears by rubbing the oxidized area with a soft, clean cloth moistened with a small quantity of sweet oil. The tool may then be set aside, and after a few days it can be rubbed with a finely powdered, unslaked lime.

Sharpening: Many sculptors observe the commendable practice of sharpening their carving tools continually while working.

Chisels should be sharpened or ground on only one side. The reverse side is best kept perfectly flat. Cutting edges of chisels should always be kept even and straight. If the edge of a chisel becomes

chipped, the nicks can be ground off on a grindstone at an angle of about 20°. After grinding, it can be resharpened or whetted on an oilstone, with the chisel held at an angle of about 25°.

Fine oilstones are generally used for sharpening flat chisels. A few drops of oil placed on the stone surface will serve as a lubricant. The chisel should be held with its beveled edge lying flat on the stone and, when this is at the correct angle, the tool should be grasped firmly with both hands and then moved back and forth. As the chisel is moved away, a gentle pressure should be exerted, and as it is

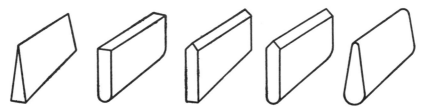

FIG. 13. SHAPED SLIPS FOR SHARPENING WOOD-CARVING TOOLS

The stones are shaped to fit the many curves and angles of the cutting edges.

drawn toward the body, the pressure should be eased. A spiral motion, utilizing a large area of the oilstone, is recommended.

With gouges, the sharpening method is generally reversed. Specially shaped slip stones (see Figure 13) are employed and the stone is rubbed on the gouge. In sharpening curved gouges, the slips should be grasped and rubbed against the blade, which is held stationary. After sharpening, it is advisable to strop the tool on a leather strop similar to that used for sharpening razors. Inside bevel gouges are whetted on stones with rounded edges.

In all cases, the length of the bevels on the cutting ends of carving tools should be retained, and particular care should be exercised during the sharpening process not to shorten the bevel.

WORKING QUALITIES OF WOOD

The ease with which woods can be worked or carved with hand tools varies considerably, but no test has yet been devised to classify scientifically varieties of wood according to their workability. The following tables have been developed from several sources.[2]

[2] The most important of these sources was the *Wood Handbook*, an unnumbered publication of the U.S. Dept. of Agriculture, Washington, D. C.

Ease of Working with Hand Tools

Softwoods

Easy to work	Medium to work	Hard to work
Balsa	Cedar, Eastern red	Douglas fir
Cedar	Cypress, Southern	Larch, Western
Pine	Fir	Pine, Southern yellow
	Hemlock	Yew
	Pine, lodgepole	
	Redwood	
	Spruce	

Hardwoods

Easy to work

- Alder, red
- Aspen
- Basswood
- Buckeye
- Soft maple
- Willow
- Yellow poplar

Medium to hard to work

- Ash, commercial white
- Beech
- Birch (types vary)
- Cherry
- Chinquapin, Western
- Cocobola
- Cottonwood
- Ebony
- Elm
- Gumwood
- Hickory
- Honeylocust
- Lignum vitae (very hard)
- Locust, black (very hard)
- Magnolia
- Mahogany (both easy and hard to work types)
- Maple, hard
- Oak
- Primavera
- Rosewood
- Snakewood
- Sycamore
- Teakwood (some varieties easy to medium to work)
- Walnut

CARVING

Wood carving is a difficult branch of sculpture, requiring both experience and a knowledge of woods, since each variety of wood and each block or piece presents its individual carving problems. It is also important for the sculptor to master his tools thoroughly and to know just what effects may be achieved with each of them. (See Plates 50 and 51.)

Solid and uniform-bodied blocks of wood, without hard or soft areas or spots, are the best kinds for sculptural use. It is, however, as difficult to determine internal defects within a block of wood as it is to judge internal defects in a stone mass. Some sculptors prefer the core or heartwood, while others like to work with the outer portion of a wood. The *Tight-Rope Dancer* by Chaim Gross (see Plate 54A) illustrates a novel method of using both the lighter outer wood and the heartwood as design elements.

While the easily carved softwoods are preferred by many sculptors, a substantial number of wood carvers relish working with the harder, chisel-resisting woods. However, it is recommended that the student wood carver avoid the harder varieties at the beginning. This does not necessarily mean that he should carve only in soft pine; mahogany may be used, but woods such as walnut and lignum vitae are best left until the carver has an adequate knowledge of his tools. It is also a good practice for the student wood carver to keep his forms compact and rounded and to avoid substantial undercutting and projecting arms and legs.

While being carved, small blocks of wood can be held securely by means of a bench or table vise, although they are occasionally held in the hand. However, the carver's hands should never be in the path of the cut. I have seen deep and dangerous wounds result from carelessly holding a wood mass with one hand while chiseling with the other.

Large blocks of wood are frequently kept secure by their own mass and physical weight, which are often sufficient to maintain the stability of the mass during carving. A wood carver will also occasionally screw a wood mass to a base and secure the base to the worktable.

The inner clasping surfaces of a metallic bench or table vise should be lined with broad strips of heavy leather or felt to prevent the marring of the surface of the wood mass. Calf is an excellent leather

for this purpose. If wooden clasps are used, cushioning will not be necessary.

A wood mass should be studied before carving, as one would study a stone block to determine the nature of the specific material and the forms to be carved from the mass. The design or shape of the forms of a wood carving should bear a relation to the shape of the mass, the density of the wood variety, and the nature of the graining.

| 11 INCHES LONG | 10 INCHES LONG | 8 INCHES LONG | 7 INCHES LONG |

"PROFESSIONAL" "STUDENT" "AMATEUR" "OLD ENGLISH"
30 oz. 16 oz. (7 to 14 oz.) (12 to 24 oz.)

Fig. 14. WOOD-CARVING MALLETS

Mallets vary in weight according to the wood they are fashioned from. The lightest mallet would be composed of beechwood and the heaviest of lignum vitae. Hickory mallets would lie midway between.

The indirect carving of wood, involving a preliminary modeling in clay, is as unhealthy and as undesirable an approach to wood carving as it is to stone carving. The pointing of wood by professionals is also practiced in wood sculpture and is fostered by a small group of dilettantes.

A block of wood should never be cut haphazardly without first considering the direction of the grain and the masses of wood in the path of the cut. Many wood carvers sketch the general form of their design on the wood mass before beginning the carving. This can be done by using ordinary chalk or charcoal.

Wood can be chipped, gouged, sliced, sawed, and pared. The gouge is generally used for blocking out initial masses and for carving the hardwoods. Fairly large instruments, supplemented by mallet blows, are usually employed during the preliminary roughing-out stages. As the carving progresses, flat chisels and small gouges are

frequently used, the tools becoming finer and the heavy mallets being supplanted by lighter mallets. (See Figure 14.) Eventually, for the final and finishing stages, the mallets are often discarded and the blows to the tool are supplied by the palm of the hand, or the instruments are directed by simple hand pressure.

The wood carver will discover in working different varieties of wood that soft woods frequently require the use of sharper chisels and gouges than do hard woods, for if dull cutting edges are used on soft wood, it may become marred or bruised.

The wood carver should try to avoid 'fighting' the wood and cutting against the grain, because carving is easiest when the 'length of the tree' or grain is followed. Carving or cutting against the grain frequently proves extremely difficult, requiring skill and experience, and the student wood carver may not always enjoy complete control of his tools.

In carving very hard woods, such as lignum vitae, it is advisable to wear goggles to protect the eyes from fast-flying chips.

TREATMENT

Many effects are possible with wood, from smoothly finished and highly polished surfaces to rough and rugged effects, where the chisel cuts are left as part of the general design or treatment. The nature of the variety of wood dictates the technique that is best employed and, therefore, directly influences form. Dense and tough varieties lend themselves to a broad treatment and many wood carvers design in terms of masses rather than in linear patterns for these hard woods. However, these varieties will also take delicate detail.

The student should experiment with different cutting instruments and carefully observe the effects of light on the contour of the cuts.

CARVING A RELIEF PANEL

The procedure employed by many wood carvers in fashioning panel reliefs consists of first making an outline drawing or sketch upon the clean wood surface, after which the sculptor proceeds to cut away the background. The uncarved portions will then represent the highest planes of the relief.

Clamps are often required in carving relief panels. The panel is generally placed flat upon the worktable with its bottom edge lined

up flush with the table edge. Insulated metal or wooden clamps are then applied to grip and hold the wood panel securely to the table surface while the carving progresses.

Reliefs should be carved very carefully and slowly. To guarantee even and clean carving, it is very important that sharp instruments be used.

SEASONING

While wood that is kept submerged under water is more durable than submerged steel, for practical sculptural purposes wood should be well dried or seasoned. A well-seasoned wood is the best kind to use for carving. This fact cannot be emphasized too strongly. The use of a 'green wood' may result in irreparable damage to a finished carving. If a wood is not adequately seasoned before it is used sculpturally, a shrinkage and possible cracking may occur as the wood dries, and a finished carving in an unseasoned wood may be ruined by the development of splits and cracks. Some sculptors make a practice of purchasing wood in logs or blocks and setting these aside in a protected bin or other part of the studio to age slowly in a uniform environment and with a maximum circulation of air about the blocks. This is an excellent practice and one to be heartily recommended.

Seasoning reduces the weight of the wood by reducing the moisture content. It serves also to increase the physical strength of the wood and to prevent undue checking, decay, and volume changes after carving. Deep cracks in a wood block result from uncontrolled drying or seasoning and are referred to as 'checks.' As a wood mass dries, the moisture or 'cell water' in the microscopic cells slowly evaporates and a contraction takes place with the greatest stress or movement across the graining. The movement with the grain is generally small.

The rate of drying of wood depends upon the size and shape of the wood mass and upon the method employed. There are two important methods of drying or seasoning wood: (1) natural seasoning or air-drying, and (2) kiln-drying or hot-air seasoning.

The natural drying of wood is commonly practiced. The wood is exposed to air outdoors but is protected from direct sunlight and rain. Fine air-drying may require long periods of time, varying from about 18 months to as long as 5 or 6 years. The quick, uncontrolled

drying of wood invariably results in a warping and checking, so that the longer the period of air-drying is, the better will be the results. The maximum moisture retention by wood after air-drying is approximately 10 to 20 per cent.

Kiln-drying or hot-air seasoning is the more economical method in terms of time and it is commonly used commercially. It is also a more complete means of ridding wood of excess moisture, as the process generally results in a wood that has a maximum moisture retention of about 5 per cent when it leaves the kiln. However, after its removal from the kiln, the wood has a tendency to reabsorb moisture from the air.

Small blocks of wood are occasionally seasoned by being boiled in water and then permitted to dry. This procedure apparently dissolves albuminous matter and permits a freer evaporation of the moisture contained in the wood, but it appears to be a dangerous procedure because it may weaken the structure of the wood.

Hardwoods are quite frequently air-dried for several months before they are kiln-dried.

Oak is an extremely difficult wood to dry or season satisfactorily. When oak and other varieties of hardwood are dried quickly with insufficient surrounding moisture, the outer portion of the block dries or 'case-hardens' and shrinks before the internal mass. The outer shell frequently checks in shrinking and the inner mass often develops checks or 'honeycombs.'

WOOD SHRINKAGE FACTORS [3]

Shrinkage should be figured in three ways:

1. Actual volume shrinkage
2. Radial shrinkage or shrinkage between the bark and the center of the log
3. Tangential shrinkage or shrinkage in the direction of circumference.

The radial shrinkage of a wood is invariably less than the tangential shrinkage. The ratio between the two is a determining factor in the resistance of wood to physical warping and twisting. The highest figures in the fourth column indicate the highest relative stability.

[3] Courtesy of the Mahogany Association, Inc.

HARDWOODS	Percentage of shrinkage in volume	Percentage of radial shrinkage or shrinkage between bark and center of log	Percentage of tangential shrinkage or shrinkage in the direction of circumference	Ratio of radial to tangential shrinkage
Mahogany, Cuban	6.0	2.7	3.3	81.8
Mahogany, Central American	7.7	3.5	4.8	73.0
Mahogany, African	8.8	4.1	5.8	71.0
Walnut	11.3	5.2	7.1	73.2
Yellow Poplar	11.4	4.1	6.9	62.7
Cherry	11.5	3.7	7.1	52.1
Maple, Silver	12.0	3.0	7.2	41.6
Ash, White	12.6	4.3	6.4	67.2
Willow	13.3	2.2	8.2	27.0
Maple, Sugar	14.4	4.9	9.1	53.8
Elm, American	14.4	4.2	9.5	44.2
Gum, Red	15.0	5.2	9.9	52.5
White Oak	16.0	4.8	9.2	52.2
Hickory, Shagbark	16.0	6.5	10.2	63.7
Pecan	16.0	4.9	8.9	53.9
Southern Red Oak	16.3	4.5	8.7	51.7
Beech	16.5	4.6	10.5	42.8
Birch, Yellow	17.0	7.9	9.0	88.0

PRESERVATION

Wood is a rather delicate material when its durability is compared with that of stone or of the sculpturally utilized metals. However, under favorable conditions wood carvings will survive indefinitely.

Moisture or humidity and atmospheric temperature are the main factors influencing wood decay, in addition to insects and plant or fungus growth. Wood that is kept dry will not decay, so that a carving exposed in a warm, humid region will be more liable to decay than one exposed in a cool, dry climate.

All varieties of wood have a tendency to swell when moisture is

absorbed and to shrink when the moisture evaporates. Fluctuating temperatures and conditions of atmospheric moisture may split a finished work in many places. I have seen large wood carvings develop enormous cracks when the works were removed from the studio and placed on gallery exhibition. When the works were returned to the studio and to previous conditions of temperature and humidity, the deep, broad fissures slowly closed to a nearly normal condition. Occasionally the use of a sealing and retouching material is required to fill checks. A mixture of wood dust that has been secured from the wood to be repaired can be mixed with plastic wood and applied to the cracks. Wood shavings or actual wedges of identical wood, which have been shaped to fit the fissures, can be glued into deep cleavages and finished with an application of wood dust mixed with plastic wood.

Many sculptors advocate saturating a wood carving by boiling it in oil to preserve and strengthen it. The application of oil or wax to a finished wood carving will tend to minimize the dangers of cracking and warping. A good floor wax is satisfactory for use in finishing wood.

An industrial process has been recently developed whereby wood is impregnated with rosin-forming chemicals, which react with the wood cellulose and alter its physical properties. The wood is thus made dimensionally stable under varying conditions of humidity and temperature. The hardness of the wood and its wearing and polishing qualities are increased and the grain is not affected.

FINISHES

Wood has been polished, oiled, waxed, dyed, or stained in imitation of other materials and other woods, gilded with metallic leaf, and completely masked with colored opaque lacquers. (See Plate 1A and C, and 54F.) In the past, the Egyptians frequently colored their wood carvings, and the architectural wood sculpture of the Greeks was very often externally colored. The Chinese and Japanese produced a large amount of polychromed wood sculpture. However, the application of colored paint to wood carvings tends to nullify and, frequently, to mask completely the natural texture and coloring of the individual wood. Gilding and the application of opaque, colored lacquers have

a similarly camouflaging effect and the contemporary tendency in sculpture is to respect the individual material and to exploit its individual qualities. All superficially applied coloring is regarded as deceptive camouflage and as aesthetically objectionable, and wood carvings are usually left in a natural condition or are polished and lightly oiled or waxed to bring out the full depth and beauty of the color and texture of the wood. The inherent beauty of a wood can be best accentuated by careful polishing and by the conservative use of clear oils or waxes.

Woods are finished with oils or waxes for several reasons:

1. To fill the pore spaces and thereby seal the exposed surfaces of the wood against the effects of moisture penetration and temperature changes
2. To reveal the full beauty of color and the depth and luster of the graining
3. To change or intensify the tone or color of the wood.

Sandpaper is occasionally employed as an abrasive for finishing wood surfaces. If abrasive papers are used, they should be applied carefully or there may be a resulting loss of detail and modeling. Hardwoods can be finished by rubbing the carving with shavings or small chips of identical wood.

STAINING

The most adequate impregnation of wood and coloring substance is achieved by the use of a vacuum process employing a water soluble stain. Some woods in the order of their suitability for this process are as follows: (1) apple, (2) hazel, (3) maple, (4) beech, and (5) birch.

A solution of gall-nut, to which has been added a minute quantity of a solution of ammonium vanadate, is frequently used for this purpose.

VEHICLES FOR STAINING

Water vehicles penetrate excellently, but raise the grain of the wood. A solution of approximately ¼ of an ounce of color is used to each pint of water.

Spirit vehicles penetrate well, but raise the wood grain slightly. About 1 pint of denatured alcohol is used to each ¼ of an ounce of color.

Oil vehicles have only a superficial surface penetration, but do not affect the wood graining. Approximately ¼ of an ounce of oil-soluble color is used to each pint of benzine.

Varnish vehicles have little, if any, effect upon the graining of the wood. About ¼ of an ounce of oil-soluble color is generally used to each pint of varnish. The mixture should be thoroughly stirred until all of the coloring matter has been evenly dissolved, and the solution should be permitted to stand overnight before it is used.

Shellac vehicles have little, if any, effect upon the graining of a wood. About ¼ of an ounce of color is used to each pint of shellac solution.

STAINS

The application of a priming coating of raw linseed oil and turpentine in equal parts will furnish a uniform foundation for subsequent oil stains.

NATURAL STAIN

Refined turpentine	1 part
Raw linseed oil	1 part
Drier	½ part

The formula given above is used as a vehicle to which may be added colors ground in oil.

MAHOGANY STAIN

Rose lake	1 part
VanDyke brown	2 parts

These proportions may be varied to secure a greater range of values from light mahogany to brown. The browns have a slight tendency to gray in time.

WALNUT STAIN

Walnut stain is made up of French ocher with red oxide of iron and lampblack in small quantities. Approximately 1 per cent of ocher is used.

CHERRYWOOD STAIN

Raw sienna	1 part
Burnt sienna	2 parts

These proportions can be varied to suit the individual requirements.

LIGHT OAK STAIN

Raw sienna	1 part
Raw umber	4 parts

DARK OAK STAIN

Burnt umber	3 parts
Raw sienna	8 parts

A small quantity of burnt sienna can be added to this formula to achieve a richer, deeper tone.

IMITATION OF GRAINING

The staining material should be thinned by the addition of a solution consisting of the following ingredients:

Raw linseed oil	2 parts
Refined turpentine	3 parts
Drier	1 part

This mixture is applied over the dry wood. Graining is achieved by dragging brushes across the wet surface until the desired effect is secured.

11 OTHER SCULPTURAL MATERIALS

AMBER

AMBER is a fossil rosin that has been used in the past as a minor sculptural medium, notably by the Greeks, who occasionally used it for small statuettes. It has also been employed by the Chinese.

Its use has been seriously prejudiced by the development of plastics, which has resulted in many beautiful, transparent, and compact materials more readily available than amber, and possessing superior working qualities.

When in working with amber it is necessary to join small pieces together, the units are first heated in an oil bath. This softens the amber and makes it flexible. The pieces can then be joined together by first lubricating the joining surfaces with an oil, such as linseed oil, and then applying heat. The amber units are then pressed together while they are hot.

BRICK

The use of brick as an artistic medium is an ancient one, but it has declined through the centuries and the medium is rarely employed at present. (See Plate 55.) However, within the past decade some sculptors have experimented with brick as an architectural sculpture medium and have achieved excellent results. The architectural carved sculpture in brick by Eric Kennington, decorating the Shakespeare Memorial Theatre, Stratford-on-Avon, and the carved brick friezes by Katherine Ward Lane, decorating the walls of the Biological Laboratories at Harvard University, are excellent examples of the possibilities of this material.

Bricks generally consist of calcined earth. The earliest-known bricks are believed to have been made in Babylonia. The Babylonians and the Assyrians used brick extensively as a building and decorative material, and frequently coated them with a colored enamel-like glaze. The Italians of the fourteenth and fifteenth centuries further developed the technique of decorative brickwork, which was actually a version of terra cotta, and introduced the application of true enamels to the material.

The brick-clays possessing the greatest plastic and tensile strength

are generally those containing a substantial proportion of hydrated aluminum silicate, the clay substance. The color of brick varies from a delicate buff to a dark, reddish brown, and is influenced by firing factors and by the proportion of iron oxide which is present in the earth used. Sand is another physical component of brick-clay.

The carving of brick is a process of gentle and careful pulverization and abrasion. Very sharp flat chisels, a very fine pick and files and rasps can be used for shaping brick into sculptural form. The material is quite brittle and will readily fracture if struck with force. Where a frieze is to be worked, a fine quality brick should be used and the units should be joined or cemented closely together.

The technique employed in the execution of the Harvard University friezes was quite simple. The frieze designs were first carved ⅓ the size of the final works. Stencil enlargements were then made and the designs were traced with chalk directly on the building walls. The carving was done with electric pneumatic tools and the depth of each cut was checked with plaster models kept on the scaffold. Only one mistake was made in the carving, requiring a few bricks to be replaced and recarved. The mortar between the bricks gave no trouble and the corners of the unit bricks did not chip away. The tools employed were the same as those used to carve granite, despite the fact that brick is not so hard as granite.

The reliefs were very simply carved. There is no rounding of the forms or modeling of the figures, although an optical illusion might lead one to feel that the forms are rounded. On clear days the figures appear to be in relief, while on dark or rainy days the outlines are darker where dust and dirt have accumulated on the rough carved brick surface. The technique adapted to the brick was evolved from studies by Miss Lane of ancient Chinese tomb sculptures of the Han Period.

Occasionally a sculptor will carve a single brick. José de Creeft has experimented with single bricks as a carving medium. The material demands a rather broad treatment.

BUTTER

Butter is very rarely employed as a serious sculptural medium in the Western world, because of its extreme perishability. It is very readily affected by temperature changes and is highly susceptible to bacterial attack.

However, it has been and is used as a sculptural medium by Tibetan monks,[1] who mix it with powdered colors and mold their forms over blackened wood panels. The fairly intricate modeling is accomplished in cold rooms, and the modelers dip their fingers frequently into cold water as they manipulate the soft material.

COAL

Coal is rarely used as a sculptural medium and is restricted to small sculpture. As it is very fragile and fractures easily, and consequently has to be worked with great care, it is not recommended for serious consideration. Hard coal or anthracite is the hardest and most compact form of the material, and it too is highly brittle and fragile. It cannot be carved with chisels and has to be worked carefully with fine files, rasps, and abrasives.

CONCRETE

Concrete is a mixture of Portland cement, aggregate, and water. *Cast stone* is basically a highly refined variety of concrete. Sculptural cast stone or concrete is similar to commercial cast stone but often special aggregates are used for their color and texture. The cement-aggregate mixture is rendered plastic by the addition of water, which reacts chemically with the cement, and the mix ultimately solidifies to a hard and strong mass. While the material is plastic it can be shaped into almost any desired but compact form by means of casting, pressing into a mold, or modeling. After it has hardened it can be carved, polished, or otherwise finished.

Cast stone possesses many qualities that recommend its use sculpturally. It is plastic when prepared for use and, after hardening, the mass is dense, strong, and durable. It has a generally attractive appearance and possesses great possibilities as a means of economically producing large and durable editions of three-dimensional works of art. (See Plates 57, 58, and 59.)

ARTIFICIAL STONE

The term 'artificial stone' is occasionally employed to describe cement and aggregate mixes, but it is deceptive and objectionable be-

[1] Rock, Joseph F., 'Life Among the Lamas of Choni,' *National Geographic Magazine*, Nov. 1928, pp. 569-619.

cause it connotes imitation. Although the appearance of virtually any of the sculpturally used stones can be closely approximated by cast stone, the trend of contemporary sculpture is away from the simulation of one material by another, and toward the development and use of each material as a separate and distinct medium, with an appreciation of its individual possibilities and limitations.[2] 'Concrete' and 'cast stone' are much more descriptive and wholesome terms to describe mixtures of Portland cement and aggregate.

CEMENT

Cement is a finely powdered compound made by grinding a mixture of lime and earth-clay or impure calcium aluminum silicate to a fine powder and calcining this powder in a furnace to incipient fusion. This 'clinker' is then pulverized and at the same time about 2 per cent of gypsum is added to retard the setting. When the finished cement is mixed with water to form a workable mix, it remains plastic for several hours, owing to this retardation.

Portland cement is composed of a complex calcium aluminum silicate and is similar in its appearance to Portland stone, an English limestone variety, from which it derives its name. Portland cement is generally regarded as the finest cement for sculptural use, because of its great strength and uniformity.

AGGREGATE

Aggregate is the term applied to the inert bulk- or body-supplying mineral portion of a concrete or cast-stone mixture. It is used primarily for reasons of economy, although its decorative value is also important, especially in sculptural work.

The ingredients of an aggregate must not react chemically with the cement, particularly if the finished work in which the aggregate is used will be subjected to the weather. Clean, chemically stable, physically strong and durable aggregate should be chosen for all sculptural concrete mixes. The aggregate particles should not be easily pulverized and should not possess structural weaknesses, such as layers or planes.

Natural stone aggregates consisting principally of marbles and

[2] There has been in the past on the part of inexperienced builders and manufacturers an unwholesome practice of using this medium to imitate other natural quarried stones; and they have tried to approximate or duplicate the texture, color, and finish of almost every natural stone.

granites are frequently used in sculptural concrete mixes. Ceramic aggregates consisting of broken ceramic bodies are also employed. The ceramic bodies are prepared by heating or burning ceramic material to vitrification, after which the hard bodies are fractured to form aggregate of suitable grading. Some sculptors feel that aggregates consisting of crushed natural stone or ceramic bodies that are crushed in the manner just described are objectionable, since they contain many flat and sharp pieces, and also may be too porous and may lose color.

Types of Aggregates: Crushed marble, white quartz, granite, and gravel have been used as stone aggregate for sculptural concrete. Other coarse aggregates sometimes used are crushed ceramic body and coarse river sand. Among the fine aggregates [3] are marble dust,[4] silica flour, fine sand, and talc. The pulverized stone chips and dust that accumulate during the carving of a specific block of stone can be collected, screened for size, and placed in labeled containers for future use as aggregate in concrete mixes. The gatherings from the carving of different-colored marbles and granites should be kept separately.

The sand used in a concrete mix should be a mixture of both fine and coarse grains, and should be adequately washed and dried before

[3] Material passing through a sieve having four meshes to the lineal inch is referred to as fine aggregate and the material retained on this sieve as the coarse aggregate.

[4] The most economical method of securing marble dust is by the pulverization of a 'dead' piece of marble without sculptural value, or by gathering the resulting residue while working on a piece of marble.

The marble block is placed upon a large piece of clean and heavy paper or cardboard, and is pulverized with a bushhammer. The marble chips and dust are gathered together at intervals by lifting the edges of the paper upwards and toward the center. They may be removed and placed in a clean box as they accumulate. Large chips may be picked out of the mass and discarded or reduced quickly to dust by a few blows of the hammer.

The entire mass of dust and small chips is slowly worked through in the second stage, which consists of placing a small quantity of the mixed residue in the center of a fine screen and sifting it over a clean box or other containing vessel.

Screens of various sizes are used for sorting the stone debris according to particle size. The finest screen is used first, and larger meshed screens are employed thereafter.

The following is a formula containing marble dust that results in fine, smooth positives:

Marble dust	2 parts
White Portland cement	8 parts

As the proportion of marble dust is increased, and the proportion of Portland cement decreased, the resulting positive surface will be rougher. Sand can be added in small quantities of up to 10 per cent of the total ingredients.

use. Washing with clean, fresh water will remove soluble salts and other water-soluble impurities, which might otherwise chemically affect the concrete mix. White sand and yellow sand varieties are both used as aggregate.

It is often necessary to sift the sand through a series of screens or sieves and then to recombine the separated sizes to obtain the desired grading of the fine aggregate. (See Plate 56.)

Size of Aggregate Particles: The size of the aggregate particles is very important in determining the workability of a sculptural concrete mix and the quantity of concrete that can be secured from a specific volume of cement and a definite proportion of water.

The use of larger aggregate particles will result in greater economy, but may yield coarser mixtures. Fine particles are necessary for a mix of marked smoothness and workability. Hence the size of the aggregate should be determined by the nature of the specific work. Many workers recommend the use of both coarse and fine types in a casting mix. The American Society for Testing Materials recommends that from 5 to 30 per cent of fine aggregate pass a 50-mesh sieve; the 1924 Joint Committee report suggests 10 to 30 per cent. The maximum size of aggregate used in the commercial manufacture of cast stone is usually ⅜ of an inch.

ARTIFICIAL MARBLE

An 'artificial marble' can be made by mixing the following ingredients:

Aluminum ammonium sulphate (Ammonium alum)	7 ounces
Water	1 ounce

The ammonium alum is first dissolved in the water by means of heating. When the solution has reached the boiling point it may be poured into the negative mold. The positive material can be colored by the addition of water-soluble aniline dyes. Plaster of Paris or talc can be added to the solution in small quantities as a filler.

MIXES

Some of the desirable qualities of a good cast-stone mix for sculptural use are:

1. Plasticity or workability
2. Adhesiveness and structural strength

3. Resistance of the finished mass to the effects of water
4. Resistance of the finished mass to the effects of temperature changes
5. Attractive appearance.

It is necessary to use good materials and to experiment. Records should be kept of the materials used in mixes, the proportions in which they were employed, and what the final results were.

The water used in mixing the cement mixture should be fit for drinking. It should be clean and as free as possible from organic impurities and significant amounts of either acid or alkali.

The proportions of ingredients in concrete mixes should vary with the nature of the work to be undertaken, the climatic or environmental conditions to which the finished work will be exposed, the grading of the aggregate, and the consistency required. The strength and other properties of concrete are affected by the amount of water used in proportion to the cement, a small amount of water giving concrete that is stronger and more resistant to the effects of weather than concrete in which larger amounts of water are used. Smaller amounts of water require mixes that are richer in cement to provide plastic, cohesive mixtures. Also wet mixes require more cement than stiffer mixes for a given proportion of water to cement. Small aggregate also requires more cement than large aggregate.

The American Concrete Institute committee on design of concrete mixes suggests the following mixes for small jobs:

Maximum size of aggregate	Pounds of aggregate for each sack (94 lb.) of cement						Sacks of cement required for cu. yd. of concrete
	Sand	$\frac{3}{16}$ to $\frac{1}{2}''$	$\frac{3}{16}$ to $\frac{3}{4}''$	$\frac{1}{2}$ to 1 in.	$\frac{3}{4}$ to $1\frac{1}{2}''$	1'' to 2''	
$\frac{1}{2}$ in.	235	190					6.9
$\frac{3}{4}$ in.	235		245				6.4
1 in.	225	110		165			6.2
$1\frac{1}{2}$ in.	225		185		135		5.8
2 in.	225	90		120		150	5.6

From the *Journal of the American Concrete Industry*, November 1943.

The weight of sand indicated is for dry material. If the sand is damp, add 10 lb. to the weight of sand and if it is very wet add 20 lb. The mixes indicated are for medium consistency. If a very wet mix is required, the quantities of sand should be reduced about 5 per cent and the coarse aggregate about 10 per cent.

A general concrete mix consists of:

> Cement 1 part by volume
> Sand 3 parts by volume
> Water, sufficient to render the mass plastic

For outdoor sculpture, the following basic formula may be used:

> Waterproof Portland cement 1 part by volume
> Sand 2 parts by volume

The proportions for unit masonry mortar may be 1 part Portland cement, 1 part lime putty, and 6 parts sand, or 1 part masonry cement and 3 parts sand.

Mixing ingredients: The proportions of ingredients in cast-stone mixes should vary with the nature of the work to be undertaken. The climatic conditions of the eventual site of the concrete work should also be considered.

The required quantities of the various ingredients of the specific mix should be carefully measured and mixed together while they are perfectly dry. This must be done as patiently and as thoroughly as possible. The sculptor should dress in old clothes and make use of a stone-carving protective mask. After the dry ingredients have been mixed to a uniform color, water can be slowly added to the mixture while mixing is continued, until the entire mass is sufficiently plastic for the intended purpose. The precise consistency required will depend on the size and shape of the negative mold. While the mixture should be plastic, it should also be cohesive and not too wet. Whenever possible, the concrete should be tamped, puddled, or vibrated into place, as this will permit a stiffer consistency.

Accelerators: Calcium chloride is a frequently used concrete accelerator. The quantity used should not exceed 2 pounds to each 100 pounds of cement, and it is advisable to experiment with small amounts before mixing large working quantities. The substance can be dissolved with the mixing water. It should not be combined directly in dry and powdered form with the cement.

NEGATIVE MOLDS

Several materials are used commercially in making negative molds for concrete or cast-stone castings: (1) sand, (2) gelatine or glue, (3) wood, and (4) plaster of Paris.

Sand molding involves the use of a wet and plastic mix that is poured into absorbent and well-packed negative sand molds. Rigid negative molding involves the use of a mix less wet, but still moist and plastic, which is tamped, puddled, or vibrated in rigid negative molds made of wood or plaster of Paris. Gelatine and glue yield partly flexible negatives and are of value in casting small to medium-sized works possessing undercuts. Wooden molds are frequently used commercially for the casting of simple geometrical forms such as slabs and monumental tablets, but for most sculptural work are much more difficult to fashion than are molds of plaster of Paris, because wood has to be carved or hollowed out. A wooden negative also manifests a tendency to absorb moisture and warp, and requires treatment with many coatings of shellac before it can be used as a containing mold for concrete.

Since a plastic cast stone or concrete mix is almost invariably a heavy mass and is frequently used for the casting of large and solid pieces, rigid negative containing molds such as those that can be fashioned of plaster of Paris are the best to employ. Plaster of Paris negative molds are excellent because they possess the rigidity required for either the fluid or the stiffer cast stone mixes, and they also have the durability that a negative for containing concrete forms requires. This latter characteristic is important because the concrete mass should be permitted to remain within its negative mold for some time subsequent to pouring, in order to cure it properly.

If plaster of Paris is used as a negative containing mold for the fashioning of concrete positives, several coats of a separating solution of shellac should first be applied to the inner surfaces of the plaster negative and after these coatings have dried the containing surfaces should be lightly oiled. The mold will then be ready to receive the concrete mix.

Concrete should be poured into the negative mold and packed well by the exertion of mechanical pressure. As material is added to charge or fill the mold, tamping can be resorted to. The consistency of a concrete mix is very important. An excess of water in a mix will tend

to unbalance a relatively uniform physical mixture, since the heavier aggregate particles are likely to settle or gravitate to the bottom of the plastic mass.

Vibration: A negative mold is sometimes vibrated when coarse particles are used as aggregate, to secure a close compaction of the aggregate throughout the mass and against the containing negative wall. The method thus results in a cast of maximum density.

Another reason that vibrating a mold charged with cast stone is superior to simple pouring is that by means of vibration more aggregate can be used and more of the positive cast-stone surface will be taken up by the aggregate and the dense positive surface will be capable of taking a fine polish.

In preparing a mix that is to be vibrated, a smaller proportion of fine aggregate is used than is required for hand placing. The proportion of cement to total aggregate and the quantity of water required to render the mix plastic are also reduced.

For vibration, the negative containing mold must be strong and thick. Plaster molds are excellent for this purpose. The inner surfaces of the plaster negative should be treated with shellac to seal the pores, and the mold should be bound with strong rope or wire. All cracks between mold sections should be thoroughly sealed before charging and vibrating the mold.

SETTING

Cement is called a *hydraulic* material because it will set or harden even when it is submerged under water.

The setting of cement is a complicated process involving chemical reactions between the water and different compounds in the cement. All Portland cements set up into a solid mass in about the same time, but the rate at which strength is gained varies. There are high early-strength cements that gain strength very rapidly, having in a few days the strength that normal cement requires a week or more to develop. In a week, the high early-strength cements will have a strength that is obtained by the normal cements in three or four weeks.

MODELING WITH CONCRETE

Cast stone or concrete can be used as a modeling medium and either developed as a solid mass or worked up over an armature. How-

ever, a solidly developed form in concrete will result in a very heavy model. Medium to large works are must satisfactorily fashioned over a framework, although when an armature is used there is always the danger that the finished piece may eventually crack.

Armatures are generally covered with wire mesh to support and to reinforce the concrete. The mesh should be covered with a layer of mix consisting of cement and lime putty in the following proportions:

Cement	3 parts
Aged lime putty	1 part

The lime putty should be aged from 3 to 4 months and may be secured from building-supply dealers. The second application consists of fine stone bits and sand aggregate in proportions of 2 parts of cement to 1 part of either sand or fine stone particles. This mixture is used to build up the model to a slightly smaller size than that of the finished work; a third mix consisting of 4 parts of cement to 1 part of lime putty is used for the final modeling.

In modeling a concrete form in the full round it is best to begin at the base of the work and to proceed *slowly* upwards, because the gravitational pull on the plastic and relatively heavy mass tends to cause a frequently disastrous slumping of the concrete mass. To begin at the top of a piece and work downward is virtually impossible. The nature of concrete as a modeling medium demands a compactness of design and a simplicity of treatment.

Modeling with concrete is difficult because of the heavy, plastic nature of the material, which tends to sag or slump. It is particularly difficult to model with a mix containing coarse aggregate. However, concrete is used satisfactorily as a medium for modeled reliefs: The procedure consists of pouring the concrete mix into a suitable containing form, which is kept in a flat or horizontal position until the material has partly hardened, after which the mass can be tilted upward slightly and the forms shaped with wooden clay-modeling tools.

CARVING CONCRETE

Concrete does not cut or carve as does natural stone. It is generally molded while in a moist and plastic condition into the approximate form of the desired work. After the entire mass has been dried and

hardened, detail and subtle surface modeling can be done with deli-
cate stone-carving instruments and abrasives.

COLORING CONCRETE

Cast stone or concrete is a highly permanent sculptural medium
that lends itself to the utilization of color as a basic design element.

A concrete mass can be colored in several ways:

1. The use of colored aggregate
2. The addition of dry, powdered color to the mix
3. The superficial application of external color to the finished work.

These methods offer an extensive and almost limitless range of
coloring possibilities.

The finest method of coloring concrete consists of incorporating the
color with the mix in the form of an inert and permanent aggregate
or by the incorporation of dry and powdered inert chemical pigments
in the *dry* mix prior to the addition of the mixing water or by a com-
bination of these methods. Powdered coloring matter can be added
to a mix in proportions of up to approximately 10 per cent of the
weight of cement. The mix should be stirred steadily for about 10
minutes following the addition of water, to insure a uniform dis-
tribution of the pigmenting material.

White Portland cement is recommended as matrix for a colored
concrete, because by its use a maximum coloring effect can be gained,
whereas gray-green cement tends to subdue or to gray the coloring.
Very finely pulverized and inert aggregate incorporated in the con-
crete mix will tint the entire mass. However, the use of finely divided
aggregate or powdered pigment results in subdued tints, and mixes
should be tested on a small scale before larger working quantities
are prepared, to determine the necessary proportions required for
the specific tint of color desired. Large particles of colored aggregate
in the concrete mass will present concentrated color areas or visible
units of color and will result in a mottled effect.

The fading of a colored concrete mass is generally caused by an
unstable pigmenting ingredient or the formation of a surface film of
calcium carbonate.

Aniline colors and organic or vegetable dyes should not be used
as concrete pigmenting agents. The earth colors have been employed
successfully, and are quite durable.

Coloring Materials

White: White Portland cement together with white marble or ceramic aggregate. Zinc oxide or inert titanium may be added if desired. Lead oxide should never be used in concrete mixes.

Gray to Black: Carbon pigments, Manganese oxide, black iron oxide.

Brown to Black: Manganese dioxide.

Buff to Yellow: Yellow ocher, Mars yellow, Chrome yellow.

Green: Chromium oxide, quite permanent as a green pigmenting agent; has only a delicate pigmenting strength.

Blue: Artificial ultramarine blue and Cobalt blue. Artificial ultramarine not as permanent as the genuine ultramarine, but less expensive. Only the best grades should be used. Prussian blue is unsatisfactory.

Red; Red-Orange: Mineral turkey red, Mars red.

Brown-Red; Red-Violet: Indian red, red oxide of iron.

Brown to Dull Red: Red oxide of iron.

Brown: Umbers and Siennas.

Lead and zinc chromates should never be used in concrete mixes. Copper-base colors should also be avoided.

SEASONING CONCRETE

The seasoning of concrete consists of *curing* and *drying.*

In order for a concrete mass to develop maximum strength and density it is necessary that it be properly cured. This is particularly important in regard to works to be exposed outdoors.

A freshly cast concrete acquires physical strength during 'aging' or curing, and the longer it can be kept moist within its negative mold, the better will be the results achieved. If several days are allowed to pass before the work is removed from the mold, the mass will be markedly stronger than if the object is removed earlier.

The hardening of concrete is caused by chemical reaction between the cement matrix and the mixing water, and the process continues indefinitely, depending upon favorable temperature conditions and the presence of moisture.

Subsequent to casting or otherwise filling a mold, the concrete positive should be kept moist and within the negative for a minimum of 48 hours, because moisture is of greatest importance to a concrete mass during the first two days after casting. In hot, dry weather the mold mass should be blanketed with wet cloths to prevent excessive evaporation of moisture.

After a concrete positive has been removed from its negative mold, it should be covered with wet cloths, which should be kept moist for at least 10 days.

A recently cast concrete mass can be quickly strengthened by keeping the mass damp and at an approximate temperature of 70° Fahrenheit. If a concrete mass is cured at a temperature lower than 70° F., it will harden more slowly.

DRYING

The time required for the drying out of a concrete mass is determined largely by variable atmospheric factors that include the heat of the room and the moisture content of the surrounding atmosphere. After being cured, the cast stone or concrete mass possesses a surplus of moisture and is similar in a sense to freshly cut wood or a recently quarried and porous stone containing 'quarry water.' It should not be exposed outdoors until it has been adequately dried.

Some sculptors advocate a minimum drying time of two weeks for a concrete cast after it has been cured.

STRENGTH OF CONCRETE

Cast stone or concrete has a fairly great compressive strength, but a relatively low tensile strength. The strength of a concrete is dependent upon the water content of the mix or the water-cement ratio, the physical nature of the aggregate, and the extent of the curing. The water-cement ratio is the ratio, by volume, of water to cement. The ratio is equivalent to the number of cubic feet of water to one cubic foot of cement. An increase in water content of the mix results in a decrease in the strength of the finished concrete. Adequate mixing and curing are other important elements affecting the strength.

Commercial samples of cast stone have sustained compressive stresses of 11,000 pounds per square inch and more. Because of the low tensile strength of concrete, forms should be kept compact or reinforced with steel mesh or bars. 'Reinforced concrete' is a term applied to a concrete mass in which has been incorporated a metallic skeleton of iron or steel.

The early strength of a concrete mix can be increased by using a high early-strength cement, which differs from the normal Portland cements in fineness and in the proportions of the major ingredients, by the use of more cement and less water, or by adding calcium chloride in proportions of up to 2 pounds per sack of cement.

SHRINKAGE OF CONCRETE

A concrete mass undergoes relatively mild volume changes under varying conditions of exposure. After casting, it will slowly shrink for several months, as the moisture contained within the mass slowly evaporates on exposure to the air. A dry, hardened concrete mass will tend to swell slightly if it is saturated with or immersed in water, but shrinkage will again take place as the moisture evaporates from the mass.

Shrinkage tends to be rapid during the initial drying stage after curing, and if the concrete form is not protected at this time to prevent the quick loss of surface moisture and superficial shrinkage, it may result in a serious checking or cracking.

HARDENING CONCRETE

Aqueous solutions of zinc fluosilicate and magnesium fluosilicate have been used for the hardening of concrete. Several applications of either of these solutions are generally made to the finished mass. The solution used for the initial treatment consists of one ounce of chemical to each pint of water. For the second and subsequent applications, the solution employed consists of two ounces of chemical to each pint of water.

The concrete surface must be thoroughly clean and dry before the application of solution is made, to insure a maximum penetration of the fluid, and each application should be permitted to dry adequately before additional treatments are made. After the final application has dried, any white crystals that have formed on the surface can be scrubbed off with water.

The following concrete-hardening formula is given by *The Chemical Formulary:* [5]

CONCRETE HARDENER

To harden concrete surfaces, clean and flush surface thoroughly, allow to dry and finally flush with magnesium fluosilicate (20° Bé.). Allow to dry for several days, and repeat flushing with the hardener once or twice more, or until the desired hardness is obtained.

PRESERVATION OF CONCRETE

Concrete or cast stone is frequently employed in architectural construction. It is used less extensively as a medium for outdoor sculpture.

A concrete mass is affected by humidity and temperature changes,

[5] *The Chemical Formulary,* ibid., vol. II, p. 308.

which may cause an alternate expansion and shrinkage of the mass, and these physical changes may result in the development of fine surface cracks or fractures. There is also the danger of freezing after moisture or water has been absorbed.

A concrete work intended for outdoor use should be compactly cast. This is an important element in determining the durability of a cast and the degree of its resistance to moisture. With a porous cast there is always present the possibility of a continuous penetration of water, which may eventually dissolve and disintegrate the calcareous components of the cement, substantially reducing its physical strength.

A concrete mass, after it has been cured and dried, can be hardened and made denser by being soaked in a solution of sodium silicate for about two weeks.

An ordinary fine quality floor wax applied to a finished concrete cast that is to be placed outdoors will tend to seal the surface pores. However, the wax may deepen or intensify the color of the finished work and the sculptor should first determine, by experimentally applying it to a small and inconspicuous area of the concrete surface, whether the change is desirable. The initial wax application should not be made before the concrete has dried. The concrete surface must also be clean. There should be several wax applications within a short period of time. An application each month for 3 or 4 months, followed by semi-annual or annual applications, should preserve and protect the work from the effects of moisture penetration.

Marbles are not recommended as cast stone aggregates for works that are to be polished and then exposed outdoors, since they tend to lose their surface polish on weathering. The harder stones, such as granite and quartz, are preferable for this purpose.

For waterproofing cement and concrete, *The Chemical Formulary* gives the following formula: [6]

> Dissolve 1 to 2 pounds of ammonium stearate (25% dry soap basis) in every 7½ gallons of gaging water.

The stearate has some water-repellent qualities, but in producing a watertight structure it is most important to use a plastic concrete mixture containing not more than 6 gallons of water to each sack of cement. The concrete should be placed very carefully to avoid construction joints and porous areas, and then cured thoroughly by keeping the mass moist for a period of at least a week.

[6] Ibid.

Finishing and Polishing Concrete

Concrete lends itself to a variety of surface effects ranging from smooth to rough finishes. Many mixes are also capable of being polished after they are cured, but this depends upon the physical nature of the aggregate and the proximity of the aggregate particles to each other. As the fineness of the aggregate particles increases, the effort required to polish the finished mass will decrease. The finished appearance desired of a specific piece should be predetermined and the selection of the aggregate and the method of casting should be made on this basis. A concrete mass should not be finished until at least ten days have elapsed after casting.

For the initial grinding or smoothing of a concrete surface, medium to coarse carborundum blocks can be used, with an abundance of water as a lubricating and cleansing agent. The concrete surface should be worked over until the grain or texture is even. Fine chisels can be used for surface tooling and for accenting detail. If air pockets are present in the cast mass, they can be filled with 'neat cement.'[7]

After being smoothed, the mass should be permitted to dry out thoroughly before it is exposed outdoors.

Storing Unused Cement

Unused cement should be adequately protected from moisture, because it is very sensitive to atmospheric humidity and will hydrate or set prematurely if it is left exposed to moist air. Once the original carton has been opened, cement is best stored in an airtight light-proof sealed container.

Gesso

Gesso is occasionally used for decorations in low relief on wooden surfaces. It is largely employed commercially for embellishing elaborate picture frames of the 'museum' type. Mixtures of parchment size and whiting have been used for this purpose; another frequently employed mixture is made up of rosin, glue, linseed oil, and whiting.

Gesso is generally used while it is hot. The material is applied to the wood surface and is quickly modeled before it has an opportunity to cool and set. After it has cooled and hardened, it may be sanded with a fine emery paper or worked with files. The hard gesso can also be carved with sharp tools, but this has to be done carefully.

[7] *Neat cement* is a mixture of cement and water. It is not recommended for sculptural use save as a retouching medium.

Gesso frame decorations are frequently painted or gilded after they have been shaped.

GLASS

Glass is a hard, generally transparent, and brittle, but fairly permanent material that has been used by man for thousands of years. (See Plate 7A and Plate 60.) The substance consists of silica and basic oxides, such as sodium, aluminum, lead, or calcium oxide. Silica is the constituent in glass that resists heat and chemical action, and the more silica a glass contains, the more permanent and difficult to work it becomes.

The physical constitution of glass is not accurately known and the material is a typical example of a substance that is not composed of individual crystalline grains, but is amorphous. Glass is sometimes referred to as a supercooled liquid, because the material has no definite melting point.

There are more possible varieties of glass than there are varieties of metals and alloys combined, and many tens of thousands of glass formulas exist.

While ordinary glass may be fractured by heat and cold changes, there are glasses available that resist extremes of temperature. Glasses also vary in weight and some are lighter than aluminum while others are heavier than iron.

The hardness of various glasses also vary. Sodium carbonate, calcium carbonate, and sand yield a soft or 'soda glass.' Hard glass contains potassium oxide in place of some of the sodium oxide. Flint glass contains lead oxide. 'Pyrex' contains boric oxide in place of some of the silica.

The presence of lead in a glass increases its fusibility and luster, and also renders the resulting glass fairly soft, so that it can be more readily cut into ornamental shapes.

In preparing a glass, the ingredients of the specific formula are usually thoroughly mixed while they are in a dry condition and melted in an earth-clay crucible at a temperature of about 2500° F. After being fused, the molten glass is permitted to cool to about 1800° F., at which temperature it is thick, viscous, and glowing red in color, and can be worked.

The objective of many glass producers is the flawless and transparent colorless glass commonly referred to as *crystal*. In order to achieve a colorless metal, the ingredients employed must be abso-

lutely pure. This factor is of the utmost importance and the materials used for crystal are always highly refined. They are also invariably subjected to very careful testing, because the presence of the slightest impurity in the ingredients will result in coloration of the glass mass. The most common impurity is iron, which imparts a greenish cast to the glass.

'Decolorizers' are occasionally added to the ingredients of a glass formula to neutralize the colors resulting from the possible presence of minute impurities. Manganese tends to neutralize the green resulting from the presence of iron; however, if too much manganese is employed, a pinkish tint will result, and, even when the manganese is used in proper proportions, the resulting glass mass frequently takes on a dull and grayish cast.

The most common flaw in crystal is the presence of bubbles, which are caused by air incorporated in the molten glass or by gases formed in the melting process. A glass that has been melted at a high temperature and over a sufficient time interval will possess a minimum of these imperfections, but glass is rarely entirely free from them.

A disadvantageous characteristic of transparent glass is that there is a loss of sculptured surface values and many carved works in crystal are finished with rough and opaque surfaces secured by means of acid or fine sandblasting, so that the modeling of the sculptured mass becomes apparent. This surface treatment is generally restricted to the carved or engraved portions, so that the areas of clear and polished transparent crystal functions as contrasting background.

COLOR IN GLASS

Glass has the property of dissolving many metals or metallic oxides, with the resulting production of colors that are peculiar to the specific metal or oxide employed. Some of the coloring agents and the colors they produce are as follows:

1. Ruby glass generally contains either colloidal gold or selenium. An amethyst to violet color can be achieved by the addition of minute amounts of manganese dioxide.

2. Blue glass can be produced by the use of cobalt silicate. The use of oxide of cobalt will yield a beautiful blue tint.

3. Green glass is generally produced by iron in the form of ferrous oxide. Ferric oxide does not appear to effect an appreciable color change. Green can also be achieved by oxide of copper or sesquioxide of chromium.

4. Greenish-yellow glass is colored by sesquioxide of uranium.

5. Brownish-yellow glass can be produced by the use of finely divided charcoal.

6. Yellow glass generally contains antimonial oxides.

7. Red glass can be secured by the addition of suboxide of copper.

8. Black glass is produced by a mixture of oxides of cobalt and manganese.

THE CASTING OF GLASS

While in a molten state, glass is flexible and ductile. The process of casting glass consists of 'pouring' or dropping molten glass into a heated mold and forcing the somewhat sluggish material into all portions of the negative mold by the exertion of pressure supplied by a hand-operated plunger. When the mass has been adequately cooled, it can be planished and polished.

Old glass can be remelted, but it will never yield good and clear castings.

Plaster negative molds have been employed industrially for the casting of glass, but as molten glass has a tendency to fuse or combine with the calcium of a plaster negative, the material is not recommended as a containing vehicle for glass.

Iron molds are the best type of negative for the casting of glass.

ANNEALING GLASS

A recently finished glass mass invariably retains a high degree of heat, and after it has been cast or modeled, the mass must be annealed or slowly cooled or it may fracture spontaneously as a result of the excessive physical strain produced by quick and improper cooling.

The industrial annealing or cooling process takes place in specially designed ovens or 'leers,' in which the glass object is slowly carried along on an endless belt through a series of steadily decreasing temperatures.

Annealing is a delicate and long-term procedure, requiring from about five to an almost limitless number of hours, depending upon the size or proportions of the glass mass. The 200-inch Mount Palomar telescope lens required over a year to cool slowly at a temperature of about 1° each day.

Glass that is quickly cooled generally possesses a great surface tension. *Rupert's drops,* formed by allowing fused glass to drop into

water, have a surface tension so great that a slight surface scratch will cause the glass mass to fracture into many fragments.

The literature on glass as a sculptural medium is relatively limited. Glass can be modeled to a limited degree while the material is hot and plastic; it can be cast into molds and finished mechanically, and it can be etched with acid, cut with abrasive stones, or engraved by copper wheels fed with fine abrasives.

There are three methods of decorating a glass surface:

1. Hydrofluoric acid baths
2. Sandblasting
3. (a) Cutting;
 (b) Engraving.

ETCHING GLASS

The use of hydrofluoric acid (H_2F_2) as a means of superficially decorating a glass surface is not recommended. The acid is very caustic, is difficult to control, and the results generally achieved are fairly coarse. The process consists of coating the glass surface with a resinous protective mixture, which protects the areas not to be attacked by the acid. An entire work may be covered with the etch-resist by dipping. After the protective material has set, the areas to be exposed to the acid are scratched away with a sharp and pointed tool, and the object is ready for the acid bath.

SANDBLASTING GLASS

The sandblasting of glass is another rather crude method of surface decoration. The process consists of protecting all surfaces that are to be preserved with an adhesive paper. The work is then subjected to the sandblasting and the exposed areas become abraded and pitted.

GLASS CUTTING

The cutting and engraving of glass are achieved by mechanical abrasion of the cold glass surface. The area to be worked is pressed against revolving wheels or discs of hard substances and the glass is slowly worn away. Iron, carborundum, and sandstone wheels are employed for this purpose, as are copper wheels fed with abrasives.

GLASS ENGRAVING

The art of glass engraving was developed in Flanders during the seventeenth century and remains the most satisfactory method of

sculpturally decorating a glass surface. Glass engraving is a shallow intaglio process in which the forms are worn away beneath the surface of the glass mass by means of slow abrasion. It is interesting to note that engravings in glass, by optical illusion, appear to be raised or in bas-relief, and the deepest portions of the sunken design will appear highest or most prominent.

The process of glass engraving is slow and delicate, requiring great patience and a high degree of skill. The tools employed consist of a small lathe into which are fitted long-handled copper wheels, small hand machines, or motors with flexible shafts, which are employed in much the same manner as are the drills operated by dentists.

Wheels are fed with an abrasive composed of linseed oil and fine emery powder and they slowly abrade or grind away the cool, annealed glass.

The glass engraver rarely works directly with his material, but first prepares a graphic or three-dimensional design, so that most 'carving' or glass engraving is, fundamentally, a process of transcription.

The fine copper wheels generally employed in glass engraving vary from a fraction of an inch up to about four inches in diameter.

Glass engraving is a process of 'drawing' on the glass surface with the small revolving copper wheels. In working with a lathe, the glass object is pressed up against the revolving wheel. The abrasive mixture drips from a strip of leather suspended immediately above the working edge of the wheel.

In engraving glass the background can be abraded or cut away or the forms proper can be cut. The former method results in a design in bas-relief. However, the latter method is that generally employed and is more economical in terms of time and energy (except in rare cases where the design area exceeds the unworked surface area), and results in sunken relief or intaglio.

MODELING WITH GLASS

When glass is in a red-hot and viscous state it can be worked or shaped into sculptural form with instruments. While the glass is being worked it is very important that the high temperature of the mass be preserved. This is achieved industrially by frequently re heating the glass in small furnaces.

Molten glass can also be permanently joined to other, equally hot glass masses while both are in a hot and viscous state. The solid

crystal elephant (Plate 60B) was worked while it was hot and plastic. The ears, eyes, tusks, and tail were shaped separately and joined to the main glass mass while all were at an equally high temperature.

SMOOTHING AND POLISHING GLASS

The processes of etching, sandblasting, and engraving glass all result in rough and white abraded glass surfaces. (Plate 60D.) For smoothing abraded glass surfaces, fine sandstones are generally employed. (See Plate 60C.)

Polishing can be done by the use of wooden wheels, which are fed with a mixture of finely powdered pumice and water and rottenstone. Brushes and felt wheels are also employed and are generally fed with putty powder to finish the glass surface finely. However, if the smoothing and polishing of the engraved areas are not carefully controlled, the smoothness, transparency, and polish of the glass will be fully restored and there will be a resultant loss of desired contrast between the opacity of the worked area and the unworked transparent and highly polished crystal background.

The chemistry of glass is quite complex, and many designers of sculptural glass work in another medium, which is eventually transcribed or reproduced in glass by skilled artisans after the glass formula has been prepared by industrial producers.

It is quite practical, however, for the sculptor to work his own crystal, providing, of course, that he has sufficient time and patience.

Designs in glass can be cast rough and finished by grinding, or geometrical blocks of crystal can be obtained by order from industrial producers of glass, and then slowly ground by the sculptor into sculptural form.

HORN AND BONE

Centuries ago, particularly in prehistoric times, horn and bone of animals were frequently used as sculptural media, but they are rarely used today.

Bone and horn or antler bone are chemically the same as ivory, but are less dense and compact. Some varieties are harder than ivory and others are softer. The leg bone and the foot of the camel are probably the best for carving purposes. The antlers of the reindeer, caribou, red deer, and American elk can also be used for carving. Many people object to the use of horn, bone, and ivory, since, to

secure any of these minor sculptural materials, the animal must be slaughtered.

Bone is not desirable for sculptural use because suitably dense varieties are difficult to get, and organic matter, such as marrow and gelatinous tissue, have to be adequately removed or thoroughly dried or they will decompose. Bone, horn, and ivory also have the undesirable tendency of gripping or binding the knife or chisel. (*See also* Ivory.)

ICE AND SNOW

Ice and snow are impermanent materials in all except the frigid zones and, therefore, cannot be considered seriously for sculpture.

There have been rare and isolated instances of sculptors working with snow. During the Italian Renaissance, Piero de' Medici is said to have commissioned the youthful Michelangelo to fashion a statue of snow, and a great deal has been said regarding this manifest lack of taste on the part of Piero.

IVORY

Ivory has been cherished as an artistic medium from ancient times and it has been used by almost every people. Prehistoric ivory carvings (see Figure 15) have been discovered in the caves of Dordogne in France, and the material is frequently mentioned in the Old Testament. Both the Egyptians and the Assyrians made use of it for sculptural and decorative purposes, and the remains of many ivory statuettes have been found in Egyptian tombs. In the East, the Chinese and Japanese have skillfully carved ivory from Antiquity. (See Figure 16, also Figure 17 for tools used by Hindu carvers.)

Ivory was very important to the Greek sculptors. Phidias employed it in his statue of *Olympian Jupiter*, which was reputedly of superb beauty. At the time, it was generally considered one of the things a person must see before he died.

Possibly the most famous sculptural application of ivory was made by the Greek sculptors in fashioning their chrysclephantine statues in which gold and ivory were used together. The precise methods employed are not known. There was a combination of flesh portions, which were fashioned of ivory, and drapery, which was made of sheets of gold. Some authorities believe that the ivory flesh portions

and the gold drapery may have been applied over a wooden core or framework.[8]

Until recently there were only a few fragmentary specimens extant of these statues of the Greek Classical period. In the Spring of 1939, French archaeologists discovered at Delphi fragments of three life-sized chryselephantine statues and five smaller ones, in addition to iron bolts, nails, and bonds, which may have been used in constructing the armature or framework for the gold and ivory parts.[9]

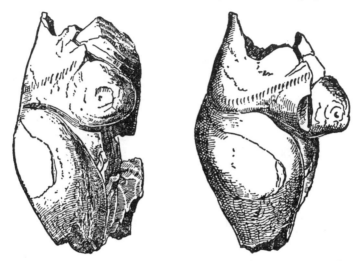

Fig. 15. VENUS OF BRASSEMPOUY (Hofmuseum, Vienna)

Ivory is an organic material secured mainly from the tusks of the African and Indian elephants, the walrus, narwhal, hippopotamus, and some wild pigs. In the strictest sense, it is the tusk material of the elephant, although all mammalian teeth have dentine, which is structurally and chemically identical with the ivory substance, as their major constituent material. Broadly, therefore, any teeth sufficiently large and containing a high proportion of dentine may be used in sculpture and referred to as ivory.

Ivory is less brittle than bone. It is a fairly dense material, with close and compact pores, and it takes a beautiful, high polish.

Pangani or *green ivory* is generally regarded as the finest variety of ivory. The material is exported from Pangani, on the eastern coast of Africa. It is a hard, heavy, and fine-grained variety. *Cape ivory* is a

[8] Richter, G. M. A., *The Sculpture and Sculptors of the Greeks,* p. 139, Yale University Press, 1929-30.

[9] The most comprehensive report is in the *Revue Archéologique,* Series 6, vol. xiv, 1939, July-Sept., pp. 71-4.

softer type, varying in color from white to a yellowish tint. *Ceylon ivory* is generally of a rose-tinted white color.

Recently cut African ivory is semitransparent, with a warm, mellow appearance. Asiatic ivory is softer than African ivory and, although

FIG. 16. NETSUKES DESIGNED TO CONFORM WITH THE SHAPE OF IVORY MASSES

denser, is softer in working, but is more difficult to polish. It also tends to change color or to yellow more readily than African ivory.

Specimens of ivory are generally yellow or brown on the outer surfaces and a snowy white within. The tusk is built up in successive layers, the innermost layer being the most recently produced. The

FIG. 17. HINDU IVORY-CARVING TOOLS

1
2 } *Ári.* Ivory cutting saws.
3

4. The *kenchi.* A tool used to cut thin ivory sheets into strips.
5. *Chhuri.* A paring knife employed in preparing a work for carving.
6. *Chhuri.* A finishing knife.
7. *Sohan.* A file used in finishing larger works.
8. *Sohan.* A rasp.
9. Flat rasp.
10-16. *Birkas.* Chisels.
17, 18. Groovers.
19-24. Files and rasps.

From the *Journal of Indian Art and Industry*

FIG. 17. HINDU IVORY-CARVING TOOLS (*Continued*)

25-29. Drills or *barmás*.
30-34. Points or punches.
35-38. *Randa.* Used for ornamental base work.
 39. *Rethi.* A file.
 40. *Barma.* A drill.
 41. *Kath-Kasht.*
 42. *Parkár.* Compasses.
 43. *Hathouri.* Hammer.
 44. *Purkár.* Fixed compasses.
 45. A drill-bow.

heart or core of a tusk is quite homogeneous structurally, but at the base there is a considerable hollow area, tapering conically for a distance from the bony socket toward the middle of the tusk.

The tusks of the elephant vary in weight from a few ounces to over 100 pounds each. The main source of ivory and the largest tusks are secured from the African elephant. These often reach a length of as much as 9 feet and quite frequently exceed 100 pounds in weight.

The curved or canine teeth of the hippopotamus are extremely dense and hard. They are closer grained than elephant ivory and quite hollow with less solid material to carve. Their use is restricted sculpturally to small works, because even in an old animal only about six inches of the tooth is solid. The hard outer enamel is generally removed by means of acid prior to working.

Walrus ivory is coarser than hippopotamus ivory, and not as dense. It is usually oval in shape and quite fibrous, with a bonelike inner core.

Ivory is a difficult material to carve and requires very sharp steel tools. It is, however, easily filed or cut with saws. The expense of ivory as a sculptural medium has unfortunately fostered the hiring of professional pointers of the material, particularly for large works.

Few tools are required for ivory carving. A type of bow saw similar to a jig saw is used to cut the tusks into lengths or slabs. The other tools are similar to those used by the wood carver: knives, gouges or chisels, and mallets, rasps, and files. Ivory carving does not require special training such as might be required for wood or stone sculpture. The nature of the medium and the best manner in which to work it are fairly quickly mastered. Ivory should be cut gently and carefully with the grain. A wood vise is occasionally of value to hold the ivory mass securely while it is worked with tools, but the clasping surfaces of the vise should be adequately insulated with thick strips of soft leather or felt to prevent any surface injury to the ivory from pressure. While bone frequently requires treatment or preparation before it is used sculpturally, ivory does not require special treatment.

For polishing ivory a gentle abrasive such as fine pumice stone is applied with a dampened, soft cloth. A finer abrasive, such as whiting, is generally used after the pumice, and this also is applied with a soft and dampened cloth for the final polishing.

Hard, dry, and generally bright ivory is harder to cut with saws or chisels and is more susceptible to cracking and warping than is soft ivory, which contains more moisture and appears to resist tem-

perature and humidity better. Nevertheless, the use of a well-seasoned ivory is regarded as an important factor in ivory sculpture.

If atmospheric conditions of temperature and humidity are not ideal, ivory may be subject to cracking, warping, and an unequal shrinkage. Moistening ivory as a protective measure against splitting and cracking from excessive drying was practiced by the Greeks. Because of the dry air in Athens, particularly on the heights of the Acropolis, water was sprinkled at intervals over Phidias' heroic chrys-elephantine statue of *Athene Parthenos.*

Unseasoned, freshly cut 'green ivory' is preferred in Europe, and many dealers in the material take great pains to prevent an ivory mass from losing its moisture. They frequently wrap ivory in several folds of clean cloth moistened with a solution of sodium chloride and water, and store it away in damp cellars.

Ivory is very difficult to secure in uncut, substantial sizes and this factor, together with the development of plastics, has substantially reduced the use of ivory as a contemporary sculptural medium. In a humane sense, this fact is to be welcomed, since it is extremely diffi-cult to reconcile oneself to the indiscriminate slaughter of animals, such as the elephant, merely to secure relatively small tusks.

Although ivory is fairly permanent, it mellows or changes color as it ages, and it is readily affected by temperature and moisture or humidity changes, which may result in warping and cracking. Water should be used sparingly, if at all, in cleaning a finished ivory work that has been exposed to the air for a substantial length of time, be-cause the moisture may cause the ivory to split. Dry cleaning may be done with a good rubber eraser, and simple brushing will frequently remove superficial dust and stains.

Grease and dry oil film may be removed by the careful application of solvents of either wood alcohol or benzine.

The warping of ivory is a common phenomenon and one that is rather difficult to prevent. A special treatment for a warped ivory carving consists of soaking the work in phosphoric acid until the ivory becomes semi-opaque or slightly transparent. It is then removed from the bath, washed with clean water, and thoroughly dried. The carving will, at this stage, be soft and yielding to pressure, and it may be gently bent back into shape. A current of air should be played over the work until it is thoroughly dried, at which time it will regain its original hardness.

The precise dilution or strength of the phosphoric acid bath is an

important element, and experiments should be made with different acid intensities and small bits of ivory before attempting the treatment on an important work. The precautions to be observed with other acids should also be observed with phosphoric acid.

Grease stains on ivory may require a bleaching treatment with hydrogen peroxide. After the application of the peroxide, the ivory should be washed carefully with clean, cool water and thoroughly dried.

LACQUER

The use of colored lacquer appears to have originated in Asia. The practice consists of applying opaque colored lacquers generally over a wood base. The material is very rarely employed in the Western world as a medium or sculptural adjunct, for while strong color notes are possible by the use of lacquers, the substance completely masks and obliterates the textural qualities of the material it covers, like a heavy, opaque blanket of colored paint. Films of lacquer tend to harden and to become brittle as they age. For this reason plasticizers must be added to a lacquer formula.

Ossip Zadkine has attempted to combine wood carving with lacquers as a surface-finishing media.

LIME MORTAR

Lime is an ancient matrix. It was known in Antiquity that varieties of lime, subsequent to setting, would resist the action of water.

When limestone or pure chalk is calcined, the substance is broken down, carbon dioxide is given off, and quicklime (CaO) remains. This lime reacts violently when it comes into contact with water, yielding *slaked lime*. A mixture of slaked lime, sand, and water constitutes *common mortar*.

Lime can be used as a matrix in the following formula, containing very finely powdered glass and marble dust as aggregate:

'BEERITE' [10]

	Parts by weight
Very fine marble dust	100
Very fine powdered glass	15
Very fine freshly slaked lime	7

[10] Clarke, Carl D., *Molding and Casting*, p. 276.

The powders should be carefully mixed and sifted. A thin, aqueous solution of sodium silicate is added to the mixture and the positive material may then be poured into the negative mold. About 4 hours are required for the positive to harden completely.

OXYCHLORIDE OR MAGNESITE CEMENTS

The magnesite cements, which are also referred to as *Sorel cements,* and as *magnesium oxychloride cements,* were discovered by the French scientist Sorel, in 1853. He found that when zinc chloride was mixed with zinc oxide, the materials united to form a product possessing great hardness and physical strength. It was subsequently discovered that mixtures of magnesium chloride and certain types of magnesium oxide behaved in a similar manner.

The magnesium oxychloride cements are used extensively by the building industry in making composition floors. They are also employed sculpturally for making three-dimensional sketches and for the casting of positives. Some contemporary sculptors, notably Amino, have recently experimented with this material as a sculptural medium.

In making the substance, crude magnesite or magnesium carbonate is calcined under special temperature control in a rotary kiln. This drives off the CO_2 leaving the caustic-calcined magnesite or MgO. About 50 per cent of the weight of the original crude magnesium carbonate is lost during the calcination, so that when a ton of the crude magnesium carbonate is calcined, it yields approximately one-half a ton of calcined magnesite.

There are also several chemical processes for producing magnesium oxides from sea water, and certain of these oxides are being used for the production of magnesium metal. By special processing and calcining these synthetic magnesites may be used for the caustic calcined cement work. However, the basic material is preferably made from the natural rock carbonate rather than synthetically from sea water. Two important differences of the synthetic magnesites as compared with the natural rock type are, first, a much finer particle size and, second, the cements made from synthetic magnesites shrink in setting instead of expanding as do the natural rock types. The synthetic magnesite is, therefore, apt to crack in the mold and, until further research eliminates this shrinkage characteristic, it will not have the wide application of the natural rock type. It may also be noted in passing that the kiln time and temperature used to calcine the mag-

nesite are important elements in determining the rate of set. The setting time of the cement may be retarded or accelerated by the kiln conditions.

Sand, dry mineral color, marble chips and dust, silica, talc, asbestos and sisal fiber, pumice, wood flour, sawdust, and other natural or artificial light-weight aggregates can be added to the dry cement mix, and this procedure is frequently followed by the sculptors who utilize the material for casting purposes. However, all of the ingredients that are mixed with the caustic calcined magnesite should be perfectly dry at the time of mixing because any free moisture will be absorbed by the magnesite and will prejudice the strength of the cement and the eventual cast.

The percentage of aggregate added to make a casting mix varies usually between about 60 to 85 per cent, by weight. The procedure consists of thoroughly mixing the dry ingredients, after which the dry mix is placed in a water-tight mixing box or bowl and then moistened with the proper solution. The chloride solution and the dry materials should be thoroughly mixed for about 10 minutes and then poured into molds or otherwise formed. The consistency of the mix for pouring should be approximately that of a heavy cream or pancake batter. A stiffer mix (obtained by using less chloride solution) may be used for troweled work.

The aggregates added to the dry mix should usually consist of both a fine aggregate such as silex (ground silica), or marble dust, and a coarse aggregate such as sand or marble chips. Dry mixes, if carefully stored, may be set aside and kept for moderate periods of time, but this procedure is not generally recommended. It is a far better practice to prepare the dry mix as it is needed, or only a day or two in advance of use. Mixes which have begun to set in the bag should not be reclaimed for future use.

Magnesium chloride solutions must be tested with a hydrometer [11] before they are used, and the working range most frequently employed varies from hydrometer readings of 22° to 30° Baumé (specific gravity 1.18 to 1.26).

About one quart of gauging or wetting solution is required to each 5 pounds of dry mix. This proportion varies slightly with the water-absorbing characteristics of the ingredients in the dry mix.

The approximate total volume of gauging solution may be estimated on the following basis:

[11] See *Hydrometry*.

Water	1 gallon
Magnesium chloride 90% by weight	7 pounds
Magnesium sulphate 10% by weight	11 ounces

This will yield about 1½ gallons of solution when the salts have been thoroughly dissolved. The most satisfactory method of dissolving the ingredients is as follows: [12]

a. The water is poured into a container sufficiently large to accommodate the volume increase resulting from the addition of the salts.

b. The magnesium sulphate (10 per cent by weight of the magnesium chloride to be used) is then *thoroughly* dissolved.

c. The magnesium chloride (90 per cent of the total weight of the salts) is dissolved in the magnesium sulphate solution.

d. After the salts have been thoroughly dissolved, the solution should be permitted to stand for about 12 hours. Solutions may be used soon after preparation provided that all of the salts have been completely dissolved by continual stirring. *The gauging solution should never be used if there are any undissolved crystals in suspension.*

The solution should be tested with a hydrometer before it is used. If the Baumé reading is not 24°, plus or minus .05°, the solution can be adjusted to 24° by adding additional water (if the reading is more than 24°), or by dissolving more magnesium chloride (if the reading is below 24°). The Baumé reading should be correct to ½° above or below 24° Baumé, and at between 60° and 70° Fahrenheit.

When a proper solution of magnesium chloride is mixed with calcined and ground magnesite, and suitable fillers or aggregates, there is formed a plastic mixture which sets to a hard and dense mass, increasing in tensile and compressive strength over a period of about 30 days.

The strength of the magnesium chloride solution is an important factor in determining the strength of the cement. If a good magnesium oxide cement is wetted with a 10° Baumé chloride solution (this is fairly weak) the cement will gain little more strength than it would if it were moistened with pure water. A 12° or 15° solution would result in a cement with increased strength, and a 20° solution would

[12] It is very important to adhere to this sequence since it is virtually impossible to dissolve the magnesium sulphate in the magnesium chloride solution. The magnesium sulphate is used to neutralize any free lime which may be present in the dry mix.

yield a fairly strong cement. There is a danger, however, in employing solutions stronger than 27° Baumé. The use of chloride solutions with densities greater than 27° Baumé are not generally recommended, since a crystallization of the excess chloride might occur, or the finished cast might manifest a tendency in damp weather of 'sweating.' This phenomenon is characteristic of magnesite when it is prepared in improper proportions with an excess of chloride, and appears to be more marked when the material is used as a direct medium.

The rate of set of a magnesium chloride cement does not appear to be materially affected by the density of the chloride solution employed.

Magnesite cement is not waterproof, but it appears to resist the action of water fairly well. Moisture tends to weaken the cast object, but the physical strength is regained when the mass dries out.

The strength of a cast magnesite positive can be supplemented by the incorporation of an armature reinforcement constructed of iron or steel. Copper screens can also be employed for this purpose. Steel surfaces are sometimes galvanized before being inserted into the negative mold and the positive material poured. However, the surfaces of metal reinforcements can be easily prepared for introduction into a plastic mix by painting with a good shellac or lacquer.

In casting with magnesite cements, the most frequently used separating medium or parting compound consists of a 10 per cent solution (by weight) of stearic acid in naphtha or carbon tetrachloride. (Castor oil or mineral oils are sometimes used as parting compounds in place of stearic acid.) This solution is applied thinly to the negative mold by means of a brush or by spraying.

Vibration or jarring of the charged negative mold is also practiced in magnesite cement casting, in order to produce a more compact, dense, and bubble-free positive mass.

A cast magnesia positive should be permitted to remain in its negative mold for at least 6 hours after pouring, depending upon the temperature of the surrounding atmosphere. The set can be accelerated by exposing the charged mold to a temperature of about 100° F., but air should be freely circulated about the mold because oxychloride cements evolve heat during the setting process and the mass may become overheated. Too high a temperature may prejudice the strength of the finished cast.

In warm, humid weather, ice may be added to the gauging solution to keep it cool, but additional magnesium chloride must also be added in order to maintain the proper Baumé reading. This will serve to retard the set of the cement. If a solution is warmed in cold weather, the set of the cement will be accelerated.

Oxychloride cement expands slightly upon setting and may adhere to an inflexible negative mold. It is recommended that castings be removed from the mold after setting, particularly if the negative mold is of the rigid type.

After its removal from the mold, the cast can be carefully retouched and sanded if this is necessary, and set aside to cure for at least two weeks at normal room temperature.

To give a specific magnesite cement formula might prove misleading to the sculptor, since desired physical properties frequently vary with the particular requirements of the specific work, and no one formula will fit all conditions.

The Dow Chemical Company gives the following magnesium oxychloride cement mixtures table:

TRIAL FORMULAS FOR MAGNESIUM OXYCHLORIDE CEMENT PRODUCTS

| | Composition of dry mix Flooring | | | Per cent by weight | | Molding mix |
| | | | | Casting mixes | | |
	Stucco	Base	Top	Stone	Marble	
Plastic magnesia	18%	35%	40%	20%	20%	25%
Silex	10	20	..	25
Ottawa silica stucco sand	70	50
Asbestos	2	2	2
Marble flour	45	..	75	60
Wood flour	4
Powdered talc	10
Sawdust	..	10
Pigment	9	5	5	5
Dried river sand	..	33

Above dry mixes should also contain sufficient technical magnesium sulphate to neutralize the active lime compounds in the plastic magnesia. Usually this amounts to 7 weights of technical magnesium sulphate per 100 weights of plastic magnesia.

Gaging solution for all above dry mixes should be 22° Baumé solution of magnesium chloride.

In cast stone mix 100-200 mesh silica banding sand may be substituted for silex with good results where darker colors are involved.

Sculptural forms that are prepared from these materials are not usually permanently exposed out of doors unless given special water-proofing treatment.

OXYSULPHATE CEMENTS

Oxysulphate cements are produced by mixing the calcined magnesite with various aggregates and wetting the dry mix with a solution of magnesium sulphate or Epsom salts, instead of with a chloride solution.[13]

The resulting strength of the set oxysulphate mass approximates that of an oxychloride cast, and resists high temperatures better than do the oxychloride cements, but they possess a lower degree of resistance to moisture than do the latter group.

The set of cast oxysulphate mixes appears to begin on the surface or outer portions of the positive mass in intimate contact with the negative mold, and to harden gradually toward the center of the cast. This reaction is not exothermic as is the oxychloride reaction, but the expansion characteristics are about the same.

PAPIER MÂCHÉ

The term *papier mâché* is derived from the French *papier,* meaning paper, and *mâché,* pp. of *mâcher* (L. *masticare*), to masticate or reduce to a pulp.

Sculpture in paper is an ancient art. The material was used as a medium centuries ago in Persia, Japan, and China, and, more recently, in Europe. Many fine decorative and grotesque festival masks have been fashioned in papier mâché.

The material is, essentially, a fragile one, although it can be a substantial and durable medium. The composition of papier mâché formulas vary. Paper is used as a filler or bulk-supplying ingredient, together with a glue or other adhesive as a binding agent. The nature of the individual formula should bear a direct relation to the type or nature of the work to be undertaken. Fine constituents should be used for fine work, and coarse constituents for large, broadly treated works and as internal strengthening mixtures for reinforcing hollow papier mâché forms.

[13] Usual strength 24° to 26° Baumé.

There are three fundamental manners of using papier mâché as a fine art medium.

1. Casting: (a) simple casting
 (b) pressure casting
2. Building up the mass by the application of consecutive layers of paper
3. Modeling.

PLASTER NEGATIVES

Plaster of Paris molds have been used as containing negatives for fashioning papier mâché forms, particularly for the construction of decorative masks. In a plaster of Paris negative mold, the inner surface of the plaster shell should be treated with a separator. Two or three coats of shellac may be used to seal the pores of the plaster, after which the surface should be very lightly oiled. A mixture of beeswax and turpentine can also be used as a separating medium. This can be prepared by first melting the wax in a double boiler and then adding the turpentine carefully to the warm, fluid wax *after* the container has been removed from the fire. The plaster containing mold should be thoroughly dry. Before the application of the wax-turpentine separator, the plaster mold should be slightly warmed. The separator is brushed into the plaster until the surface is saturated and the pores thereby sealed. Any excess wax should be removed by heating the mold and wiping away at the wax with a clean cloth. After this has been accomplished, the area should be rubbed for smoothness. A few drops of linseed oil can be applied to a clean rag and rubbed over the waxed surface for a final polish before the papier mâché is used.

CASTING

Paper can be soaked in water until it is of a soft and homogenous doughlike consistency. Boiling it will cause a ready separation of the fibers. Glue is added to the soft, moist mass as a hardening or binding agent. A small amount of preservative can also be added at this stage. Plaster of Paris in powdered form can be added to the mixture for additional physical strength and bulk. Finely divided asbestos or pumice powder is occasionally added to the pulped paper-glue mass to form positive material.

The pulped paper mass should be compactly pressed into the mold

and against the plaster negative impression. If the pressure employed is inadequate, the resulting positive mass may dry rough and lumpy and the form will be distorted.

Metal negative molds and metal positive forms or inner cores, which are slightly smaller in size than the negative, are used commercially for mechanistically manufacturing papier mâché reproductions in large quantities. The wet, pulped paper formula is squeezed compactly and firmly between the metallic negative and inner positive with a great deal of pressure, and the paper mass is permitted to dry in place within the mold. This method results in perfect papier mâché positive forms, but metal molds are fairly expensive.

Another method used consists of utilizing sheets of paper that have been soaked in a mixture of paste or glue and water. These are pressed firmly into the plaster negative mold, one layer over the other, until the desired paper thickness has been achieved. The mass should be carefully dried.

BUILDING UP FORM

Possibly the most common method of using papier mâché consists of slowly building up a form by the application of consecutive layers of paper to the desired shape and thickness. Although a paste or glue is used as an adhesive, this is occasionally omitted from the primary layer of paper, which comes into direct contact with the model when decorative papier mâché masks or impressions are fashioned over modeled composition clay or other positive forms. The strips of paper used in building up three-dimensional form should be well soaked or boiled in water. The adhesive can be added to the wetting water.

MAKING A PAPIER MÂCHÉ BUST

In fashioning a papier mâché bust, plaster negative containing molds of 2 or more pieces [14] may be employed.

Papier mâché is applied to the containing surfaces of each negative section until the forms are built up to their desired thickness. Reinforcing strips of thin paper are then added to the inner surfaces of the two positive papier mâché sections at their joining edges, and are carefully trimmed so that they are flush with the joining edge.

The sections or mold halves are now joined together and when the units are in place they are united along the joining edges with

[14] A two-piece negative mold is generally adequate to care for the particular work and is preferable to a mold consisting of more unit parts.

strips of burlap or scrim soaked in plaster of Paris. The inner reinforcing is accomplished by introducing the hand through the opening at the neck or bottom of the negative mold.

Papier Mâché Masks

Papier mâché masks can be fashioned by two methods. One involves the successive application of layers of paper to the outer surface of the original, and the other consists of building up the mask by successively applied layers of paper to the inner containing surfaces of a plaster negative mold. When more than one copy of a mask is desired, plaster negatives are used and the containing surfaces of the mold are treated with shellac and separator before the application of the papier mâché.

The papier mâché mask can be lifted away from the form or mold after the surface of the paper shell has become perfectly dry.[15]

In removing a papier mâché mask from a mold, the paper form should be lifted away carefully so that any undercuts that may be present are gently cleared. The mask should now be set aside to permit the inner surfaces to dry out.

When the mask has been thoroughly dried it can be trimmed down with scissors, retouched wherever necessary, and painted with color, if this is desired. The dry, finished mask can be treated on both the front and back surfaces with shellac or lacquer as preservative measures against the possibilities of soiling and warping.

Use as a Modeling Medium

Papier mâché has rarely been used as a modeling medium to build up finely detailed form, although it can be used for this purpose. The procedure consists of preparing a pulp from scraps of paper mixed with water. This blended pulp is thoroughly dried and ground to a fine powder, after which it is mixed with a glue and a small quantity of potassium hydroxide. The entire mass is then stirred to a fine, smooth paste, which can be modeled with ordinary clay-modeling tools.

Paper

Almost any variety of paper can be used for papier mâché work. Fine tissue paper is regarded by many workers as an excellent me-

[15] Under normal conditions of temperature and humidity, the drying out of the average life-sized mask requires about 24 hours.

dium. Others prefer more bodied varieties. Ordinary newspaper has been very extensively employed, but its major disadvantage is the fact that it is always covered with printed type and the final appearance of the work is not attractive unless the mass is painted over with opaque color.

PRESERVATIVES

Small quantities of oxyquinoline sulphate, salicylic acid, or carbolic acid can be added to the moist, pulped paper mass as a preservative. Some workers favor the use of formaldehyde for this purpose.

DRYING

A recently completed papier mâché work should be dried carefully. It can be dried in a warm place, but precautions should be taken that the temperature is not very high, since quick drying may result in an uneven shrinkage and a warping of the paper form.

WATERPROOFING PAPIER MÂCHÉ

A fairly waterproof papier mâché can be made by adding the whites of eggs or calcium oxide (lime) and glue to the formula. The use of oil, varnish, shellac, or lacquer as a finishing treatment will also serve a waterproofing function. Similarly, if oil colors are used to paint and thereby decorate the finished work, the material will serve to waterproof the papier mâché form.

FIREPROOFING PAPIER MÂCHÉ

The addition of plaster of Paris, chalk or whiting, borax, pumice powder, or asbestos to the papier mâché formula will serve to reduce the combustibility of the finished work.

FINISHING PAPIER MÂCHÉ

A finished work in papier mâché can be oiled or treated with shellac, lacquer, or varnish. The inner surface of a hollow papier mâché form should also receive a protective coating of shellac or varnish. Works in papier mâché, particularly decorative masks, are frequently painted with opaque oil colors.

A formula used by the American Museum of Natural History [16] is as follows:

[16] Butler, Albert E., *Building the Museum Group.* Guide Leaflet Series No. 82, p. 28. The American Museum of Natural History, New York, 1934.

DEXTRINE MÂCHÉ FOR MODELLING OR POINTING UP TREE BARK

4 measures Dextrine
4 measures cold water } boil

Add

5 measures dry paper pulp
1 measure manikin sawdust
7 measures whiting
7 measures plaster } mixed thoroughly together first

The 'set' may be varied by using more or less plaster.

In mixing plaster, fill the pan with water to about half the bulk of plaster required. Sift the plaster into this until it stands dry above the water level. Let stand until the whole is wet, then mix thoroughly with the hand until smooth and creamy. If too thin, the plaster will be weak; if too thick, it will not flow easily.

Never remove plaster from the object being cast until the mixture has become quite warm. At this point it has sufficient 'set' to be removed without breaking.

Always wet a plaster surface where a fresh plaster coat is to be applied.

PLASTICS

A plastic substance is any substance that can be softened and cast, molded, or pressed into a desired shape or form. Industrially, the term has taken on a new meaning, being applied specifically to a rather large group of synthetic materials. (See Plate 61.)

Among the characteristics of many solid plastics are a lightness of weight and the ability to be dyed virtually any color. Plastics are produced in varying degrees of transparency and translucency and will take a high polish. While many varieties are fairly inexpensive, it is frequently quite difficult to secure substantially proportioned units of certain plastics for carving purposes.

VARIETIES

There are many varieties of plastics. The *casein plastics* were invented when Dr. Spitteler of Hamburg decided to make a white 'blackboard' for classroom use. He mixed formaldehyde with sour milk and secured a shiny, bonelike casein plastic. The casein plastics are not satisfactory for sculptural use because of their tendency to absorb moisture and warp. The *ureas* also have a tendency to absorb moisture and swell.

The *cellulose nitrates,* including celluloid [17] and pyroxylin, are highly inflammable and are not to be recommended for sculpture for this reason. They are generally available in thin, small units. Large pieces of *cellulose acetate* are quite expensive.

The *phenolic-formaldehyde condensates* are also referred to as *cast phenolic resins* and are composed principally of carbolic acid and formaldehyde, to which are added catalysts and other materials, such as lactic acid and alcohol. This group is relatively inexpensive, more easily worked than many of the other varieties of plastics that are generally available, and appears to be best suited for sculptural purposes.[18]

The cast phenolic resins are generally prepared commercially by first pouring or casting the material into lead negative molds and then curing by baking the mass for variable periods of time extending in the case of very large castings up to nine and ten days at temperatures as high as 180° Fahrenheit. The cast phenolics do not absorb significant amounts of moisture, are noninflammable, have a fairly high tensile strength, and are about one and a half times the weight or specific gravity of water. They can be secured in almost every color and tint, in either an oqaque or transparent form. However, the standard sizes of many available cast phenolic resins are not very substantial and should the sculptor desire to work a larger block than is normally available, he can advantageously resort to the casting process for fashioning large masses for carving purposes.

Some plastics are available in the form of 'molding powders,' but these are not recommended for sculptural use since they frequently require elaborate equipment to shape them into desired form. Many more varieties are available as solids, in the form of sheets, rods, and tubes of various sizes, and some plastics of the cast phenolic family can be secured in a liquid form and cast solidly or hollow (slush molding) in suitable molds.

Plastics, when employed for casting purposes, are generally more economical than are metal castings such as bronze, and they are, as a group, less fragile and more permanent than plaster of Paris as a positive casting material.

Several types of negative mold material are employed commercially for casting phenolic resins. The lead negative mold, made on a *steel*

[17] Celluloid was the first plastic, having been discovered about 1872.
[18] The Constructivists, *c.* 1914, appear to have been the first to have employed plastics sculpturally.

arbor,[19] is probably the most widely known and the most expensive. These lead molds are fashioned by dipping the steel arbor into a vessel containing molten lead, and then immersing the hot lead-coated arbor in cold water to cool and harden the lead layer.

Plaster of Paris has also been used as a negative mold for cast phenolic resins and is the most economical, particularly when only one copy of a work is desired. When plaster of Paris is employed for fashioning the negative mold, the porosity of the plaster negative should be reduced by the application of a thin, aqueous solution of liquid latex, which is poured into the mold and then poured out, leaving a thin latex coating to dry upon the containing surfaces of the plaster negative. A solution consisting of equal volumes of latex and water can be used for this purpose. After the latex separator has dried, the negative can be charged with the fluid resin.

The flexible variety of negative mold, including the gelatine and latex-rubber types, are recommended for sculptural use, particularly when the object to be cast possesses intricate undercuts. With proper care and drying, the gelatine negative can be used for several castings. However, the latex variety of negative requires less skill in fashioning, and appears to be the finest for this purpose, especially when many copies of a work are desired.

With adequate lubricating agents and care in curing the cast, the life of a rubber mold can be markedly prolonged. Just before casting, the receiving surfaces of a rubber negative may be treated with an alcohol rinse or with a mixture consisting of 9 parts of alcohol to one part of castor oil or glycerine.

To form the rubber negative mold, the original model is coated with successive applications of latex until an adequately bodied negative mold has been built up. After this, a plaster mother mold is fashioned.

Precautions should be observed in preparing and using phenolic resins to avoid the incorporation of air bubbles in the positive mass. Molds may be vented to permit the ready escape of air from undercuts. If mixing is required during the preparation of the resin for use, it should be done thoroughly but carefully. Air bubbles, incorporated in the resin during the mixing process, are removed commercially by applying a vacuum to the fluid resin.

[19] Steel arbors used to fashion lead negatives for casting plastics are precise, machined steel models or positives.

CASTING PLASTICS

Slush casting and slush molding are terms used to describe a process of casting that results in hollow plastic positives. The fluid plastic material is rolled or slushed around in the negative mold until setting begins, after which it generally becomes rigid very quickly and can be removed. However, the plastic mass of some phenolic resins at this stage is generally comparable in consistency to that of soap, and while it may be easily removed and worked, it is still quite soft and should be handled very carefully. Moderate exposure of the mold and its contents to low temperatures is occasionally employed at this stage to harden the plastic positive mass, but this is not always a necessary procedure, because many plastics cure naturally in about a day. Natural curing is generally preferable to the utilization of heat, since baking may injure a rubber negative mold, which should be left intact over the plastic mass during the curing period. The baking temperatures usually employed in curing cast phenolic resins tends to shorten the life of the rubber negative mold, which may thereby yield only one or two positives before it becomes useless as a negative. Solid castings require longer curing periods than do hollow castings.

Accelerators, such as hydrochloric acid diluted with water or alcohol, are sometimes used to hasten the setting of a cast phenolic resin, but the manufacturers of the particular resin should be consulted before accelerators are used, because some accelerators result in a crazing [20] of the positive.

CARVING PLASTICS

Difficulties are frequently encountered in working many varieties of plastics which tend to grip or bind the knife or chisel.

Hesketh, one of the very few sculptors who carve directly in plastics, uses very fine and sharp, flat wood and stone-carving chisels for working plastics into sculptural form. Sandpaper, rasps, and files are then employed for further developing the forms, and different grades of sandpaper, steel wool, and pumice stone are used to complete the piece.

High polishes may be achieved by hand rubbing or by machine buffing.

[20] See p. 51.

Chaim Gross has recently experimented with a block of Catalin [21] and discovered that wood-carving gouges worked very well with this material.

SOAP

Soap is an inexpensive, readily available and easily worked material that is steadily gaining in popularity as a wholesome and interesting avocational carving medium. (See Plate 62.) The major disadvantage of the substance is its marked lack of durability. A work in soap is subject to a degree of physical shrinkage as it dries out and this may result in the development of fine surface cracks, which may in time fracture through the entire piece. As a soap mass dries out there is also a resultant change in appearance, from the soft and attractive surface the block has while it is fresh and possesses an abundance of moisture, to an opaque and dull surface after the bulk of this moisture has naturally evaporated from the mass on exposure to the atmosphere. However, a finished soap carving can be treated with one or two thin coatings of colorless and transparent lacquer, which will serve to prevent the marked evaporation of moisture from the mass. Much of the attractive appearance of a freshly carved block of soap can thereby be preserved, and the permanence of the work substantially increased.

Soap is a physically fragile material and portions of a work possessing elaborate undercuts or projections may easily break off under impact or pressure. The nature of the medium therefore demands that all forms be kept solid and compact.

Simple knives and small hardwood modeling tools are generally used in fashioning soap into significant three-dimensional form. The variety of soap selected should be compact, fairly soft or fresh, and uniformly bodied. Any lettering on a bar, together with the hard, superficial surface formed on exposure to the air, should be cut away before carving is begun. Bars of soap can be joined together by the use of a cementing agent such as sodium silicate for contemplated

[21] Catalin is an economical and beautiful cast phenolic resin normally available in many colors and in varying degrees of transparency and translucency. It carves very much like ivory. The material is noninflammable and is relatively light in weight, having a specific gravity of 1.3. It can be worked with wood-carving instruments, or filed into form with rasps and files. After the carving has been completed, the plastic form can be sanded and buffed or rubbed with steel wool to achieve the high polish this material is capable of taking.

works that are to be larger than available soap sizes. Thin, metallic pins are also used to join bars together.

Since the soap is very soft, knives must be used carefully. The cut or direction of the knife should be toward the body. The hand can be balanced by resting the thumb with pressure on the soap mass while the blade is pulled toward the thumb with the other fingers in much the same manner as a potato or apple is pared. All soap-carving tools should be kept sharp and clean and free from soap particles, to guarantee smooth and even cutting.

A finished soap carving can be polished when dry by careful and gentle rubbing with a soft paper napkin.

TERRAZZO

Terrazzo is a variety of cast stone that has been used rather extensively in building construction, but that has only recently been applied to sculpture.

By utilizing a fairly large, varied-colored aggregate, mosaic effects may be achieved. The medium is particularly suitable for large architectural works, and may be made by mixing Portland cement with differently colored marble chips, about ¼ inch thick. However, the size of the aggregate particles should be determined by several factors, the most important of which are the size of the work and the effects desired.

A plaster negative mold may be used for casting. Wet stone bits are placed against the wall of the mold. A colored cement mix is then poured into the mold and this is hollowed at the center and worked about the stone-chip layer to the desired thickness.

The *Heroic head* by Fasano (Plate 57C) was fashioned in this manner and is about 2 inches thick.

After the mass has completely set, the external surfaces may be further developed and polished with stone abrasives.

Appendix

SCALE OF HARDNESS

Minerals vary substantially in their degree of hardness. For convenience and as an aid in classification, mineralogists have adopted the following scale of hardness, which is also known as *Mohs* scale of hardness:

1. Talc: Easily scratched by the thumb nail.
2. Gypsum: Harder than talc, but can be scratched with the thumb nail.
3. Calcite: Easily cut with a knife, but not very readily scratched by the thumb nail.
4. Fluorite: Can be cut by knife pressure, but less easily than calcite.
5. Apatite: Can be cut by knife pressure, but with difficulty.
6. Feldspar: Can be cut with a knife, but with great difficulty and only on thin edges.
7. Quartz: Scratches glass. Cannot be cut with a knife.
8. Topaz: Harder than quartz. Cannot be cut with a knife.
9. Corundum: Harder than topaz.
10. Diamond: The hardest substance known. Cut only with other diamonds.

Some sculpturally used materials classified according to their place in the Scale of Hardness:

Alabaster	1.7	Dolomite	3.5-4.
Alum	2.-2.5	Feldspar	6.
Aluminum	2.	Flint	7.
Amber	2.-2.5	Glass	4.5-6.5
Anthracite	2.2	Gold	2.5-3.
Antimony	3.3	Graphite	0.5-1.
Asbestos	5.	Gypsum	1.6-2.
Barite	3.3	Iridium	6.
Brass	3.-4.	Iron	4.-5.
Copper	2.5-3.	Kaolin	1.
Corundum	9.	Lead	1.5

Marble	3.-4.	Steel	5.-8.5
Palladium	4.8	Talc	1.
Phosphor bronze	4.	Tin	1.5
Platinum	4.3	Wax (0°)	0.2
Quartz	7.	Woods metal	3.
Serpentine	3.-4.	Zinc	2.5
Silver	2.5-3.		

HYDROMETRY

The hydrometer is an instrument used in measuring the density of liquids and based on the principle that the weight of a body floating in a liquid under the influence of gravity will be equal to that of the fluid displaced. The instrument consists of a slender glass tube having a calibrated stem and weighted on the bottom.

There are two types of hydrometers, one used with fluids less dense or lighter than water, and the other designed for use with fluids denser or heavier than water. The latter is calibrated by immersing the instrument perpendicularly in pure water. The stem is then marked at the level of the water and forms the zero of the scale. Fifteen pure standard solutions of common salt (sodium chloride) in water are then prepared containing 1, 2, 3 per cent, etc., of the salt by weight. The hydrometer is then immersed in each of these solutions and the stem is marked at each level. In some cases the instruments are marked up to 80°.

When fluids are to be tested with the hydrometer, they should be poured into a narrow glass cylinder or hydrometer jar, and the hydrometer then carefully placed into the liquid [1] and permitted to float. The specific gravity of the fluid may then be read from the line at which the surface of the liquid meets a calibration mark on the hydrometer.

The external surfaces of hydrometers should be kept perfectly clean and it is recommended that they be washed and dried after they are used, for if dirt or dried solutions accumulate on the hydrometer, the weight of the instrument will be increased and will lead to inaccurate readings.

The hydrometer is considered accurate to within about 0.2 Baumé. When extreme accuracy is required, the pycnometer or specific gravity bulb is generally used.

[1] Liquids are generally read at ordinary room temperatures of 70° F., unless otherwise specified in formulas.

MELTING POINTS OF METALS AND ALLOYS [2]

Metal	Approximate	Metal	Approximate
Aluminum	1220° F.	Iron, ingot	2795° F.
Beryllium copper	1750	Iron, wrought	2700-2750
Brass	1650	Lead	620
Admiralty brass	1715	Lead, antimonial	477-554
Naval brass	1625	Lead, chemical	620
Red brass	1830	Monel, cast	2400-2450
Yellow brass	1710	Muntz metal	1660
Aluminum bronze	1940	Nickel	2646
Manganese bronze	1645	Nickel silver	2000
Nickel bronze	1970	Palladium	2831
Phosphor bronze 5%	1920	Platinum	3225
Silicon bronze	1865	Silver	1761
Chromium	3275	Stainless steel	2550
Copper	1980	Tin	449
Gold	1945	Zinc	786
Iron, cast	2150		

APPROXIMATE MELTING TEMPERATURE OF SOME ALLOYS OF TIN AND LEAD

Tin	Lead	M.p.
		449
		620
25 to	75	452
28	72	446
30	70	440
33⅓	66⅔	416
35	65	406
38	62	390
40	60	384
42	58	377
45	55	368
46	54	365
50	50	356
52	48	352
54	46	347
56	44	346
58	42	348
60	40	350
62	38	354
64	36	355
66⅔	33⅓	349
70	30	345
75	25	352

[2] Compiled from several sources.

SPECIFIC GRAVITY

The specific gravity of a stone or other substance is the ratio of the weight of that substance to that of an equal volume of water. Since a cubic foot of water weighs 62.5 pounds, multiplying 62.5 by the specific gravity of any substance will give the weight of a cubic foot of the substance. A cubic foot of diabase, which has a specific gravity of 3.12, would weigh 3.12 times the weight of a cubic foot of water (62.5 pounds) or 195 pounds. Sculpturally, this is of importance in determining the weights of blocks of wood and stone and metal.

The specific gravity of varieties of stone and wood may vary somewhat, owing to variable factors of moisture content in both groups. In stone there are also the additional factors of variance in quantity of constituent minerals and the porosity or compactness of the stone.

THE SPECIFIC GRAVITY OF SOME METALS AND ALLOYS [3]

Aluminum, hard drawn	2.7
Antimonial lead	10.90
Brass, average	8.46
Bronze, average	8.85
Chromium	6.9
Copper, annealed	8.89
Gold, cast	19.3
Iron, pure	7.86
Iron, wrought	7.80-7.90
Lead	11.34
Monel	8.60
Nickel	8.8
Nickel-silver	8.75
Palladium	11.5
Platinum	21.4
Silver	10.50
Steel, stainless	7.9
Tin	7.3
Zinc	7.10

TEMPERATURE CONVERSION FACTORS

To convert a Centigrade temperature to Fahrenheit, multiply by 9, divide the result by 5 and add 32. This can also be worked out as follows, arbitrarily assuming that the Centigrade reading is 60°.

[3] Compiled from several sources.

$$F.° = \tfrac{9}{5} \times 60 + 32$$
$$F.° = {}^{540}\!/_5 + 32$$
$$F.° = 108° + 32°$$
$$F.° = 140°$$

To convert a Fahrenheit temperature to Centigrade, subtract 32, multiply by 5 and divided the result by 9. This can also be worked out as follows, arbitrarily assuming that the Fahrenheit reading is 140°.

$$C.° = \tfrac{5}{9}(140°\text{-}32°)$$
$$C.° = \tfrac{5}{9}(108°)$$
$$C.° = 60°$$

TEMPERATURE EQUIVALENTS OF CONES [4]

THE SOFT SERIES

Cone number	When fired slowly 20° C. per hour		When fired rapidly 150° C. per hour	
022	585° C.	1085° F.	605° C.	1121° F.
021	595	1103	615	1139
020	625	1157	650	1202
019	630	1166	660	1220
018	670	1238	720	1328
017	720	1328	770	1418
016	735	1355	795	1463
015	770	1418	805	1481
014	795	1463	830	1526
013	825	1517	860	1580
012	840	1544	875	1607
011	875	1607	905	1661

THE LOW-TEMPERATURE SERIES

Cone number	When fired slowly 20° C. per hour		When fired rapidly 150° C. per hour	
010	890° C.	1634° F.	895° C.	1643° F.
09	930	1706	930	1706
08	945	1733	950	1742
07	975	1787	990	1814
06	1005	1841	1015	1859
05	1030	1886	1040	1004
04	1050	1922	1060	1940
03	1080	1976	1115	2039
02	1095	2003	1125	2057
01	1110	2030	1145	2093

[4] These tables are based upon the results of tests by the National Bureau of Standards.

The Intermediate-Temperature Series

Cone number	When fired slowly 20° C. per hour		When fired rapidly 150° C. per hour	
1	1125° C.	2057° F.	1160° C.	2120° F.
2	1135	2075	1165	2129
3	1145	2093	1170	2138
4	1165	2129	1190	2174
5	1180	2156	1205	2201
6	1190	2174	1230	2246
7	1210	2210	1250	2282
8	1225	2237	1260	2300
9	1250	2282	1285	2345
10	1260	2300	1305	2381
11	1285	2345	1325	2417
12	1310	2390	1335	2435
13	1350	2462	1350	2462
14	1390	2534	1400	2552
15	1410	2570	1435	2615
16	1450	2642	1465	2669
17	1465	2669	1475	2687
18	1485	2705	1490	2714
19	1515	2759	1520	2768
20	1520	2768	1530	2786

The High-Temperature Series

Cone number	When heated at 100° per hour	
23	1580° C.	2876° F.
26	1595	2903
27	1605	2921
28	1615	2939
29	1640	2984
30	1650	3002
31	1680	3056
32	1700	3092
32½	1725	3137
33	1745	3173
34	1760	3200
35	1785	3245
36	1810	3290
37	1820	3308
38	1835	3335
[5] 39	1865	3389
40	1885	3425
41	1970	3578
42	2015	3659

[5] The last four cones were heated 600° per hour.

MILLIMETERS INTO INCHES

Mm.	In.	Mm.	In.
1	0.039	130	5.118
2	0.079	140	5.512
3	0.118	150	5.906
4	0.158	160	6.299
5	0.197	170	6.693
6	0.236	180	7.087
7	0.276	190	7.480
8	0.315	200	7.874
9	0.354	250	9.842
10	0.394	300	11.81
12	0.472	350	13.78
14	0.551	400	15.75
16	0.630	450	17.72
18	0.709	500	19.69
20	0.787	550	21.65
22	0.866	600	23.62
24	0.945	650	25.59
26	1.024	700	27.56
28	1.102	750	29.53
30	1.181	800	31.50
35	1.378	850	33.46
40	1.575	900	35.43
45	1.772	950	37.40
50	1.969	1000	39.37
55	2.165	1250	49.21
60	2.362	1500	59.05
65	2.559	1750	68.90
70	2.756	2000	78.74
75	2.953	2500	98.43
80	3.150	3000	118.1
85	3.346	3500	137.8
90	3.543	4000	157.5
95	3.740	4500	177.2
100	3.937	5000	196.9
110	4.331	7500	295.3
120	4.724	10000	393.7

One millimeter is equal to 0.0393700 inches.

CONVERSION OF SPECIFIC GRAVITY INTO OUNCES AND GRAMS

Specific gravity	Ounces per cu. inch	Grams per cu. inch	Specific gravity	Ounces per cu. inch	Grams per cu. inch
1.00	0.578	16.350	1.51	0.872	24.689
1.01	0.584	16.513	1.52	0.878	24.852
1.02	0.589	16.677	1.53	0.884	25.016
1.03	0.595	16.840	1.54	0.890	25.179
1.04	0.601	17.004	1.55	0.896	25.343
1.05	0.607	17.168	1.56	0.901	25.506
1.06	0.612	17.331	1.57	0.907	25.670
1.07	0.618	17.494	1.58	0.913	25.833
1.08	0.624	17.658	1.59	0.919	25.997
1.09	0.630	17.821	1.60	0.924	26.160
1.10	0.636	17.985	1.61	0.930	26.324
1.11	0.641	18.148	1.62	0.936	26.487
1.12	0.647	18.312	1.63	0.942	26.651
1.13	0.653	18.475	1.64	0.948	26.814
1.14	0.659	18.639	1.65	0.953	26.978
1.15	0.664	18.802	1.66	0.959	27.141
1.16	0.672	18.966	1.67	0.965	27.305
1.17	0.676	19.129	1.68	0.971	27.468
1.18	0.681	19.293	1.69	0.976	27.632
1.19	0.687	19.456	1.70	0.982	27.795
1.20	0.693	19.620	1.71	0.988	27.959
1.21	0.699	19.783	1.72	0.994	28.122
1.22	0.705	19.947	1.73	1.000	28.286
1.23	0.711	20.115	1.74	1.005	28.449
1.24	0.716	20.274	1.75	1.010	28.613
1.25	0.722	20.438	1.76	1.017	28.776
1.26	0.728	20.601	1.77	1.023	28.940
1.27	0.734	20.765	1.78	1.028	29.103
1.28	0.740	20.928	1.79	1.034	29.267
1.29	0.745	21.092	1.80	1.040	29.430
1.30	0.751	21.255	1.81	1.045	29.593
1.31	0.757	21.419	1.82	1.051	29.757
1.32	0.763	21.582	1.83	1.057	29.921
1.33	0.768	21.746	1.84	1.063	30.084
1.34	0.774	21.909	1.85	1.069	30.248
1.35	0.780	22.073	1.86	1.075	30.411
1.36	0.786	22.236	1.87	1.080	30.575
1.37	0.792	22.400	1.88	1.086	30.738
1.38	0.797	22.563	1.89	1.092	30.897
1.39	0.803	22.727	1.90	1.098	31.065
1.40	0.809	22.890	1.91	1.104	31.229
1.41	0.815	23.054	1.92	1.109	31.392

Specific gravity	Ounces per cu. inch	Grams per cu. inch	Specific gravity	Ounces per cu. inch	Grams per cu. inch
1.42	0.820	23.217	1.93	1.115	31.556
1.43	0.826	23.381	1.94	1.121	31.719
1.44	0.832	23.544	1.95	1.127	31.883
1.45	0.838	23.708	1.96	1.132	32.046
1.46	0.844	23.871	1.97	1.138	32.210
1.47	0.849	24.035	1.98	1.144	32.373
1.48	0.855	24.198	1.99	1.150	32.537
1.49	0.861	24.362	2.00	1.156	32.700
1.50	0.867	24.525			

In converting to ounces per cubic inch, multiply the specific gravity by 0.5778. In converting to grams per cubic inch, multiply the specific gravity by 16.35. To compute specific gravity, multiply the pounds per cubic foot by .01604. To compute pounds per cubic foot, multiply the specific gravity by 62.4. To compute pounds per cubic inch, multiply the specific gravity by .0361.

Bibliography

The importance of a personal art reference library to the student sculptor cannot be overemphasized, and it should be the conscious objective of each student to build up intelligently a comprehensive collection of this nature.

The following list of publications is included for further reading and study. While this list is by no means complete, an attempt has been made to select outstanding and representative works on each topic, and many of the more important references mentioned in the text are repeated here.

A number of the references listed in the following pages contain additional bibliographical listings.

The following publications list extensive bibliographies:

Art Bulletin, vol. xi, no. 3 (Sept. 1929).
Lucas, F. L., *Books on Art, A Foundation List,* Cambridge, Mass., 1936.

INTRODUCTORY READINGS

Gardner, Helen, *Understanding the Arts,* New York, 1932.
McMahon, A. Philip, *The Art of Enjoying Art,* New York, 1938.
Rindge, A. M., *Sculpture,* New York, 1930.
Wilenski, R. H., *The Meaning of Modern Sculpture,* Faber and Faber, London, 1932.

PHILOSOPHY

Collingwood, R. G., *Outlines of a Philosophy of Art,* New York, 1925.
Hildebrand, A., *The Problem of Form in Painting and Sculpture* (Tr. Meyer and Ogden), New York, 1932.
Stein, Leo, *A-B-C of Aesthetics,* New York, 1927.
Torossian, A., *A Guide to Aesthetics,* Stanford, 1937.

For additional reference material consult:

Hammond, W. A., *A Bibliography of Aesthetics and of the Philosophy of the Fine Arts,* New York, 1933.

HISTORY

Chase, G. H., and Post, C. R., *A History of Sculpture,* New York, 1925
Gardner, Helen, *Art Through the Ages,* Rev. ed., 1936, New York.

Robb, D. M., and Garrison, J. J., *Art in the Western World,* New York, 1935.

For biographical accounts of Renaissance sculptors read:

Vasari, Georgio, *The Lives of the Painters, Sculptors and Architects,* tr. by A. B. Hinds, New York, 1927, 4 vols. (Everyman's Library).

A very fine photographic reference set on Egyptian, Mesopotamian, Greek, and Roman sculpture is the following:

Encyclopédie Photographique de l'Art (Le Musée du Louvre), 3 volumes, Editions Tel, Paris, 1938.

CONTEMPORARY SCULPTURE

Casson, Stanley, *Some Modern Sculptors,* Oxford, 1928.
 Sculpture of Today, London, New York, 1939.
Curcin, M., *Ivan Meštrović,* London, 1919.
Hildebrandt, H., *Archipenko,* Berlin, 1923.
Hoff, A., *Wilhelm Lehmbruck,* Berlin, 1933.
Martel, J. J., *Sculpture,* Paris, 1929.
Parkes, K., *Sculpture of Today,* 2 vols., London, 1921.
Powell, L. B., *Jacob Epstein,* London, 1932.
Rewald, John, *Maillol,* New York, London, 1939.
Thorp, J., and Marriott, C., *Eric Gill,* London, New York, 1929.

AGAR

Butler, Albert E., *Building the Museum Group,* Guide Leaflet No. 82, The American Museum of Natural History, New York, 1934.
Clarke, Carl D., *Molding and Casting,* Baltimore, 1940.
Gross, Paul, *A New Negative Mass for Making Accurate Plastic Reproductions,* Archives of Pathology, XIII, no. 6.
Poller, Alphons, *Das Pollersche Verfahren zum Abformen an Lebenden und Toten sowie an Gegenstanden,* Berlin, 1931.

ANATOMY

Thompson, Arthur, *A Handbook of Anatomy for Art Students,* Oxford, 1930.

ARCHITECTURAL SCULPTURE

Agard, Walter R., *The New Architectural Sculpture,* New York, 1935.
Aumonier, W., *Modern Architectural Sculpture,* N. Y., 1930.
Cheney, S., *The New World Architecture,* New York, 1930.

BRONZE

For casting see:

Ashbee, C. R., *The Treatises of Benvenuto Cellini on Goldsmithing and Sculpture,* 'On the art of casting in Bronze,' Edward Arnold, London.
Cellini, B., *Autobiography,* Several publishers. See for Cellini's description of how he cast his *Perseus.*

Johnston, R. W., *The Practice of Direct Casting, Technical Studies in the Field of Fine Arts*, Fogg Art Museum, Harvard University, vol. VIII, no. 4, Apr. 1940.
The Direct Casting of Figures, Technical Studies in the Field of Fine Arts, Fogg Art Museum, Harvard University, vol. IX, no. 4, Apr. 1941.
Lenz, Hugh H., *The Alfred David Lenz System of Lost Wax Casting*, National Sculpture Society, New York, 1933.

For corrosion and treatment see:
Fink, C. G., and Eldridge, C. H., *The Restoration of Ancient Bronzes and Other Alloys*, The Metropolitan Museum of Art, New York, 1925.

CEMENT

Burren, F., and Gregory, G. R., *Molds for Cast Stone and Concrete*, Concrete, Chicago, Illinois.
Childs, H. L., *Manufacture and Uses of Concrete Products and Cast Stone*, Concrete, Chicago, Illinois.
Fingesten, P., *Sculpture in Cement*, American Artist, 7:22-3 Jan., 16-17 F. '43.
Stearn, I. L., *Art Marble*, Proceedings of the American Concrete Institute, 1927, p 220.
Tucker, Walker and Swenson, *The Physical Properties of Cast Stone*, R.P. 389, Supt. of Documents, Government Printing Office, Wash., D. C., also appeared in the Proceedings of the American Concrete Institute, 1932, vol. 28, p. 243.

CERAMIC SCULPTURE

Andrews, A. I., *Ceramic Tests and Calculations*, New York, 1928.
Binns, C. F., *The Potter's Craft*, New York, 1922.
Cox, Warren E., *The Book of Pottery and Porcelain*, 2 vols., New York, 1944.
Griffith, H. R., *Clay, Glazes and Enamels*, Indianapolis, Ind., 1896.
Orton, Edward, Jr., Ceramic Foundation, *The Properties and Uses of Standard Pyrometric Cones*, 2nd ed., May 1937, Columbus, Ohio.
Ries, H., *Clays, Occurrence, Properties and Uses*, 3rd ed., 1927, New York.
Walters, Carl, *Ceramic Sculpture, Tools and Materials*, American Magazine of Art, Aug. and Sept. 1935.

COPPER

Hofman, H. O., *The Metallurgy of Copper*, 2nd rev. ed., 1924, New York.
Rose, A. F., *Copper Work*, 8th ed., Metal Crafts Publishing Co., Providence, R. I.

DRAWING

Blake, Vernon, *The Art and Craft of Drawing*, London, 1927.
Nicolaïdes, K., *The Natural Way to Draw*, Boston, 1941.

ELECTROPLATING

Blum, W., and Hogaboom, G. B., *Principles of Electroplating and Electro-forming*, New York, London, 1924.

FORMULAS

Bennett, H. (Chief editor), *The Chemical Formulary*, New York, 1935.
Prinz, Heimann, *Dental Formulary*, 6th ed., 1941, Philadelphia.

GLASS

Neri, A., *The Art of Glass*, trans. into English by Christopher Merritt,
 London, 1662. Privately printed at Middle Hill, Worcestershire,
 1826.
Powell, H. J., Chance, H., Harris, H. G., *The Principles of Glass Making*,
 London, 1883.
Waugh, Sidney, *The Art of Glass Making*, New York, 1939.

IVORY

Burns, Cecil L., *A Monograph on Ivory Carving*, Journal of Indian Art and
 Industry, vol. ix, no. 75, July 1901.
Kunz, G. F., *Ivory and the Elephant in Art, in Archeology, and in Science*,
 New York, 1916.
Maskell, A., *Ivories*, London, 1905.
 Ivory in Commerce, and in the Arts, Journal Royal Society of Arts,
 Volume 54, Nos. 2815-2817, Nov. 2, 9 and 16, 1906.

JADE

Fischer, H., *Nephrit und Jadeit*, 2nd ed., Stuttgart, 1880.
Kunz, G. F., Ed., *Investigations and Studies in Jade*, New York, 1906.

LEAD

I have not been able to discover any technical reference literature on
the use of lead as a direct sculpture medium. The following is a scientific
treatise:
Hofman, H. O., *The Metallurgy of Lead*, New York, 1918.

MAGNESIA CEMENT

Plastic Magnesia Cements, Dow Chemical Company, Midland, Michigan.
Seaton, Max Y., *Plastic Magnesite and Oxychloride Cement*, Chemical and
 Metallurgical Engineering, vol. 25, p. 233, New York, 1921.

MODELING AND SCULPTURE

Glass, Frederick J., *Modelling and Sculpture*, London, 1929.
Jagger, Sargeant, *Modelling and Sculpture in the Making*, London, 1933.

Lanteri, E., *Modelling*, 3 vols., London, 1904-1922, 2nd ed., Chapman and
 Hall.

PLASTER OF PARIS

Fredericks, F. F., *Plaster Casts and How They Are Made*, 3rd ed., 1927,
 W. T. Comstock Co., New York.
U.S.G. Master Caster Manual, United States Gypsum Company, Chicago.

PLASTICS

DuBois, J. H., *Plastics*, 3rd ed., 1945, American Technical Society, Chicago.

POLYCHROMY

Collignon, M., *Histoire de la Sculpture Grecque*, 2 vols., Paris, 1892-7.
Robinson, E., *Did the Greeks Paint Their Sculpture?* Century Magazine,
 xLIII, 1892, pp. 869 ff.
Solon, L. V., *Polychromy*, Architectural Record, New York, 1924.

SOAP CARVING

Gaba, Lester, *Soap Carving*, Studio Publications, New York, 1940.

STONE

For properties and varieties see:
Kessler, D. W., and Sligh, W. H., *Physical Properties of the Principal Com-
 mercial Limestones Used for Building Construction in the United
 States*. U.S. Bureau of Standards Tech. Paper 349, 1927, 94 pages.
Lent, Frank A. (compiled by), *Trade Names and Descriptions of Marbles,
 Limestones, Sandstones, Granites and other Building Stones
 Quarried in the United States, Canada and Other Countries*. New
 York, 1925, 41 pages.

For weathering and preservation of stone see:
Marsh, J. E., *Suggestions for the Prevention of the Decay of Building Stone*,
 Oxford, Basil Blackford, 1923.
Schaffer, R. J., *The Weathering of Natural Building Stones*, Dept. of Sci.
 and Indust. Research: Building Research Special Rept. 18, London,
 1932, 149 pages.
Warnes, A. R., *Building Stones, Their Properties, Decay and Preservation*.
 London, 1926.

STONE CARVING

Gill, Eric, *Sculpture, An Essay on Stone-Cutting*, St. Dominic's Press, Ditch-
 ling, Sussex, 1925.

TECHNIQUE

Partridge, W. O., *Technique of Sculpture*, Boston, 1895.

For Early Greek methods see:

Casson, Stanley, *The Technique of Early Greek Sculpture*, Oxford University Press, 1933.

For Renaissance methods see:

Vasari on Technique, trans. by L. S. Maclehose, New York, London, 1907.

WOOD

For varieties see:

Howard, Alexander L., *Manual of the Timbers of the World; Their Characteristics and Uses:* revised edition to which is appended an index of vernacular names. Toronto, 1934.

Pearson, Ralph S., and Brown, H. P., *Commercial Timbers of India; Their Distribution, Supplies, Anatomical Structure, Physical and Mechanical Properties and Uses,* Bombay, 1932.

Record, S. J., and Hess, R. W., *Timbers of the New World,* New Haven, 1943.

Reyes, Luis J., *Philippine Woods* (Technical bul. No. 7), Bur. of Science, 1938.

Snow, C. H., *The Principal Species of Wood,* New York, 1910.

Stone, Herbert, *Textbook of Wood,* New York, 1921.
 Timbers of Commerce and Their Identification, New York, 1918.

Wood Handbook, an unnumbered publication of the U.S. Department of Agriculture, Washington, D. C.

For wood carving see:

Durst, Alan, *Wood Carving,* Studio, Ltd., 1928.

Maskell, A., *Wood Sculpture,* London, 1911.

Glossary

Aggregate: The inert or body-supplying ingredient that is mixed with a cement in making a casting mix.

Air vents: Tubes fashioned in a mold to permit air and gases to escape readily when the mold is filled with the molten metal. Also referred to as 'air-jets.'

Akrolith: A statue with head and extremities of stone; the trunk generally consisting of wood.

Alloy: A combination of two or more metals.

Annealing: A method of softening hammer-hardened metal by means of heating and gradual cooling.

Arbor: A term used to describe a master steel-positive mold from which lead negatives are made for casting plastics.

Armature: A supporting framework upon which may be fashioned a work in clay, wax, or plaster of Paris.

Bidri: A variety of metal surface decoration, similar to *niello.*

Binder: A body-uniting adhesive.

Boucharde: A metal stone-carving hammer with striking ends divided into rows of metallic points or teeth. The tool is also referred to as *bushhammer.*

Bronze: A compound of copper and tin to which are sometimes added other metals, particularly zinc.

Bronzing: A term used to describe the process of coloring a plaster cast in imitation of bronze. It is also employed to describe methods of imparting a bronze appearance to other metals and non-metallic materials.

Bush chisel: A hand tool possessing a striking surface similar to the boucharde.

Bushhammer: Same as *boucharde.*

Bust peg: A length of wood attached vertically to a flat, wide wooden board to form the basic foundation upon which a bust may be modeled.

Butterfly: Two pieces of wood bound together with wire in the form of a cross. 'Butterflies' are suspended from the armature and serve to support weight and prevent excessive sagging of plastic earth masses.

Calipers: Measuring compasses.

Carving: The act of cutting wood, stone, or other material into form with instruments, generally chisels. The term is also employed to describe a finished work so fashioned.

Casing: A reinforcing shell generally composed of plaster and serving to support flexible negative masses such as agar, gelatine, and rubber negative impressions.

Cast: A work of art that has been produced by means of a mold.

Casting: A reproductive mechanical process whereby the form of an object is reproduced in another, generally more durable, material.

Cast stone: A highly refined variety of concrete. The term is also used broadly to include other casting materials.

Cement: A binding or body-uniting material.

Ceramics: The potter's art.

Charge: To fill a negative mold with the positive material.

Chasing: A mechanical process of finishing a metal surface.

Chassis: A calibrated framework employed in making an enlarged or reduced replica of a model, which is generally of plaster.

Chipping mold: The act of removing a waste mold from a positive cast by means of hammer or mallet and chisel.

Chisel: A metallic carving instrument, generally fashioned of steel, one end of which serves as the cutting end while the other receives the motivating pressure or blow. The act of carving with or using a chisel.

Chryselephantine: Made of or covered with ivory and gold, as the famous Greek chryselephantine statues.

Cire perdue process: A method of metal casting in which the modeled wax form is melted away and the space left between the core and the outer mold is filled with the molten metal. The process is also referred to as the *lost-wax method.*

Claw chisel: A toothed chisel used in stone carving.

Clay: A term rather broadly employed to include the plastic earths and composition clays.

Clay water: A solution of earth-clay and water of the approximate consistency of milk. The material is employed as a separator to prevent sections of plaster negatives from adhering to each other.

Colossal: Larger than *heroic.*

Composition clay: An artificially compounded oil or wax-base plastic modeling material.

Concrete: A mixture of cement, aggregate, and water.

Cone: See *pyrometric cones.*

Core: A term employed in metal casting to denote the solid internal portion of a mold. The space between the internal core and the external mold investment determines the thickness of the metal casting.

Crystallization: The act or process of crystallizing.

Damascene: To inlay one metal with another metal or material for decorative purposes.

Dead plaster: Plaster that has lost its 'life' by being exposed to dampness. A plaster so exposed will not set hard when it is mixed with water.

Dead stone: A stone that has 'died' from exposure to the elements. When struck with the sculptor's steel hammer it yields a dull, absorbent thud. Limestones and marbles are more frequently affected by this change than are the igneous stones, which are more compact and long-lived.

Direct carving: A method of carving in which the approach is direct and without recourse to preliminary three-dimensional models. Also referred to as *taille directe.*

Electrolyte: A substance that when added to a slip in small quantities, markedly increases the fluidity of the slip.

Electroplate: To cover or to give a metallic coating to an object by means of electric current.

Enamel: A semitransparent, opaque, or colored substance used in coating porcelain or metal surfaces, which are later fired.

Facing: The first layer or intimate application of the negative mold investment material which comes into direct contact with the object that is to be cast in metal.

Faïence: A word derived from Faenza, an Italian center for the manufacture of majolica. The term is broadly applied and has several meanings. Some use it to describe tin-glazed pottery; others to include any variety of glazed pottery save porcelain; and some as a general descriptive term embracing all types of glazed stoneware.

File: An abrasive tool fashioned of metal.

Filler: The inert ingredient(s) used to supply physical body or bulk to a formula.

Firing: The process of baking an earth-clay mass hard, in a kiln.

Flat chisel: A straight-edged chisel employed for stone carving and finishing.

Fume patination: The patination of a metal surface by means of fumes.

Glaze: A vitreous surface coating.

Gouge: A kind of chisel with a curved cutting edge.

Heat of crystallization: The heat evolved during crystallization.

Heroic: Larger than life-size. About 6 or 7 feet in height for full figures.

Hydraulic cement: A cement capable of hardening under water.

Igneous: Formed by the action of fire.

Indirect carving: A method of carving in which the approach is indirect and involves the use of a previously prepared three-dimensional model as a guide.

Intaglio: A variety of incised relief in which the design is sunk below the surface.

Ivory: The hard white substance of the tusks of certain animals, such as the elephant.

Japan: To lacquer with Japan, a hard varnish.

Killed plaster: Plaster that has been permitted to remain too long under water before it is mixed. The material is used for patching defects in a plaster cast.

Kiln: A stove or oven that may be heated for drying, baking, or hardening earth-clay forms.

Life size: Equal to life.

Live stone: A stone that is well preserved or fresh from the quarry, and so suitable for sculptural use. When struck with the sculptor's stone-carving hammer, the mass gives off a clear, ringing sound.

Lost-wax method: Same as *cire-perdue.*

Matrix: The cementing or binding material.

Media: The plural of *medium.*

Medium: The vehicle, material, or instrument employed by the artist: stone, wax, mallet and chisel, etc. The word is most frequently used in referring to materials.

Melting point: The temperature at which the solid and liquid states of a substance are in a condition of equilibrium.

Metamorphic: Igneous or sedimentary formations that have been radically changed by factors such as pressure, heat, and chemical reaction.

Modeling: The act or art of fashioning a work of art in a plastic material.

Mold: The form in which an object is shaped or cast. To fashion in or by means of a mold.

Mother mold: The negative into which the positive material is poured in casting. The term is also used to describe a *casing.*

Naturalism: A close adherence to reality.

Negative: The shell-like impression or mold into which the positive casting material is poured or pressed.

Niello: An ancient method of decorating metal surfaces, consisting of filling designs engraved in the metal surface with a black composition.

Papier-mâché: Pulped paper, used as a sculptural medium.

Pâte-sur-pâte: A method of modeling very low reliefs. The process consists of painting thin, successive applications of slip on a background with a brush. The slip used for this purpose is generally of a paste-like consistency.

Patina: A term generally used in describing the finish or color formed on metals or metallic alloys by natural causes, such as the atmosphere, or by artificial means, such as the application of acids.

Pick: A pointed metallic stone-carving hammer used to crack and chip away large masses of stone.

Piece mold: A negative fashioned in several pieces over a model in order to preserve the original in an undamaged condition. A mold of this type, fashioned of several sections, permits many positive casts to be taken.

Plaster of Paris: A gypsum cement.

Plastic: A material capable of being shaped into desired form by molding, casting, or pressing. The term is also used to denote synthetic industrial materials.

Plastic earth: An earth-clay employed for modeling purposes.

Plastic wax: A modeling wax.

Point: The *punch,* a simple, pointed metal stone-carving tool.

Pointing: A mechanical means of copying from a three-dimensional model.

Polychromy: The art of using many colors.

Porcelain: A variety of terra cotta which fires pure white and translucent at a high temperature range.

Portland cement: A fine type of hydraulic cement.

Positive: The cast achieved by filling a negative mold with the casting material.

Pyrometric cones: Clay bodies that react to kiln temperatures and duration of firing in a manner similar to that in which ceramic bodies react. They are employed in determining and controlling kiln firing temperatures and duration of exposure.

Quarry water: The moisture frequently present in a freshly quarried porous stone.

Quenching: Quickly cooling a heated metal tool, by immersion in brine or oil.

Rasp: A metallic abrasive tool with sharp, pyramidal teeth.

Reinforced concrete: Concrete physically strengthened by metal bars or a network of iron or steel internally incorporated in the mass while it is in a soft and plastic state.

Relief: A form of sculpture in which figures or forms project from a background to which they adhere.

Repoussé: A form of sculpture in which sheets of metal are shaped into desired forms by means of pressure or hammering from one side or alternately from both the front and back of the sheet.

Rock: A term used to denote a crude mass or formation still physically a part of its original earth bed.

Rubbing: A process of smoothing surfaces such as stone by the application of abrasives and friction.

Sculpture in the round: Free-standing, three-dimensional carved or modeled forms.

Sedimentary: Formed by the action of water.

Setting: In casting, the hardening of a material such as plaster of Paris or cast stone.

Slip: Dry earth-clay that has been pulverized to a fine powder and then mixed with water to the consistency of heavy cream.

Slip casting: The process of casting with slip in absorbent negative molds.

Solvent: A substance capable of dissolving another substance.

Squeeze: A positive impression in a plastic material such as wax or clay, taken from a mold by pressing or squeezing the plastic substance against the containing surfaces of the mold.

Statuette: A little statue.

Stone: A mass, block, or fragment, separated from or broken off its original rock bed or formation.

Stucco: A term rather broadly applied commercially to include all varieties of externally applied plastering, regardless of whether composed of lime or cement matrix. *Sculptural stucco* is a refined material consisting of finely pulverized marble as aggregate and either lime, cement, or gypsum as matrix.

Style: A characteristic manner or fashion of working.

Symbolism: Representation by means of symbols.

Taille directe: Same as *direct carving.*

Technique: The method of performance or treatment. The skills, methods, and tools used by the sculptor.

Temper colors: The color changes that appear on a metal surface as it is slowly heated during the tempering process.

Tempering: The process of scientifically regulating the hardness of tool steel.

Terra cotta: Hard, fired earth-clay. The term means 'baked earth.'

Transitory medium: A temporary medium in which a work is begun and worked. The transitory media usually lack permanence and are subject to easy alteration or destruction.

Treatment: The act or manner of manipulation.

Undercut: The part or portion of a three-dimensional object or mold that prevents the safe and easy removal of the positive impression or the negative mold.

Vent: In casting, a channel or passage through which gases can escape from a mold. The act of fashioning channels or passageways in a mold.

Vibration: The mechanical agitation of a mold and its fluid positive contents.

Waste mold: A negative mold destroyed or 'wasted' in freeing the positive cast.

Water of crystallization: Water associated with a substance in the formation of crystals.

Wetting down: A method of testing a block of stone to discover veins and specks by flooding the surface of the stone mass with water.

Index

A CATALOG OF SELECTED DOVER
BOOKS IN ALL FIELDS OF INTEREST

CONCERNING THE SPIRITUAL IN ART, Wassily Kandinsky. Pioneering work by father of abstract art. Thoughts on color theory, nature of art. Analysis of earlier masters. 12 illustrations. 80pp. of text. 5⅜ × 8½. 23411-8 Pa. $3.95

ANIMALS: 1,419 Copyright-Free Illustrations of Mammals, Birds, Fish, Insects, etc., Jim Harter (ed.). Clear wood engravings present, in extremely lifelike poses, over 1,000 species of animals. One of the most extensive pictorial sourcebooks of its kind. Captions. Index. 284pp. 9 × 12. 23766-4 Pa. $12.95

CELTIC ART: The Methods of Construction, George Bain. Simple geometric techniques for making Celtic interlacements, spirals, Kells-type initials, animals, humans, etc. Over 500 illustrations. 160pp. 9 × 12. (USO) 22923-8 Pa. $9.95

AN ATLAS OF ANATOMY FOR ARTISTS, Fritz Schider. Most thorough reference work on art anatomy in the world. Hundreds of illustrations, including selections from works by Vesalius, Leonardo, Goya, Ingres, Michelangelo, others. 593 illustrations. 192pp. 7⅛ × 10¼. 20241-0 Pa. $9.95

CELTIC HAND STROKE-BY-STROKE (Irish Half-Uncial from "The Book of Kells"): An Arthur Baker Calligraphy Manual, Arthur Baker. Complete guide to creating each letter of the alphabet in distinctive Celtic manner. Covers hand position, strokes, pens, inks, paper, more. Illustrated. 48pp. 8¼ × 11.

24336-2 Pa. $3.95

EASY ORIGAMI, John Montroll. Charming collection of 32 projects (hat, cup, pelican, piano, swan, many more) specially designed for the novice origami hobbyist. Clearly illustrated easy-to-follow instructions insure that even beginning papercrafters will achieve successful results. 48pp. 8¼ × 11. 27298-2 Pa. $2.95

THE COMPLETE BOOK OF BIRDHOUSE CONSTRUCTION FOR WOOD-WORKERS, Scott D. Campbell. Detailed instructions, illustrations, tables. Also data on bird habitat and instinct patterns. Bibliography. 3 tables. 63 illustrations in 15 figures. 48pp. 5¼ × 8½. 24407-5 Pa. $1.95

BLOOMINGDALE'S ILLUSTRATED 1886 CATALOG: Fashions, Dry Goods and Housewares, Bloomingdale Brothers. Famed merchants' extremely rare catalog depicting about 1,700 products: clothing, housewares, firearms, dry goods, jewelry, more. Invaluable for dating, identifying vintage items. Also, copyright-free graphics for artists, designers. Co-published with Henry Ford Museum & Green-field Village. 160pp. 8¼ × 11. 25780-0 Pa. $9.95

HISTORIC COSTUME IN PICTURES, Braun & Schneider. Over 1,450 costumed figures in clearly detailed engravings—from dawn of civilization to end of 19th century. Captions. Many folk costumes. 256pp. 8⅜ × 11¾. 23150-X Pa. $11.95

STICKLEY CRAFTSMAN FURNITURE CATALOGS, Gustav Stickley and L. & J. G. Stickley. Beautiful, functional furniture in two authentic catalogs from 1910. 594 illustrations, including 277 photos, show settles, rockers, armchairs, reclining chairs, bookcases, desks, tables. 183pp. 6½ × 9¼. 23838-5 Pa. $9.95

AMERICAN LOCOMOTIVES IN HISTORIC PHOTOGRAPHS: 1858 to 1949, Ron Ziel (ed.). A rare collection of 126 meticulously detailed official photographs, called "builder portraits," of American locomotives that majestically chronicle the rise of steam locomotive power in America. Introduction. Detailed captions. xi + 129pp. 9 × 12. 27393-8 Pa. $12.95

AMERICA'S LIGHTHOUSES: An Illustrated History, Francis Ross Holland, Jr. Delightfully written, profusely illustrated fact-filled survey of over 200 American lighthouses since 1716. History, anecdotes, technological advances, more. 240pp. 8 × 10¾. 25576-X Pa. $11.95

TOWARDS A NEW ARCHITECTURE, Le Corbusier. Pioneering manifesto by founder of "International School." Technical and aesthetic theories, views of industry, economics, relation of form to function, "mass-production split" and much more. Profusely illustrated. 320pp. 6⅛ × 9¼. (USO) 25023-7 Pa. $9.95

HOW THE OTHER HALF LIVES, Jacob Riis. Famous journalistic record, exposing poverty and degradation of New York slums around 1900, by major social reformer. 100 striking and influential photographs. 233pp. 10 × 7⅞.
22012-5 Pa $10.95

FRUIT KEY AND TWIG KEY TO TREES AND SHRUBS, William M. Harlow. One of the handiest and most widely used identification aids. Fruit key covers 120 deciduous and evergreen species; twig key 160 deciduous species. Easily used. Over 300 photographs. 126pp. 5⅜ × 8½. 20511-8 Pa. $3.95

COMMON BIRD SONGS, Dr. Donald J. Borror. Songs of 60 most common U.S. birds: robins, sparrows, cardinals, bluejays, finches, more—arranged in order of increasing complexity. Up to 9 variations of songs of each species.
Cassette and manual 99911-4 $8.95

ORCHIDS AS HOUSE PLANTS, Rebecca Tyson Northen. Grow cattleyas and many other kinds of orchids—in a window, in a case, or under artificial light. 63 illustrations. 148pp. 5⅜ × 8½. 23261-1 Pa. $1.95

MONSTER MAZES, Dave Phillips. Masterful mazes at four levels of difficulty. Avoid deadly perils and evil creatures to find magical treasures. Solutions for all 32 exciting illustrated puzzles. 48pp. 8¼ × 11. 26005-4 Pa. $2.95

MOZART'S DON GIOVANNI (DOVER OPERA LIBRETTO SERIES), Wolfgang Amadeus Mozart. Introduced and translated by Ellen H. Bleiler. Standard Italian libretto, with complete English translation. Convenient and thoroughly portable—an ideal companion for reading along with a recording or the performance itself. Introduction. List of characters. Plot summary. 121pp. 5¼ × 8½.
24944-1 Pa. $2.95

TECHNICAL MANUAL AND DICTIONARY OF CLASSICAL BALLET, Gail Grant. Defines, explains, comments on steps, movements, poses and concepts. 15-page pictorial section. Basic book for student, viewer. 127pp. 5⅜ × 8½.
21843-0 Pa. $4.95

FRANK LLOYD WRIGHT'S HOLLYHOCK HOUSE, Donald Hoffmann. Lavishly illustrated, carefully documented study of one of Wright's most controversial residential designs. Over 120 photographs, floor plans, elevations, etc. Detailed perceptive text by noted Wright scholar. Index. 128pp. 9¼ × 10¾.
27133-1 Pa. $11.95

THE MALE AND FEMALE FIGURE IN MOTION: 60 Classic Photographic Sequences, Eadweard Muybridge. 60 true-action photographs of men and women walking, running, climbing, bending, turning, etc., reproduced from rare 19th-century masterpiece. vi + 121pp. 9 × 12.
24745-7 Pa. $10.95

1001 QUESTIONS ANSWERED ABOUT THE SEASHORE, N. J. Berrill and Jacquelyn Berrill. Queries answered about dolphins, sea snails, sponges, starfish, fishes, shore birds, many others. Covers appearance, breeding, growth, feeding, much more. 305pp. 5¼ × 8¼.
23366-9 Pa. $7.95

GUIDE TO OWL WATCHING IN NORTH AMERICA, Donald S. Heintzelman. Superb guide offers complete data and descriptions of 19 species: barn owl, screech owl, snowy owl, many more. Expert coverage of owl-watching equipment, conservation, migrations and invasions, etc. Guide to observing sites. 84 illustrations. xiii + 193pp. 5⅜ × 8½.
27344-X Pa. $8.95

MEDICINAL AND OTHER USES OF NORTH AMERICAN PLANTS: A Historical Survey with Special Reference to the Eastern Indian Tribes, Charlotte Erichsen-Brown. Chronological historical citations document 500 years of usage of plants, trees, shrubs native to eastern Canada, northeastern U.S. Also complete identifying information. 343 illustrations. 544pp. 6½ × 9¼.
25951-X Pa. $12.95

STORYBOOK MAZES, Dave Phillips. 23 stories and mazes on two-page spreads: Wizard of Oz, Treasure Island, Robin Hood, etc. Solutions. 64pp. 8¼ × 11.
23628-5 Pa. $2.95

NEGRO FOLK MUSIC, U.S.A., Harold Courlander. Noted folklorist's scholarly yet readable analysis of rich and varied musical tradition. Includes authentic versions of over 40 folk songs. Valuable bibliography and discography. xi + 324pp. 5⅜ × 8½.
27350-4 Pa. $7.95

MOVIE-STAR PORTRAITS OF THE FORTIES, John Kobal (ed.). 163 glamor, studio photos of 106 stars of the 1940s: Rita Hayworth, Ava Gardner, Marlon Brando, Clark Gable, many more. 176pp. 8⅜ × 11¼.
23546-7 Pa. $11.95

BENCHLEY LOST AND FOUND, Robert Benchley. Finest humor from early 30s, about pet peeves, child psychologists, post office and others. Mostly unavailable elsewhere. 73 illustrations by Peter Arno and others. 183pp. 5⅜ × 8½.
22410-4 Pa. $5.95

YEKL and THE IMPORTED BRIDEGROOM AND OTHER STORIES OF YIDDISH NEW YORK, Abraham Cahan. Film Hester Street based on Yekl (1896). Novel, other stories among first about Jewish immigrants on N.Y.'s East Side. 240pp. 5⅜ × 8½.
22427-9 Pa. $6.95

SELECTED POEMS, Walt Whitman. Generous sampling from Leaves of Grass. Twenty-four poems include "I Hear America Singing," "Song of the Open Road," "I Sing the Body Electric," "When Lilacs Last in the Dooryard Bloom'd," "O Captain! My Captain!"—all reprinted from an authoritative edition. Lists of titles and first lines. 128pp. 5³⁄₁₆ × 8¼.
26878-0 Pa. $1.00

THE INFLUENCE OF SEA POWER UPON HISTORY, 1660–1783, A. T. Mahan. Influential classic of naval history and tactics still used as text in war colleges. First paperback edition 4 maps. 21 battle plans. 640pp. 5⅜ × 8½.
25509-3 Pa. $12.95

THE STORY OF THE TITANIC AS TOLD BY ITS SURVIVORS, Jack Winocour (ed.). What it was really like. Panic, despair, shocking inefficiency, and a little heroism. More thrilling than any fictional account. 26 illustrations. 320pp. 5⅜ × 8¼. 20610-6 Pa. $8.95

FAIRY AND FOLK TALES OF THE IRISH PEASANTRY, William Butler Yeats (ed.). Treasury of 64 tales from the twilight world of Celtic myth and legend: "The Soul Cages," "The Kildare Pooka," "King O'Toole and his Goose," many more. Introduction and Notes by W. B. Yeats. 352pp. 5⅜ × 8½. 26941-8 Pa. $8.95

BUDDHIST MAHAYANA TEXTS, E. B. Cowell and Others (eds.). Superb, accurate translations of basic documents in Mahayana Buddhism, highly important in history of religions. The Buddha-karita of Asvaghosha, Larger Sukhavativyuha, more. 448pp. 5⅜ × 8½. 25552-2 Pa. $9.95

ONE TWO THREE . . . INFINITY: Facts and Speculations of Science, George Gamow. Great physicist's fascinating, readable overview of contemporary science: number theory, relativity, fourth dimension, entropy, genes, atomic structure, much more. 128 illustrations. Index. 352pp. 5⅜ × 8¼. 25664-2 Pa. $8.95

ENGINEERING IN HISTORY, Richard Shelton Kirby, et al. Broad, nontechnical survey of history's major technological advances: birth of Greek science, industrial revolution, electricity and applied science, 20th-century automation, much more. 181 illustrations. ". . . excellent . . ."—Isis. Bibliography. vii + 530pp. 5⅜ × 8¼.
26112-2 Pa. $14.95